From diamonds to Daimlers, A GARDEN PLANTED WITH PORCELAIN ROSES, A MANTLE SEWN WITH 45,000 FEATHERS, A STAIRCASE FASHIONED OF CRYSTAL, AND TEA SERVED IN A $36 MILLION CUP, HERE IS LUXURY AS PLEASURE, LUXURY AS SPLENDOR, AND LUXURY AS BEYOND. ACROSS 14 CHAPTERS, LONGTIME *VOGUE* EDITOR JILL SPALDING CHRONICLES WHAT LUXURY ENTAILED FOR SUCH OF HISTORY'S ICONS AS CLEOPATRA, CHARLEMAGNE, KUBLAI KHAN, MONTEZUMA, ELIZABETH I, MARIE DE' MEDICI, LOUIS XIV, SHAH JAHAN, AND THE EMPEROR QIANLONG. DISCOVER HOW LUXURY FLOURISHED THE TABLE, THE ARTS, TRAVEL, AND ARCHITECTURE; HOW LUXURY DROVE FASHION, MARKED POLITICS, AND ADVANCED RELIGION.

HOLDING THAT LUXURY REMAINS A GLOBAL PURSUIT, SPALDING LINKS ITS EVOLUTION AND IMPACT TO MODERN-DAY ASPIRATION. HOW DID LUXURY DEFINE THE ROTHSCHILDS, THE VANDERBILTS, THE ROCKEFELLERS, J.P. MORGAN, AND WILLIAM HEARST? WHAT HAS LUXURY MEANT TO COCO CHANEL, ELIZABETH TAYLOR, VALENTINO, DAPHNE GUINNESS, AND LEONARDO DICAPRIO? FIND THEM ALL IN THIS PANORAMIC NEW SURVEY. INFORMATIVE, ENTERTAINING, AND ILLUSTRATED WITH MORE THAN 300 ICONIC ARCHIVAL IMAGES, *LUXURY: A HISTORY* IS A STUNNING, ESSENTIAL READ FOR HISTORY LOVERS, FASHION ENTHUSIASTS, ART AFICIONADOS, AND MORE.

JILL SPALDING

LUXURY

A HISTORY

PARAMETER PRESS
NEW YORK | LONDON

ACKNOWLEDGMENTS

M̲y ardent thank-you list is as long as the 30 years this book has taken to write and reduce down to one volume, but among those without whom I would have had to spend 30 more are: Prince Amyn Aga Khan, Douglas Bergeron, Dr. James Cuno and the team at the Getty Museum, Philippe Daudy, Dr. Layla Diba, Dr. Amin Jaffer, Dr. Navina Najat Haider, Constance McPhee, and their colleagues at The Metropolitan Museum of Art, Rajkumari Hitesh Kaur (Sarah Singh) of Patiala, Professor Frederick Negem, Dr. Sunayana Rathor, HE Sheikha Paula Al Sabah, Tikka Raja Shatrujit Singh ji of Kapurthala, Ivan Shaw and the team at Vogue Archives, Charlie Scheips, Dr. John Walsh, and Selim Zilkha.

PUBLISHED IN THE UNITED STATES BY PARAMETER PRESS, NEW YORK, 2021

DISTRIBUTED BY TWO RIVERS DISTRIBUTION

ISBN 978-1-62097-563-3 (HC)

CIP DATA IS AVAILABLE

THIS BOOK WAS MADE POSSIBLE BY GENEROUS SUPPORT FROM
THE FREDERICK W. RICHMOND FOUNDATION.

COVER AND INTERIOR DESIGN BY SHAWN DAHL, DAHLIMAMA INC

THIS BOOK WAS SET IN WALBAUM AND KLEIN

PRINTED IN THE UNITED STATES OF AMERICA

10 9 8 7 6 5 4 3 2 1

OPPOSITE
SCENE FROM *THE TALE OF GENJI*: LADY-IN-WAITING MURASAKI SHIKIBU'S 11TH-CENTURY ROMAN-À-CLEF, HELD HISTORY'S FIRST NOVEL, INVOLVING A PRINCE, A CONCUBINE, AND THE HIGH ART OF SEDUCTION.

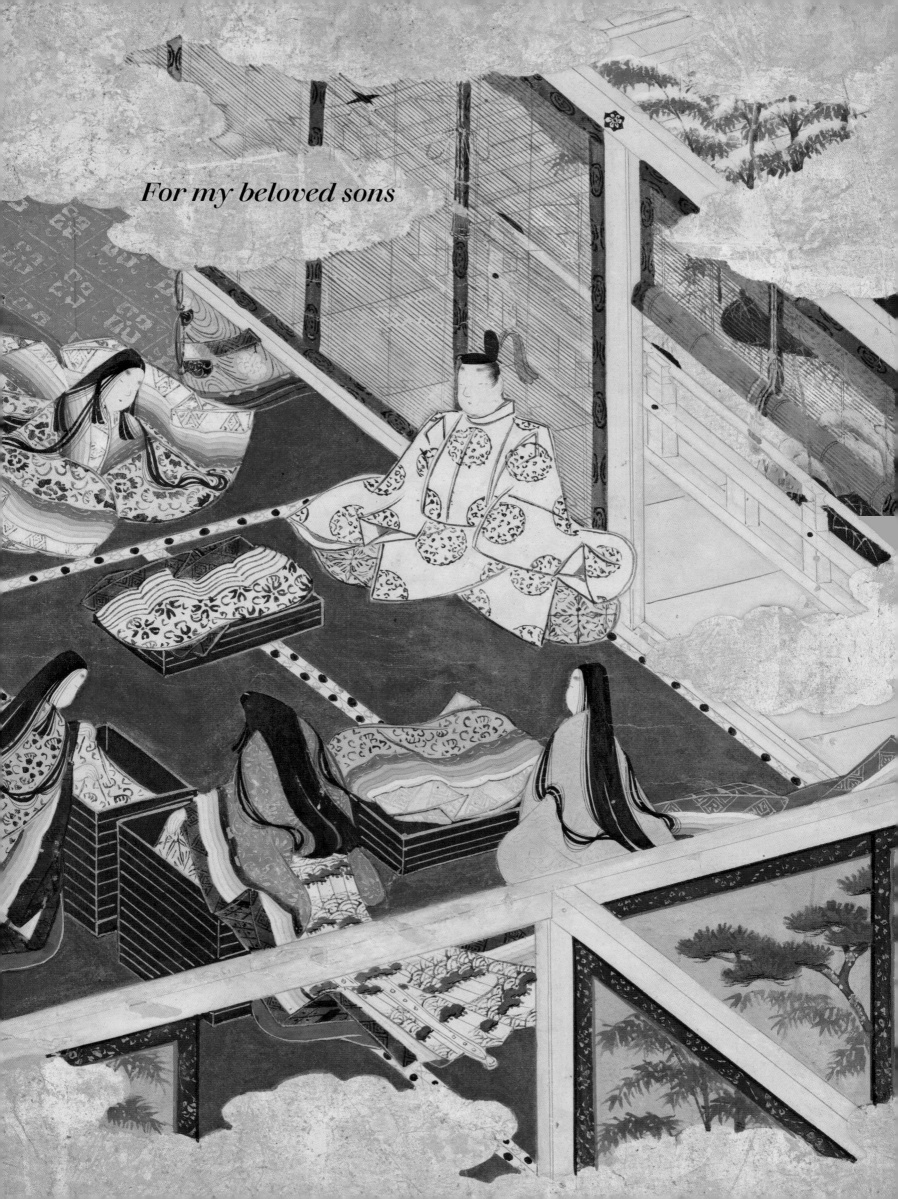

For my beloved sons

CONTENTS

Gladdening, empowering, and addictive, luxury is defined here as a material object or condition that exceeds the necessary, transcends the ordinary, raises self-esteem, and gilds public image.

Relating the history of luxury to that of humankind, this survey tracks its evolution along the great routes of desire, from the perfumes of Arabia and the gardens of Babylon to the court of Versailles and the Crystal Cathedral, to show how the impulse to embellish and outdo has directed the pastimes, politics, beliefs, and aesthetic of the world's major civilizations. As with every broad view, there are lacunae. Not every era or culture is covered under each heading. Early accounts are unreliable and document mainly the elite. As has been said, if fish could write history, history would be about fish. Enough evidence survives, nonetheless, to conclude that the pursuit and attainment of the best and the beautiful has shaped history, and that luxury fully realized has lifted the world.

PROLOGUE

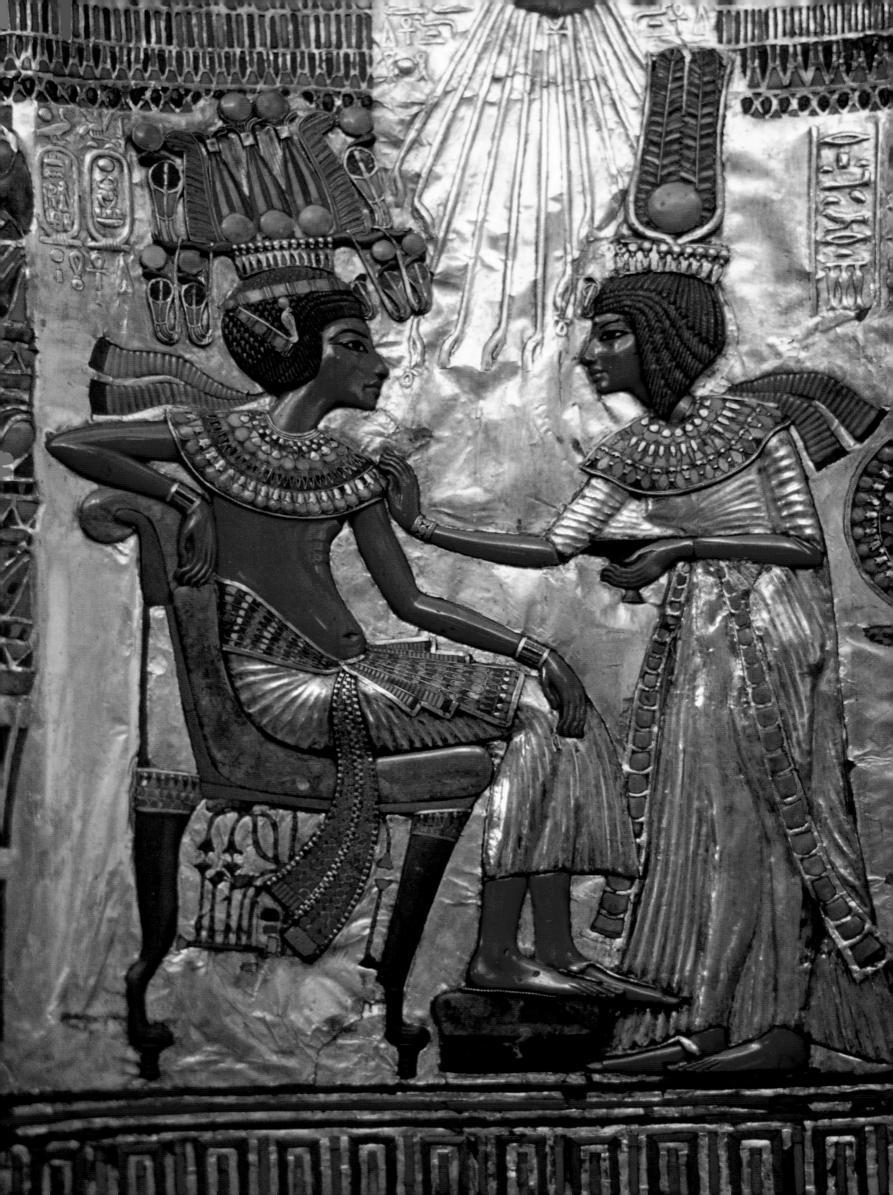

Luxury is riding high and lying low. At once aura and brand, object of desire and signpost of inequality, the luxury permeating our culture is both alluring and suspect. Ascribe the ambivalence to too broad a definition.

Eat, drink, and be merry
ECCLESIASTES 8:15

LUXURY CONSIDERED

Money makes the world go round

PIERRE DE MARIVAUX, *LE TRIOMPHE DE PLUTUS*

Branded luxury is manufactured and marketed to entice. Luxury as addressed here is sui generis, a need born of longing and driven by dreams. Relevant, too, is the distinction between baubles (the pushback against the human condition Thomas Hobbes calls "solitary, poor, nasty, and brutish") and Versailles's Hall of Mirrors (the studied realization of cultivated aspiration). Ultimate luxury, like Prester John's kingdom, is a dream just beyond, a threshold of desire not readily attained. Unlike the coin that Vespasian placed under his son's nose to prove that "money has no odor," luxury's agenda has impacted beyond bounds and reason: deployed for power, it destroyed; engaged for rapture, it regaled. The fallout has been faulted, but never the radiance.

The kingdoms of antiquity posted power with inordinate luxury—Sargon II's waterworks, Khufu's pyramid, Darius the Great's palace. Absolute rule had to rank standing, sign superiority, convey reach. Only Hellenistic royalty might sport a white ribbon, only the Emperor of the Aztecs could suspend a turquoise from his nose, only feudal nobility wore heraldry. So luxury manifested. As wealth spread, the baron aspired to the splendor of the king; the burgher to the status of the baron; the workingman to the wealth of the burgher. So luxury democratized.

The flow chart of material luxury follows the money—the dynamic that historian Niall Ferguson holds "essential to the ascent of man." Visceral luxury, in contrast, is a state of mind. Nero gave his palace jeweled ceilings, pearl-lined cubicles, and perfumed halls before stating, "At last I shall be housed like a human being!" China's literati gave a lifetime to attaining the three perfections of the soundless poem. Renaissance man strove

for *sprezzatura*, the effortful elegance of artful accomplishment. Penultimate luxury is the full realization of self. When the Raj forbade the maharajas to wear crowns, they fixed tiaras to their turbans. When a depletion of silk banned domestic use, Japan's elite had silk robes woven to resemble cotton. Benjamin Guggenheim donned white tie and tails to meet his end on the *Titanic*: "Now we are dressed like gentlemen and ready to go."

Relevant, too, are history's hardships: famine, drought, disease, war—luxury was a pushback against all. To live well and die rich was to triumph. To be prodigally buried was to forestall oblivion. "Tell me where is the sema of Alexander the Great," asked a 4th-century bishop of Constantinople of a tomb never found.

Conditional on era and circumstance, the definition of luxury is relative. For the Greeks anything Cretan: for the Romans everything Greek. The poor value rice: the rich value service. The worker dreams of time off: the jobless dream of time on. The same flowery rocks for which Huizong mortgaged his empire were flung at the Mongols as missiles. Broken pottery discarded in the West was mended in the East with pure gold. Elizabeth I paid the price of a castle for a narwhal tusk thought from a unicorn. And those "mere" beads traded for Manhattan were in fact the day's marvels, worked of never-before-seen Czechoslovakian glass.

As desirables multiplied, addictions grew singular. The Marquise de Breuil was passionate for buttons; John D. Rockefeller Jr. obsessed on Chinese porcelain; Erik Satie hoarded umbrellas. As cultures diversified, desire shifted the goalposts. Secure in her birthright, Gloria Vanderbilt asked: "Everywhere

order, and it was perfect. And it lived with such ease. Is that what luxury meant?" Not to Elon Musk, whose exorbitant dream is "Take us to Mars."

There is, nonetheless, a consensual idea of luxury. Elaborate, exotic, sumptuous, rare, and beautiful pertain. So do extremes—the sublime or the frivolous, the biggest or the smallest, the most or the best: Empress Elizabeth of Russia's wardrobe of 15,000 gowns; the 49 hams that the Prince de Soubise's chef exacted to make a sublime reduction for the 50th; the Brussels tapestries woven with gold "pour le plaisir des yeux"; the 3,000 dishes presented daily to the Emperors of China; Count Borromeo's palace on Isola Bella, so obsessively detailed that patron and architect had died before its completion.

Pleasure is the object, duty, and goal of all creatures

VOLTAIRE

Pertinent, too, is preeminence: the lions Mark Antony harnessed to his victory chariot to vaunt his dominance over nature; the ship Venice built in a day to stun a French king; Korea's Temple of the Golden Pavilion, gilded twice over to vaunt its wealth; Rome's palazzo wars that built the Odescalchi's palace façade twice the length of the Colonna's. Prestige is luxury's prime mover, noted the sociologist Thorstein Veblen, whose seminal theory of conspicuous consumption derived from observing the upwardly mobile spend disproportionately on the filmy cottons and white shoes denoting upper-class leisure.

Compromise has no place here. The art of the deal can't deliver life's superlatives. Nor can luxury's oxymorons—the practical, facile, average, and lucrative. Splendid that illusionist David Copperfield owns an island in the Bahamas, except that he rents it out. Impressive that gallerist Jean-Gabriel Mitterrand owns a sculpture park, were the works not for sale. Shanghai tycoon Liu Yiqian's instant art collection fills four museums but can't match the one that Sergei Shchukin took years to assemble. And those thousand pairs of shoes that Imelda Marcos collected with her ill-gotten gains denote cupidity, not luxury. Coco Chanel rightfully held luxury the opposite, not of poverty, but of vulgarity.

Critical to our story is luxury's arc. As with Joris-Karl Huysmans's fabled tortoise, killed by the gemstones set into its shell, luxury has devastated. Caesar invaded Scotland for its pearls, Spain subjugated the Americas for their gold, a hyper-priced tulip bulb brought down Holland's economy, and Britain's craving for the tea traded for opium cost China her empire.

Luxury at its crudest was the flaming ostrich tongues served at the banquets of Emperor Elagabalus and the dwarves mounted as table décor at Burgundian fêtes. Luxury at its vainest was the affectation of Louis XV's Perfumed Court to wear a different scent every day and Boniface de Castellane's despair when Charles of Portugal turned up in red to a ball that specified white— "flowers, gowns, liveries, all are ruined!" Luxury at its blithest was the yards of fabric given Christian Dior's New Look when post-war Paris was on food rations. Luxury at its vilest entitled robber baron Jay Gould to inform strikebreakers imported during a walkout that he could hire half the working class to kill the other half, and Henry Clay Frick to disregard

Too much of a good thing can be wonderful
MAE WEST

warnings that widening the road to his lake resort would compromise a dam protecting the town, causing a flood that killed 2,000 people. Luxury at its nadir was the human lives thrown at the Great Wall, the marshes of St. Petersburg, and the Suez Canal.

Flip the arc to see luxury's splendor. Luxury fully deployed gave us the Acropolis, the Alhambra, Chartres, Venice, the Taj Mahal. Luxury at its most refined was the time given to weaving a shawl that slipped through a wedding ring, and the care given to orchids that bloom once in a lifetime. Luxury at its most rarefied covered a hill in white silk to convert shogun Ashikaga Yoshimitsu's summer banquet to winter, and placed lanterns in every window of Sultan Amir ibn Abd Al-Wahhab's palace in Yemen so that he could ride into the hills and look down on its glory. Luxury at its grandest glittered the Field of Cloth of Gold for the brinkmanship encounter of Henry VII and François I. Luxury at its subtlest enabled artist Nek Chand Saini's Mughal garden, complete with waterfalls and temples, created in secret on thirteen remote acres of Chandigarh where no one would discover them. Luxury wholly engaged is detailed in the epitaph of Babylon's legendary Queen Semiramis: "I constrained the rivers to flow where I wanted. I pushed roads over mountains. And for all these concerns I found time for my mansions and my passions."

Where is that glory today? Those nostalgic for past splendor sigh that luxury is dead, and as unbridled prerogative, it is. No longer shall cosmic fortunes be spent unaccountably. But dreams of luxury live on. The striver still overreaches to create life as it might be, and the wealthy still relate fulfillment to consumption.

"I have not yet indeed thought of a remedy for luxury," observed Benjamin Franklin, "I am not sure that in a great state it is capable of a remedy.

Is not hope of one day being able to purchase and enjoy luxuries a great spur to labor and industry?" More urgently, routine will prove numbing if we can't gladden leisure, and acquisition will satiate if we don't refine longing. More critically, luxury may prove conducive, perhaps even vital, to the fully realized self: "Life is a pill," held moralist Samuel Johnson, "which none of us can bear to swallow without gilding."

Whatever its fate, luxury won't atrophy; its aura is contagious, its allure seductive, its luster ingrained. "The superfluous," wrote Voltaire, is "a very necessary thing." Even as this paragon of common sense noted of his final years, "We have finally come to enjoy luxury only in taste and convenience," he employed a dozen servants, covered his furniture in red morocco, and acknowleged the inevitable: "Men have declaimed against luxury in verse and in prose for two thousand years, but they have always loved it."

Carpe diem
HORACE

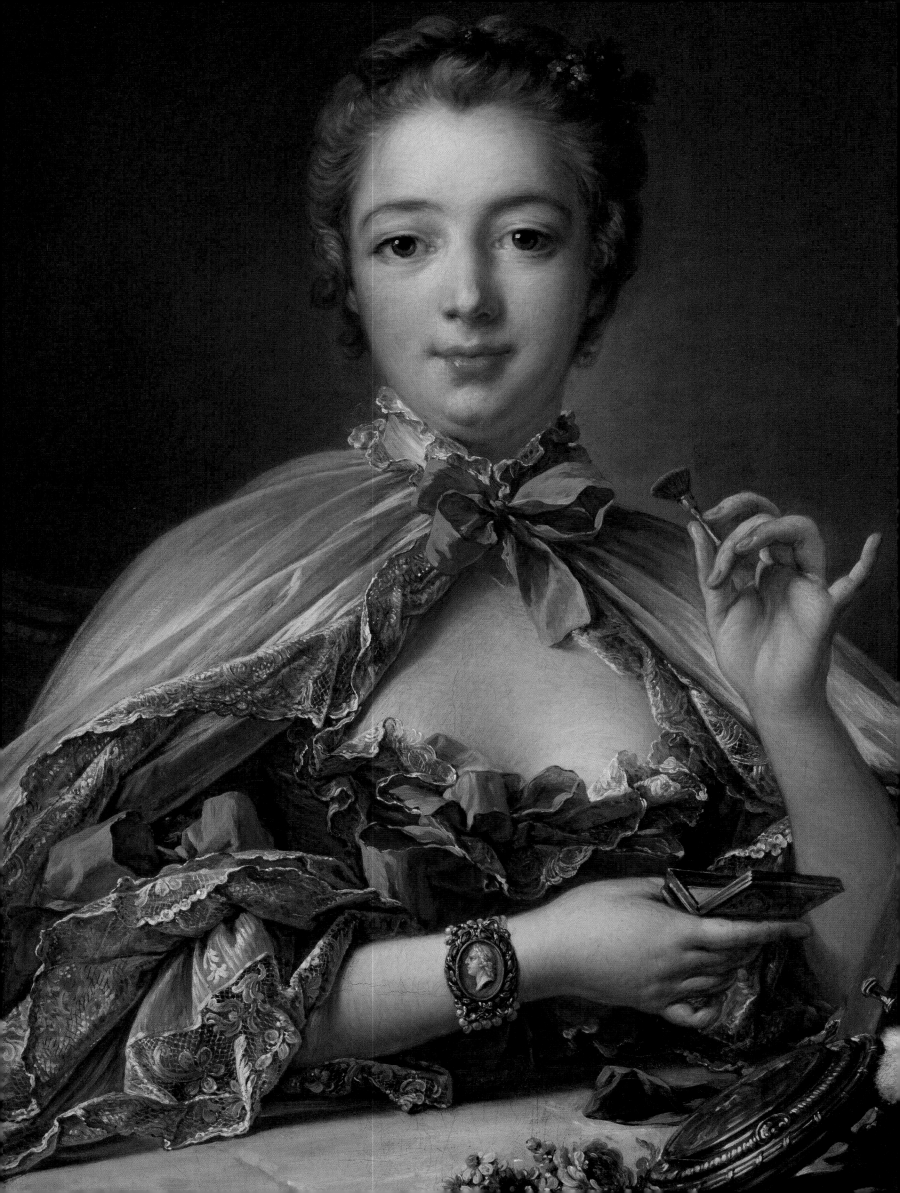

To wash one's hair, make one's toilette and put on scented robes, even if not one person sees me, these preparations still produce an inner pleasure

THE PILLOW BOOK OF SEI SHŌNAGON

INTIMATE PLEASURES

Allure—Bodily form is a given, but beauty is in the eye of the beholder. "There is the 'animal' human being, who is practical," observed the mythologist Joseph Campbell, "and there is the 'human' human being, who is susceptible to the allure of beauty, which is divinely superfluous." Enhancing cosmetics were prized across cultures—in Mesopotamia, such a luxury that they were taken to the grave. Allure for the Hellenes was a body dusted with gold. Cleopatra, whose looks Plutarch held "not altogether incomparable," relied on mascara ground from lapis lazuli and several manicures daily. Edo Japan coded the subtle appeal of lips and eyebrows tinted with crushed safflowers. Imperial China valued black lips and berry-stained nails long as twigs.

The courts of Renaissance Europe called on face patches, eyebrows of mouse fur, and an array of enhancers that made a vanity of the dressing table. Both sexes engaged a crushed-porcelain face cream to designate them indoor creatures of leisure. Pity the parvenu parodied by Count Baldassare Castiglione "who seems to have put a mask upon her face and dares not laugh for fear of cracking it." Marvel at Madame de Pompadour, who worked her makeup routine into a court ritual. And lament the English aristocrats—most famously, Maria Gunning, Countess of Coventry—who succumbed to the deadly lead-whitener, *ceruse*.

Modern-day formulas gave the affluent a pricey arsenal of makeup, leaving the shopgirl to affordable lipstick. Glamorous and sexy, lipstick so raised morale that both the U.S. and U.K. governments declared it a wartime necessity.

Allure's purview has morphed. Yesterday's tribal tattoos are today's emojis, manicures constitute social poster boards, and eyeliners and blushers are but the starter kit of cosmetics devised to enhance and renew. Extending to orchids sourced from the rainforest, an exorbitant menu of luxurious ingredients fuels an industry that posits allure as a commodity and the lavish products that deliver it as an imperative.

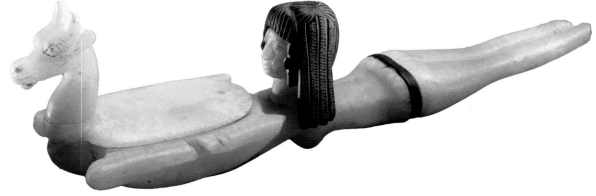

A woman who doesn't wear perfume has no future

COCO CHANEL

Fragrance—Biologists hold that receptors for odor evolved for survival, but poet Count Maurice Maeterlinck differed: "Perfumes are completely unnecessary to our existence, and yet we have been given an organ that rejoices in them. Smell is a luxury dictated by nature." From 1850 BCE, when Cyprus established the first known olfactory industry, perfume permeated the ancient world, masking the stench of decay and infusing the temples.

It was but a short step from pleasing the gods to indulging the self. Egypt developed an aroma of cassia for the body and an extract of roses for the breath. Mesopotamia created the first brand attars, so prized that their inventors were ennobled. Headier scents, thought to possess mystic powers, were sought for seduction. "I'll bathe my belly in incense so that my skin may melt in your mouth," crooned Scheherazade to the ruler she satiated for one thousand and one nights. To attract an eligible princess, King David's robes were infused with myrrh, aloe, and cassia; to seduce King Ahasuerus, Esther steeped in fragrant oils for a year; and Cleopatra, recounts Suetonius, beguiled Mark Antony by dipping her hands once into a pricey perfume then discarding it. The ploy persisted. A diarist at the Ming court noted the emperor's success with a blend of ambergris and opium that left ladies swooning, and France's Henri III was said to have fallen head over heels for Marie of Cleves at the first whiff of her blouse.

If love had no price, vanity did. The caustic Roman historian Pliny the Elder held the aromas of jasmine, violet, and iris wafting in on the trade routes "the most superfluous form of luxury," and assailed "all that money paid for a pleasure that is enjoyed by someone else, for the woman wearing the scent doesn't smell it herself." Worse was the trickledown: "Haven't we seen the last of the Caesars perfume his feet and the least citizen scent the bathroom floors? Even the parade flags are perfumed!"

Regardless, the ages sprayed on. So would Charlemagne return from the battlefield to furnishings scented with civet, and Philip the Good liven his parties with sculpted putti peeing ambergris. Scarcer were the perishable attars of crocus, mimosa, and jasmine from Asia that raised Venice over Baghdad as the go-to luxury marketplace. Scarcest were oud, oliban, myrrh, and the famed balm from Gilead that was imported under armed guard and secured in vaults.

The first bespoke fragrance was "Hungary Water," developed from rosemary for a 14th-century queen of Hungary. There followed a rash of distinguishing formulas, cued by the perfumed gloves given Elizabeth I by the 17th Earl of Oxford (his library still exudes it). Detailed in Huysmans's *À Rebours*, Louis XIII's signature scent "swirled" with iris, musk, and civet; Louis XIV's owed its "pompous allure" to the "mystical, powerful, and austere scents of oliban and myrrh"; Louis XV's combined the "wearying and sophisticated refinements of frangipane and maréchale." It must

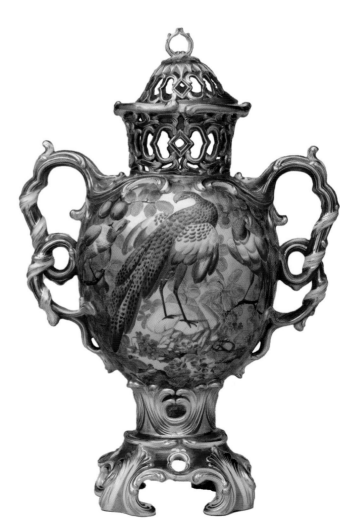

have given Marie Antoinette cold comfort that the perfume she wore to prison evoked the parterres of Versailles.

Status marker or exigency? It spoke to the era's poor hygiene that a pricey scent of violets infused the Tudors' waxy wigs, that Catherine de' Medici waved off the odors of governance with gloves steeped in musk, that Louis XIII assigned the eminent Cardinal Richelieu to spray the dank halls with white jasmine, and that heady tuberoses circled Louis XIV's smoke-drenched bed-hangings. It spoke to privilege unchallenged that Louis XV turned to conceit the profession of *maître de parfums* and instructed the thereby-called "Perfumed Court" to wear a new fragrance daily and scent every need— dress, cushions, paper—even the porcelain roses planted in La Pompadour's garden.

Diluted, the luxury perfumed overcoats, uniforms, and undergarments, surviving revolution for Napoleon to freshen up with 60 bottles of eau de cologne monthly, and for Josephine to saturate her closets at Malmaison with so much musk that during a recent restoration two workers fainted.

Aromatics pervaded the East. Sasanid Persia bathed body and furnishings in rosewater. India imbued every aspect of life—grooming, seduction, hospitality, ritual—with attars sourced from native woods, herbs, and flowers. The Chinese belief that extracting nature's essence transmuted its soul steeped robes, paper, homes, and temples in essence of lilies, jasmine, and chrysanthemums that they might induce the six moods of *heang*: tranquil, intimate, refined, beautiful, noble, and luxurious. The most expensive, oud ("liquid gold"), was held widely transformative—by Taoists, calming; by Buddhists, stimulating; by Muslims, healing.

Greatest was the luxury of a signature scent. Ottoman Mehmed II's carpets, gardens and undergarments exuded *rosa damascena*: "I am the King of Sultans, the Rose is the Queen of the flowers, so we are destined for each other." The true Rose Queen was Mughal Empress Nur Jahan, credited with compounding from the oil of a thousand roses the world's first celebrity perfume.

Today's synthetic scents can't replace the real thing: one kilo of musk costs $80,000 and one ounce of Joy exacts

*The man is happy when
the woman smells of udi*
SWAHILI PROVERB

10,000 jasmine flowers. The process itself is expensive, the "nose" hired to develop an exceptional scent earns more than the French President, and the formulas are so closely guarded that when one of Guerlain's was denied a patent all were reformulated. Supremely luxurious, a timeless fragrance must exude an ineffable aura: "What do I wear in bed?" breathed Marilyn Monroe, "Chanel No. 5, of course."

How, then, offer such a treasure? In the most precious of vials! Objects of high art, incense and perfume containers were fashioned from the day's costliest materials—alabaster, jade, crystal, porcelain. High-end dispensers were gilded (4711), given a silk barbichage (Shalimar), or crafted by artists (Eau du Soir). Aspirants to a perfume encased in 24-karat gold filigree paid $228,000 for Clive Christian's No.1, special-edition, Passant Guardant.

Subsequent designer scents were marketed as collections and rated like wine—five stars for the one that Serge Lutens, self-crowned Emperor of Perfume, combined to evoke a "huge gray ostrich-feather boa to wear with purple devoré velvet at a poet's funeral." Most anticipated was the perfume born of a new hybrid—say, Nevarte, developed over five years from a specially bred rose. Most indulgent was the bespoke scent—$20,000, with a wait of two years for those that Olivier Creed customized for such as Madonna. The reverse-chic alternative was a $30,800 bottle of 'everything,' the "aroma-bouquet" compiled by the Dutch artist team Lernert & Sander from a sampling of the 1,000 new scents put out in 2012.

Ablution—Ritual immersion is as old as the rivers. Bathing for pleasure premiered with plumbing in India 4,500 years ago at Mohenjo-Daro, the world's earliest spa. The Egyptians introduced luxuries. During the reign of Sesostris I, the exiled Sinuhe was thus welcomed on returning from Asia: "I was taken to a princely abode that held a large room for bathing, staffed by the King's attendants, and filled with wonderful things—fine linens, myrrh, and unguents. The past years fell from me with the dirt and rough clothes of my banishment, as I was shaved and combed, wrapped in soft towels, and rubbed with fragrant oils."

The Minoans enjoyed bathing but would have soaked on in streams had not an enterprising queen ordered river water piped to her palace at Knossos, entailing the network of plumbing that enabled the first bathtub. It would be centuries before its equal, but the idea of pampered immersion took hold. Rome's elite headed to Pergamon for Asklepion's mud baths, leaving the public to grandiose public baths, built by the emperors to quell civic unrest. Diocletian's famed compound covered 32 acres with marbled spas, theaters, a concert hall, a library, and

OPPOSITE TOP QING DYNASTY INCENSE BURNER: LUXURY OBJECT ARTICULATED TO PERFUME THE AIR FROM UNDER THE ROOSTER'S WINGS.

OPPOSITE BOTTOM CHELSEA PORCELAIN PERFUME VASE MADE FOR BRITAIN'S WIDENING LUXURY MARKET WITH AN EXCESS OF SCROLLWORK AND OVER-THE-TOP GARNITURE.

RIGHT MUGHAL EMPIRE PERFUME BOTTLE: FASHIONED OF RUBIES AND GOLD, SIZED TO CARRY IN A POCKET.

a gymnasium vast enough for Michelangelo to convert to the great church of Santa Maria degli Angeli. The luxury didn't survive the empire's collapse, but steam baths took hold in Roman outposts like Aix-les-Bains. A diarist noted of the Gauls: "Giddy from the vapor, they get quite excited. The sauna is their substitute for the bath, since they never bathe." The historian Jules Michelet said of the land barons: "they didn't take a bath for a thousand years"—unjustly. Charlemagne himself steeped in Aix-la-Chapelle's boiling waters, and even commoners frequented thermal baths, condemned as "vice pits" by the Church but tolerated by custom. A century later, the fledgling town of Lyon boasted 28 public baths. Their appeal, though, until cinder paste yielded to fine soap from Lebanon, was more diversion than hygiene.

Aborted by the bubonic plague then revived by a fragrance from Cologne that was thought to repel it, the practice went viral. Starved for amusement, the aristocracy took to receiving in scented pools; at Stuttgart, King William I of Württemberg, in the spirited company of Blanche La Flèche, spent up to six hours a day so engaged. An unprincipled clergy disported freely, shedding vestments and scruples to splash among ladies wearing little more than their jewelry, whose locks, like their own, were tied up with silk ribbons. By the 19th century, "taking the waters" translated to the mud baths easing society's dyspepsia, while "spa" referenced the high doings at Széchenyi, Wiesbaden, and Baden-Baden, whose grand opera and palatial Brenner Park Hotel called on a new gown every night. "It's extraordinary these resorts," observed French author Guy de Maupassant, "they are the only fairylands left on earth."

Tycoon America railed to Saratoga Springs in upstate New York for its tonic of racetrack and balls, and to Indiana's West Baden Springs for restorative cocktails under the eponymous hotel's world-wonder dome. San Francisco offered the glass-enclosed baths of operatic dimension, installed by silver king Adolph Sutro:

BATHS OF DIOCLETIAN: ROME'S MARBLE PUBLIC BATHING COMPLEX HELD A WORLD WONDER FOR THE LAVISH EMBELLISHMENTS AND AMENITIES.

I took a bath once a month, whether I needed it or not

ELIZABETH I

"A small place would not suit me, I must have it large, pretentious, in keeping with the ocean itself, so I filled the whole cove."

Eastern ablution evolved around ritual, providing the ancient Koreans "a glow of serenity" and the Chinese "a cleansing of soul." The beauty of the famed seductress, Yang Guifei, said to be so overwhelming it could topple a city, was credited to bathing in tea leaves picked at dawn from a very high peak. Japan's spatial constraints grew communal bathing into festivals, announced weeks ahead, like a great ball in Europe. Fully indulgent, the Turkish hammam inflated to Istanbul's richly tiled public baths—virtual resorts offering restorative massages, relaxation rooms, and warmed, scented towels.

Private ablution had a separate trajectory. The nicety of a bathtub evolved from a hollowed tree trunk to a vanity that inflamed Seneca: "Which Roman today would skimp on his bath? He'd feel like a pauper if its walls weren't jeweled, if its Alexandrian marbles weren't inlaid with Numidian marbles, if its intricate marquetry wasn't inset with precious stones matched to the colors of the walls, if the ceilings weren't mirrored, if the water didn't flow from silver faucets!" It marked that Queen Isabel's marbled bathroom at the Hôtel Saint-Pol held a copper-and-gold studded bathtub, and that Philip of Cleves possessed four fashioned of silver—each in a chamber painted with nymphs. The water, however, lacking Roman engineering, remained cold and, while the Tudors indulged in a washbasin (solid gold for Elizabeth I), the luxury of a private cabinet was unimaginable. Even Versailles lacked facilities, leaving the urgent act to be performed on the lawn, in a stairwell, or, by the king, in a coach.

The first designated *salle de bain* served as a display case, a marker of privilege entrusted to the day's greatest architects. Louis XIV, though he rarely bathed, had Le Vau fashion an upholstered marble tub. Le Sueur himself painted the Hôtel Lambert's master bathroom, the eminent Viollet-le-Duc designed plumbing fixtures, and so opulent was the *baignoire* Louis XV ordered from Ange-Jacques Gabriel that daughter Adélaïde had it moved to her apartments. Feel for the commoner, reduced to renting a wooden tub, and that only once or twice yearly.

STYLE EMPIRE LAVABO: NEOCLASSICAL ADAPTATION BY THE SEMINAL FRENCH ARCHITECT/DESIGNER CHARLES PERCIER OF EMPEROR NERO'S GOLDEN HOUSE BRAZIER.

My beloved is to me a bundle of myrrh, lodged between my breasts

QUEEN OF SHEBA, SONG OF SONGS

Today's luxury amenities mark with custom detailing and touch-free technology that conjures a mood. The $6,400 BainUltra Amma tub boasts 58 jets, a heated backrest, and three choices of sensory therapies. The $10,000 Neorest Toto toilet warms, lifts, dries, washes, and flushes by remote. To "expand consciousness," the purveyors Molton Brown and Goop heighten the "bath experience" with gold-flecked gels, scented oils, and soaks in crushed amethyst. To pamper body and soul, Sisley's Saint-Tropez sanctuary in Hôtel Byblos offers a rain-shower room, radiance facials, and a 150-minute zen-harmony treatment; the spa at the Inkaterra Machu Picchu Pueblo Hotel engages a toxin-exorcising coca leaf extract; Yucatán's lavish Chablé Resort offers Mayan rebirth massages; and the Faena Hotel's Miami Beach Tierra Santa Healing House payrolls a shaman to promote spiritual wellness.

Such book-now luxury is undeniably spoiling, but does it top that of the Duchess of Burgundy, who journeyed with Louis XIII and his court to Marly, had six vats of boiling water poured into the river and two leafy screens set up on the bank, shed her gown behind one of them and jumped in to the accompaniment of flutes?

Hair, dressed with the sunrise, styled for the fashion, and altered at whim, proved a cross-cultural vanity. Engaged by men as a power logo, by women as adornment, and by all for seduction, hair shaped to pronounce came close to vapidity.

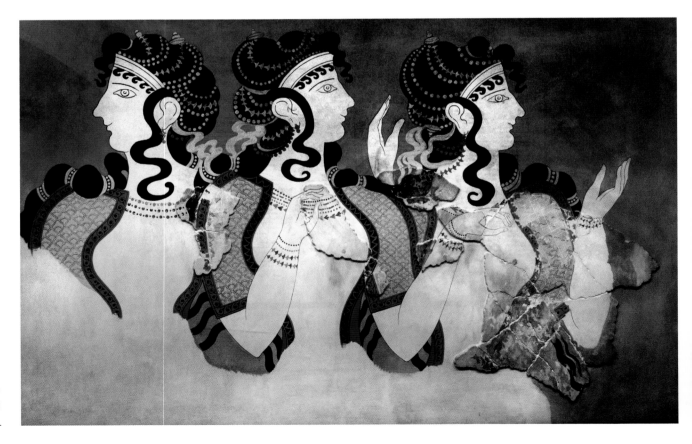

THE ELABORATE MINOAN HAIRSTYLE TAKEN UP BY THE ROMAN ELITE WITH MIXED RESULTS.

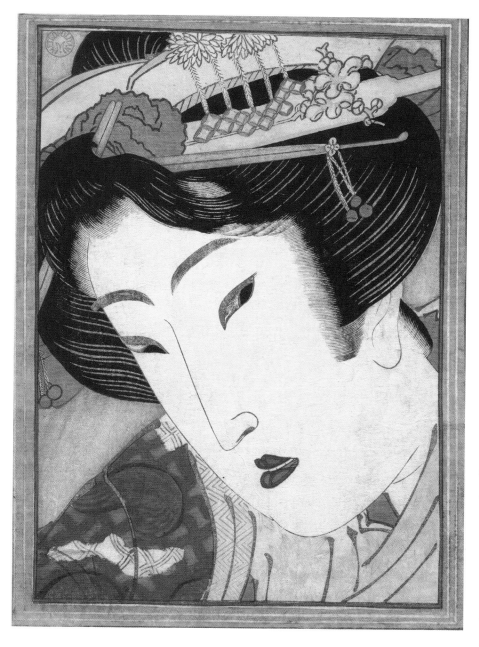

A LACQUERED WIG DISTINGUISHED A FULLY ACCOMPLISHED GEISHA FROM AN APPRENTICING MAIKO.

Beards served as billboards. Egyptian entitlement wove them with gold; the Confucian ideal grew them long; Alexandrian etiquette shaved them off. Emperor Hadrian launched the fashion for a signature beard that by the Middle Ages nested jewels—until the Bishop of Amiens refused communion to any who wore one. Sending mixed messages, piety bearded the Israelites and braggadocio whiskered the Tudors, while Peter the Great's resolve to modernize Russia taxed any presentation of hair on the chin. The beard's English moment was quashed in favor of wigs, despite Charles Dickens's rousing defense: "glorious, glorious . . . charming, charming. Without them, life would be a blank."

A fine head of hair, though, was ever an asset, and one to make visible. As had the Minoans, the Hellenes styled for looks (Alcibiades with the long locks of Hermes, tinted and perfumed). The Romans styled for status (the elite with a sidelock and permanent wave achieved with a scorched-hair technique the satirist Lucian mocked as "a sort of frizzing of the hair").

Wigs, first adopted in Egypt to protect from the sun, came to rank when only the pharaoh wore a fancy one. Rome's elite possessed several to suit each occasion. It marked that Emperor Commodus owned a chamber-full, each flecked with gold and costing more than a complete set of clothing, and that Faustina, wife of Marcus Aurelius, matched her wigs to her gowns and over a period of 19 years launched 300 new "looks." Centuries apart, the Roman satirist Martial gibed that "Fabulla swears her hair is her own—she's telling the truth since she bought it"; the theologian Clement of Alexandria quipped that when the bewigged were blessed the blessing remained in the wig; and the moralist Tertullian of Carthage railed that "perukes, paint, and powder" were "inventions of the devil."

War-torn Europe retired the fashion until it roared back to address Elizabeth I's thinning hair. Trace French usage to one Abbé de la Rivière, who appeared in a *perruque* before the prematurely bald Louis XIII. Borrowed for vanity by the king and taken up for majesty by his son, the conceit introduced the celebrity coiffeur. Louis XIV resolved to outdo Champagne's creations for the Polish nobility with those

of a certain Binet, which proved enhancing but excessive: "I would pluck all the heads of Europe to adorn that of my sovereign." Colbert plotted the gouger's downfall—unsuccessfully: Binet had addicted the king to overwrought ringlets, and the ladies to dioramas of orchestras and espaliered trees. In turn, Madame de Pompadour adopted Legros de Rumigny's vertiginous poufs, maintained through the week by sleeping sitting up.

Remarkably, both these and the periwigs climbed by the court of George III to an altitude William Hogarth derided as "architectonical" were eclipsed by Léonard Autié with confections that had to be dismantled for the carriage ride and reassembled on arrival. Those created for Marie Antoinette worked up to oceans nesting full-masted frigates. Maria Theresa admonished her daughter: "I read in the gazettes that your hairdresses of ribbons and feathers get higher every day. You know that I have always been of the opinion that one should follow the fashion in moderation. A pretty young queen with natural attractions has no need to indulge in such follies. On the contrary, a simple headdress should serve only to enhance her charms and is also more suited to her rank. It is for her to set the fashion and everyone will follow whatever she chooses to do." Unheeding, Marie Antoinette surrendered her coif to none but the guillotine. Revolution only broadened the conceit: "Who, in this enlightened age," asked chronicler Jacques-Antoine Dulaure, "would put the least confidence in a physician who wore his own hair?"

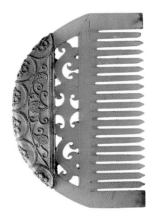

Headed east, the vanity derailed under Elizabeth of Russia. Unable to wash out pounds of powder, the empress dyed her hair black, to such ghastly effect that she had it shaved off and ordered her retinue to wear what one bewailed as "ill-combed black wigs" until the royal locks grew out. The empress would have felt better in Japan, where black-lacquered hairpieces were held artworks and given opulent headrests that preserved them through the night. China styled hair to rank—for warriors up, for women, down, for the lower classes, shaved of all but a braid—so it didn't startle that Emperor Qianlong had his wife arrested for cutting her hair short. Less concerned with rank than potency, indigenous cultures worked hair into heraldry. Papua New Guinea wove in cassowary feathers; sub-Saharan Africa empowered with cowrie shells and coral; the Pacific Northwest signed with totemic hair combs.

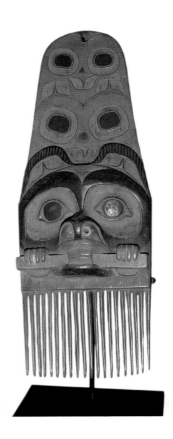

Ornaments worked of precious materials flagged wealth: for the Hellenes, gold *fillets*; for the Romans, gold-tipped needles; for Hebrew women, silver-mesh hairnets; for Kublai Khan's several wives, gold-filigreed hairpins. The nomadic Turkmen wove in a dowry's worth of silver and gemstones.

It awaited French royalty to attach the crown jewels—Isabeau de Bavière embedded the sapphires, Marie de Valois, the pearls, and, centuries later, Queen Marie Leczinska wove in the fabled "Regent," charmingly tilted to whomever she

*There seems to be no end to the little luxuries that
are devised for the person who makes a proper toilet*

ELSIE DE WOLFE

addressed. Those not privy to a treasury engaged the day's luxuries—for China's courts, combs of jade; for Madrid's mantillas, tortoiseshell combs the length of the poor creature's back. A ribbon moment introduced by Margaret of Austria ceded to ostrich plumes, plucked from the horses leading funeral corteges when a shortage set in. Cherished strands were enshrined. Whereas a celebrity snippet held intrinsic value ($38,837 for a hair from the head of Abraham Lincoln), a lover's locks begged a gold locket.

It fell to Paris to restore the one-name coiffeur. Antoine's confections ruled until challenged by Alexandre's "artichoke" cut, created for Elizabeth Taylor when she took to bed while filming, claiming only he could revive her. Making styling a luxury item, Vidal Sassoon's pricey pixie cut gave swinging London the "new look," Margaret Heldt's "beehive" lifted the Chicago set, and Mr. Kenneth's bouffant profiled New York society, until Oribe's pledge to replicate *any* look built a thousand-plus client list.

Latter-day work schedules discouraged high styling. Those seeking a "hair experience" could still drop $26,000 on Stuart Phillips's London Diamond VIP package, which included a limo, massage, and live music. But, apart from confections devised for performance, extravagant coifs manifested elsewhere. Black Africa, for example, styled for power with plaits, twists, and height—Nigeria's "Onile Gogoro" climbed two feet. Maintenance, however, remained a *luxe de rigueur*, as evidenced by the $10,000 monthly French Prime Minister François Hollande billed France for his hairdresser.

OPPOSITE GREEK 225–175 BCE: FILIGREE AND REPOUSSÉ GOLD HAIRNET, ORNAMENTED WITH ATHENA AND EROS TO AFFILIATE WEARER WITH GODS.

HAN DYNASTY COMB, FASHIONED OF THE INDURATE WHITE JADE THAT ONLY A MASTER COULD WORK.

TLINGIT COMB: TOTEMIC EMBLEM SIGNING TRIBAL RELEVANCE OF HAIR TO STATUS.

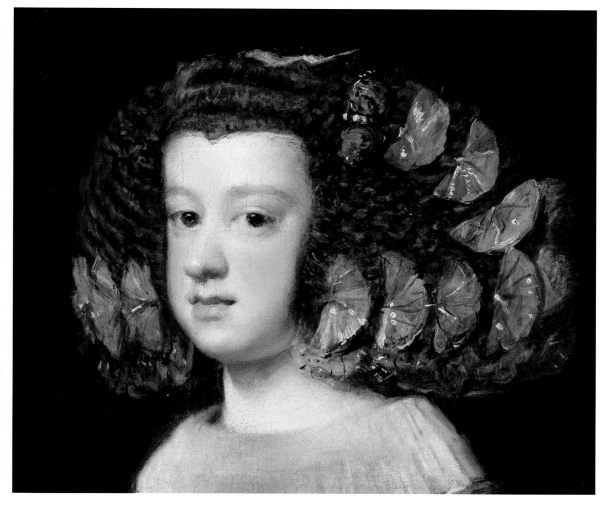

MARIANA OF AUSTRIA, NIECE AND WIFE OF PHILIP IV, BY DIEGO VELÁZQUEZ: THE RIBBONS WERE OF HER CHOOSING, THE IMMOBILIZING HAIR ARCHITECTURE, PROBABLY NOT.

We must powder our wigs; that is why so many people have not bread

JEAN-JACQUES ROUSSEAU

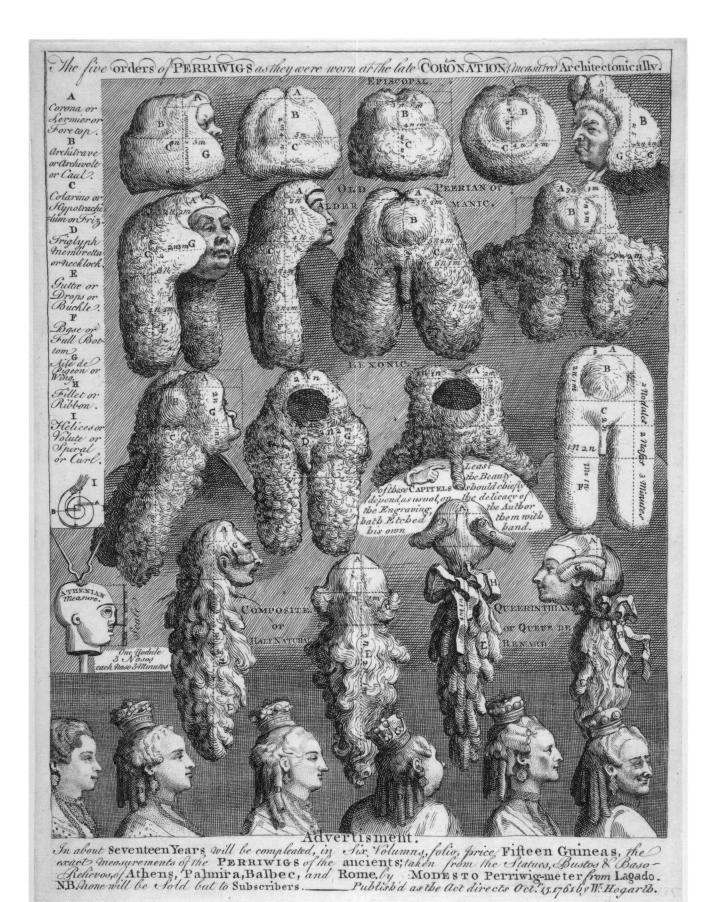

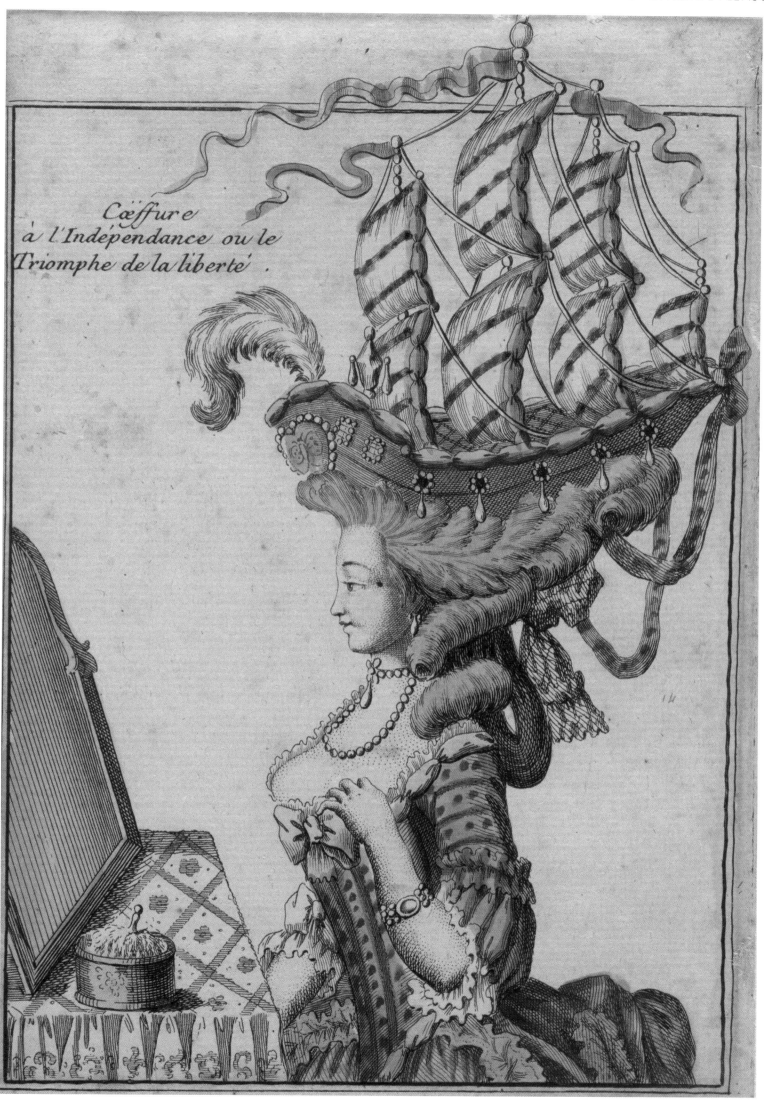

Cœffure
à l'Indépendance ou le
Triomphe de la liberté.

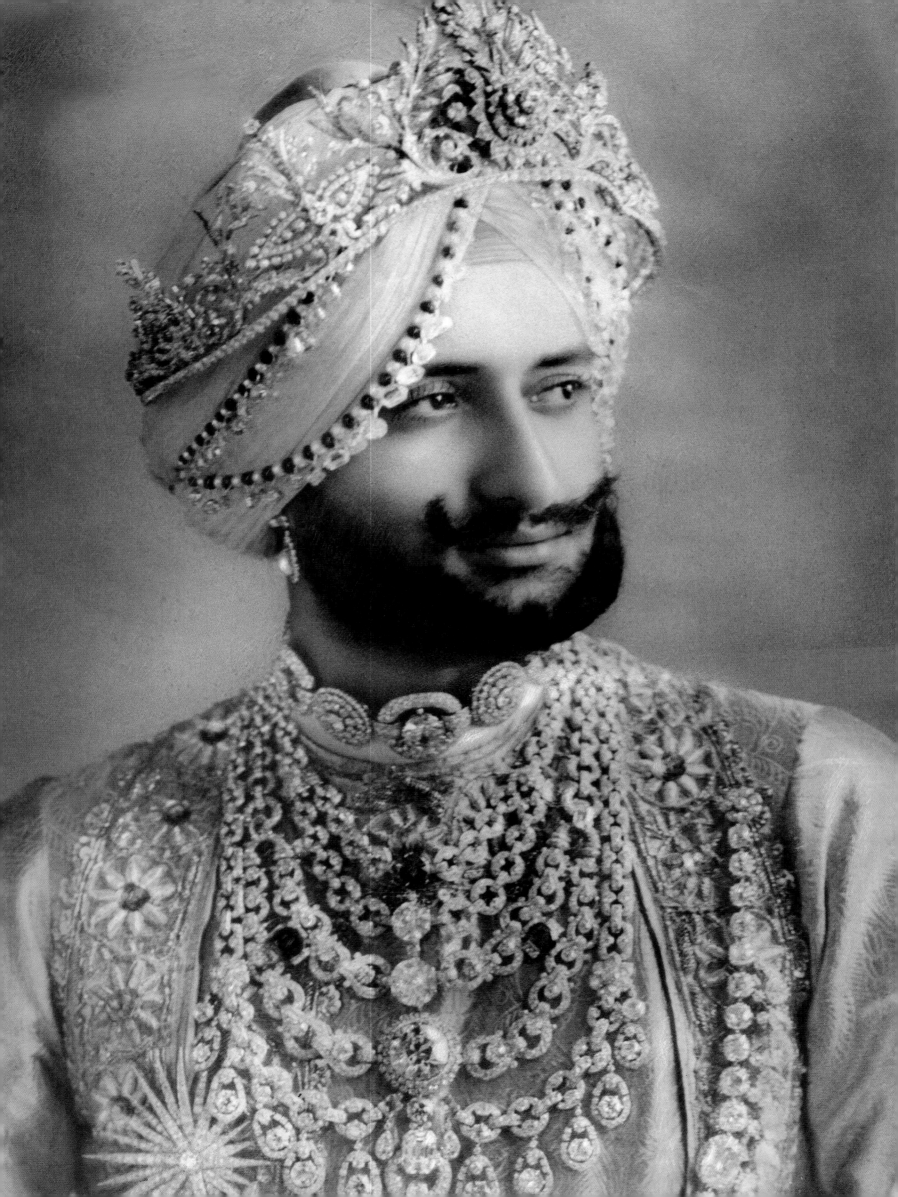

Water is best,
but gold shines
like fire, blazing in
the night, supreme
of lordly wealth

PINDAR

DECKED OUT

J*ewelry*, "personal ornament made of precious materials and precious stones," is by definition a luxury and one evidenced since the beginning of time. The Neanderthals sported eagle talons; ancient China favored jade; the Americas adopted the Spondylus shell, culled at great peril from the seafloor. Mining techniques gave the Hittites iron cuffs, the Israelites, copper collars, and the Thais, bangles of cast bronze. None outshone gold. Immutable, malleable, and above all scarce (it's said that in all of history, less has been mined than would fill three Olympic-sized swimming pools), gold so defined wealth that before the advent of banks a lord moved about like a portable ATM with all he could wear. The labor of extraction alone (up to 250 tons of crushed rock for one ring) denotes the value of the heavy gold amulet placed

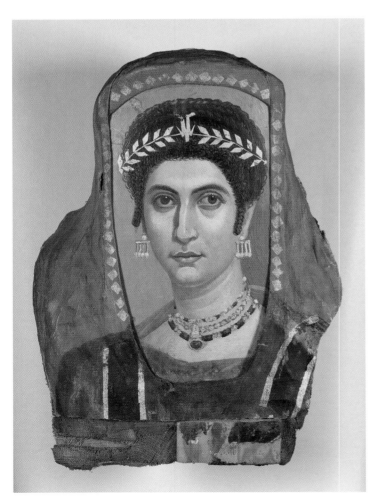

between the breasts of the 2500 BCE noblewoman found at Mohenjo-Daro, and the massive gold crown profiling the Celtic Princess of Vix. Belief that gold's durability delivered immortality sent Khufu's mother to the grave with 20 gold bracelets and removed from circulation to the tomb of six nobles in Tillya Tepe, Afghanistan, an astounding 20,600 gold necklaces, belts, medallions, and crowns.

Semiprecious stones both flattered and ranked. Wondrous, the necklace circling Queen Puabi! Lustrous beads crafted from lapis lazuli and hematite marked status until surpassed by a magical jewel born of the sea. Imbued with magical properties, pearls were attributed by Attica to solidified dew, by the Middle East to the gods' teardrops, by India to celestial condensation, and by China to raindrops impregnated by

CHAPTER OPENER HIS HIGHNESS MAHARAJA YADAVINDRA SINGH OF PATIALA, WEARING THE NONPAREIL DIAMOND NECKLACE COMMISSIONED FROM CARTIER BY MAHARAJA BHUPINDER SINGH.

MUMMY PORTRAIT OF AN EGYPTIAN: THE GOLD AND BEADED NECKLACE SIGNS HER STATUS.

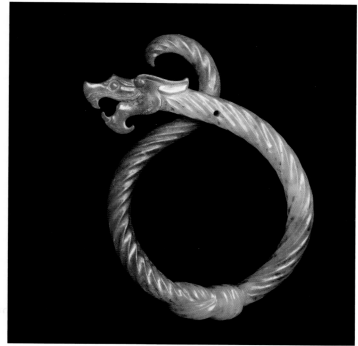

thunder and lustered by moonlight. Their beauty drove the Romans to folly. Seneca tells of women who wore pearls to bed so that "even in their sleep they might be conscious of possessing the rare gems." Suetonius relates that Julius Caesar invaded Scotland for its freshwater pearls and that the general Vitellius financed an entire military campaign with just one of his mother's pearl earrings. To post her status as Caligula's wife, Lollia Paulina attended a festival with documents listing the value of the pearls she was wearing. Most coveted were the enormous Red Sea "Cleopatrines," companions to the one, worth $15 million today, that Egypt's queen dissolved in wine to impress on Mark Antony the resources of her empire.

Empress Theodora brought the luxury to Byzantium, but it awaited the wealth accrued by the rulers of India to wear them roped into layers. The discovery of rich oyster beds off South America brought the first significant "sea gems" to Europe, and to frenzy, as the reigning houses of Habsburg, Valois, Borgia, and, most visibly, Tudor, vied for the largest. Elizabeth I's self-regard mandated ropes of "nutmeg" size pearls that reached down to her knees, and only fractionally smaller ones for her crowns, rings, pendants, and 80 wigs.

ABOVE LEFT SUMERIAN NECKLACE FASHIONED FOR QUEEN PUABI WITH LAPIS LAZULI AND CARNELIANS.

ABOVE RIGHT ZHOU DYNASTY KNOTTED DRAGON PENDANT: THE INTRICATE CARVING IMPARTS THAT JADE WAS PRIZED OVER GOLD AS THE "ESSENCE OF HEAVEN AND EARTH."

Carried forward, their radiance distinguished ladies who mattered. Like the old school tie, a single rope of matched pearls sufficed as an introduction to society—it took a ranking parvenu, the Creole Empress Josephine, to layer them. History documents the trophies: the 250,000 gold rubles sautoir that Alexander III bought for Princess Alexandra of Hesse from Fabergé (its largest-ever transaction with the Tsars) on her betrothal to his son; the seven matched strands, held the world's finest, owned by the Maharaja of Baroda; the $1 million, 128-pearl rope traded to the Morton Plants by Cartier for their Fifth Avenue mansion; and Empress Eugénie's spectacular 500-pearl rope gifted by William K. Vanderbilt to wife Alva (to rival sister-in-law Alice who, later, at tea with her granddaughter, cut hers in two and had half passed round on a platter saying, "Gloria, all Vanderbilt women wear pearls"). Frugality did not enter into it. The director of Tiffany & Co., asked by President

*As I look at some of
my jewels, I realize what
a very lucky girl I am*

ELIZABETH TAYLOR

Eisenhower for a discount on a silver frame ordered for Mamie, pointed to the portrait behind him of a former First Lady wearing Tiffany pearls, saying, "We didn't give one to Mr. Lincoln."

Whatever the value, provenance upped it. To establish his actress wife in society, George Jay Gould shelled out an unprecedented $700,000 ($12 million today) for five freshwater pearl strands and a diamond-feather brooch once belonging to an emperor of China. To place his wife on a par with sister-in-law Eva Stotesbury, automobile tycoon Horace E. Dodge paid Cartier one million dollars for the five fabled strands (though he'd "never heard of her") of Catherine the Great. Few achieved the notoriety of the three matching strands photographed on the otherwise unclad Margaret, Duchess of Argyll, in flagrante with a mystery man said to be Douglas Fairbanks Jr. And none topped the who's-who list of the six priceless cordons given by Pope Clement VII to niece Catherine de' Medici, filtered to Mary Stuart, purchased by Elizabeth I, deeded to James I, bequeathed to his daughter Elizabeth of Bohemia, transferred by marriage to the Hanoverian treasury, and repatriated by George I to the fair neck of Elizabeth II, where they reside to this day.

Only translucent stones rivaled. Thutmose III's wives rejoiced in cornelians. Joined by a rainbow of cabochons, they caravanned across deserts to dazzle the Romans. "Gold has become a mere accessory," wrote the ever-critical Pliny the Elder of the jeweled rings flashing from the fingers of an affluent citizenry. The stones reserved to the emperors bled the treasury: Nero sported a diadem valued at a stunning four million sesterces and viewed the Games through a monocle ground from an emerald. Addiction sped out of control—Mark Antony exiled the senator Nonius for refusing to surrender an almond-sized opal—but Pandora's box had flown open. Thenceforth, the prestige conferred by a knock-em-dead gemstone outweighed its allegorical meaning.

A great jewel was indisputable pronouncement—the marker of a prosperous house, a strategic alliance, a strong rule. In France, sumptuary laws sporadically denied the luxury to the lower classes while allowing the nobility a fulsome display. Queen Radegund relinquished her jeweled clasps only on entering a nunnery, Charlemagne's daughter wore her crown to the hunt, and Jeanne de Bourbon, it was said, wore her crown to bed. Charles IX, marveled Jeanne de Navarre, whose own collection was legendary, "recently purchased 100,000 crowns worth of gems and buys many almost daily for the single-color parures he bestows on his bride that she might appear in a different one every night." Marie de' Medici trumped with the dazzling family jewels that touted her regency.

MARIE DE' MEDICI:
WEARING THE FAMILY
JEWELS THAT SIGNED
HER TRAJECTORY FROM
COMMERCE TO QUEEN.

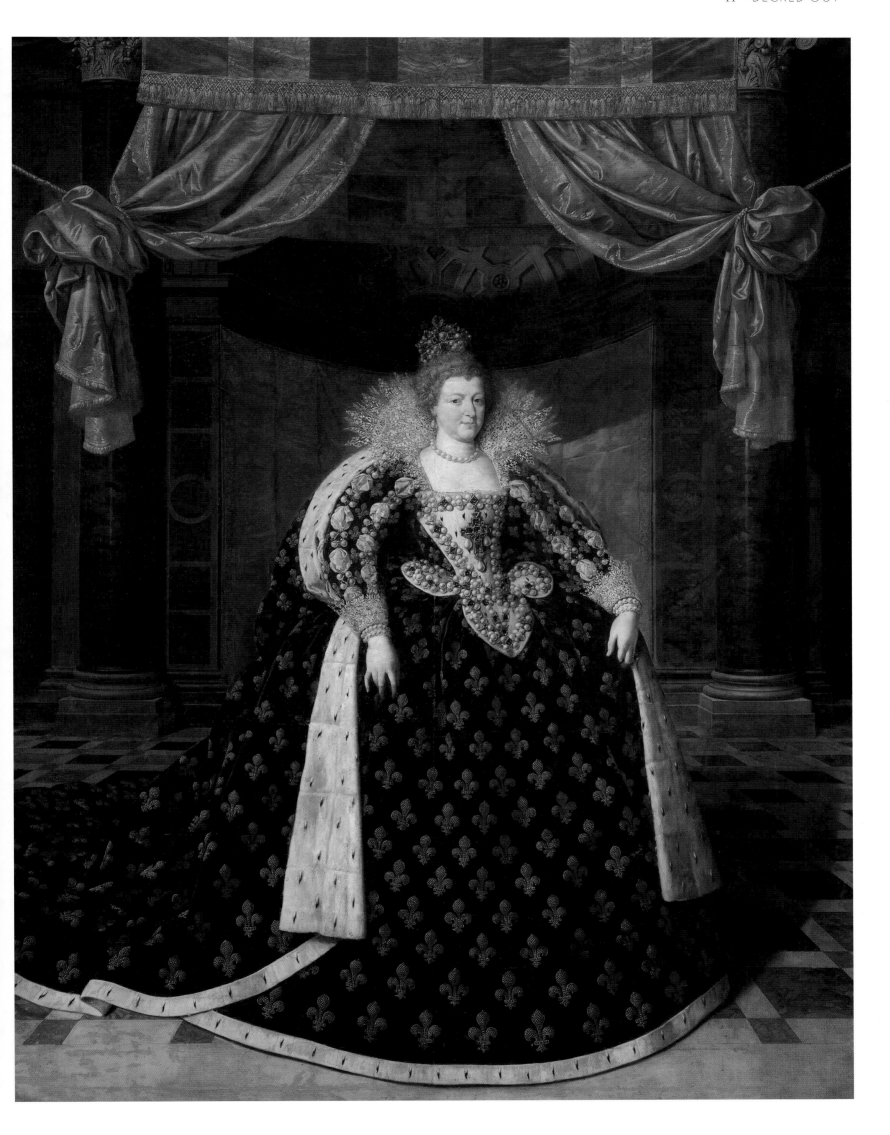

*It's magical,
it's historical,
and, above
all, it's rare*

CHRISTIE'S, OF
"LA PEREGRINA"

Arguably, the greater, if subtler, luxury was matchless craftsmanship. Skills of chasing, embossing, granulation, and filigree perfected in, respectively, Egypt, Mesopotamia, Greece, Etruria, and Byzantium, surfaced later in Europe to flag discernment and taste. Prominent cities developed lucrative signatures; champlevé for Limoges, carved coral for Naples, micro-mosaics for Florence. Master goldsmiths were held in high honor, their finest pieces locked in vaults.

Tellingly, eye-popping gemstones won the day. Lust for the New World headlights that made wealth blindingly visible valued the Crown of the Andes less for its delicate goldwork than its 448 emeralds—blind to the abuse of those who had mined them. India's blue white diamonds were deployed like chips in a power game. Cardinal Mazarin relieved England's war-depleted treasury of Elizabeth I's "Mirror of Portugal" and James II's "larger-than-a-nugget-of-coal" "Sancy" to complete the set of 18 "Mazarins" that occasioned the reckless adventure of the Four Musketeers and so aroused Louis XIV that the cardinal thought it prudent to bequeath them. Craving more, the king traded a staggering 897,831 livres for a clutch of 1,166 brilliants led by the matchless 112-carat "Blue." Louis XV wore the Golcondas like regalia, holding audience with the "Regent" pinned to his shoulder and the "Madras" to his hat. Less solvent, August II's hotheaded purchase of the exorbitant "Dresden Green" forced him to withdraw the military support pledged to

BELOW LEFT GREEK 2 BCE EARRINGS: THE SACRED SYMBOLS OF BULL AND EROS FASHIONED WITH FILIGREED GOLD COMPONENTS AND PEARLS WORTH A RANSOM.

BELOW RIGHT CROWN OF THE ANDES: WROUGHT OF PRIZE EMERALDS AND EXCEPTIONAL GOLDWORK, BESTOWED ON A STATUE OF THE VIRGIN MARY, AND PARADED ANNUALLY THROUGH THE STREETS.

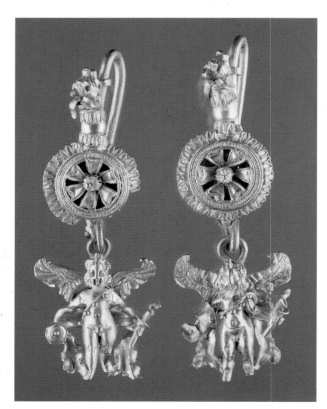

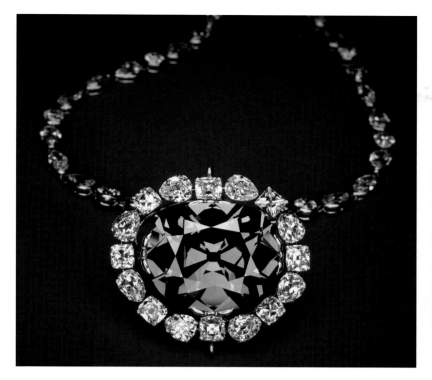

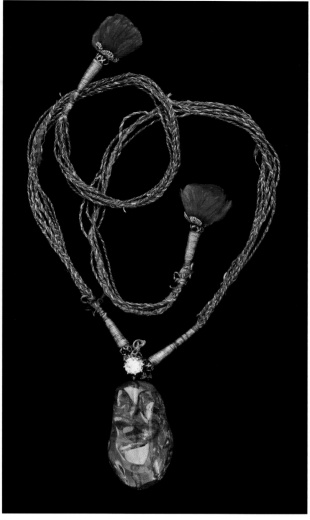

the ruler of Prussia. Less astute, Napoleon III bestowed several state diamonds on Empress Eugénie, only to lose them, when he abdicated, to Tiffany & Co.

The East proved Aladdin's cave. Premodern India had maintained a largely mythic relationship with jewels, holding them a social skin conveying messages of kinship, healing, and sexual intimacy that far exceeded their material value. Allegory, not glamour, carved pendants of jade and studded armbands with cabochons; indeed, the first headlight diamonds disgorged by the Kollur Mine were viewed with suspicion. It fell to Mughal resplendency to measure status in carats. Shah Jahangir led off with Babur's pink "Agra" diamond and the famed "Timur" ruby gifted by Shah Abbas. In 1616, Sir Thomas Roe wrote breathlessly to King James: "His revenue is far greater than that of any European monarch . . . his collection of jewels is the largest in the world." Not understood was the deeper luxury—the layered significance of a great gemstone's history and the virtue bestowed on its owner.

Cue the maharajas, whose belief in a jewel's measure of self-worth launched a game of one-upmanship that pitted the Jodhpur "Star of Asia" against the Mewar three-tiered emerald necklace and "Pears of Indore." Jagatjit Singh of Kapurthala, standing on carpets woven of jewels, flashed a turban that cradled the world's largest emerald. To the 409-carat emerald buckle that traced his royal lineage to Persia, Maharaja Kanderao Gaekwad of Baroda added the "Star of the South," a breastplate displaying the auspicious count of 1,001 diamonds, a five-tiered diamond necklace, and another holding emeralds big as spoons. Maharaja Bhupinder Singh of Patiala descended on Cartier with 40 servants, 20 dancing girls, 30 carats of rubies, and 2,930 diamonds headlined by the 234.65-carat "De Beers" to commission the "world's grandest necklace," then sauntered over to Boucheron for tiaras and aigrettes with "six caskets filled with 7,571 diamonds, 1,432 emeralds, sapphires, rubies, and pearls of

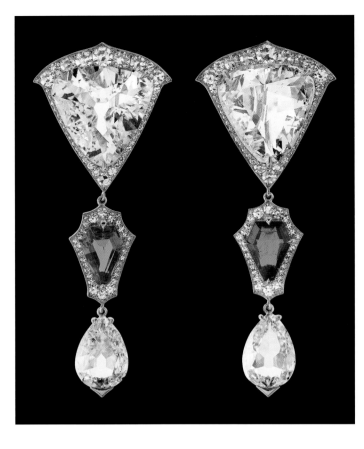

incomparable beauty." All tiddlywinks compared with those gathered by the Nizams of Hyderabad (worth $2 billion today) that headlined three champion Golconda diamonds and the fabled square emerald gifted by the Emperor Aurangzeb. They might have added the "Koh-i-Noor" (whose value, Babur had said, could feed the world for two days) but that the Persian conqueror Nadir Shah, knowing it hid in the vanquished Muhammad Shah's turban, exacted a goodwill turban exchange, and snagged it. Token of conquest, but also of longing. Even Hyderabad's Mir Mahboob Ali Khan collected obsessively—endlessly fingering and pondering the pearls, rubies, and diamonds that he allotted separate rooms to. Emotion ceded to investment. By the turn of the century, their market value increased by new skills of cutting, diamonds lost all significance beyond buy-and-sell—an asset strategy led off by Farouk's 143-carat "Jonker 1."

No royal collected more ravenously than the *grandes horizontales*. Lola Montez winkled all but the crown jewels out of Ludwig I of Bavaria, La Païva married into the fabled Donnersmarck diamonds, and Cora Pearl's haul from the Duc de Morny flashed even the shoes of her dance act. None rivaled Carolina "La Belle" Otero, who, over the years that she taught ingenue admirers the art of true giving, drained four royal treasuries of a staggering $4 million worth. Lest William Vanderbilt think to score with a basket of oysters each nesting a seed pearl, the diva tossed out the pearls and wore the shells to their rendezvous: point taken, Vanderbilt shelled out for a long rope from Tiffany. That he had competition was evidenced by Otero's appearance at a premiere: "She was covered from head to foot with jewels. Their abundance was even more remarkable than the scantiness of her dress," wrote the *Daily Express*. "Her breast was cuirassed in diamonds. Mingled with pearls and rubies, they encircled her neck up to the chin. . . . The largest article of jewelry was her combined breastplate and girdle, consisting of a hundred diamonds and 500 emeralds. Her neck was covered with necklaces of varying shape. First there was her dog collar of ten rows of matching India pearls divided by upright rows of diamonds. Over this was a necklace of two strands of large pearls, then a long double string containing two hundred pearls and a necklace of pure white diamonds; one of rubies, one of diamonds and emeralds. . . . On top of her head she wore her principal diamond tiara. . . . Her arms were covered with bracelets up to her elbows and all her ten fingers were covered with rings."

When reversals of fortune consigned historic jewels to auction, new money smoothed their passage to the bosoms of America's matriarchs. Caroline Astor ruled her soirees in Empress Eugénie's diamond-bow brooch and Edith Rockefeller

ABOVE EARRINGS INCORPORATING DIAMONDS FROM THE REIGN OF THE NIZAM OF HYDERABAD: ONE OF THE KRISHNA CHOUDHARY DESIGNS FOR SANTI THAT DRAW ON THE FAMILY'S STORIED COLLECTION OF GEMSTONES.

BELOW MASTER GOLDSMITH ELIZABETH GAGE'S SIGNATURE AGINCOURT RING: FASHIONED OF WOVEN GOLD AND AN HEIRLOOM EMERALD TO EVOKE EUROPE'S RENAISSANCE COURTS.

CEREAL HEIRESS
MARJORIE
MERRIWEATHER
POST AND DAUGHTER
(DINA MERRILL), WHOSE
MANTRA "I PUT MY
MONEY TO WORK"
TRANSLATED TO
PHILANTHROPY, FIVE
MANSIONS, AND
JEWELRY AT THE LEVEL
OF THIS EMERALD
AND DIAMOND
CARTIER BROOCH.

McCormick lit hers with the peerless emeralds of Catherine the Great. Chicago's formidable Bertha Palmer reigned as the "nation's hostess" in a seven-strand dog collar composed of 2,268 pearls, a tiara of diamonds large as lima beans, a sunburst the size of a baseball, and a stomacher of diamonds said to have, on a crossing of the SS *Kaiser Wilhelm II*, "stopped a soprano from the Metropolitan Opera right in the middle of a high note." Surpassing all, Marjorie Merriweather Post raked in 200 irreplaceable showstoppers.

Men didn't hold back. J. P. Morgan added the 563-carat "Star of India" to his treasure-chest and silver king Clarence Mackay attached a 130-grain pearl from Cartier that he held the only thing to have impressed him in his life. Diamond Jim Brady paraded diamond rings, an emerald-crusted watch chain, and a staggering $87,300 worth of diamond cufflinks and studs: "Them as has 'em wears 'em," he'd say.

Price wasn't everything (a rash of burglaries introduced the high chic of "faux" with Coco Chanel's statement brooches and Madame Gripoix's fabled copies of royal parures fashioned for the great couturier houses) but workmanship was. And still is. Modern-day addiction chases Elizabeth Gage's imperial rings, Wallace Chan's pendants carved of petrified oak, Santi's heritage settings, and master glyptographer Andreas Zadora-Gerlof's tiny gemstone automatons. Status, nonetheless, still entails diamonds clear as water and big as the Ritz. In the face of economic meltdown, Dalyah Duek-Flaks opened a diamond emporium on Madison Avenue because "Tastes are big—the small demure doesn't fly here." Nor anywhere. The 59.6-carat "Pink Star," auctioned at Sotheby's for a record $83.2 million, is by weight the world's priciest commodity. Diamonds, it seems, *are* forever.

*B*erobed—Born naked, we are buried clothed. Lifeless flesh needs no protection from the elements. What purpose, then, the final accoutrement? Hardly modesty—a simple sack would serve—but rather, history shows, signage. The conceit held as true for the living. Revisionist history now interprets Lady Godiva's "nude" gallop through Coventry as "not dressed in her finery." Tellingly, it is largely the superfluous garment that survived. Not the rope sandal, flannel nightgown, or shift, but attire

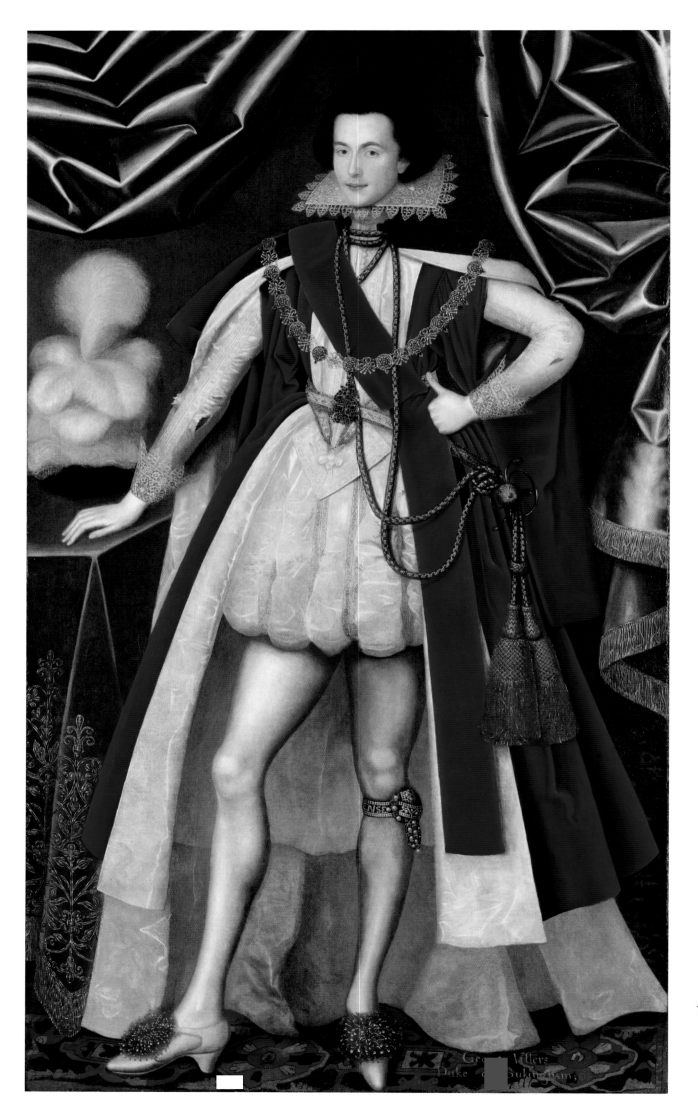

PORTRAIT OF
GEORGE VILLIERS, FIRST
DUKE OF BUCKINGHAM:
THE COURT DARLING AND
ROYAL ENVOY WHOSE
WARDROBE ECLIPSED
THAT OF QUEEN ANNE.

If you are not in fashion,
you are nobody

LORD CHESTERFIELD

that entitlement held prerogative. Such were pearl-soled slippers too fragile to walk on, handkerchiefs too lacy to sneeze in, and fans too richly embroidered to fold. Foolish? Undeniably. But the sartorial impulse is likely inborn.

Clothing as adornment traces back to late Neanderthal flax weavings and 27,000-year-old Venus figurines' raffia skirts. Charles Darwin reported giving red cloth to a native Fijian, who "though he stood in need of protective clothing, tore it up and distributed it among companions, who used it decoratively." The later concept of clothing as fashion introduced a rapid succession of hues, fabrics, and shapes. Of all sartorial affectations, need for "the latest" was the vainest, giving attire the half-life of a moth.

Color first marked with ancient humans' use of ochre and came to rank with the vivid hues returned by far-flung expeditions. Force and subterfuge guarded the sources, as when Carthage cut off the Strait of Gibraltar to secure a monopoly of Tyrian purple, and Spain hid that a coveted red came from an insect. Dyes arduously extracted from minerals and botanicals coded status. The pharaohs posted authority with indigo; the Polynesians with scarlet. Eastern tradition parsed more closely; for Achaemenid rulers, red shot with blue and white; for Byzantine royalty, Tyrian purple. Imperial China ranked by a color's scarcity: yellow for the emperor; purple for classes one, two, three; vermilion for classes four, five, six; green for seven, eight; turquoise for class nine; and for the lower castes, black or white. Japan coded more subtly, wearing pure white, for example, (a dye supremely difficult to achieve) to denote detachment from manual labor.

Western societies signed clearly. A Roman toga whitened with chalk implied a life of the mind. Black, expensive to dye, signaled Dutch sobriety and Spanish preeminence. That new hue that rendered last season's obsolete relayed English affluence—a conceit the Macaronis brought to parody with a rainbow of shades paired to velvet vests, buckled shoes, and tinted *perruques*. Les Incroyables startled Directoire Paris with a sartorial manifesto of cropped coats and spiked collars that promoted as fashionable the color of dung. Credit formal black to the 19th-century taste-setting dandy, Alfred, Comte d'Orsay. Having cycled through faddish hues of citron, cyclamen, and chartreuse—all instantly copied—he appeared at a royal ball dressed in head-to-toe ebony, to establish for all time the chic of no color.

Privilege peacocked as vainly with extremes of yardage and shape; flared skirts for the Minoans, layered silks for China's courts, nine-yard-long sarees for India's elite. Edicts curbed trickledown but spared the nobility. During the famine of the Hundred Years' War, France's palace lintels were raised to accommodate the newly

Caricatures Parisiennes

Le Goût du Jour, Nᵒ 21.
Les Modernes Incroyables.

A Paris, chez Martinet, Libraire, rue du Coq Sᵗ 13 et 15.

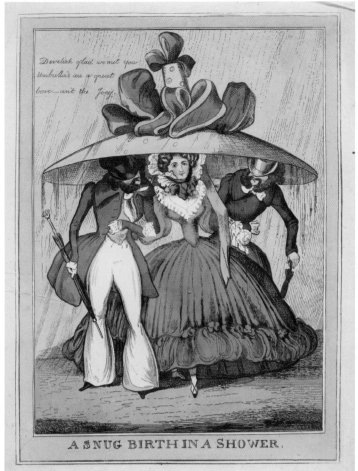

Devilish glad we met you
Umbrella's are a great
bore—aint the Joey.

A SNUG BIRTH IN A SHOWER.

fashionable peaked hats, and in the midst of a crop failure Henri III premiered a ruff that ate 15 meters of mousseline. If Henry VIII owed his massive girth to the table, his cantilevered shoulders were a manifesto of dominion.

The subtext of sartorial exaggeration was a battalion of servants. Conceits like overblown sleeves, unwieldy bustles, ruffs cantilevered to the shoulder, dresses hooked down the back, and tightly-laced corsets that didn't let ladies bend down, entailed round-the-clock service to fasten, adjust, remove, and retrieve them. Sumptuary laws addressed overkill (mandating, for example, that seats flanking the queen's hooped entourage be left vacant so those behind them could see) but could not contain vanity. With apparel having proved as transformative as Superman's cape, edicts restricting a specific color, cut, or cloth were widely ignored. By 1600, even commoners sported patterned silks, fringes, and seven-meter-wide skirts, and by the century's end, clothing purveyors were encouraged to "change the fashion as much as you can every year."

Observance of each trend was essential. The quick-tongued Lady Mary Wortley Montagu noted the "disdainful smiles" that arose "when anybody appears that isn't dressed exactly in fashion." Society portraits made the point: "the latest fashion is absolutely necessary for a painting," Édouard Manet insisted, "It's what matters most."

Tailoring, the skilled art that sculpts form, owes its subtlest luxury to cut. Shaped apparel traces back to the pleats of Malta and the diaphanous gowns draping the Hellenes like water. In rapid succession, stays, panniers, stomachers, bustiers, and guardainfantes, slimmed, rounded, and attenuated the feminine ideal. It followed

ABOVE LEFT LES INCROYABLES: SUBVERSIVE 1790S SUBCULTURE OF THE FRENCH ARISTOCRACY, THEMSELVES BECOME RISIBLY DECADENT.

ABOVE RIGHT *A SNUG BIRTH IN A SHOWER*: WILLIAM HEATH CARICATURE LAMPOONING REGENCY ENGLAND'S SARTORIAL EXCESS.

I cannot keep track of fashion

OVID

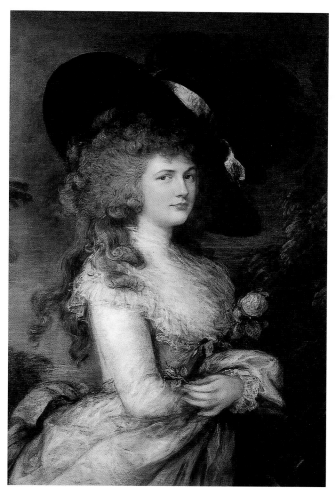

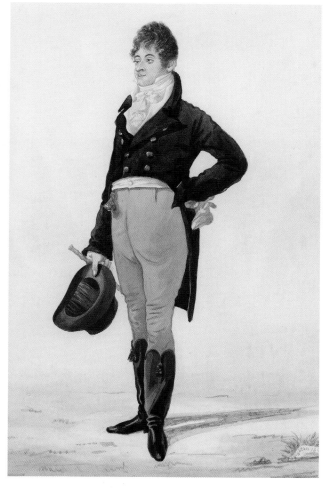

that each newly featured attraction—ankle, wrist, hip, bosom, waist—entailed a fresh wardrobe. Advanced skills gave a person of fashion *le dernier cri* in form and design. In dizzying sequence, skirts were draped, hooped, and bustled; sleeves sheathed and fanned; slacks bloomered and penciled. Gentlemen showed off torso and thigh with tapered coats, padded shoulders, narrowed breeches, and, for such peacocks as George Buckingham, with apparel shaped to seduce.

Subtler was the sartorial insouciance affected by London dandy George "Beau" Brummell, who put inordinate effort into a seemingly effortless appearance. Introducing the impeccable elegance that would enshrine Savile Row, Brummell assigned his jacket to one tailor, his vest to another, and his trousers to a third. Obsessing over fit, he had gloves razed paper-thin to mold to his hands, and each finger stitched by a different glover. More lastingly, Brummell raised attire to an art form. Before wearing a new suit, he obliged his valet to wear it twice, gave inordinate attention to marrying two tones of beige, and polished his boots with Champagne. Thenceforth, a fellow must be meticulously turned out yet appear born to it. And on no account could an article speak its cost—irredeemable that Benjamin Disraeli showed up in Parliament wearing gold chains *outside* his vest and rings *over* his gloves!

As formal menswear reduced down to suit, shirt, and tie, only fit distinguished. George Bernard Shaw thought the Indian mystic Krishnamurti, dressed by Huntsman of London, "the most beautiful being I ever saw," and when the physicist John von Neumann presented in evening clothes for his 1926 doctoral exam, allegedly the only question the mathematician David Hilbert posed was "Pray, who is the candidate's tailor?"

ABOVE LEFT THOMAS GAINSBOROUGH'S RENOWNED PORTRAIT OF GEORGIANA CAVENDISH, DUCHESS OF DEVONSHIRE, THE ENGLISH BEAUTY RENOWNED FOR HER WARDROBE.

ABOVE RIGHT GEORGE "BEAU" BRUMMELL: THE ENGLISH DANDY WHOSE EXQUISITE SENSIBILITY ASSIGNED EACH ITEM OF CLOTHING TO A DIFFERENT TAILOR.

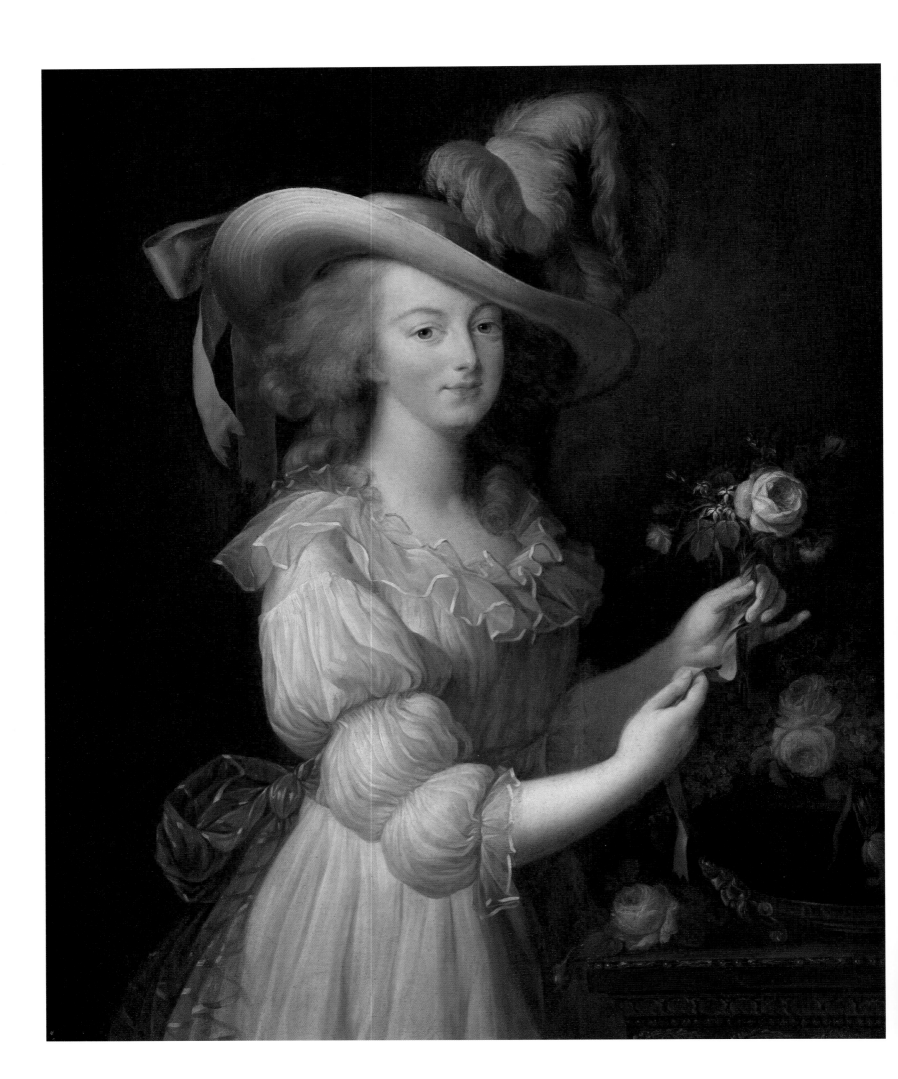

Society is founded upon cloth

THOMAS CARLYLE

Bespoke filtered east, where Savile Row's Henry Poole outfitted the last emperor of Japan; filtered down with Anderson & Sheppard's restrained tailoring for "men who wish to look right without giving the appearance of having studied their clothes"; clad the hip generation in Michael Fish's supremely cut florals, metallics, and signature Kipper tie; and marks now with the tailor-mades fashioned by Richard Anderson, Martin Margiela, and Carol Christian Poell from guanaco, distressed fabrics, and woven rubber.

Textiles, the world's first industry, informed across cultures—the finest traded and hoarded like jewels. Cotton, spun in the Indus Valley 5,000 years ago, fully distinguished when dyed and layered, and, being difficult to work, remained a high luxury until the advent of the spinning wheel. Tellingly, Marie Antoinette's fondness for muslin is said to have triggered America's cotton—thus, slavery—trade. Patterning heightened value, reserving *ikat*'s intricate weaves to the Uzbek elite, those of *patan patola* to Gujarat royalty, and India's painted palampores to the wealthy.

Pricier, the *shahtoosh*, woven of hair from the throat of a Kashmiri goat into a shawl so diaphanous it could pass through a ring: held the "mink coat" of India, it served for a lifetime, until Empress Josephine's fancy to match one to each outfit addicted the court to a rainbow assortment. Mesoamerica graded wool by affordability: llama for commoners, alpaca for nobility, and, for the Emperor of the Andes, vicuna—all hunted to virtual extinction.

Happier the history of a magical textile from China. Arduous to produce and entailing 2,500 cocoons for one robe, silk has ravished since developed from moth larvae 6,000 years ago by the legendary Empress Leizu. Reserved initially to the court, stepped-up production sped the luxury to any with means. "The town ladies love broad sleeves," went a verse from the 77 CE *Yu-t'ai-hsin-yung*, "everywhere a roll of precious silk is used for them." A gold-threaded dragon robe, however, was valued above gold, and the secrets of sericulture were closely guarded, until leaked to Korea around 200 BCE and, five centuries later, to Japan. Worked into paintings, the Edo kimono occasioned lavish embroidery, elaborate pattern books, and a sell-out passion for silk that provoked edicts against home use—a slight the shogunate met with *yuki* (a silk woven to look like cotton) whose cost only the wearer knows. To this day, *yuki* denotes the subtle elitism the Japanese most admire.

The first silk to file west on its eponymous trade route was a coveted marker. No sooner had Cleopatra posted power in a barge fitted with silk sails than the Romans made the luxury their own. Inviting accusations of decadence, Marcus Agrippa celebrated conquest in a "luminous" silken coat, Caligula claimed divinity in a

MARIE ANTOINETTE: THE OFF-DUTY PORTRAIT BY ÉLISABETH LOUISE VIGÉE LE BRUN THAT SPARKED THE MUSLIN CRAZE SAID TO HAVE GALVANIZED THE SLAVERY TRADE.

nimbus of silk robes, and Elagabalus sought dominion dressed head to toe in brocade. Filtered down, retainers adopted the filmy striped silks from the Island of Cos. Julian faulted the excess, to no avail: "But I asked for a barber!" cried the emperor when the royal groomer appeared clad in silk, unaware that the fellow enjoyed a princely salary, 20 horses, and 20 servants of his own.

The late Middle Ages saw France's burgeoning middle class so besotting on taffeta from Byzantium as to startle Jeanne de Navarre on her sortie through Bruges: "I thought I alone was queen but here I see hundreds more!" A high luxury, nonetheless: even after the secrets of production leaked to Europe, manufacture remained so arduous that Florence could produce only 60 meters of its trademark silk-velvet annually. It awaited Renaissance wealth to collect silk garments like artworks. Lucrezia Borgia was said to own 200 silk blouses, some stitched with gold, and Isabelle d'Este hired a personal shopper to locate blue silk for a gown and black satin for a mantle "such as shall be without rival in the world."

Louis XI thought to establish a French manufactory with gifts of silk-velvet gowns to his sisters-in-law, triggering a backlog of orders and cries of monarchal excess. Trickledown incurred edicts forbidding silk undergarments to boys under 12 and specifying which textiles women could wear in public. In 1583, Henri III placed under arrest anyone presuming to layer silk over silk—an ostentation that placed *soie sur soie* in the lexicon as a synonym for surfeit. Anthony van Dyck's portrait of Charles I in a trio of silk outfits similarly addicted the English: "What a pretty little thing I saw out walking the other day" wagged a wit, "covered in silk ribbons as though she'd raided

TOP QING DYNASTY DRAGON ROBE: EMBROIDERED WITH THE 12 SYMBOLS DESIGNATING THE EMPEROR'S AUTHORITY TO MEDIATE BETWEEN HEAVEN AND EARTH.

BOTTOM LATE EDO PERIOD SUMMER KIMONO: SILK WOVEN WITH SOCIAL SIGNIFIERS—CARP, MORNING GLORIES, WATER LILIES, AND FAMILY CREST.

I change my shoes
about six times a day

DEE HEMINGWAY

every shop. A Greek frigate navigating a storm would have made less waves than this layered doll when the wind filled her skirts."

Silk's widening availability didn't lessen its value. In China, well into the Qing dynasty, a slave girl traded for five pieces of spun silk, and a mandarin's outfit cost a year's salary. Prices held abroad because navigating the silk craze was rough sailing. In 1609, James I planted five acres of mulberry trees, unsuccessfully. In 1853, as France reached its maximum production of 26 million kilos of cocoons, all died of disease. America's craving for silk replaced crops with mulberry trees that reached crazy prices, until the whole scheme collapsed and the fields were dug up and planted as before.

Only lace rivaled, sprouted so copiously by the bourgeoisie as to provoke an edict regulating the "Superfluity of Dress." Royals exempted, the Sun King radiated 7,000 écus worth of lace from his sleeves and his boots. When the luxury crossed the Channel to trim foppish collars and gold-threaded vests, Queen Victoria's wedding dress trailed an 18-foot-long lace veil that set back the crown a thousand pounds, a cost justified by exacting it never be copied. Not forgiven, however, was the lace parasol that fatefully signed the insouciance of Tsarina Alexandra Feodorovna.

As indulgent, lacy lingerie—a turn-of-the-century delight—introduced the frisson of unmentionables. Lace-trimmed bustiers sprouted feathers and demi-monde garters flashed pearls (the one Carolina "La Belle" Otero flung at an admirer landed in the Victoria and Albert Museum). Jean Cocteau's 1913 account of

LEFT *TRIPLE PORTRAIT OF CHARLES I*: ANTHONY VAN DYCK'S WIDELY COPIED DEPICTION OF SARTORIAL EXTRAVAGANCE THAT TRIGGERED A RUN ON TAFFETA AND LACE.

RIGHT MRS. DANIEL DENISON ROGERS, POSING FOR PAINTER-DU-JOUR SIR JOSHUA REYNOLDS IN STATUS-DEFINING OSTRICH FEATHERS.

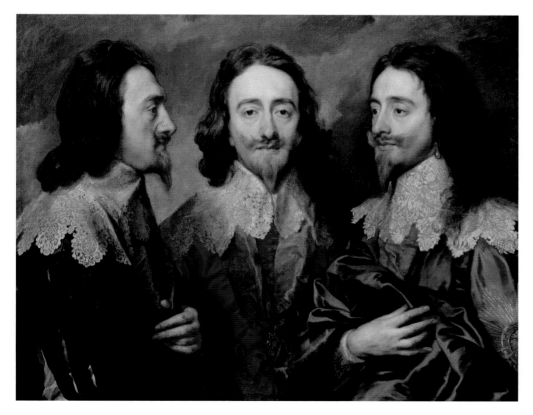

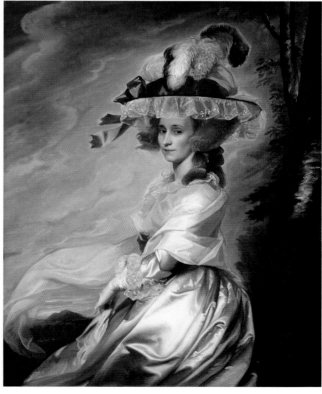

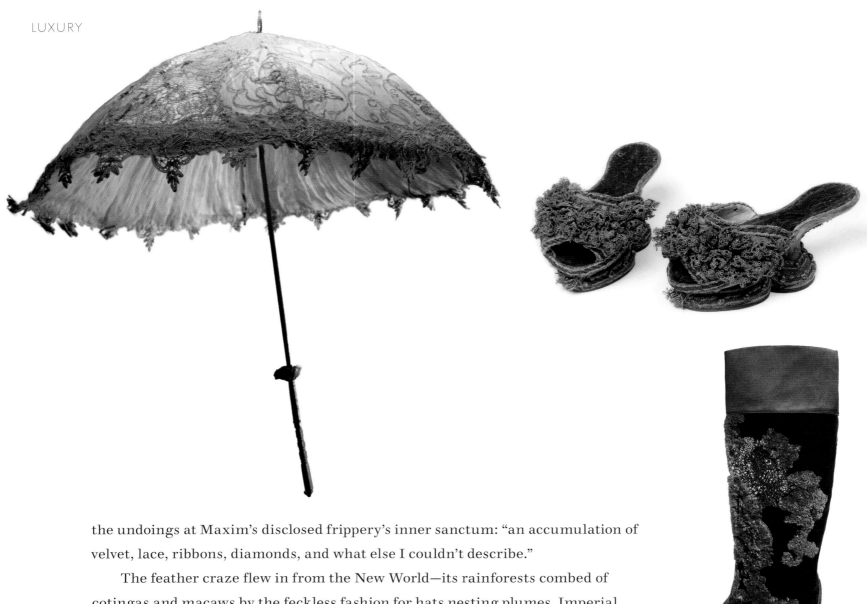

the undoings at Maxim's disclosed frippery's inner sanctum: "an accumulation of velvet, lace, ribbons, diamonds, and what else I couldn't describe."

The feather craze flew in from the New World—its rainforests combed of cotingas and macaws by the feckless fashion for hats nesting plumes. Imperial aviaries supplied the quetzal birds plucked for Mayan regalia, but the mamo bird was brought to extinction by such imperatives as the 450,000 golden feathers given the cape of Hawaii's King Kamehameha I—a labor of 30 years. Priced like diamonds, ostrich feathers from Algeria and Madagascar plumed helmets ("*Suivez mon panache blanc*" constituted Henri IV's battle cry) and raised Georgian headdress to distinguishing heights.

Supremely luxurious was garb worked with precious materials. Early texts note Agamemnon's gold-threaded mantle, Ulysses's gold-embossed cloak, and the nonpareil cloth-of-gold adopted by Emperor Constantine to outshine Rome. Tracing to Korea's Joseon Dynasty, gold and silver threaded embroidery distinguished by weight and the hours of stitching that sidelined a good part of the workforce. Elizabethan flamboyance led Baron Henry Berkeley to sue his tailor over a suit missing 80 ounces of silver thread. Bavaria's Ludwig II exacted hangings for his gold-leafed bed at Herrenchiemsee that took 30 women 7 years to embroider.

Jeweled apparel tipped the scale. The monk Abbo of Saint-Germain-des-Prés blamed Carolingian frippery for the Viking invasion of 885: "A gold clasp fastens your robe. You use precious purple to keep yourself warm. Only a jeweled belt may circle your waist. Only gold bands may fasten your shoes." What would he have thought of the Valois? Philip V's courtiers sported diamond-buckled shoes that extended two feet before them—a mark of idleness so reviled as to elicit a ban—and Philip the Good

TOP LEFT TSARINA ALEXANDRA FEODOROVNA'S PARASOL: THE INORDINATE COST OF THE LACE FLAGGED ROMANOV INATTENTION TO THE PLIGHT OF THE PEOPLE.

TOP RIGHT VENETIAN CHOPINES: DEVISED TO LIFT SILK GOWNS OVER MUDDY STREETS AND RAISED HIGHER TO SIGN STATUS.

ABOVE THE $16,000 ROGER VIVIER SATIN KIMONO BOOT, DISPLAYED IN THE SALESROOM BEHIND GLASS.

partied in a jacket sewn with 22 sapphire roses. Glitter measured English clout more intentionally. It brought attention to the island kingdom that Richard II's cloak nested so many rubies as to leave no fabric visible, and that the quantity of pearls sewn to Elizabeth I's apparel assigned two attendants to retrieve those "lost from Her Majesty's back." Centuries later, an emerald sewn to the gown of Tsarina Alexandra Feodorovna for a 1902 gala led the Grand Duchess Maria Georgievna to remark that it must have been through just such a glass that Nero watched Rome burn.

Furs came to rank with their scarcity. Whereas Ötzi the Iceman's goat-hide leggings had been protective, ermine capes signed sovereignty. Initially reserved to France's male line, it spoke to female ascendancy that Charlemagne's daughter, Bertha, Anne de Bretagne, and Catherine of Cleves, all adopted it. Expeditions to North America returned the beaver that collared the Dutch burghers, and two centuries later, when a pelt sold in England for the annual rent of a farm, built the colossal fortune of John Jacob Astor. When the Jazz Age snuggled shoulders into fur, sable became the showgirl's investment item. When mink coats were the fashion, every socialite had to have one. Wearing a fortune on one's back could backfire (Eva Perón's full-length mink caused a stir) but status trumped. When endangered species went underground, farm-sourced pelts gave society Missoni's "fun furs." The eminent sculptor Louise Nevelson, wanting something "comfortable" to work in, had her old paisley shawls lined with chinchilla.

Accessories, ornamented beyond need and often beyond usage, had ever been fashion's ally. Footwear served as the Morse code of rank. Wealthy Scythian women, sitting cross-legged by custom, flashed slippers soled with pearls; Byzantine royalty affected shoes nesting gemstones; the Merovingian elite signed with silver-strapped sandals. The heels that steadied Persia's cavalry in their stirrups rode west to raise ladies'

ABOVE MRS. WILLIAM HEARST'S FAN: ACCESSORY ORNAMENTED MORE TO RANK THAN TO FUNCTION.

RIGHT TURBAN ORNAMENT: OTTOMAN STATUS EMBLEM WORKED OF ENAMELED GOLD AND PRECIOUS STONES.

skirts over puddles and courtesans above prostitutes. Inched up into power logos, heels elevated Elizabeth I above her peers and, built higher and dyed crimson, lifted Louis XIV above all. Thenceforth—buckled, jeweled, stitched, feathered, and matched to each garment—shoes rated their own closets: that of Elizabeth of Russia held 270 pair, that of the danseuse Mistinguett, 300, and that of Imelda Marcos, 1,000. Comfort was never addressed. A 19th-century diarist relayed her cobbler's response to complaints that her shoes hurt: "Ah, Madame must have walked in them!"

Headgear provided a cross-cultural message board. The Duc de Valois stared down Louis XII in a cap crusted with rubies. Henry VIII's velvet hats nested diamonds, many a monarch attached a crown jewel, and ladies' *chapeaux* followed the 17 styles launched by Marie Antoinette—a luxury that survived revolution to give Paris 1,000 millineries. To the East, Mughal India signed with jeweled aigrettes, and imperial China with peacock feathers and pearls. Messaging standing across classes,

PORTRAIT OF A GENTLEMAN: JAN GOSSAERT'S DOUBLE ENTENDRE ON BURGHER WEALTH—THE VELVET, BROCADE, FUR, FEATHERS, LACE, RINGS, AND GLOVES UNDERCUT BY THE INSCRIPTION, IN FRENCH: "HE WHO HOLDS TOO MUCH WEARIES HIMSELF IN VAIN."

Japan's "floating world" courtesans styled with ornate fabric flowers and carved combs.

Gloves served as the gesture's ambassador—unthinkable that gentry should present a bare hand! To dine with the Tudors, gloves cut off at the knuckle for large rings. For a debutante ball, white kid gloves to the elbow.

The fan, wielded as the extension of the hand, was so subtly coded as to require a manual: "An elegant lady must have dozens of fans, assorted to her outfits," advised the Marquise de Garches: "For grand affairs, I advise one made of ostrich plumes set in blonde tortoiseshell monogrammed in diamonds; for the theater, black ostrich plumes mounted on brown tortoiseshell; for the country, an immense fan of raw silk mounted on wood. Presently the fashion is to have an original verse composed by a poet of one's acquaintance engraved on the corner."

The same lady of fashion called on enough undergarments to warrant their own closet. Again the marquise: "She must have endless layers of underskirts; black moiré, for rainy days; one of glazed taffeta; one of pastel silk ruffled with lace; a brocaded one embossed with gold or silver flowers." Such confections were replaced yearly; basic lingerie, monthly; and even after the innovation of dry cleaning no gentleman wore an item that hadn't been brushed, aired, and pressed.

The handkerchief served as heraldry—a miniature flag conveying with gold stitching the family crest and fortune. Indicative of their cost, Henri IV owned only five; his queen, three; and his mistress, Gabrielle d'Estrées, two—one acquired during the calamitous Siege of Paris for a shocking 1,600 ducats. Trickledown gave ladies of quality handkerchiefs woven of cotton too fine to serve more than once. Gentlemen stocked *mouchoirs* by the hundreds, each monogrammed and perfumed—a conceit that bespoke suits still stitch a pocket for.

The handbag first distinguished when the high art of petit point applied over 500,000 stitches to the famed Brussels Purse. A fashionista's reticule, ideally matched to her dress (Lady Norah Docker's, to her gold-plated Daimler) opened to the solid-gold trifecta of powder case, lipstick-holder, and cigarette lighter. Today's

FASHION-DEFINING
CONFECTION
BY MILLINER
EXTRAORDINAIRE
PHILIP TREACY.

Chanel gave women freedom.
Yves Saint Laurent gave them power.

PIERRE BERGÉ

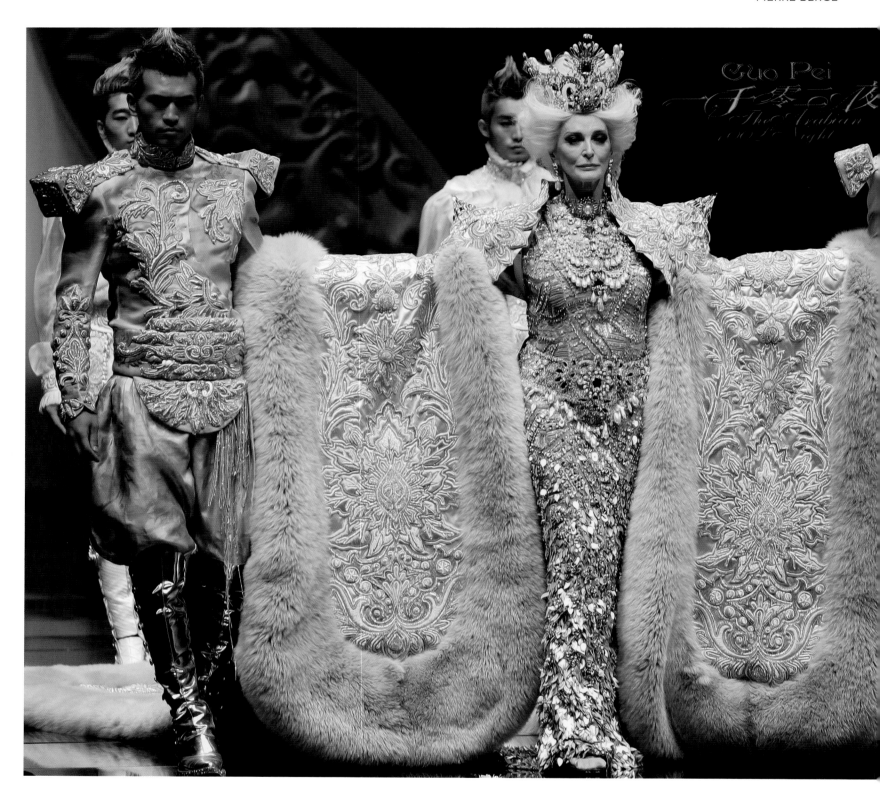

THE FROZEN QUEEN,
A SILVER-THREADED,
EMBROIDERED SILK
EXTRAVAGANZA BY
CHINESE DESIGNER
GUO PEI, INVOLVING A
LABOR OF 30,000 HOURS
BY 60 SEAMSTRESSES;
MODELED BY CARMEN.

totes are collectibles—$25,000 for Cartier's crocodile 100th anniversary edition and (to David Beckham for his wife) $379,261 for a Hermès Birkin set with white gold and 245 diamonds.

Whichever the wardrobe item, it was tripled; fancy was fun, but accumulation was all. A marking inventory spoke to reach. Abbasid Caliph Harun al-Rashid (he of the Arabian Nights) owned hundreds of vestments—all catalogued by color, fabric, and design. French courts followed. While a peasant possessed one outer garment in a lifetime, Henri II's circle owned up to 30 and wore a different one daily. England's growing number of social events tailored the gentry into fops. "The art of being a gentleman," observed the playwright Ben Jonson, "turned on the ability to turn 500 acres of your best land into two or three trunks of apparel." The 18th century exceeded; Dresden's Count Von Brühl admitted to 500 outfits, each of "high quality." Elizabeth of Russia possessed 15,000 dresses and never wore the same twice.

Practicality didn't factor in: skirts trailed through mud, sleeves through sauce, and only a two-foot-long spoon saved a lace collar from the soup. Entitlement did: Elizabeth I had all who ignored her edict on cuff-size turned away at the gate, Philip IV's prominent Adam's apple provoked a ban on ruffs, and Gustav III's resolve to quash middle-class aspiration imposed national dress.

All changed with invention of the sewing machine, which gave country girls a city wardrobe and the newly affluent a rapid succession of styles that raised arriviste profile. Block-long department stores like Macy's and Marshall Field's vied for America's 4,000 millionaires with tea rooms, theaters, art galleries, gardens, even miniature zoos. Londoners frequented Whiteleys for its rooftop golf course, and Selfridges for its ice rink, shooting range, and—a winning first—elevators. A glass-domed Le Printemps brought *le citoyen parisien* a taste of *la belle vie* provided to the elite by the great houses of Worth and Doucet, whose gowns cost 25 times the annual salary of those who had stitched them.

Socialites whose middle name was "best dressed" courted the press with up to eight changes daily of the luxurious hand-painted organzas, crushed velvets, and silks shimmered with dragonfly wings so fancifully worked by Paul Poiret, Madeleine Vionnet, and Fortuni. Rita Lydig joined a three-year waiting list for embroidered slippers from Yantorny and stored them in cases lined with white velvet. Designers were lionized. Mona Williams, on learning that Cristóbal Balenciaga had died, went into shock: "She didn't come out of her room for three days," recalled *Vogue*'s Diana Vreeland. "It was the end of a certain part of her life." The famed editor's lament that "the life of fashion was very strenuous" referenced the five

fittings for her lingerie and the effort put into achieving the artful "simplicity" to which she owed her success.

Fashion transmuted to "the look," led by Mary Quant fun wear and Zandra Rhodes punk. Glamour settled in Hollywood where Gloria Swanson swanned in a gown sewn with 100,000 pearls and Marlene Dietrich held court in a creation by Hermès that she had thought *trop cher* until the salesman protested: "But it's a dress you could wear at least three times!" Yves Saint Laurent empowered the next generation with his black satin tuxedo, and Paco Rabanne took them forward with a chain-mail plastic minidress, reworked for posterity in gold and diamonds of a weight that Françoise Hardy refused to model until the hemline was cut, reducing its value to $2 million. Elsa Schiaparelli's elaborate designs raised garments to artworks. Rei Kawakubo's extreme Tumor dress shocked, but Roger Vivier's glamorous satin Kimono boot sold out—as did Christian Louboutin's zipper-less thigh-high Monica boots that took two to remove, and the pumps soled with rubies that supported his mantra, "a shoe has so much more to offer than just to walk." Rich backers underwrote the need for a John Galliano gown exacting 220 meters of black lace and rivers of sequins, and a Hanae Mori wedding dress so weighted with rhinestones it had to be forklifted onto the airplane.

The Generation X style-shift to trashy-is-classy reduced the aesthetic to ripped jeans and T-shirts. Valentino rang down the curtain on an era marked by "dresses that make parties stop when the woman enters the room." The runway ceded to "capsule" collections, pop-up ready-to-wear, and Nathalie Rykiel's concept presentations: "We will be saying 'Come to my house. Look at and feel the clothes.'" Hubert de Givenchy lamented: "I do not see a future for haute couture as I knew it: Haute couture means for me perfection."

VOGUE EDITOR HAMISH BOWLES'S GENDER-BENDING TAKE ON CAMP FOR THE METROPOLITAN MUSEUM'S 2019 COSTUME INSTITUTE GALA—A JOHN GALLIANO FOR MAISON MARGIELA ARTISANAL OSTRICH-EDGED CAPE, RIFFING ON BRITISH AESTHETE QUENTIN CRISP'S STUDIED ARTIFICE WITH A JACQUARD BROCADE, VIOLET DUCHESS SATIN, AND SHOCKING PINK POODLE DESIGN.

One had as good be out of the world as out of the fashion

COLLEY CIBBER

Luxury moved to label accessories. "We live in a world where you can wear yoga clothes," stated accessories king Michael Kors, "but if you've got the right handbag, great sunglasses, and your watch is gorgeous, you're ready to roll." Join the rich by "dressing down" with luxury brands—$40,000 for auto-lacing Nike Mag sneakers and $250,000 for Dussault Apparel's accessorized Thrashed Denim jeans. Surviving houses kept fashion afloat with aggressively marketed logos (lo, the double CC!) and a fresh "brand experience" (at Balenciaga, sneakers!)

Fashion fanatics, nonetheless, went the distance for the fillip of difference that blows you away; the filigreed Dior gown that Veronica Hearst said "feels like nothing"; Guo Pei's operatic riffs involving 30,000 hours of embroidery; Kiton's $21,000 handmade suits with sleeves slit for the buttons because it is elegant "to have them and never open them"; and the wardrobe that Giorgio Armani designed to appear effortless and showcased in a Fifth Avenue store whose $37 million investment, he noted, "I will probably not get back for 20 to 25 years."

Leaving eco-chic to Natalie Portman's vegan shoes and Pharrell Williams's G-Star Raw T-shirts woven from recycled plastic, luxury moved to laboriously reproduced textiles: a Burmese cloth woven from lotus stems; Japan's stencil-dyed *kata-yuzen*; jacquard (the weave that clad royalty); *gazar* (a sheer, double-yarn, crisp organza); *kesi* (a Qing dynasty silk woven in Suzhou to form an image beneath the warp); and Korea's wondrous "painting with needles" technique—famously resurrected by Young Yang Chung—which silk-wraps each thread variously to float the image.

Let designers build into each new look the demise that retail titan François-Henri Pinault calls "the normal life cycle of modern luxury," fashionistas hold bespoke raiment eternal: such were Philip Treacy's storybook hats created for Isabella Blow, and Shaun Leane's gold-and-diamond armored glove crafted for Daphne Guinness. Magical, too, the wizardry of Iris van Herpen's 3D-printed gown, Hussein Chalayan's remote-controlled dress, and Madison Maxey's lightup prints.

Apparel's penultimate luxury is identity (why else was Beyoncé's face embroidered on her already fabulous dress?) because recognition is everything. Heeding Charles Gordon-Lennox's counsel to create a "personal style signifier, and ignore wearability in the pursuit of everything next," designer Marc Jacobs attended a gala in a see-through lace dress, fashion icon André Leon Talley worked seminal moments out of floor-length furs and nine pairs of Uggs, *Vogue*'s Hamish Bowles mined designer tropes to create one uniquely his own, and Alexander McQueen, because "the world needs fantasy, not reality," wrought blazonry from bracken, horn, clamshells, locusts, and the 12-inch-high lobster claw boots that profiled Lady Gaga. Donatella Versace, her Lucite runway filled with 25,000 orchids, summed it up: "At times like these, people need fashion, not basics."

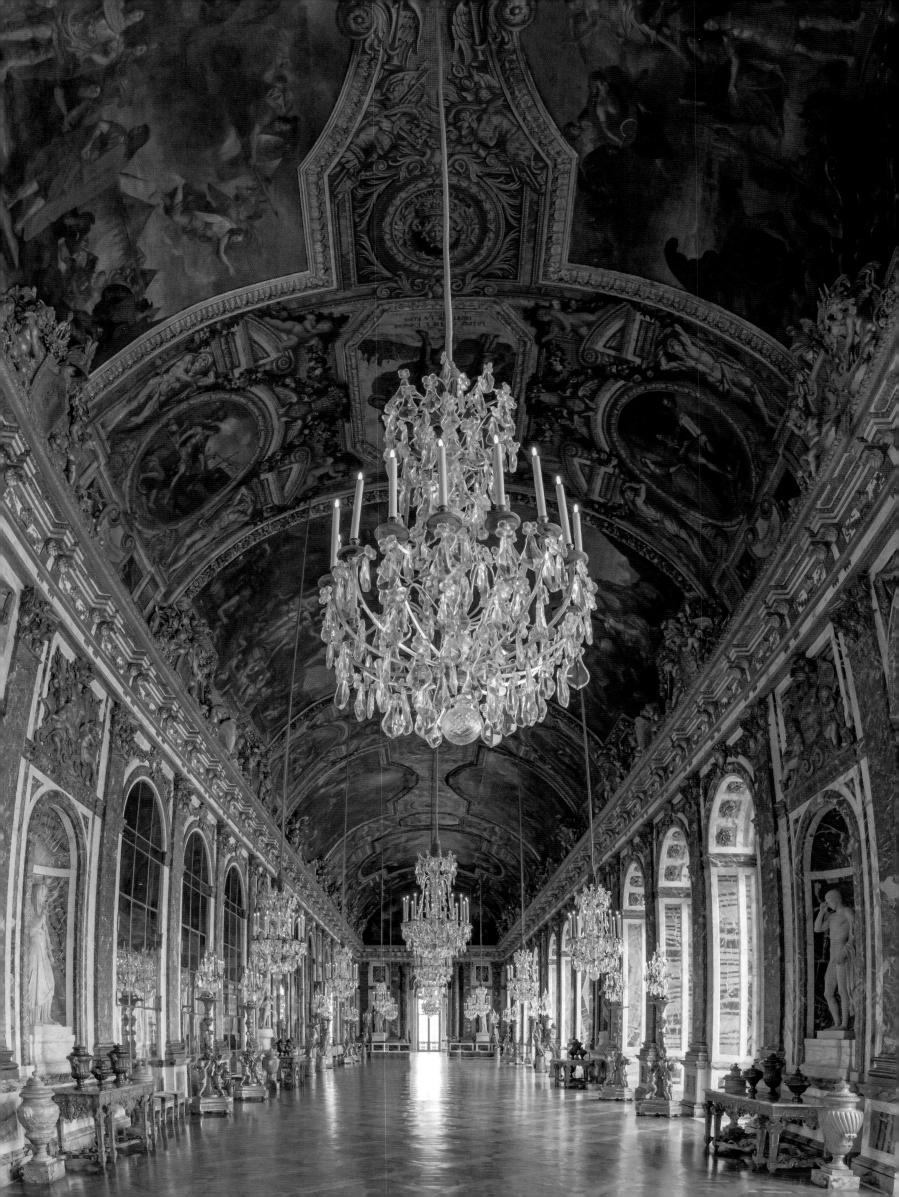

*Building is a craze
which costs much,
but every fool likes
his own hat*

ELECTOR-ARCHBISHOP OF MAINZ

HAUTE HABITATS

What defined luxurious lodging? "Location," said sociobiologist E. O. Wilson, having traced to prehistory the desirability of a hill with a view, a tree-shaded savanna, and proximity to water. Size came to matter, then show, and then privacy. Rooms were set apart for dining, for gathering, for bathing, for thought. Ambitious agendas added imposing façades, superfluous courtyards, and lawns stretched to the horizon. Four walls and a roof do the trick, yet it took no time at all to override function with froth and a need to outclass that deployed cohorts of stonemasons, metalsmiths, painters, plasterers, furbishers, and joiners to fashion, essentially, a place to lie down.

As early as 2500 BCE, the habitations at Mohenjo-Daro featured multiple stories and individual courtyards. Crete's mansions at Phaitos enjoyed plumbing not equaled until Victorian times, Egypt's elite luxuriated in shaded colonnades and manicured gardens, and Greece's patricians reclined under peristyles lined with statuary. Rome's young Republicans lived opulently, in tiled, columned mansions, and, like Cicero, who owned 12 country villas and several mansions in town, benefited from a system of absentee ownership. They kept excess in check, though, famously demoting a senator because his silver was too heavy.

It fell to imperial vanity to introduce surfeit. Such was the escalating ostentation that even the notoriously extravagant villa of Tiberius at Capri paled before Nero's "House of Gold." Built on the ashes of the destroyed capital, the scheme struck Tacitus as extreme: "Gold and gems were but background to what it enclosed; fields, lakes, woods, plazas. . . ." Not to mention the assignation rooms lined with pearls, bathtubs that piped in the sulfurous water from Albule, a banqueting room mechanized to rotate like the earth, another piped for perfume, and Nero's 99-foot-tall bronze likeness in the vestibule.

Ironically, it was the generally moderate Emperor Hadrian who first ornamented an official residence for leisure—an immodest habitation at Tivoli that covered eight miles and enfolded 30 buildings, an exemplary Alexandrine garden, and miniature replicas of favorite sites from Rome's provinces. The poet Statius extolled the Villa Adriana's "gilded columns, thousand portals carved of Mauritian ivory, vividly colored marbles. All the statuary was of gold and ivory inlaid with gems large enough for finger rings." Fatal praise. Although the complex accommodated the business of the state, its compounding delights—baths, theaters, library, philosopher's chamber,

CHAPTER OPENER
THE HALL OF MIRRORS:
THE SHOWPIECE THAT
BROUGHT GLAMOUR TO
POWER, AND VERSAILLES
TO THE TEMPLATE FOR
A ROYAL RESIDENCE.

You can tell a rich man by what he has on the floor

J. PAUL GETTY

and pools—were so clearly conceived to provide a nice time that the fallout cost Hadrian his empire.

More lastingly, the ideal of a retreat launched the world's first leisure class, afflicting affluent Romans with the deep need to relax in a columned villa by the sea among cooling fountains and, as at Antioch, elaborate mosaic parterres. Some got out of hand. Seneca the Stoic pilloried the consul Servilius Vatia ("famed for nothing else than his life of leisure") for fashioning one at Baia that "blocked the wind for the entire town." To no effect: surfeit now so permeated the culture that even the refined villas of Herculaneum and Pompeii flashed a surfeit of silver and spas the size of arenas. In turn, the push to empire flourished outlying provinces with domains that lodged dignitaries in high style for weeks, often months—until plunged into gloom by visigoth hordes.

Only after Barbary had ceded to chivalry, and looting to trade, could Europe focus again on domestic arrangements. By the late Middle Ages, a thriving bourgeoisie aspired to the visible luxury of a mansion with the stonework of the "Jew's House" in Lincoln, or the mullioned windows given the "Musician's House" in Reims. Lords outclassed only by the number of holdings—domains collected for status and revenue. Greatly provoked, Charles V taxed the presumption of any owning over 300 castles. Greatly annoyed, the Prince de Croÿ stopped at exactly 300. Whatever the levies, the privileged dodged them, leaving façades blank, for example, when glass was a luxury that taxed mansions by the number of windows.

STUDIOLO OF FEDERICO DA MONTEFELTRO IN GUBBIO; ELITIST CONCEIT CONVEYING SUPERIOR TASTE AND COGNIZANCE WITH INLAID DEPICTIONS OF SCIENTIFIC INSTRUMENTS, INCUNABLA, AND *OBJETS DE VERTU.*

Happily, the Renaissance endorsed ornament, since no sumptuary law could restrain Italy's breakout class. Merchant mansions strove for the glamour of palaces, placing overnight the Pitti, Grimaldi, Strozzi, and Bevilacqua on the same playing field as nobility. The Rucellais impressed Florence with a three-tiered façade. The Borgheses and Barberinis seduced Rome with exteriors by Borromini and ceilings by Tiepolo. Trends tripped over each other in the rush to outdo—mirrors, murals, caryatids, gilded stucco. Medallion-crusted ivory furniture marked Ferrara, variegated marbles lit Naples, grandiose stairways lifted Genoa, long colonnades defined Bologna, and marquetry—after Federico da Montefeltro had Botticelli inlay his study—profiled Gubbio.

None outshone the merchants of Venice, who glossed everything. Fattened on maritime trade, the fairy-tale city had glittered in Europe's imagination since the Grand Canal lined up palaces. *Horror vacui*—the dread of empty space that had tiled every surface of the rich Arab's domicile—imported the high luxury of pearly mosaics and blown glass that fully suited the braggadocio of the Republic's first Golden Age. Intended to shimmer in the waterways like a dream, the palazzos boasted carved balconies, marbled flooring, and such talking points as 2.5 million blocks of stone floated in for the Gritti. Added to frescoes by Veronese and flourishes like the gardens of the Villa Aldobrandini, they bought entry to the who's-who "Libro D'Oro."

Such overboard ornamentalism had been orchestrated mainly for show. Not so, the diversion proposed by the day's most influential architect, Andrea Palladio—an elegant getaway framed as a farmhouse. If it remained essential to preserve a palace presence in the city, it was now critically fashionable to own a rural retreat by the Master. A conceit of simplicity, the Palladian villa was in actuality a highly sophisticated affair. While sharing the formal vocabulary of pediments, planters, sculpted basins, and ponds that so refined the new aesthetic, form occasionally usurped function with ornate pilasters, arches, domes, and a façade intended to "add very much to the grandeur and magnificence of the work." The famed Villa La Rotonda, conceived primarily as a place to luxuriate, was so finely detailed that client and architect died before delivery. Ostentation won out in the end. An exercise in 18th-century puffery, the Doge Alvise Pisani's retreat at Stra climbed on caryatids to 96 rooms and ceilings frothed by Tiepolo.

With pleasure become principle, even the dour North had unbuttoned. What clout they presented, those fortified castles housing Scotland's powerful clans— Edinburgh, Holyrood, Crathes, Stirling, Brodie, Balmoral, Hamilton! Their panache of towers, turrets, gables, mahogany, plasterwork, and rich furnishings, and the vaulting staircases that afforded the owners a grand descent to their guests, informed the baronial aesthetic that flourished later colonial mansions. England

OPPOSITE TOP VILLA LA ROTONDA: ANDREA PALLADIO'S MASTERWORK, COMMISSIONED FOR ENTERTAINING BY BON VIVANT PAOLO ALMERICO.

OPPOSITE BOTTOM HAMPTON COURT PALACE: THOMAS WOLSEY'S RESIDENCE WHOSE REFULGENCE SO RILED THE KING THAT THE CARDINAL HAD TO SURRENDER IT.

How beautiful, O Jacob, are your dwellings

NUMBERS 24:5

SYON HOUSE: THE ADAM BROTHERS' TRADEMARK PROFUSION OF MARBLE AND PLASTERWORK THAT SWEPT IN NEOCLASSICISM.

strove for their splendor. Although Henry VIII already owned 69 palaces, Cardinal Wolsey so richly appointed Hampton Court—with ceilings painted by artists from Italy and water piped in from the Thames—as to hugely annoy him: "Why should a subject build such a gorgeous palace?" Wolsey had reserved an entire wing for the sovereign but could only reply, "To give it to his master." Mollified but mettlesome, the king took it over then made his own statement with Nonsuch: "A lavish piece of Nonsense" quipped a wag about the frivolous pleasure-palace imposed on a town that had been leveled for the purpose.

A newly flush nobility sought parity with marking domains. Though the so-called prodigy houses (Aston Hall, Wollaton Hall, Bolsover Castle) were officially aggrandized to accommodate a royal visit, Bess of Hardwick built Chatsworth into such an immoderate showcase for her coronet as to place Elizabeth I on her guard. Bess stood her ground, but waving luxury at royalty was a delicate dance. Just as John of Gaunt's flashy palace at Savoy had provoked Richard II to confiscate his estate, so Edward Hyde would blame the refulgence of Clarendon House and its "abundant way of life" for inciting the "just envy" that incurred his downfall. Burghley House, the brazen 110-room palace built by Elizabeth I's Lord High Treasurer, William Cecil, escaped *lèse-majesté* only because its wings formed the royal "E."

Thenceforth, rival ambition aspired to a notable country house a short distance from London. With classic English understatement "house" translated to a castle that held upward of 85 rooms and stone staircases wide enough to ascend on horseback. At the ready to provide one, master masons-become-architects marshaled a battery of builders. For the 1st Duke of Devonshire, Chatsworth was remodeled after Bernini's expansion of the Louvre. For the 3rd Earl of Carlisle, Castle Howard received a baroque exuberance of urns, domes, pilasters, and protracted wings.

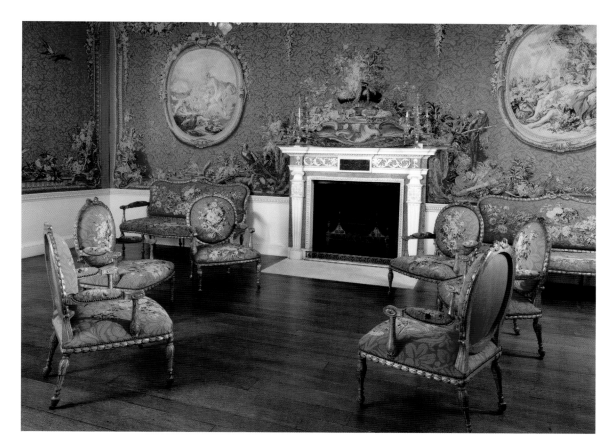

GOBELINS TAPESTRY ROOM FROM CROOME COURT: EVERY ELEMENT—CEILING, PANELING, CHIMNEYPIECE, AND FURNITURE—ASSIGNED TO A DIFFERENT ARTISAN.

Chiswick House, the architect-patron 3rd Earl of Burlington's riff on La Rotonda, established the social marker of symmetry that led Sir Robert Walpole to have the day's talent (Colen Campbell, James Gibbs, William Kent) fashion Houghton Hall into the grandest Palladian house in all England—a stunning excess of marble and gilt whose first-ever designated dining room, together with the 522 cases of Châteaux Margaux and Lafite judiciously dispensed therein, elevated Walpole to Britain's first prime minister.

Some 50 years later, the sought-after Adam brothers virtually dictated taste with neoclassical ensembles whose every element was designed for decorative allure. So influential was their pastiche of Roman triumphalism and French rococo that every significant English demesne of the time—Kedleston, Newby, Kenwood, Derby, Harewood, Lansdowne, Luton Hoo—unfurled a breathless opulence of nymphs, griffins, garlands, urns, pieced marbles, painted ceilings, carved paneling, and stucco medallions—all impressively fronted by long colonnades. Carte-blanche expenditure gave the Duke of Northumberland's Syon House a blue-and-gold frieze and 12 golden gods on magnificent columns dredged at great cost from the Tiber; weighted the Duke of Roxburghe's Floors Castle with onyx, tooled leather, and wildly expensive stained glass; and profiled the 6th Earl of Coventry's Croome Court with an entire room tapestried by Gobelins, from designs (only the English, it was said, went to such extremes) by François Boucher. The suffusion of plasterwork given Sir Francis Child's Osterley Park threw Horace Walpole's famed irony into overdrive: "Oh the palace of palaces—and yet a palace sans crown, sans coronet; but such expense! such taste! such profusion!"

Such demand! Now only a major commission could attract a top craftsman. Walpole himself ordered Strawberry Hill made into a "Gothick" extravaganza that

undermined the Adams aesthetic. William Dalrymple retained the services of the great Thomas Chippendale for Dumfries House by assigning him everything—from cupboards to armchairs to four-poster beds (a triumph that in 2007 led Prince Charles to raise $40 million to rescue it). Only the Crown was still waiting, six centuries after the spate of castle building launched by England's first kings, to give itself a defining new home. Victoria could have taken over the refurbished Westminster Palace but preferred the faded familiarity of Buckingham Palace. Parliament, meanwhile, had indulged England's greatest hero, rewarding John Churchill's decisive victory over the French with the title of duke and housing on 12,000 acres deeded by Queen Anne. Alas, Sarah Churchill's vanity blew Blenheim's budget with a 67-foot-high Great Hall, pretentiously long wings, and vaulting doorways incised with their fledgling coronet. Most egregiously, she directed John Vanbrugh to create a grand view by razing a hunting lodge dating back to Aethelred II. Appalled, the master sought to save it by diverting her attention at each visit, extending the project's completion to nine years, for which he was fired. Successors lined up to bloat Blenheim into the world's largest trophy case—a seven-acre palace surrounded by nine miles of walls. The patent hubris of the attendant assemblage of arches, columns, towers, and 220 rooms awash in military gloriana, incurred the wrath of the queen and cast the hapless Churchills into exile.

Noting how sumptuous domains had ennobled their neighbors, the Irish went for glory with close approximations of the same. Such were Curraghmore, "the largest and most splendid demesne in Ireland," and Powerscourt House, whose domed towers viewed on 49,000 acres of gardens closely modeled on Versailles. A visitor to Ballinlough noted the frescoes by Dutch masters and ceilings by Italy's brothers Francini, but fixated on the furnishings: "Some idea thereof may be formed from the fine marble chimney piece purchased in Italy. . . . I took the liberty of inquiring what might have been the expense of this article and Sir Hugh informed me only 500 pounds sterling, a sum that would establish a tradesman in business." Distinguishing signifiers were passed down like jewels. Thus did Lord Mount Florence deed to his heir "all the marble chimney pieces and cut stone for the colonnade at Florence Court."

Walls, be they four or four hundred, are but the envelope. As marking are the contents, the rich fittings sought out since antiquity. The caravan arteries of conspicuous consumption supplied lacquer from China, ebony from Egypt, and bronze from Byzantium. Blame booty from Carthage and imports from Asia for inflaming the Romans to extremes of desire. Acceptable, the appetite for the translucent mold-blown bowls signed by Ennion; less so, the fever for couches

upholstered with pearls and those pretentious silver beds that the historian Sallust deplored. Even Pliny the Elder, no stranger to luxury, decried the silken divans of Pompeii and Herculaneum perched atop cast-bronze extremities of wild beasts.

There was not yet, however, a sense of décor. Furnishings were acquired over time as separate items, and feudal domains remained defense systems geared to imminent flight, with the activities of sleeping, eating, and gathering carried out in the same hall and the functions of bed, chair, and table combined for ready transport. Tapestries, the only buffer between bed and pneumonia in spaces too vast to heat five feet farther than the fireplace, were the day's main indulgence. Poor lighting, too, dimmed the glory. Long after relative peace had encouraged Carolingian splendor, Charles the Wise suffered the gloom of the Château de Vincennes's heavy oak

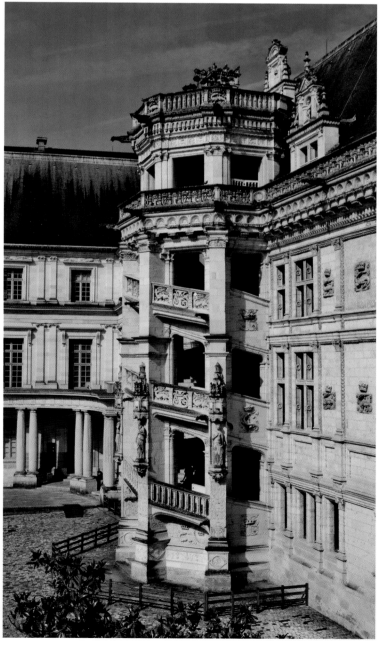

CHÂTEAU DE BLOIS: CEREMONIAL STAIRCASE ADDED BY FRANÇOIS I FOR VISITORS TO WATCH THE COURT ACCESS THEIR CHAMBERS.

furniture and drapes choked with smoke. Even after new luxuries had sailed in from the Orient, Jean de Berry—the son, brother, and uncle of kings, arguably the first Renaissance man, and first to prioritize ornament—lived in opulent discomfort.

The concept of comfort developed in 15th-century Holland when a lull between wars revived commerce and habituated prospering merchants to a life centered on home. Although their trading halls were magnificent and domestic furnishings plush, living arrangements could be called almost cozy. The Dutch innovations of ventilation, indoor plumbing, and heating; rooms and furniture assigned specific functions; and upstairs corridors accessed by multiple stairways, introduced the luxury of privacy that accorded the upwardly mobile a lifestyle (though the term is too modern) at once elite and homey.

Renaissance wealth widened luxury's agenda. While the Farneses dined in the splendor of Rome's muraled salons, and the Hesses assembled wonder cabinets, and Don Gutierre de Cárdenas (between buying up towns) received under the richly carved ceilings of his palace in Toledo, France raced to catch up. The bleak castle chambers that Jacques Coeur, financier to Charles VII, had transformed into richly intimate apartments had stirred the king's envy. The Loire castles of Blois and Amboise, built for the stark

purpose of defense, became lustrous and lavish, replacing the solemnity of oak with gilt from Florence, mirrors from Venice, and art bought or confiscated from impoverished nobility. François I gave Fontainebleau an Italianate makeover and grew Chambord into the kingdom's largest castle—its stalactite towers, double spiral stairway, 440 rooms, and rich furnishings an exercise in refulgence held to prefigure Versailles. Officially built to profile the nation, both largely served the king's pleasure.

Arguably, it was Marie de' Medici, raised with splendor, who taught the French court the decorative excess that gave indulgence new reach. Cardinal Mazarin's stunning agglomeration of 450 paintings, 306 statues, 98 tapestries, and tortoiseshell cabinets crammed with esoterica, introduced a young Louis XIV to the éclat of worldly possessions, and the socially driven to the advantage of a showcase habitation. With salons become showrooms and gardens laid out like parks, Prince Louis de Condé rode so smoothly to gilded retirement at the Château de Chantilly as to be known evermore, to his open delight, as Le Grand Condé.

This was the standard that Nicolas Fouquet, finance minister to the now-savvy Louis XIV, challenged at his peril with Vaux-le-Vicomte, a castle whose majesty resounded throughout Europe. Fouquet's sky's-the-limit ambition tapped Louis Le Vau for the architecture, André Le Nôtre for the horticulture, and Charles Le Brun for the interiors. Alas, the outlay for the opulence Sainte-Beuve described as "anticipating Versailles," not to speak of the village destroyed to deliver views to the horizon, was said by Voltaire to be so astronomic as to excite a royal fit. Certainly none believed that Fouquet was imprisoned for mishandling funds, just as all understood that castle-envy triggered the grandest housing project ever realized outside China.

Luxury habitation can be defined by Versailles alone. Intent on never being outshone again, the Sun King embarked on a lodging that went so far beyond shelter as to forever set the bar for willful indulgence. Never had the Western world witnessed such expenditure for a single domain, whose swaggering surfeit of furnishings, though providing employment for an army of workers and lodging for the burgeoning court, was indisputably born of pique over Vaux-le-Vicomte. The king's open purse funded solid silver furniture for himself and boudoir delights for his favorites. An anonymous pamphlet accused Mademoiselle de la Vallière of "changing four times a year the richest furniture ever made in France." By the time *Sa Majesté* was satisfied, the cost of his domicile had climbed to 500 million francs, handily eclipsing Vaux and vastly depleting the treasury.

The orders that began piling up from a copycat bourgeoisie now royally instructed in the advantage of display were manna for the trade. Versailles veterans Louis Le Vau and Jules Hardouin-Mansart supplied a flurry of "hôtels"—Lambert,

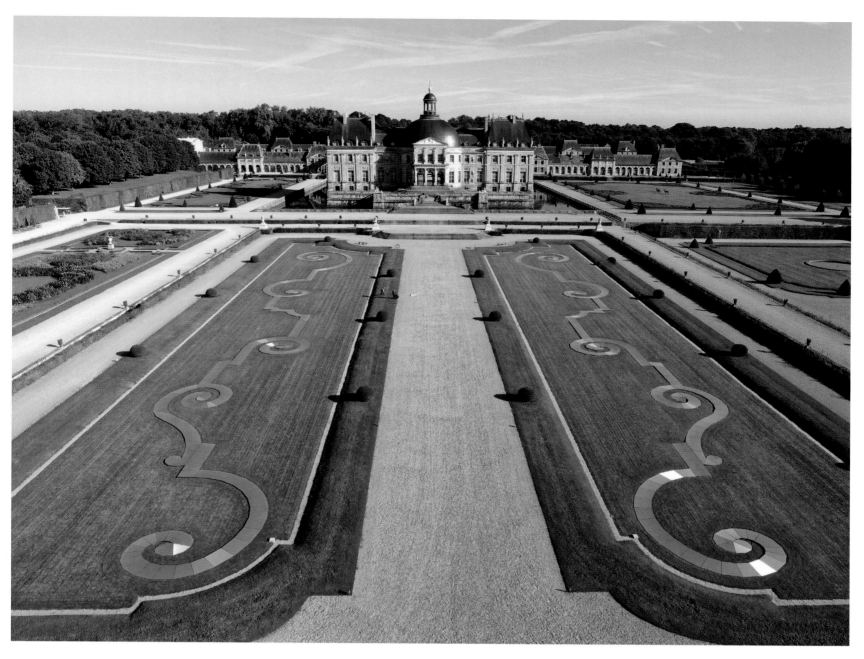

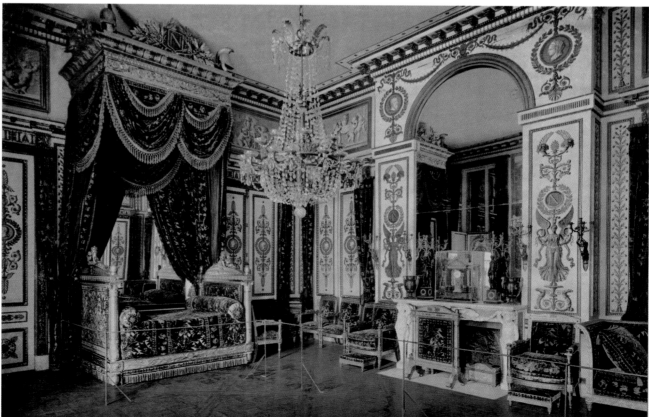

ABOVE VAUX-LE-VICOMTE: THE SPLENDIFEROUS PRONOUNCEMENT THAT LANDED NICOLAS FOUQUET IN PRISON AND RESOLVED LOUIS XIV TO AGGRANDIZE VERSAILLES.

RIGHT ONE OF FONTAINEBLEAU'S 1,500 ROOMS WHOSE EMBELLISHMENTS, LIKE THOSE OF VERSAILLES, BROUGHT THE DECORATIVE ARTS TO A PINNACLE, AND MARIE ANTOINETTE TO THE GUILLOTINE.

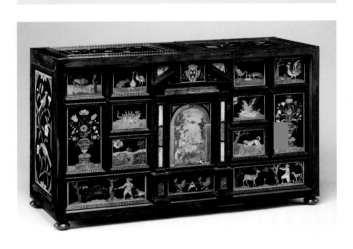

Bretonvilliers, Sully—scaled up for receiving with yawning courtyards, imposing façades, and eye-blinding embellishments. Manufactories were besieged (in 1683, one Henry Havard placed a single order for 800 yards of damask), with a single yard of patterned velvet from Genoa reaching, in current money, $2,000. Rival egos vied for top artisans. August the Strong looked to Albrecht Biller for vaulting mirrors and silver-gilt tables. Prince-bishop Johann Philipp von Schönborn called on Balthasar Neumann to embellish a palace the philosopher David Hume would call "more complete and finished than Versailles"—and this, four years before Tiepolo painted the ceilings.

Improved skills and the newly invented curved-saw tailored the *mobilier* into variegated commodes, and tables assigned to writing, sewing, reading, or gaming. Each had to be wondrous to elicit another commission, spurring maître-ébénistes Riesener, Roentgen, Risenburgh, Boulle, Roussel, Nahl, Oeben, Dubois (their surnames sufficed) to at once define and enhance the new look. Parade pieces were incised with tortoiseshell, ivory, horn, fruitwood, or mother-of-pearl, and mounted with gilded motifs by Jacques Caffieri and Pierre Gouthière. Cabinetry involving secret chambers and spring drawers postponed delivery (the intricate "Bureau du Roi" made for Louis XV took nine years to complete), quadrupling the cost. Friedrich Wilhelm I of Prussia couldn't pay Roentgen for an elaborate secretary until his father had died, raising its price, with interest, to 12,000 thalers—the most expensive piece of furniture on record. Master artisans, nonetheless, remained in ruinous demand. Northern Europe cultivated craftsmen who worked balustrades into tendrils, and Florence turned out miracles of *pietre dure*. The glorious Badminton Cabinet, assembled over six years for the 3rd Duke of Beaufort, was never equaled.

Only fashion mattered more. Just as styles changed with the sovereign—out with Louis XIV Baroque, in with Louis XV Rococo—so must trappings now be "of the latest." One minute the mood was for glass—gold-inlaid Hellenist bowls, cameo-glass Roman cups, Islam's gilded vessels, and Murano's vapor-thin goblets. Moments later, attention shifted to Tuscany's translucent enamels and Giovanni Pisano's delicate figurines carved from elephant ivory. A sudden interest in lacquer introduced a

gold-leaf technique that for each item of furniture entailed a full year of labor. On to chintz—glazed cottons from India bought on the black market. Next, silver (flatware, candelabras, even furniture) that called on new patterns yearly. Porcelain, heretofore the province of nobility (*eight* rooms of Schloss Favorite given over to it) now signed bourgeois aspiration. Strivers had to keep up—only old guard aristocrats like Amalia van Solms dared recycle a look.

More capricious was the craze sparked by a mood or a moment. The press ridiculed *le goût grec*: "The Greek taste is the rage—our furniture, our jewelry, our silks, our hairstyles, our carriages—it is only our souls that are not Greek." Cartoonists had a field day with *la folie de giraffe* when Zarafa's slow walk from Marseilles to the court of Charles X planted giraffes on hats, pots, and table legs. The compulsion to adopt a "look" addicted 18th-century society to such slight flights of fashion as to credit the era with the birth of faddism. The sudden frenzy for chinoiserie that surrendered to La Pompadour's penchant for rococo, then to Jeanne du Barry's neoclassical passion for porcelain-mounted furniture, was replaced by Marie Antoinette's insatiable longing for everything exquisite. The queen's Turkish boudoir at Fontainebleau ceded to suites of formal salons, then to intimate apartments furnished with the latest appointments. Her burgeoning orders for ormolu, inlay, petit point, tassels, painted wallpapers, and gilded mirrors, raised French craftsmanship to a level never seen, French furnishing to a refulgence never surpassed, and the populace to a wrath not forgotten.

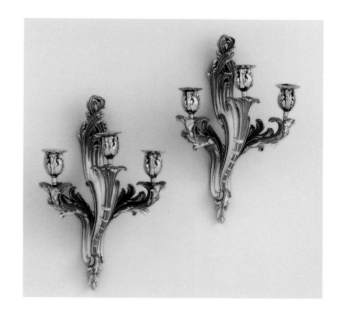

Luxury took a detour, exported to the New World for those who exploited it. At a safe remove from the guillotine, the roof-tiled fazendas of Brazil's thriving coffee plantations were given a French makeover, the vast estancias of Argentina's cattle barons borrowed the gilded opulence of Spanish baroque, and Peru's mining

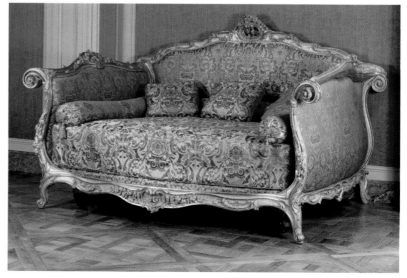

fortunes flashed château furnishings of pure silver. Yucatán's Spanish land grant estates, grown into miniature kingdoms from exports of mescal, agave, livestock, and the sisal fiber known as "green gold," rivaled for which hacienda held the priciest mother-of-pearl and tortoiseshell (*enconchado*) furniture.

Back home, the *métiers d'art* were recovering. The intense rivalry between the portly Prince Regent and his Corsican nemesis polarized taste. Leaving England's gentry to the Regency's brass-and-mahogany aesthetic, Bonaparte's ploy of empire-by-association imposed on the court, thus on all of France, an Egyptian revival. Triggered by the exhaustive *Description de l'Égypte*, commissioned to document his quixotic campaign, a thirst for *le style empire* tented beds, ordered en suite furniture, and collected objects gilded by Pierre-Philippe Thomire, and tossed out everything *Directoire*. The fortune that Empress Josephine poured on the look foretokened Waterloo. Marie Antoinette may have been the first "fashionista," but Josephine was more covetous, going through in ten years over half the $15 million that her husband had pulled in from the sale of 800,000 acres to America.

It took the twin advent of Liberalism and Industry for a rich bourgeoisie to allocate style, heretofore dictated by monarchy, to that new purveyor of taste and pronouncer of trends, the "interior

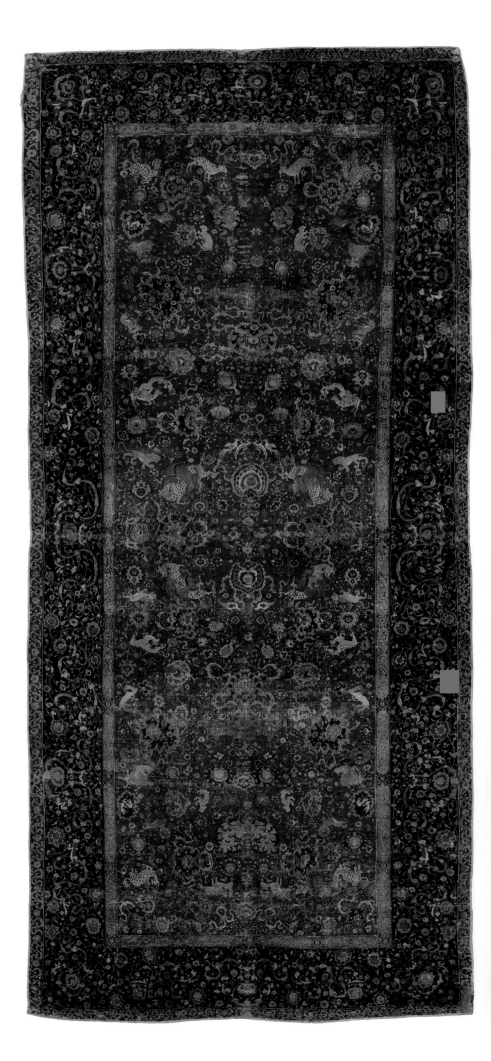

It does not matter if your son remains unmarried, but your courtyard floor must not be left unadorned

RAJASTHAN SAYING

designer." Overnight, parquet floors were in and then out; drapes gathered, then pleated; salons wallpapered into an aviary, a seascape, a camel trek.

As influential were *mécènes* whose prodigal commissions marked a movement. Paris industrialist Auguste Rateau had *ensemblier* Lucien Lévy-Dhurmer gather the day's finest craftsmen for a habitation whose tendriled "Wisteria" dining room defined Art Nouveau. In turn, Brussels financier Adolphe Stoclet's directive to Josef Hoffmann to embrace the Wiener Werkstätte mantra ("Better to take ten days to create one object than to make ten objects in one day") produced a mansion whose detailing, down to the silverware, furniture, toys, and Gustav Klimt's ravishing *Tree of Life*, profiled the Vienna Secession.

Style, in the sense of a look, mattered less to the East, whose correlating identity derived from a refulgent aesthetic evolved from centuries of opulence. Nomads sweeping down from the steppes had readily adapted the opulent lifestyle of the Persian courts they had plundered. By the late 7th century, the Umayyads had become grandly sedentary, perfumed, bejeweled, and ensconced in Damascus in habitats furnished for their personal enjoyment. It spoke to infallibility that Caliph al-Malik gave his sleeping quarters a carpet costing 10,000 dinars, and that those woven of silk for Shah Tahmasp I detailed paradise.

India had come to effulgence when Persia was its province. Emulating, said Megasthenes, "the well-known vanity of the Persians," the 3rd-century BCE conqueror Chandragupta Maurya abandoned an agenda of reform to rule for 23 years from a position of escalating splendor. Luxuriance proved overwhelming, driving the emperor to monkhood and eventual suicide. Maurya's grandson, Ashoka, gentled by Buddhism, endured the rich life more serenely. The royal palace at Pataliputra so dazzled that, six centuries later, the Chinese pilgrim, Faxian, thought only spirits could have hauled in the rock, raised the walls, and executed such lavish embellishments.

THE EMPEROR'S CARPET: GARDEN-OF-PARADISE MASTERPIECE LIKELY MADE FOR SHAH TAHMASP, ACQUIRED BY PETER THE GREAT AND PASSED TO THE HABSBURGS. "COME," READS ITS INSCRIPTION, "FOR THE BREEZE OF SPRING HAS RENEWED THE PROMISE OF THE MEADOW.

The Hindu aesthetic ornamented princely domains as it did sacred ones. By the mid-1600s, travelers were reporting the intricate carving given the formidable Chittor fort-palace of Rajput Rana Kumbha of Mewar, the Bidri metalwork signing Deccan preeminence, and Gujarat's palace furnishings shimmered with mother-of-pearl. Outshining all, the Mughal propensity to work pieced-mirror and cabochons into everything inflated princely aspiration from the refinement of a subtly patterned carpet to a refulgence signaling unparalleled wealth. Shah Jahan literally costumed the Red Fort into the glory of murals, marbles, and silk cushions that informed the famed inscription on the Audience Hall's silver gilt ceiling: "If there is paradise on earth, it is this, it is this, it is this."

Quality's nice, but quantity makes a show

HELENA RUBINSTEIN

Only when Mughal effort was spent did the maharajas preempt. The Jat ruler of Bharatpur looted Agra and transferred its riches to his Peacock Palace at Dig, and such was the treasure Sawai Jai Singh II brought to Jaipur that it was guarded round the clock and visitors led to it blindfolded. The only contenders were East India Company traders, uncultured fortune-seekers with a sizable army who rose from sitting on cushions to Western-style chairs and tables so richly inlaid with ivory and tortoiseshell that gentry back home had to own at least one, and Queen Charlotte, forty. Even as Victoria's viceroys leeched their power, regional rulers fell over each other to cut the most dash. Leading the day's luxuries were F. & C. Osler's cut crystal transparencies—the knock-em-dead crystal staircase and 40-foot-tall chandeliers (largest ever made) supplied to the Maharaja of Gwalior that moved the lords of Patiala, Bikaner, Udaipur, and Serampore to order them, too. Extravagant palaces inscribed glitter as the maharajas' middle name. For just himself and his wife, Sayajirao Gaekwad III of Baroda built the domed, arched, tiled, marbled, 170-room, Laxmi Vilas Palace into the world's largest private residence. West Bengal's Nripendra Narayan gave the Cooch Behar a still longer façade and the dome of St. Peter's in Rome. Indore's Yashwant Rao Holkar II enlisted the renowned Eckart Muthesius to build (along with his rail coach and planes) the vast Manik Bagh, and for its interiors none less than Le Corbusier, Brâncuşi, and Ruhlmann. To rival, Kapurthala's Jagatjit Singh Bahadur modeled his mega-palace on Versailles, given floors polished to a mirror the staff used to tie their turbans. To outdo, Hyderabad's Nawab Sir Viqar ul-Umra spent 22 years making the Falaknuma Palace grand enough to receive Tsar Nicholas II, then went broke and had to surrender it to the Nizam. None outshone Jaipur's lilting Amber Palace, but Umaid Singh's last-hurrah Jodhpur residence topped for sheer count—347 rooms, each detailed with vivid marbles and Art Deco furnishings.

All this time, China had enjoyed an unimagined level of opulence. Qin Shi Huang's newly imperial agenda had set the bar. The entrepreneurial Han had but to reconcile the Zhou dynasty's "mandate from heaven" with free enterprise to blur the line between public and private expenditure. Thus could the Three Kingdoms Emperor Cao Wei build official-use palaces in a park landscaped for pleasure. Four centuries later, Sui Emperor Yangdi's "fickle affection" for a rash of new palaces— together with his unbridled spending on such urgent diversions as a courtyard built to hold one thousand singsong girls—testified to an overreach that brought the dynasty down.

As ambitiously if more sanely Tang aspiration worked a refined aesthetic into status domains. The dynasty's appetite was gargantuan but they had the culture, the labor, the materials, and the money. New construction techniques embellished

OPPOSITE TOP FALAKNUMA PALACE: DISPLAYING A FRACTION OF ITS PRODIGIOUS 138-ARM F. & C. OSLER CHANDELIERS.

OPPOSITE BOTTOM AMBER PALACE: RAJA MAN SINGH'S HINDU-WARRIOR PALACE-FORTRESS, FAMOUS FOR ITS PRE-MUGHAL OPULENCE AND THE LUXURIOUS LIVING QUARTERS ACCORDED EACH OF THE RAJPUT'S 12 WIVES.

the 30-plus structures of the Great Shining Palace and a burgeoning number of rural estates.

Dynasties came and went, splintering here and there into diminutive kingdoms, but luxury remained so defining of status that by the 12th century China's elite were sitting on cinnabar lacquer and dining off Ru Ware lustered with agate. Their dwellings remained standard (the profession of architect not yet established) but held exceptional ceramics and scrolls, and posted standing by size. Although Confucius had encouraged restraint (once admonishing an upstart for lavishing a pavilion with motifs reserved to the palace), his descendants' Kong Family Mansion, comprising 463 structures on 39 acres, remains China's largest-ever civic residence.

It fell to Ming aspiration to expand the imperial residence into a simulation of paradise the size of a town. Officially the seat of political power, the Forbidden City enfolded a network of palaces designed to

THE FORBIDDEN CITY: THE WORLD'S LARGEST IMPERIAL RESIDENCE, EACH OF ITS 980 BUILDINGS AND 90 PALACE COMPOUNDS WAS STYLED FOR A SPECIFIC ROYAL HOUSEHOLD OR ACTIVITY.

shield leisure from affairs of state. Entire buildings were set aside for enjoyment with rooms designated variously for music, meditation, poetry, morning tea, evening supper, dawn mist, setting sun, and so forth—all exquisitely furnished. If such luxury was lost on the commoner (a contrarian text, *Yan Tie Lun*, pronounced carved lacquerware "ten times as expensive as bronze, without being any more useful") widening prosperity fed middle-class aspiration. By the late 19th century, the entrepreneurial Wang commanded a richly appointed demesne covering two-thirds of the village.

Japan aspired to parallel luxury, with appointments whose cost was invisible to the untutored eye. The artful carving (Kumiko Ramma) supporting a Kyoto palace roof projected the moon's shadow on the floor or the sun breaking the horizon in one room and rising over flying geese in the next. Fortunes were spent on achieving *kazari* (treasured objects positioned to heighten their meaning), a scroll, say, placed by a bronze vase, or a patterned bowl paired with a bonsai.

Only fashion distinguished between cultures. When roofing ranked, Koreans signed with patterned tiles and the Chinese with technically difficult turned-up edges. A floor moment drew old money to exotic woods, and merchant wealth, in a much-mocked lapse of taste, to solid silver. In turn, new ceramic techniques ceded the scarlet underglaze of the Yuan to the overglaze favored by the Ming and the Qing predilection for busy vases floating blossoms and butterflies.

Meanwhile, wars and uprisings had been draining the strapped courts of the West. Only Ludwig II was still building—a trio of fantasy castles that almost bankrupted Bavaria. To have shaped Neuschwanstein as a romantic tribute to Wagner, Herrenchiemsee as a nod to Versailles, and Falkenstein as a setting for the king's nocturnal Gothic fantasies, was held certifiably mad. Only the rococo folly of the Linderhof was completed, and its opulence proved Ludwig's undoing.

Industrial fortunes preempted, lodging Europe's bankers and merchants in a style envied by royalty. Such were the mansions of the four barons Rothschild, virtual treasuries stocked with the finest and scarcest of everything money could buy.

NEUSCHWANSTEIN CASTLE: ALTHOUGH PRIVATELY FUNDED, ITS BOUNDLESS ORNAMENTATION SPOKE TO THE EXCESS THAT BROUGHT LUDWIG II DOWN.

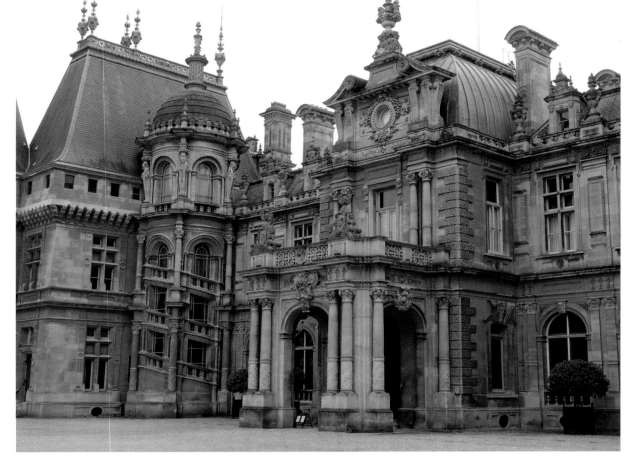

WADDESDON MANOR:
BUCKINGHAMSHIRE
PASTICHE OF A
LOIRE CHÂTEAU—
QUINTESSENTIAL
MANIFESTATION OF *LE
GOÛT ROTHSCHILD*—
PURPOSED BY BARON
FERDINAND EXPRESSLY
FOR ENTERTAINING.

Mayer so marked with Mentmore Towers—a turreted 64-room castle commissioned
from Crystal Palace architect Joseph Paxton—that brother James asked for the same
outside Paris, "only, twice again as big." Duly delivered, the Château de Ferrières
was a legend in its time. Noted poet and frequent guest, Heinrich Heine: "The palace
unites everything the spirit of the 16th century could conceive and the money of
the 19th century could pay for. Two years have been spent on the decoration. It is
the Versailles of the financial absolute monarch." Friedrich Wilhelm I of Prussia
appropriated the estate for his headquarters: "Kings could not afford this, it could
only belong to a Rothschild!"

The barons rivaled on. Ferdinand dazzled England with Waddesdon Manor,
fashioned with materials from demolished French castles. And it was said of Henri's
Paris palace that the doors could accommodate four giraffes walking abreast, and
(by a Tokyo emissary) of Lionel's Italianate Gunnersbury estate that viewed on an
elaborately landscaped Japanese garden, "We have nothing to equal it."

Just as it seemed that sumptuous living could go nowhere but more cluttered,
developments across the Atlantic, broadly called the Industrial Revolution and more
blithely the jackpot, shot habitation into unfettered territory. The catalyst was quick
money and the target was entrée. Colonial America had not stinted, indeed, had
energetically worked European techniques of carving, gilding, and trompe l'oeil
into the convoluted furnishings that had brought the word "fancy" to domestic
arrangements. It had been wholly within the Founding Fathers' understanding
that wealth fostered the pursuit of happiness. Himself ruffled and periwigged,

Thomas Jefferson outfitted Monticello with the latest of everything French. Fellow Philadelphians, wait-listed for Chippendale highboys made of mahogany from Cuba, shellac from Asia, and varnish from Africa, readily paid extra for scallops and trefoils.

Even God had signed on: There was nothing filthy about lucre to Reverend Thomas Hunt, who titled his 1836 bestseller, *The Book of Wealth: In Which It Is Proved from the Bible That It Is the Duty of Every Man to Become Rich.* His was the colonial ideal of wealth as prime mover, the engine to lift the community and open acquisition to beauty. So did the Federal townhouse convey standing and wealth without the need to outshine. As befitted gentry, expensive cupboards were painted black to keep merchant profile in line with the neighbor's. Even in the rapidly rising whaling communities of Nantucket and Massachusetts, imported furnishings such as profiled Samuel McIntire's marking Gardner-Pingree House strove for a pedigreed restraint.

What turned reserve to lust were windfalls from the galloping troika of industrial innovation, the mother lodes out west, and no income tax. California struck gold, Nevada struck silver, Texas struck oil, and 14 million tons of steel, 200 million tons of coal, 10 million bales of cotton, and 763 million bushels of wheat flushed America's new barons into such a full-blown fever of spending as to give proof-positive of luxury's genesis in humankind's DNA. Whereas the wealth

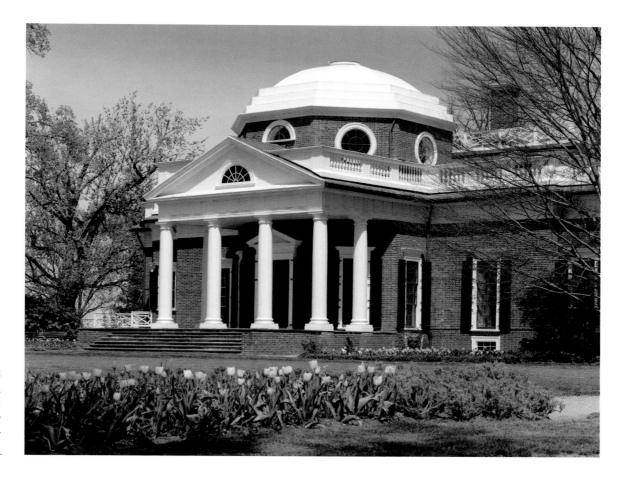

MONTICELLO: THOMAS JEFFERSON'S VIRGINIA HOME; THE "ESSAY IN ARCHITECTURE" THAT REALIZED HIS DREAM BUT BANKRUPTED HIS FAMILY.

of dynastic Europeans (measured against Archduke Friedrich of Teschen's then $750 million-net-worth) was largely frozen in land, America's overnight millionaires had full access to their fortunes. By 1852, the 100,000 gold bars sent to Manhattan banks weekly had joined them to the world stage of big players and triggered a spending spree that only the Great Depression would curtail.

Thenceforth, low profile was for losers, accumulation was good, and display was better. "In order to gain and hold the esteem of men," Thorstein Veblen noted, "it is not sufficient merely to possess wealth or power. The wealth or power must be put in evidence." It's unlikely that August Belmont, the Rothschilds' upstart agent, could have won old-line Commodore Perry's consent to marry his daughter had he not offered her a square block of Manhattan and the city's first freestanding mansion. Adding rich furnishings was held an investment. Early Gilded Era acquisition cared less for the goods than their return on the dollar. From treasures bought, alchemy was sought—art into patina, mansions into status. As new fortunes wrested from sweat, scrub, and slag raced one another up society's shiny ladder, their names grew iconic: Astor, Vanderbilt, Rockefeller, Carnegie, Frick, Gould, Fair, Altman, Havemeyer, Pulitzer, Mackay.

Hard at their heels, a pack of architects and purveyors elbowed to place the new titans in the lexicon of who mattered. With social visibility the entrée, only a drop-dead dwelling could anoint. In 1860, Manhattan's *très nouveau* retailer, Alexander T. Stewart, threw the first gauntlet, eclipsing the old-guard Brevoorts' stately brownstone with a 55-room white marble palace whose extravagant

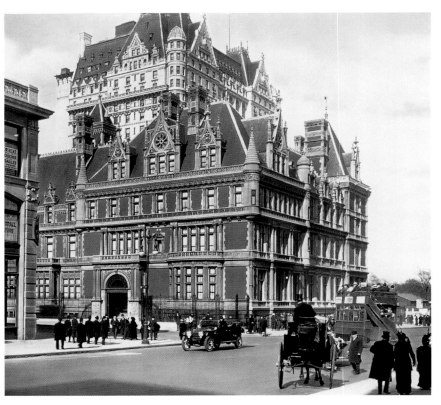

appointments took 500 workers six years to complete. Gushed *Appleton's Illustrated Guide*: "Of all the famous buildings on Fifth Avenue, none will ever be so famous." To qualify his ambitious spouse, Caroline, William Backhouse Astor Jr. had Robert Morris Hunt build a mansion at 350 Fifth whose ballroom was sized to enthrone her as *the* Mrs. Astor. To more grandly entrench wife Alva 20 blocks north, William Kissam Vanderbilt had

THE SIX-STORY, BLOCK-LONG FIFTH AVENUE CHÂTEAU (NOW BERGDORF GOODMAN) ORDERED BY CORNELIUS VANDERBILT II TO ECLIPSE BROTHER WILLIAM'S.

Good architecture is a luxury

FRANK GEHRY

Hunt fashion a facsimile of the Château de Blois—the first to assign rooms different historical periods and detail them with spoils from abroad: "Vastness is the first impression in this truly magnificent house, splendor is the second impression, and luxury is the third," the *New York Times* remarked of its gilded boiseries, painted ceilings, Boucher tapestries, Gothic banqueting hall, and monolithic stone stairway. Annoyingly, its offending flamboyance—a block of paving stone that weighed 22 tons, fireplaces shouldered by caryatids, a stained glass depiction of the royal encounter at Calais, and a rosewood table that inset in mother-of-pearl a constellation as it had appeared at the date of William K's birth—moved the U.S. Senate to cap expenditure on private domains. Undaunted, sibling Cornelius Vanderbilt II demolished eight houses at 57th and Fifth for a 130-room Fontainebleau that upped the requisite ballroom with a three-story stone staircase, a Moorish smoking room wrought by Tiffany, and each upstairs room duplicated for Alice.

In rapid sequence, eight more scions positioned themselves grandly on what became known as Vanderbilt Row. Hot on their tail, a pack of contenders lined Fifth Avenue with dwellings designed to astound. "Course and ignorant," sniffed the 1883 *Real Estate Record and Builders' Guide* about the florid mansion on 93rd Street that signaled beer baron Jacob Ruppert Jr.'s ascent from the Lower East Side: "It is evident that there are a great many things in the house and that the house cost a great deal of money. But it is impossible to discern any more artistic purpose than to exhibit these two facts." Of William A. Clark's six-year effort to give a Beaux Arts veneer to the mining fortune that had shot him to the Senate, a wag punned: "Senator Copper of Tonapah Ditch/ Made a clean billion on minin' and sich. / Hiked for New York where his money he blew, / Buildin' a palace on Fift' Avenoo. / Looked like a peacock, he strutted the proudest / And built him a house that would shout out the loudest, / Frenchified windows that look at the park / And fancy glass fixtures for light after dark. . . . / So King Copper just broods with a painted on smile / While the rest of us laugh at his parvenu pile."

Invariably, novelist Edith Wharton noted, splash won out. Marquetry, mirrors, and Tiffany glass worked interiors into stage sets. The designer George Schastey inlaid entire rooms with mother-of-pearl. Even the once-exclusive Mrs. Astor built a humongous new mansion for herself and her son, at 840 Fifth, with a ballroom for 1,200, suites of reception rooms that "piled splendor upon splendor" of mullioned windows, bronze chandeliers, Flemish tapestries, mirrored doors, and velvet drapes, and two dining rooms seating 200 each.

Size delivered—it impressed that steel magnate Charles M. Schwab had bought a block of Manhattan for a 75-room mansion with a bowling alley and pool, and that banker Otto H. Kahn had built the second-largest house in America—but for the seasoned player an urban château was a starter kit. Panache still marked—as when

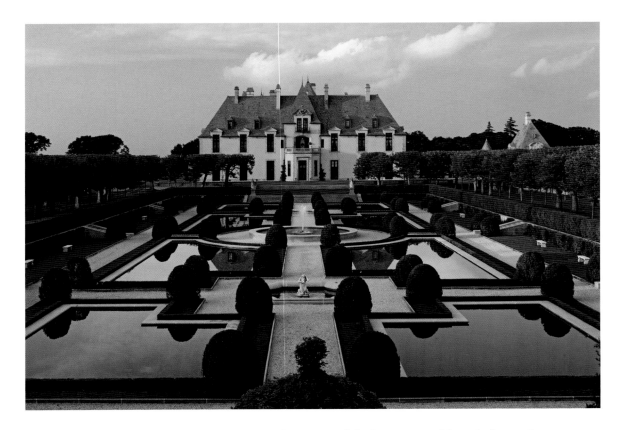

Thomas Fortune Ryan purchased two lots on Fifth Avenue and leveled one for a rose garden—but culture aced. Anything imported, historic, or unique—Greek statues, say, or a collection of Meissen. The masterworks transferred from the Continent to industrialist Henry Clay Frick's block-long Beaux Arts residence softened his image as "the most hated man in America." High society sought invitations to 2 East 57th street for Collis P. Huntington's Rembrandt-stacked salon, to steel magnate Henry Phipps's Renaissance townhouse for its parquet floor inlaid with cherubs and harps, and to financier Henry Marquand's R. M. Hunt mansion for its ivory-and-moonstone furniture fashioned by Lawrence Alma-Tadema. Sugar baron Henry Havemeyer came to prominence with a music gallery designed by Louis C. Tiffany to display his Stradivarius violins. J. P. Morgan stepped out from his father's shadow with the nation's first residence wired for electricity, and another to hold his collection of everything wondrous.

Acquisition fever trailed west. In Minneapolis, the paintings and objects piled up by lumber baron Thomas B. Walker spilled from his mansion to eight annexes and on to specially built galleries. In Pasadena, California, Henry E. Huntington shed his reputation as "a most uncouth person" with a Beaux Arts mansion showcasing a trove of Sèvres, four Beauvais tapestries, Savonnerie carpets commissioned by Louis XIV, and a flurry of 18th-century English portraits railed out by the tireless Duveen. "The emigration of European masterpieces," noted writer Harold Acton of the exodus, "was on so vast a scale that one could foresee a future in which Europeans would have to go to America to study art."

Some overdid. So swiftly had Duveen provided the Philadelphia Stotesburys with 500 paintings, the requisite tapestries, and suites of French furniture, that Eva showed her guests around holding a list to identify them. Some overreached. So hastily had Bavarian immigrant Henry Villard gentrified his overnight railroad

ABOVE OHEKA CASTLE: AMERICA'S SECOND-LARGEST RESIDENCE, GIVEN AN 18-HOLE GOLF COURSE TO PROVIDE SOCIAL ENTRÉE.

OPPOSITE *AUTUMN LANDSCAPE*: TIFFANY STUDIO STAINED-GLASS MASTERWORK, COMMISSIONED FOR A REAL ESTATE MAGNATE'S GOTHIC REVIVAL BOSTON MANSION, BUT NEVER INSTALLED.

fortune with a Manhattan facsimile of Rome's Palazzo della Cancelleria (now
the Palace Hotel) that months later bankruptcy railed the entire extravaganza of
balustrades, mantels, carpets, mosaics, and tapestries to the auction house. Some
never made it. So elaborate was the habitation that the Amory Carharts asked of
Carrère and Hastings that by the time of delivery both were dead. A few overstepped.
In 1901, when the average worker earned less than $1 a day, Andrew Carnegie sold
his steel corporation to J. P. Morgan for more than the U.S. federal budget, and
on a blighted corner of upper Manhattan erected a 64-room Georgian mansion.
Excoriated for its wasteful lawn, purified water system, pioneering humidity control,
and sidewalks cut on-site from flagstone hauled in from the north, the magnate
added an iron fence—shutting out the homeless and shutting in the world's richest
man to end his years in embittered isolation.

More justly vilified were the railroad barons who waved off the immigrants
poured in from Europe: "In a country where nominal respectability so closely
infringes on the question of money," blasted the *Daily Graphic*, "there was nothing
reprehensible about these squatters but poverty." Tarrytown's mayor roundly
refused the offer of Jay Gould's 550-acre compound for a community museum on the
grounds that the robber baron should indeed be remembered but "certainly not for
honor or exaltation."

Predictably, each newly polished generation shunned the arriviste. Alice
Gwynne Vanderbilt, on hearing that a parvenu had bought a bronze gate she'd
had auctioned, had the other sunk at sea. Hers was but a finger in the dyke of the
dreaded "middle class," a baffling category of striver launched by industry—clerks,
shopkeepers, and accountants, who fancied the good life. The only recourse was to
leave town.

Thus was Newport reborn as an exclusive resort whose entrée was a "cottage."
Annoyed that the *New York Times* had crowned her sister-in-law's Manhattan
mansion the "Finest Residence in America," Alva Vanderbilt asked for one on
Bellevue Avenue that none could outclass. Fueled with $11 million ($282 million
today), Richard Morris Hunt delivered Marble House, a dazzling facsimile of
Le Petit Trianon. Its appointments—velvet-covered bronze furniture, $7 million
worth of chalk-white Italian marble, and a lacquered cliffside teahouse accessed by a
miniature train—would have won Alva her crown had Cornelius II not engaged the
same architect and 2,500 workmen to place Alice forever foremost with a cottage *sans
pareil*. Titled The Breakers, its Corinthian columns, wrought-iron fence entailing
$5,000 yearly to repaint, 70-ton entrance door, 60-square-foot reception hall, frescoed
dining room, and 69 other elaborate rooms—one shipped from Paris and all piped
with fresh and salt water—duly pulverized Newport. By this time, however, Alva
had moved down the street and taken the title of Mrs. Oliver H. P. Belmont, which

OPPOSITE, FROM TOP
BILTMORE HOUSE:
AMERICA'S LARGEST
PRIVATE RESIDENCE,
STILL IN THE VANDERBILT
FAMILY, THE LAWN STILL
MOWN IN STRIPES.

MARBLE HOUSE: WILLIAM
K. VANDERBILT'S
$11 MILLION GIFT TO WIFE
ALVA, COMMISSIONED
TO CROWN HER QUEEN
OF NEWPORT.

THE BREAKERS:
BROTHER CORNELIUS
VANDERBILT II'S PRICE-
ON-REQUEST GIFT TO
ALICE TO UNSEAT ALVA.

brought with it, not one cottage, but two.

Elsewhere, new money engaged provenance more overtly. Edward J. Berwind modeled The Elms on the Château d'Asnières; Robert Goelet gave Ochre Court a $25,000 medieval stained-glass window, and Mrs. Hermann Oelrichs livened Stanford White's grand scheme for Rosecliff with an exorbitant replica by the great Augustus Saint-Gaudens of Versailles's Court of Love. Harvester heir James Deering's 180-acre, Vizcaya estate riffed on Renaissance Italy with a colossal sculpted gondola and an historic Roman fountain complete with its piping. Walter and Lucie Dodge Rosen lifted Caramoor with a 17th-century Burgundian library, a gilded bed tracing to Pope Urban VIII, and a chinoiserie lacquer-paneled chamber lifted from Turin's Palazzo Ricasoli.

The next Monopoly move was a glorious site. On Fishers Island, Bethlehem steel king Garrett Linderman viewed his 50-room, mahogany-paneled "cottage" on a horizon garden whose drainage system could have serviced a city. In the Berkshires, Anson Phelps Stokes showcased his pricey French furniture in a 100-room granite castle. In Southampton, Long Island,

Colonel H. H. Rogers built two cottages, one inland for a bachelor retreat and one seaside with a $250,000 swimming pool for polite entertaining. In North Carolina, George Washington Vanderbilt II's request to master landscaper Frederick Law Olmsted for a "small pleasure garden, the rest farm and forest" delivered America's largest private home, the 179,000-square-foot, 250-room, R. M. Hunt–designed, château-style Biltmore House, overlooking 125,000 acres of contoured perspectives.

Palm Beach occasioned inordinate ostentation. Having created the resort from Florida swampland, Standard Oil baron Henry M. Flagler reconciled his wife to the move with a mandate to Carrère and Hastings for "the finest residence you can think of." The resulting "73-room Beaux Arts Whitehall," gushed the *New York Herald*, with its attendant $3 million assemblage of faux–Louis XV gilded furniture, bronze doors, Arabian lace curtains, 1,249-pipe organ, and 40,000-square-foot marble foyer, was "more wonderful than any palace in Europe, grander and more magnificent than any other private dwelling in the world." Flagler welcomed the publicity but confessed to a friend: "I wish I could swap it for a little shack."

Once understood that a sumptuous mansion sped Everglades Club entrée, aspirants sought out architect Addison Mizner for an oceanfront "cottage" flaunting his self-described "Bastard-Spanish-Moorish-Romanesque-Gothic-Renaissance–Bullmarket–Damn-the-Expense-Style." El Mirasol, the Moorish palace designed to entrench Mrs. Edward Stotesbury as the resort's doyenne, eclipsed even their 6-story, 145-room, 45-bathroom, 14-elevator Philadelphia Whitemarsh Hall that the Spanish ambassador had likened to the Royal Palace in Madrid. Outdoing even himself, Mizner lifted the George Meskers with La Fontana (an Italianate palazzo frothed with stained-glass windows and oriental carpets leading out to the pool) and gentrified oilman Joshua Cosden with the Playa Riente (a faux villa whose ballroom held nine murals by the great Josep Sert). That Cosden died broke deterred no one, certainly not Postum heiress Marjorie Merriweather Post, then Mrs. Edward Hutton and America's wealthiest woman, who crowned her myriad estates (a 16,000-acre shooting preserve on the Combahee River, the lavish Hillwood estate in D.C., and the Camp Topridge lodge in the Adirondacks that accessed the lake by funicular) with the fabled Mar-a-Lago. The aggregate of superlatives describing this 128-room ocean palace built of stone shipped from Genoa included a castle tower, Venetian arches, a golf course, a million-dollar dining table, and a boudoir modeled—but of course—on Versailles.

East Coast highlife was not lost on the cattle barons out west. In Wyoming, John Kendrick topped a hill with Trail End—a castle whose silk-covered walls, mahogany stalls, and $4,000 Kurdistan rug boasting 11 million knots sped him to senator. In Missouri, Harvey Vaile's wedding-cake mansion made headlines for its 48,000-gallon

SAN SIMEON: WILLIAM RANDOLPH HEARST'S FANTASY CASTLE, SO OBSESSIVELY DETAILED THAT IT NEVER WAS FINISHED.

wine cellar and flush toilets fed by a 6,000-gallon water tank. In Texas, the home that anchored Robert Kleberg Jr.'s million-acre King Ranch boasted bronze stairways, Tiffany stained glass, and—"money thrown to the wind"—outdoor air-conditioning. Older money embraced the American Craftsman aesthetic of the Greene brothers—a rigor belied by the blank-check lamp-to-carpet Pasadena mansion delivered to David and Mary Gamble.

Grand, grandiose, wondrous—all pertained. But one magnate took luxury living into the realm of too much. Not one to hold back, publisher William Randolph Hearst grew his directive to architect Julia Morgan for "something more comfortable than a tent" into the folly of San Simeon—a $7 million, 30-years-in-the-making, Moorish castle on 240,000 acres of California's coast, so impossibly splendid that it was never completed. From its inception, the effort was lunatic. Every day, five tons of material— steel, sand, topsoil, grass, plants, trees—together with artwork, furnishings, and exotic animals imported for the world's largest private zoo, were hauled 1,600 feet up backbreaking terrain. The fortune that Hearst poured on his 97,000-square-foot dwelling raked in carpets, chalices, urns, inlaid gold bedsteads, choir stalls from a Gothic cathedral, hardware from a Venetian palace, a ceiling from the Alhambra, a 14th-century confessional for an elevator, an entire Roman temple, *two* Spanish monasteries, *three* swimming pools—the Roman one cost $400,000 just for the marble, and twice that, when its pipes corroded, to have it rebuilt. Plans were revised again and again: a movie theater planned for 100 now had to hold 150; windows were moved to provide a view from the bed; an assembly hall added 20 feet to

Her whole being dilated in an atmosphere of luxury. It was the background she required, the only climate she could breathe in.

EDITH WHARTON, *THE HOUSE OF MIRTH*

accommodate tapestries once belonging to Louis XIV; and a 137-foot bell tower was raised higher for bigger bells, so grating when installed that they were never played again. The writer Ludwig Bemelmans reported "no undecorated space," a bedroom with "a heavy gold ceiling . . . as are all the ceilings here," a salon as large as "half of Grand Central Station," and a 60-foot fireplace, "perhaps the rarest in the world."

Of all Gilded Age vanities, Hearst Castle best represents the spiraling excess that was brought to its knees by Black Thursday—as dramatic a marker, some said, as the fall of Rome or the slide of Byzantium. The resulting Great Depression brought a reversal of fortune that halted the work, truncated the staff, and sold off $11 million worth of fittings. Fortunately for the labor force, the titan's assets recovered—"now he'll start buying again," noted one, "and that's good for everybody." Gladdest was Hearst. "As long as he builds," said his architect, "he thinks he won't die."

Comedown, for the plutocrat, remained relative. Whereas in 1877 Cornelius Vanderbilt possessed one-ninth of all the U.S. currency in circulation, his great-grandson at his death was worth "only" $4 million. Retrenching for the affluent did not mean moving to a boardinghouse for impoverished gentility but, rather, to the turreted Ansonia Hotel, which boasted the world's largest indoor pool and a fountain holding sea lions, or to a duplex in a Renaissance-pastiche building fashioned by Rosario Candela and James Carpenter into that new expression of chic—the apartment house. The adjustment was not painless. Florence Vanderbilt Twombly lamented the servants sacrificed to the workplace: "This week we lost four, and from the pantry alone!" Even building rules designed to "weed out undesirables" couldn't reconcile such as the Havemeyers to only 11 maids' rooms and staff lost to careers. Still, living "on mere shelves under a common roof" did not greatly discomfort those relocating to the richly marbled 960 Fifth (William A. Clark's erstwhile boondoggle) or to 740 Park with its nickeled lobby, or to River House with its private marina. Grandest was Marjorie Merriweather Post's triplex at 1107 Fifth, built atop her razed mansion, which replicated all of its 54 rooms—one just for ball gowns.

An apartment, to distinguish it from the one above and below, relied on décor—a new take on luxury designed more to *épater* than overwhelm. Enter the decorator, purveyor of style and all that amused. Leaving Syrie Maugham to such tasteful conceits as books bound in white vellum, Elsie de Wolfe made a career transforming domestic interiors into signatures. Capricious herself to the point of matching her hair to her aquamarines, she adroitly fed the craving for a new look each season with the ultimatum of "so in" or "so out." Oak paneling was glossed white, Aubusson ceded

THE PARIS SALON ORNAMENTED BY HENRI SAMUEL FOR COUNT HUBERT AND COUNTESS ISABELLE D'ORNANO AROUND THE COUNTESS'S ANCESTRAL PORTRAIT OF BARBARA RADZIWILL, QUEEN OF POLAND.

to zebra, and those deadly drapes surrendered to a downpour of light. A personalized aura was created around Tiffany mosaics or, for Henry Clay Frick, an instant collection of master paintings or, for the trendsetter, the thrillingly modern aesthetic of Art Deco.

An injection of new capital restored war-torn Europe. Munitions enriched the Axis estates of Fritz Thyssen and Gustav Krupp. Trade furbished the country domains of the newly titled Simon Marks, Charles Clore, and Alan Sainsbury. Italy's

speedboats, scooters, and racecars entrenched the Rivas, Piaggios, and Agnellis. France revived on fortunes built abroad by such as Bolivian tin king Simón Patiño, and Chilean "grand amateur" Arturo López-Willshaw, whose resolve to restore everything Louis XIV began with replicas for his Paris mansion of the solid-silver mobilier. Taking up his charged aesthetic for such as Sadruddin Aga Khan and Hubert and Isabelle d'Ornano, carte-blanche tastemaker Henri Samuel introduced the cultivated artifice that made *de trop* the byword for monied sophistication.

Farther east, the revived fortunes of powerful families like the Safras and Kadoories reprised a life stocked with mansions, cars, servants, and museum-worthy art. New on the scene, overnight oil barons quick to wrest glory from sand looked to Iranian entrepreneur Habib Sabet, whose Teheran palace cloned the Petit Trianon.

Back across the Atlantic, the booming 1980s introduced a new golden age. In Quebec, Paul and Jacqueline Desmarais profiled their pheasant shoot with a Palladian villa featuring the bed of Empress Josephine and a Valerian Rybar décor defined by gold-trimmed bathroom curtains costing $50,000 a yard. America's millionaires played McMansion: In Dallas, developer Braden Power's "creative outlet" gave his domain a $500,000 lighting system; in Houston, Dr. Anthony Walter's need "to live in an extremely beautiful space" coffered a 100-foot-long hallway with 48,762 cubic zirconias. In Sagaponack, New York, Ira Rennert's wife's longing for "the

HABIB SABET'S PETIT TRIANON (TEHERAN'S LARGEST HISTORICAL MANSION): ITS EVERY DETAIL WAS REPLICATED WITH NO COST SPARED FOR THE WORKMANSHIP, MATERIALS, AND AUTHENTIC DETAILING.

biggest house in America" produced Fair Field, which, annoyingly, fell far short of Biltmore House, but showcased furniture from Versailles. Channeling Versailles more overtly, high rollers David and Jackie Siegel embellished an ever-expanding dream palace with such Sun King imperatives as a $250,000 stained-glass window, until downturn forced them to put it on the market "as is." Asked why he had embarked on such a folly, the erstwhile time-share king shrugged, "Because I could."

The millennium marked the end of an era. Ancien-régime estates were converted to museums and the bibelots profiling social arbiters Betsey Cushing Whitney, Beatriz Patiño, Marella Agnelli, the Duchess of Windsor, and Rachel (Bunny) Mellon, were auctioned off. It was less luxury itself on the block than a way of life defined by its time.

Plutocrat ambition proved more muscular, posting prestige with a surfeit of splendor. In Mumbai, energy czar Mukesh Ambani sealed his status as India's richest man with a billion-dollar, world's-largest, 27-story family home holding nine elevators, a ballroom, a 160-car garage, and three helipads. In London, phosphate magnate Andrei Guriev expanded Witanhurst, already the city's largest residence after Buckingham Palace, to accommodate a cinema, gym, 70-foot-long swimming pool, and 25-car garage. Silicon Valley one-upmanship moved Melinda and Bill Gates to better the world from a Xanadu compound near Seattle that handed guests a sensor to adjust temperature, lighting, and the art on the wall. Manhattan achievement was a starchitect building with a "luxury attaché" and infinite view: "It's expensive, of course," said Dmitry Rybolovlev's lawyer of the $88 million penthouse that the Russian fertilizer magnate bought for daughter Ekaterina, "but if it's the standard of her living, it's the standard of her living." The hedge-fund-billionaire standard set by William A. Ackman's $91.5 million for-entertaining-only penthouse at One57 was topped by Kenneth Griffin's $238 million penthouse in the Western Hemisphere's tallest residence.

The flip side of posting luxury is pouring a fortune into hiding it. In Marrakesh, perfumer Serge Lutens spent 40 years combining 20 houses into a palace that presents as a monastic retreat. In China, architect Steven Holl took on projects whose "metaphysical dimension" was achieved with "nonmaterialist ideas."

Tell that to Swiss aviation magnate Thomas Flohr, whose seven-story James Bond aerie in St. Moritz displays a "garage gallery" for his *Goldfinger* Aston Martin and a wall-length video simulation that turns the underground spa into the Engadin Valley. David Bowie, whose alter ego was all about excess, understood the dichotomy: "We only need to create a warm, loving environment for our family; we don't need multiples or multi-colors of anything, but we insist on making 1,000 kinds of chairs and 15 colors of plates—it's a sign of the irrational part of man."

*Every thing that grows/
Holds in perfection
but a little moment*

WILLIAM SHAKESPEARE

VERDANT VANITIES

There are gardens that grow staples and gardens that grow dreams. At once showy and intimate, fragile and resilient, unforgiving and obliging, beholden to nature and responsive to nurture, the ornamental garden is to housing what coif is to hair. Manipulated and tended, gardens big and small adorn and distinguish.

Such were the tapestries of living color rolled out by the rulers of antiquity: Crete's leafy mazes conceived to bemuse; Persia's lilting gardens of paradise; the plantings suspended over cliffs, seeded in marshes, grown in sand; the landscapes planted overnight to woo or amaze. Such, too, were the flowerbeds fashioned to bloom in a different season for each of Prince Genji's four wives, the fragrant parterres planted for the blind Earl of Coventry to inhale as he walked, and Dorothy Una Ratcliffe's park in Westmorland sewn with 30,000 bulbs annually to herald spring. All met the longing for distinction, and for—that supreme luxury—beauty. Even farming communities set aside land for flowers, while many a royal garden, like that of Montezuma II, who believed a great ruler should not exploit pleasure, grew nothing edible.

Noble or arrogant? To shape a garden is to dominate nature. To impose a design is to work land into logos. The Abbasid Caliphate's paradise gardens at Samarra were as declarative of power as of discernment. The day's manual for control would have counseled: shape boxwood (as had Emperor Augustus) to spell out your name; divert a river (as did Chancellor of the Exchequer, John Aislabie) to create cascades; dispatch a botanist (as would a 19th-century profligate) to locate a rare tree. Or, like English gentry, mow your lawn into stripes to show how much unprofitable land you don't profit from.

Those not privy to flowerbeds focused on one species, one bloom. The Romans shipped roses from Egypt to display under glass; the Persians grew record-size peonies; the Japanese manipulated 350 varieties of the venerated chrysanthemum. Amateurs obsessed on the exotica that occasioned invitations to a viewing, which for the cultivator was ever the point. Travelers detoured to the Villa Carlotta in summer for its giant magnolias, to Duc Philippe d'Orléans's palace in winter for the jasmine climbing its halls, and to the Prince Regent's greenhouses year-round for fairy-tale florets trekked in from China and Africa.

Expert cultivation connoted connoisseurship. Confucius compared entering a room full of orchids to "association with a superior person." A perfect bloom replaced jewelry and in portraits spoke to majesty. The Turks wore them like regalia—it was

CHAPTER OPENER
VILLA D'ESTE: THE LIVING MUSEUM DEVELOPED BY BORGIA SCION CARDINAL IPPOLITO D'ESTE TO DISPLAY HIS WEALTH AND ERUDITION.

OPPOSITE THE SEMPER AUGUSTUS: EMBLEM OF HOLLAND'S 17TH-CENTURY TULIP CRAZE, A SINGLE BULB SOLD FOR SIX TIMES A WORKER'S ANNUAL SALARY.

Semper Augustus,

not out of sentiment that Mehmed the Conqueror held a rose for his portrait. The Mughals adopted declarative signatures. When Shah Jahangir took to roses, the entire court planted roses; when he fixated on tulips, rooftops were planted with bulbs. Only blossoming fruit trees skirted whim—transplanted with great difficulty from China and Persia, they constituted living collectibles.

On the Continent, social standing derived from a posy of hothouse blooms worn in the décolletage, or from flowerbeds turned over each season to stunning effect. As with dress and décor, floriculture followed fashion, prizing, in turn, anemones, carnations, pinks, and violets. Protected by guilds, rare species conferred status through the implication of cognizance. "If tulips were rendered common," observed the renowned *fleuriste* Charles de la Chesnée-Monstereul, "it would deprive men of honor of the sweetest society between them."

Holland's tulip mania, nonetheless, can be ascribed only to greed, a fever that raised coveted varietals to a commodity quoted on the stock exchange for higher prices than land. A single bulb of the "Viceroy" traded for a bed, a suit, 60 pounds of cheese, 4 oxen, 12 sheep, and 8 pigs. A still scarcer specimen drew an offer of a tandem-drawn carriage plus 4,000 guilders more than Rembrandt charged for *The Night Watch*. Prices rocketed—an Amsterdam merchant sold one bulb of the scarlet-striped "Semper Augustus" for twelve times the sum that sustained the average

The soul cannot thrive in the absence of a garden. If you don't want paradise, you are not human.

THOMAS MORE

family for a year—until in February 1637 an innkeeper's prize collection failed to sell, relegating tulip profiteering to a cautionary tale.

The English valued excellence regardless of class (many a commoner won best of show) but titled achievement was better documented. Few could rival the rhododendrons that Baron Lionel de Rothschild grew at Exbury to a record 20 meters; Lord Astor's unparalleled 1,000-yew maze at Cliveden; and the 10,000 orchids costing up to 1,500 pounds each that Lord Israel Sieff's "orchidelerium" sheltered in greenhouses fitted with ventilation systems, cross-fertilization labs, and the filtered light of their habitats. Sieff wrote off the extravagance to "the exoticism of their origins and the pleasure of growing them—the cultivation of beauty for itself."

Cost paled before effort. Planting a garden is a hope; maintaining it is the luxury. Wondrous, the attempts to master climate and soil! To shade the desert and block the wind, the Egyptians hauled in mature trees and rotated massive flowerpots. A garden, by its upkeep alone, constituted a high offering to the gods. Ramses III wooed Amun with 514: "I've created immense gardens for you . . . filled with date palms and with vast basins planted with jasmine and jonquil." Equating gardens with paradise, the Sasanids worked living paintings from an interlacing geometry of fruit trees and flowers, many imported and all sustained at great cost. Khosrow II's Eternal Spring Garden, depicted in the famed 84-square-foot "Winter Carpet" with gold thread and cabochons, dazzles still.

Horticulture's foremost luxury was water: wars were fought to secure it, gods were regaled to protect it, and fortunes were poured into channeling it. Early desert settlements depended on closely managed oases—Uruk's on intensive irrigation and Egypt's on extended canals. More elaborate schemes awaited leaps in technology. The miraculous Hanging Gardens of Babylon relied on purified seawater pumped up a steep cliff to terraces braced to shoulder tons of soil, imported flora, and 50-foot-tall trees. Few could muster the vast workforce needed to dig out the Canal of the Pharaohs, channel the upper Irrawaddy for Burma's fabled gardens, and install India's deep-water tanks. Well into the 19th century, over 250 of the Maharaja of Baroda's 1,000 servants were assigned just to watering the gardens.

Transport alone was prohibitive. Only wealthy societies could afford aqueducts. Rome erected ten to supply households before allotting one to landscaping. It astounds that the Aztecs grew their food in marshes but built three-mile-long aqueducts for their gardens. Remarkable, too, that Persia's rulers crisscrossed the desert with boxed trees, plants, and pipes to lay out a garden by each oasis they stopped at.

Europe wasn't short of water but taxed usage so heavily that display was left to the wealthy. Monarchs were exempt, letting Charles VII power the Caserta's lavish hydraulics from a 21-mile-long aqueduct, and Electress Sophia of Hanover hoist Herrenhausen with a record-high fountain. More ambitious schemes rationed even the Crown. Cued by the Pont du Gard, a young Louis XIV resolved to bring water from the Eure with a prodigious three-tier aqueduct. When four years later 30,000 workers had delivered but one section of one tier, the project was canceled and Versailles's 55 fountains placed on a meter: as the king approached, gardeners opened the valves, and when he left, shut them.

Gardens rarely survive war so until designs were recorded it fell to the monasteries to sustain them. Selected mainly for medicinal properties, medieval plantings were woefully drab, and the cloistered gardens that followed—intended for meditation, not show—were lackluster.

Happily, like a late spring, the Renaissance brought Italian refulgence outdoors, transforming the garden from a refuge for thought to a canvas for visual excitement. With every rich household now desiring one, the artful garden was entrusted to professionals and designs were laid down. In 1459, Leon Alberti's scheme for a Florentine villa shaped topiary into "spheres, porticoes, temples, urns, philosophers, popes, and cardinals." In 1538, Niccolò Tribolo profiled Cosimo I's Villa Castello with a labyrinth and keyed fountain that artist-critic Giorgio Vasari thought "the most magnificent in Europe." Thenceforth, every notable garden begged a signifier: for Pope Julius III's Villa Giulia, a long allée of perfectly matched cypress; for Pier Francesco Orsini at Bomarzo, grotesques carved into bedrock; for Ferdinando I's Villa Medici, foliage shaped to glimpse the city below and shine poetic circles of light on the bronze statue of Mercury that had ravished Velázquez when he visited.

Evolving taste replaced controlled schemes with the enchantment of a lawn whose central axis unfurled to an inspirational monument, a surprise, or a view. At Count Agostino Giusti's eponymous villa in Verona, an alley of cypress led past pergolas and Roman ruins to a cavernous pool flamed with a fire-spouting gargoyle. At Count Carlo Borromeo's Isola Bella on the Lago Maggiore, greenery was terraced up to float the island like a ship. These were coats-of-arms gardens, at once pronouncements and calling cards. Who of importance had not visited Cardinal Ippolito II's Villa d'Este, whose *giardini delle maraviglie* worked statuary from Hadrian's villa around the beguilements of an organ timed to the waterfalls, birdsong muted when an owl perched on the rock, and the brilliantly engineered Hundred Fountains that Montaigne so admired?

France's growing obsession with splendor replaced the Italianate garden's walled intimacy with grand dioramas. To realize Nicolas Fouquet's vision for Vaux-le-Vicomte, Le Nôtre expanded the existing geometry of topiary, fountains, and boxed

parterres with multiple waterfalls, architectural surprises, and a kilometer-long canal—each positioned to reveal new perspectives. Riled by its glory, the king threw Fouquet in jail and had the trees and embellishments moved to his gardens at Versailles, which, naturally, he ordered made grander. Le Nôtre complied with a stunning panorama of flowering parterres, long allées, and manicured hedges that the king could admire from his chambers. Never had nature been so extensively managed. The Trois Fontaines Bosquet alone stretched the length of two football fields. From Rueil's bulging nurseries, 1,200 gardeners refreshed the beds daily, the floral designs bimonthly, and the borders seasonally, with poppies, anemones, carnations from India, and the royal sunflowers. Even irrigation was brought to heel. Become his own landscaper, Louis devised a master plan of fountains and verdant arabesques fed by a water system piped from the Seine. His majesty's pleasure was boundless, if no longer childlike. While personally gratifying, the king's role as horticulturist was exploited for *gloire*, to position his court as the arbiter of magnificence and himself as its genesis.

The 18th century reverted the garden to playground. Hedge, shrub, and tree were espaliered, clipped, curlicued, coppiced, pleached, pollarded, porticoed, arched, ruched, pyramided, swirled, squared, or flattened. At the Prince de Ligne's Château de Beloeil, a canal fed three ponds—one mirrored, one for red carp, one for hydrojets— and a lake with an islet accessed from the royal bedchamber by cable car.

In England, a new sensibility flipped the garden as radically as it had that of its houses and hats. Discarding imposed design as "mathematical"—even, claimed satirical poet Alexander Pope, "monstrous"—William Kent's Arcadian ideal informed the "picturesque" aesthetic of the great Lancelot "Capability" Brown. A garden must now suggest the simple life, induce philosophical musings, and present nature as idyll. On an unprecedented scale, the tidy Dutch topiary introduced by William of Orange ceded to pastoral parkland, parterres were mowed under, and statues replaced by faux ruins. At Chatsworth, for the 4th Duke of Devonshire, Brown diverted a river; at Croome Park, for the 6th Earl of Coventry, he devised the "eyecatcher follies" that birthed the day's most influential landscape. More extravagant still was the bucolic delight conjured at Blenheim for the Marlboroughs. The drawings alone were exorbitant, not to speak of the cost of importing 1,600 oak trees and planting long lawns to display trophy monuments.

With such outlay become mandatory, even historic Hampton Court endured a "Capability" makeover that grew out the topiary and meandered formal elements of fountains, cascades, and maze to a simulated wilderness of languid lawns, fragrant meadows, pools of still water, and brooks rippling through dappled groves. Detailed in two famous albums, the entire design was acquired by Catherine the Great for a ruinous sum to rework the Peterhof Gardens into a "Versailles à l'anglais." By

then, though, Brown's marshaled schemes, fallen victim to Jean-Jacques Rousseau's revelation that personal happiness resides in raw nature, were dismissed as rudely intrusive: "Long gravel walks with puerile knots of flowers / Of taste and grandeur still destroy the powers / With intersected plats of useless grass / Which seem to interrupt us as we pass. . . ."

Back on the Continent, where Rousseau's aesthetic had trellised jasmine and wisteria along walls and bowers to create a disheveled romanticism of spontaneous enchantment, now all was plowed under for the scenic splendor announced by Prince Hermann von Pückler-Muskau's "parkomanie"—an overhaul that entailed so much architecture of water and moving of earth as to plunge him forever into debt. Deeper purses prevailed. For a climactic view, hills were built or leveled, trees imported or uprooted, and rocks hauled in or out, until spectacle yielded to Ange-Jacques Gabriel's controlled neoclassicism.

Even historic gardens bowed to fashion. At the Caserta outside Naples, Queen Maria Carolina reworked Luigi Vanvitelli's famed 17th-century landscape into a neo-Gothic amusement park. At the Villa Marlia in Lucca, Elisa Bonaparte Baciocchi transformed the Orsettis' seminal Italianate design into an English arcadia. The 15th-century garden at Parma's Colorno Palace was thrice converted: by the Farneses

BLENHEIM PALACE: THE TROPHY HOME WHOSE INORDINATE GRANDEUR PROVED THE CHURCHILLS' UNDOING.

to French parterres, by Empress Marie Louise to "English picturesque," then back to the original layout. Chatsworth, already twice overhauled, added a 200-foot-high cascade and a prototype of Joseph Paxton's Crystal Palace.

The greatest outlay was for whim. Bored by the flatness of his estate at Gaillon, the Cardinal d'Amboise had 1,480 workers build a mountain from scratch. Told that a rock ordered for his Paris garden couldn't be hoisted over the wall, Marquis Bollioud de Saint-Julien paid more than for the land to have one dug out in situ. Belgian Archduchess Marie-Christine took eight years to erect the Rocher d'Attre for an observatory she fancied, then paid double for a ruin to hide it. Philip V splurged three million francs to give a park at La Granja long allées and 26 mighty fountains for, said his landscaper, "three minutes of amusement." Beguiled by the new notion of happiness, Marie Antoinette asked for a *jardin anglais* that led past a "Temple of Love" to an illusion of deep country with tangled meadows, sunny glades, hidden grottoes, thatched cottages, and, for diversion, a real dairy where the queen could milk cows. "I must be mad or dreaming," exclaimed the Prince de Croÿ when he visited, "never have two acres so completely changed their form nor cost so much."

For ultimate reach one must look to the East, where Babur's deep nostalgia for the Timurid enclosures of his youth resolved the ruthless Mongol, wherever he conquered, to lay out ravishing gardens. Enchantments that doubled as pronouncement, they informed his descendants' ideal of paradise. Advanced engineering raised Mughal gardens to an art form, guiding water around boulders artfully positioned in pools to create ever-lovelier worlds for dalliance and contemplation. Most wondrous was the terraced cliff-garden, watered from a lake 600 feet below, that was built for Shah Jahangir's revered teacher, whose only communication was by pigeon. Most poetic were Shah Jahan's fabled Shalimar Gardens at Lahore, whose 100-mile-canal powered five cascades and 410 fountains. Ambrosial, too, the garden that Jahan dedicated to the memory of his queen: although modest in scope, the Taj Mahal's plantings were exquisitely laid out. A chronicler of the time described the painstaking attention to proportion and shading as "the honor of the terrestrial world . . . with no like and equal on the surface of the earth in spaciousness of area and novelty of design."

The gardens of Imperial China took paradise to another level altogether. For 4,000 years, an aesthetic developed to convey the harmony of man and nature shaped vast stretches of countryside to artfully simulate a chanced-upon landscape. More constructed than planted and intended to simultaneously stir the mind and soothe the soul, the ideal garden had to conjure the atmosphere of a painting from artificial elements manipulated to appear intrinsic. The conceit of unfolding rather than subjugating the natural world called on engineers, botanists, artisans, and serious outlay. Early schemes disregarded public viewing. The 2000 BCE semi-legendary

Gardens are not made by saying, "Oh, how beautiful!" and sitting in the shade

RUDYARD KIPLING

King Jie is said to have created the lavish Jade Terrace for his enjoyment alone, and the subsequent embellishments extending to multiple fishponds, menageries, and winding walkways were restricted to the rulers' inner circle. The philosopher Mencius blamed Shang obsession for the dynasty's decline: "They turned fields into parks, depriving people of their livelihood, thus did the mighty Shang end, succumbing to luxury." Undeterred, Han Emperor Wu ordered a "heavenly paradise" of 12 unique gardens enfolding temples, ponds, lakes, and ornamental structures—that of the Jianzhang Palace was endlessly depicted and eulogized. The elite classes, too, achieved gardens of great beauty—the Jingu Yuan, built by a court official near Luoyang, held "everything to please the eye and delight the heart"—but couldn't rival the emperors for size or complexity. Unchecked indulgence invited hubris. Sui Emperor Yangdi's resolve to give Xiyuan "a thousand prospects and a variegated beauty unequaled in the world of man" hemorrhaged the treasury for a 75-square-mile park whose six-mile-long man-made lake and pavilion-studded islands felled so many workers as to provoke the rebellion of 616. For his profligate arrogance, the emperor was assassinated, together with his son, thus ending the dynasty.

Li Yuan, first emperor of the Tang, set out more judiciously—"I do not want you to dig ponds. Nor to make gardens, nor to build pleasure parks at the expense of the farmers!" But a manipulated landscape had grown integral to the Chinese sense of self. As wealth trickled down, the literati followed suit. Wang Wei's garden at Wang Chuan led past subtle transitions of forest and mist-threaded mountains to a dock on the lake where the poet sat in blissful reverie for hours on end. The noted scholar Liu Zongyuan converted a tangled site into a languid tapestry of ponds, lakes, and willows, positioned to reveal their layered meaning to those convened there for collation and poetry.

Besides delighting, a manipulated landscape distinguished. Of the three traditional gambits—copying, adapting, and borrowing—copying was hardest. It was held miraculous that the 4th-century calligrapher Wang Xizhi reproduced, in Shaoxing's radically different climate, the Orchid Pavilion's famed "borrowed garden" (so called because it re-created the earlier garden's key elements), and an incredible feat for 11th-century writer Su Shi to have reproduced the three-mile-round border of West Lake's famed lotus pond. City dwellers had to re-create an idyll from scratch—build mounds, import rocks, establish plants, and pipe in water. A Chinese scholar's diary detailed the luxury: "For 20 years, I continued to build the garden. I sat on a sit—I thought a thought—I rested a rest—it was still not very good. But that year, I gave my entire heart to the affair. I thought only of the garden. I increased the size,

adding 15 plots of land. I made 17 pools. I also bought many fields and devoted the entire revenue from these to beautify the garden."

Imperial desire was less patient. The Song Emperor Huizong, himself a painter and landscaper, created a four-mile-long lake to anchor an overnight scheme of pavilions, terraces, botanicals, bamboo forests, and a waterfall controlled by a sluice that was opened when he passed. Still dissatisfied, he imported material for a three-mile-round, 225-foot-tall mountain detailed with cliffs, chasms, and waterways. A self-confessed petromaniac, Huizong sent south for scholar's rocks (prized for their cryptic significance) from the bottom of Lake Tai—an extravagance that, together with the damage their transport inflicted on the roadways, triggered the dynasty's downfall.

The Mongols were not garden builders, though Kublai Khan had a tasteless moment with a mile-long rocky island rendered green with malachite, reflecting crystals, and an emerald-tinted palace. It fell to the Ming to revisit "spread" gardens (at the Palace of Nine Perfections the pavilions had to be accessed on horseback) and to the Qing to take the conceit to the stratosphere.

Qianlong's achievement northwest of Peking was the luxury of perfection. The landscape designs acquired from his tours of the south grew the Summer Palace into the greatest garden complex the world would ever see—an 865-acre pleasure park enfolding 160,000 square miles of buildings, art, and diversions. Although imperial garden building persisted, none in China or elsewhere would rival the glory and ambition of the Yuanmingyuan's "Garden of Ten Thousand Gardens." Its hills and streams, grottoes and groves, bridges, rockeries, ponds, and terraces combined to create the illusion of heaven that Father Attiret, first to visit from the West, famously eulogized as "Paradise on Earth." Qianlong's grandfather, Kangxi, had already positioned 29 structures and 9 gates based on the rules of feng shui; landscaped 180 sites according to the three overriding principles for stimulus and harmony ("putting up structures," "tidying up water," "piling up hills"); and dedicated the ravishing Peony Terrace viewing area to the delicate flower—all 90 species of it.

Now Qianlong, advantaged by accumulating wealth, directed an army of workers to give the best of those sites every mood, every sound, every color and contour of water, rock, flora, and mound that had enchanted him on his travels. The loveliest, "Forty Views," would be rendered by generations of painters and poets. Carefully positioned to be seen in the round, each view displayed gardens within gardens. With every element designed for pleasure (the "Eternal Spring Garden" alone contained 480 exquisitely detailed buildings), all in the Yuanmingyuan delighted. Lavishly decorated structures like the "Apricot Grove," "Spring Rain" gallery, and "Green Shady Hall" viewed on islets layered with compounds of pavilions

THE YUANMINGYUAN:
SCENES FROM THE
FABLED QING GARDEN
THAT REPRODUCED
EVERY VIEW EMPEROR
QIANLONG ADMIRED.

A garden isn't meant to be useful. It's for joy.
RUMER GODDEN

and valleys landscaped to contemplate beauty. The emperor dallied at favorite sites—"Rising Sunset," "Blue Wave," "Peach Blossom," "Orchid Fragrance"—taking inspiration from "rosy rays of light," "last radiance of the setting sun," or "sounds of rain," to write and illustrate verse. Waterways fed ponds ornamented with water lilies and carp, and pathways unfolded embellishments drawn from one hundred legends. Most remarkably, in only three years, every view pleasing to the emperor from hearsay or memory had been painstakingly replicated to look entirely natural. A coveted item that couldn't be replicated was requisitioned and given a specially built site—in the case of a resonant bell, an exceptionally deep trough to heighten the sound. Most improbably, Qianlong's attraction to all things Western extended to copying the gardens of Versailles, a task achieved with great difficulty, and at a cost that alarmed the generally accommodating ministry. Only the lawns were omitted, because grass ("though no doubt," quipped a contemporary, "very pleasing to the cow") did not nourish the intellect. Most prodigally, every structure—terrace, pavilion, belvedere, studio, gazebo, gallery, cottage, chapel, pagoda, and bridge—was incorporated many times over.

Qianlong's outlay was not mindless (a prized rock occasioned the verse "I deserved to have it not, but it pleased me so immensely"), but his longing was insatiable. In 1749, he drew on the treasury and thousands of artisans for the Forbidden City's most ambitious expansion, the Palace of Tranquil Longevity—27 pavilions embellished for imperial retirement, projected 40 years thence, that led through jade-inset moon gates to grottoes and plantings sited to inspire future poetry.

The Japanese garden manifested luxury differently. The intrinsic relationship of landscape to painting and of artifice to nature, although derived from China, was subject to space restrictions that left no margin for error. Emblematic of the rigor delivering perfection, bonsai trees were manipulated over centuries to create atmospheres like "overhang" or "windblown." Passed down as heirlooms, these stunted marvels sell now for over $1 million. Domestic gardens, restricted to formulaic ponds, bridges, and closely planted islets, were further constrained by the Zen mantra of disciplined minimalism that held greenery "disordered." As exemplified at Ryoanji, the aesthetic of an impeccably raked garden pared down to rock, sand, and gravel was exacting. Nonetheless, all aspired to the *shibui* precision that only a cultivated taste could appreciate. So did tea master Sen no Rikyū, at his fabled Sakai Garden, frame a fountain with foliage that obscured the sea until the visitor stooped to wash his hands, glimpsed the waves, and made the connection between flowing and piped water, between the universe and himself.

Thenceforth, the least garden was landscaped into haikus. Consummate effort was given to calibrating a bamboo tap to produce a certain musical tone and to positioning "viewing stones" to harmonize and inspire. Cost related to the quality

and scarcity of materials, and the care to realize every possible variation of the governing principles required to create, in a restricted space, the antipodal illusion of immediacy and infinity. A perspective's ten elements involved near, middle, and distant mountain; mountain spur; cascade mouth; four short and central islands; and hill for cascade. Each element's singularity—waterfall arrangement, bridge connection, rock contour, stepping-stone, pond configuration, and islet position—was carefully pondered. Such was the aura conferred by a prized element that, in Momoyama-period Kyoto, competing generals fought a war over a particular rock that had accrued a layered significance.

A century later, admired gardens like Suizenji Park copied in miniature such hallowed sites as Mount Fuji, calling on the highest artifice to make every element appear natural. Royal estates like Shugakuin, venerated for its ponds and star-shaped moss carpeting, focused on achieving *shakkei*—a system of planting and cutting that draws the eye across multiple vistas to a distant panorama. Adding complexity, viewing etiquette required as striking a setting in a confined space as in a wide one. Thus did a noted Kyoto garden convey, on just one-sixth of an acre, the illusion of seeing eight different landscapes from a boat.

RYŌAN-JI TEMPLE: RENOWNED JAPANESE DRY-LANDSCAPE GARDEN, COMBINING THE CLASSIC ZEN ELEMENTS OF PATTERNED GRAVEL, ONE BURST OF COLOR, AND 15 STONES POSITIONED TO NOT BE VIEWED SIMULTANEOUSLY.

The idea of no space too small birthed the cult of the single exquisite flower, bred over generations and presented in a vessel designed for it. A famous Edo-period story tells of the day that a powerful shogun, angered at not having been invited to view a rival warlord's famous iris garden, rode over abruptly, to find all the flowers beheaded. Demanding an explanation, he was led into the house where awaiting him, in a beautiful vase, stood one perfect iris.

The garden as we know it evolved more precociously. Botanist Sir Frederick Stern won a wager that there were no bad sites, only bad gardeners, by growing, at considerable expense, finicky orchids on the chalk cliffs of Brighton. In Monte Carlo, Prince Tcherkassy retained 48 gardeners so as to not view the same flowerbeds twice. At Port Lympne, Sir Philip Sassoon selected each season's flowerbed color-scheme from a rainbow of lighters supplied by Cartier. At Groussay, silver-mining heir Carlos de Beistegui gave his park a new folly every year—Chinese pagoda, Palladian bridge, Tartar tent—each unveiled with a fête. At Giverny, Claude Monet kept six gardeners to provide the palette he wanted with variegated botanicals and ponds filled with water lilies. "All my money goes into my gardens," the artist noted, "but I am in rapture."

The advent of steam travel opened new possibilities, dispatching botanists to foreign lands at all cost for the theretofore unobtainable—say, a California sequoia or a trumpet-shaped regal lily. Plant explorer David Fairchild gave Florida a botanical garden that introduced pomegranates, nectarines, peaches, dates, and rare flora from the Orient, imported on a specially built boat. Botanist Ernest Wilson, sent to locate the only known specimen of a giant feathery-leafed dove tree before someone else did, trekked a thousand miles up the Yangtze and across unmapped mountains to find it had been made into a cabin. Perseverance uncovered six seeds, forwarded forthwith, as was Wilson—this time to search for a poppy, *Meconopsis integrifolia*, which turned up on a ridge between China and Tibet.

No craving went unrequited. The wealthy expatriate could have an instant *jardin français*, or the Renaissance garden created in Tuscany for the Actons and (at Villa I Tatti) for Bernard Berenson. At home, double the money bought a replica of both grounds and villa. In Honolulu, the Walter Dillinghams of the railroad fortune had Stanford White duplicate La Pietra; in Illinois, Harold and Edith (Rockefeller) McCormick had Charles Platt replicate La Favorita; at Grosse Pointe, Anna (Mrs. Horace) Dodge had Horace Trumbauer re-create the Petit Trianon. Cloning anthology gardens seen abroad gave Newport extravagant showplaces—most notably the flora copied for Fairman Rogers from a sumptuous Persian carpet, and the Eden fashioned for William Fahnestock around specimen trees hung with 14-karat

THE MOUND
AT PORTRACK,
DUMFRIESSHIRE:
FASHIONED BY
THE HONG KONG
TAIPAN'S DAUGHTER,
MAGGIE KESWICK,
TO RESOLVE A
PHILOSOPHICAL
QUESTION.

gold fruit. Where land was plentiful, schemes inflated. California railway magnate Collis P. Huntington laid down miles of track to rail in massive boulders for gardens themed around azaleas and cacti.

With money no object, water presented no problem. In Tarrytown, John D. Rockefeller installed an irrigation system that activated 20 fountains at the touch of a button, and another at Kykuit for gardens that cost more than the mansion. In Capri, Mona Williams had a boatload of water shipped in daily for a cliff garden that consumed twice what the island allotted. In New Jersey, James Buchanan Duke diverted the Raritan River to supply nine man-made lakes and daughter Doris installed 11 indoor gardens reproduced from countries she had toured. Philanthropists sustained trees. In California, giant redwoods, expensively rescued from the sawmill, were deeded in perpetuity to a national park. In Delaware, on an impulse he diagnosed as "an attack of insanity," Pierre DuPont bought a "small" property to conserve its old trees, and as an afterthought added the topiary, dancing fountains, and sublime conservatory that now constitute Longwood Gardens.

Latter-day indulgence delivered $65,000 Globe Norway maples by helicopter, trucked in instant lawns, and wrapped hedges against frost. A signature garden distinguished absolutely. Outside Rio, Brazil's modernist landscaper Roberto Burle Marx color-coded living Edens. At Charlevoix, Quebec, horticulturalist Francis Cabot intermingled grasses and topiary and allegorical bronzes. At England's Arundel Castle, designers Isabel and Julian Bannerman fashioned verdant tributes to Inigo Jones. At Portrack in Scotland, landscape architect Maggie Keswick addressed the conundrum of "how what goes up comes down" with a massive grass mound whose ascending and descending paths don't converge. At their 17th-century Wijlre Castle near Maastricht, Marlies and Jo Eyck worked trees into portraits. At Ascott, Lady Lynn Forester de Rothschild created a dialogue between the famed topiary

and a Richard Long installation. In Newport, placemaker Ronald Lee Fleming gave Bellevue House a baroque cascade, a Japanese garden, and, at staggering expense, America's only nymphaeum. Such was the obsession of fashion designer Valentino Garavani that he dropped everything when the "hundreds of thousands" of roses came into bloom at his Château de Wideville: "There are many things you must do in life but you cannot ignore the roses. When they demand to be seen, you simply have no choice but to go to them." Helpless, too, Jane Percy, Duchess of Northumberland, who for 70 times the starter price of Alnwick's $2 million garden, added Jacques Wirtz's scheme of an *eau-et-lumière* wonderland: "How can I be doing this?" sighed the Duchess, "I felt like Marie Antoinette." But to her husband's query, "At what price? Will it kill you?" she responded, "I have to."

Perhaps not for long. With verdant dreams yielding to a stressed ecosystem, the ornamental garden faces extinction. Duke Farms, for one, has spent "several tens of millions" to rework its indoor gardens into "healthy habitats." Luxury has moved to curated cactus beds, botanist Patrick Blanc's leafy walls, and architect Stefano Boeri's "vertical forests." The rare specimen once cultivated in a conservatory is no longer a salon display item—those gold and blue Vanda orchids from the rainforest

A ROBERTO BURLE MARX
PARADISE GARDEN—ITS
DESIGN LAID OUT
LIKE A PAINTING.

are now sourced for face creams. Tomorrow's indulgence may be virtual planting: the million-dollar garden cantilevered 200 feet over a canyon in Los Angeles by light-artist James Turrell is seeded with nothing but a synergy that pulses washes of light to the sky.

Service—The life of luxury could not have existed without servers. Horizon lawns entailed gardeners; lace-up corsets, a maid; and formal dining, a footman behind every chair. "Luxury," noted Baroness Alix de Rothschild, "is leaving to others the unpleasant tasks of life." Slaves, serfs, and hirelings fed the horses, clipped the hedges, staffed the kitchens, mopped the floors, drew the bath, made the beds, manned the banquets, and polished the silver that distinguished the lifestyles of those they served from their own.

Even in the vaunted democracy of Attic Greece, one-fifth of Athens's population was enslaved and both Socrates and Plato, positing the fulfilled life as one free of chores, owned slaves. The Romans marked status with the count; 400 supported the lifestyle of the merchant Aulus Umbricius Scaurus. Enslavement was not always for life—any with talent or pedigree might be freed and advanced—but treatment was arbitrary, and suicide frequent.

The Mediterranean slave economy followed the trade routes. The Vikings peddled thralls to Byzantium, where they were respected as long as they "kept to their place" but had no recourse to law or salary. The practice worsened in Russia, where serfs sustained the empire's entire capillary system: to service the royal estate at Kolomenskoye, the population of five villages and nine hamlets was bonded, made to work overtime and to surrender their daughters to the insidious *droit de seigneur*; a century later, a ukase records, entire families were still being sold "like cattle, one by one." Tolerance of forced labor gave

THE *NYMPHAEUM* AT BELLEVUE HOUSE NEWPORT: ONE OF THE ADDITIONS TO RONALD LEE FLEMING'S PLACE-RESONATING NARRATIVE THAT DESIGNATE IT "THE GREATEST FOLLY GARDEN IN AMERICA."

lie to the Enlightenment. No matter that Aquinas had championed equality; and Dante, humanism; and Rousseau, the rights of man—privilege prevailed. Through to the end of the 19th century, the peasantry constituted over 80 percent of the population and most were subjected to servitude without recourse. In Poland, even after it became illegal for a lord to murder a serf, the indentured could be sold off as collateral.

Western Europe, with the exception of a few enclaves like Lisbon, left outright slavery to its outposts, evolving subtler arrangements to service the ever-richer domains of God, king, and burgher. At a time when French law dictated "no lord without land, no land without a lord," the villeins providing baronial estates a life without hardship, though protected, were indentured.

England developed a dual arrangement. Leaving its colonies to source from its slave-running ventures, the aristocracy relied on an upstairs-downstairs serving class dignified by proximity to the monied, yet obligated by birth or lost fortune to sustain them. The high luxury of Cardinal Wolsey's Hampton Court employed 100 such domestics, plus cooks, heralds, minstrels, clerks, armorers, and stable boys drawn from the villages. Even as they multiplied, all knew their station: a disciplined staff was conditional to Victorian self-image, and total loyalty assumed. Thirty-five years after a move to Paris shuttered Hertford House with its tapestries, silver, and Titians, Sir Richard Wallace took possession to find all awaiting him, faithfully maintained by the servants' children.

No such accommodation met the hideous needs of New World exploitation. Colonial rule indentured the indigenes to assure Portugal's new barons heady profits from the coffee, cattle, and sisal that propped up their plantations. England's Caribbean sugar and mahogany monopolies gave Robert Ashby 200 slaves to bathe him every morning and hold his chamber pot every night. "In the depth of its grain, through all its polish, the hue of the wretched slaves," wrote Charles Dickens of Jamaica's branded chattel. Colonial America, while holding all white men equal, imported slaves along with the china and crystal to ease life on the plantations. Their number signaled a household's standing, and ownership was absolute. Thomas Jefferson's earliest memory was of being passed to a slave on a pillow, and his last words were to the slave who adjusted his pillow. By 1790, when the state of Virginia alone held 200,000 slaves, it was unheard of for a southern belle to carry her own shawl—let alone iron or cook.

Eastern entitlement was supported by round-the-clock service. Indentured to imperial China's rigid hierarchy and India's intractable caste system, servants were ill-paid, ill-used, and, as the saying went, plentiful as nuts. A visitor to the Barodas's Laxmi Vilas Palace noted "over a thousand people doing various jobs and always

I bought Cézanne's view

PICASSO

a servant or two lurking behind every door." Even after the Raj abolished slavery, servants were so bound as to be virtually captive. As the young Winston Churchill observed of those serving the British officers, "There was nothing they would not do . . . no toil was too hard, no hours were too long. . . ." Africa revived its own history of subjection: at Eden Roc's Hôtel du Cap, the Emperor of Ethiopia brought an attendant to the pool just to take off his trousers.

Western lifestyles were no less reliant. Robin Russell, 14th Duke of Bedford, had enough outdoor staff to sustain Woburn Abbey's model farm, Chinese dairy, Père David deer, Mongolian horses, and—the day's sensation—wooly bison. Sixty domestics maintained the Bedford gold dinner service and 80 fires in winter, and it was completely accepted that the duke kept 12 housemaids, 8 chauffeurs on call, and his London establishment fully staffed for only two yearly visits—to his club and the dentist.

Poland's Count Joseph Potocki had lived still more royally at Antoniny, a 200-room palace on 120,000 acres in Ukraine, amidst Tintorettos, Watteaus, and books from the library of Marie Antoinette. Having built the railroad that crossed his land, the Count reserved the right to stop and board any train that convenienced him. His was a way of life unthinkable without servants to drive the coach, dust the Sèvres, change the flowers, polish the gold banquet service, and maintain the outlying stables, horses, tea pavilion, golf course, and polo field. To this day, Czech Prince Jaroslav Lobkowicz maintains multiple palaces and regrets the shortage of staff that made him sell the other 27.

Even in the modern age, hired help was congenitally attached. In the late 1930s, when the Edward T. Stotesburys discharged the in-house bakers, carpenters, hairdresser, couturier, electrician, barber, 45 domestics, 70 gardeners, and 4 chauffeurs who had propped up their lifestyle, it was not clear to where they would go. Latter-day presumption led Nan Kempner (the New York socialite who sent her gowns to Paris for cleaning and converted her grown children's bedrooms into closets) to hold it an unpardonable crime to "steal" a friend's butler, and commendable that Tina Onassis had gifted a friend with a fully trained maid. And I still remember Mrs. Gilbert (Kitty) Miller sobbing to my mother when her housekeeper died: "Never again shall I find someone who can take red wine out of blue chinchilla!"

While today's nobs call on club staff (Pratt's London members still address all the females "Georgina" and all the males "George") and the blithe 1% juggles nannies, butlers, maids, chefs, and chauffeurs sourced from M.I.T. and the Ritz, 46 million people are held in bondage worldwide; forced labor sustains illegal enclaves of logging, mining, brickmaking, cotton-picking, fishing, and sex-traffic; and outright slavery fuels jihad.

*I know not whether
the joy be greater for a
prince who finds a man
after his own heart or
for the artist who finds a
prince willing to furnish
him with the means for
carrying out his ideas*

FRANÇOIS I

TROPHY ART

Art, it would seem, is unique to our species: many animals make marks but humans alone create form and design. The idea of art remains relative but not art's relevance to luxury. Art first met luxury with an object embellished beyond need. Luxury first met art with work flipped from a must-see to a must-have. Addiction applies when longing spins into a compulsion for more, for unique or for ruinous. Ambition pertains with empowering collections that from antiquity have written the collector into history.

Defined as a skillfully rendered creative expression, art-making traces to the portrait carved on a 2.7-million-year-old Makapansgat pebble. The urge to ornament tessellated Paleolithic hand axes, painted Neanderthal therianthropes, and danced magical animals along the walls of Lascaux. By 40,000 BCE, artistic impulse had crafted a five-hole flute from a birdwing and worked an animal tusk into the sensual Venus of Hohle Fels. In China, the capacity for abstract thought crafted household vessels with notions of symmetry and self. The letters, music, and performance came to luxury with illuminated texts, elaborate instruments, and prodigal staging.

There was no early sense of art as we understand it (the Sumerians, for one, had no word for art) but the drive to embellish was universal. How else explain Uruk's gilded mosaics, Assyria's carved ivories, and Etruria's finely wrought metals? Visit the treasure disgorged by ancient tombs to see desire directing workmanship—Amenhotep III's passion for blue enamel, the gold-embossed plaques in the Scythian hoard, the silver lyres in the Royal Cemetery at Ur, the massive cast-bronze vessels that Huizong raked in from the empire's four corners. As cultures diversified, the wealthy sought out the day's luxuries—pearly glass, sculpted marbles, tooled leathers, and pottery fired to an exorbitant iridescence.

Nascent aesthetics prioritized color. Arduously extracted from plants and insects, ochre, purple, and crimson dyes were traded like gold. Most valued was the color of sky—the blue ground from lapis lazuli that saturated the robes, ceramics, and texts of antiquity.

Form and design came to matter with the Hellenes, first to appreciate a work for its beauty alone. Although not indifferent to ornament (Phidias was

asked to fashion a colossal Zeus out of ivory and gold) they attached greater value to the formal aesthetic that first capitalized Art. Esteemed artists were made citizens and richly rewarded; Attalus skimmed the treasury of an astounding 6,000 sesterces for a *Bacchus* by Aristides. Sculpture was widely collected; Rhodes alone held 30,000 statues, Delphi and Olympus many more, and Corinth a number beyond counting. Works by Praxiteles were so prized that when the king of Bithnyia offered to cancel the debt of the people of Knidos in exchange for their Aphrodite, they refused.

Warring societies came to art via plunder. Before Xerxes destroyed Athens, he had every portable work transferred to Persepolis and the statue of Penelope secured in the treasury; when Marcus Claudius Marcellus torched Syracuse, he spared an area that held a fresco he wanted. How Rome's elite salivated when Carthage disgorged pretty things! Cicero reproved Verres of Sicily, who compiled "silver vases, pearls, Corinthian bronzes, ivories, and marbles," as "passionate for masterworks to the point of criminality," and faulted the orator Lucius Crassus for splurging on two silver goblets, though he "for shame" never used them. Yet Cicero himself paid an unprecedented 10,000 sesterces for a lemonwood table. Roman craftsmanship sent collectors into overdrive. Pliny the Elder recorded the mania for glass: "As gold and silver became too available, we mined crystal and myrrhin, whose fragility made them costly. It was a sign of wealth, a supreme luxury, to possess an object that could suddenly shatter." There followed an obsession with objects wrought from *rosso antico*, the Greek marble that Hadrian made fashionable.

To the east, the arts called on complex emotions that conflated status with joy. The Sasanian soul opened to five-million-knot carpets, accumulated one by one and unrolled for private contemplation or public display. The Seljuqs marked their brief rise to empire with decorative lustered ceramics and proclamatory gold-and-silver inlaid bronzes. The Safavids refined miniature painting into life-affirming biography, illustrated in increasingly ornate versions of poet Ferdowsi's *Shahnameh*, the 10th-century epic exalting Persia's classical age in 50,000-plus rhyming couplets.

Hindu sensibility had long valued craftsmanship—embossed metals, furnishings pieced with ivory, and stone carved like butter. The subcontinent's evolving aesthetic added the pleasure—at its optimum, revelation—derived from "tasting" the *rasa*, or flavors, of a work and measuring its excellence by the depth of the emotion experienced. The Mughals evinced this sensation most profoundly with exquisitely rendered depictions of domestic and spiritual life. Akbar, himself a skilled draftsman, founded the atelier that established miniature painting as North India's leading art form: son Jahangir's open purse and refined taste raised it to a level never surpassed.

OPPOSITE COURT OF THE GAYUMARS: LAVISHLY DETAILED FOLIO FROM THE SHAH TAHMASP SHAHNAMEH DEPICTING PERSIA'S LEGENDARY FIRST RULER PRESIDING OVER HIS KINGDOM.

LEFT *BELLES HEURES DU DUC DE BERRY*: ONE OF THE ILLUMINATED MANUSCRIPTS THE EXTRAVAGANT BIBLIOPHILE COMMISSIONED FROM THE LIMBOURG BROTHERS.

*Look at my shape and contemplate;
thou wilt see my excellence /
For I appear to be made of silver
and my clothing from blossoms.*

INSCRIBED ON THE FREER VASE

Newly imperial, Qin dynasty China married excellence to opulence. Eleven surviving pieces of the lavish Imperial Swimming Dragon Set convey the Eastern Han's passion for gold, and a 1st-century Szechuan chronicle documents a prodigal outlay for lacquer. Credit the Six Dynasties period for refining the Chinese aesthetic, best defined by a dual feeling—at once a fierce desire to possess beauty and a longing to partake of its aura—that valued equally an object transformed by man or by nature: a painted fan, say, or a rock etched by water. Jade combined both, revered for the symbolic power of its long river journey from Central Asia and for a hardness only a master could shape into the objects the courts paid so dearly for. Confucius sang its attributes: "Anciently superior men found the likeness of all excellent qualities in jade. Smooth and glossy, it appeared to them like benevolence; fine, compact, and strong, like intelligence; angular but not cutting, like righteousness . . . its flaws not concealing its beauty, nor its beauty its flaws, like loyalty." The Tang formed impressive collections, pausing to meditate on each piece. Emperor Ming Huang, although his court was admired for its five orchestras, theater, and the world's first (by centuries) academy of Letters, addressed his verses to the jades.

Ceramics ravished from the moment the Han fired kaolin into the addiction called porcelain. Collectors obsessed on the shimmer of Xing, the agate glaze of Ru ware, the creamy glory of Jingdezhen. Greedy for each variable—lusterware, blue-white, opaque, *yangcai*, famille verte, majolica, and slipware—the emperors stockpiled and wrote poems to them all.

The Japanese aesthetic was more edited but not spartan. Householders saved up for one perfect object. If an exceptional bowl shattered it was mended with gold, its beauty held heightened. Evolving taste fixed on an acrobatically carved netsuke, a lacquered spoon, a paper-thin teacup. All were expensive, but connoisseurship, not cost, conferred status. Let Japan's factories supply parvenus with overwrought housewares and mother-of-pearl-crusted beds, the cognoscenti had refined down to a sublime folding screen or a uniquely glazed vase, and the scholar chose to live frugally rather than pass up a scroll by a master.

The Letters were held in universal esteem. Bablyonian clay tablets immortalized the Sumerian Epic of Gilgamesh, narrative verse covered Lachish palace walls, and 700,000 scrolls furnished Alexandria's library. The Romans collected for show. When less than 5 percent of the populace could read, books distinguished: "Nothing," crowed Cicero, " is more elegant than my library." At a time of shifting principalities,

Just buy it

CHARLES FREER

the courts of the Middle Ages gathered ancient texts for the pen's power over sword. A brisk barter in manuscripts led Aldfrith, king of Northumbria, to trade eight families and their lands to Ceolfrid's abbey for a treatise on cosmology, and the Countess of Anjou to exchange several martin skins, 200 sheep, and a great quantity of grain for the homilies of Haimon, Bishop of Halberstadt. Religious works were prodigally illuminated and lesser tomes set with cameos to display as bibelots. The first systematic bibliophile may have been Jean de Berry, but the first addict was Lorenzo de' Medici, who paid a stunning 30,000 gold ducats for 800 manuscripts clasped with silver and fanned out 30 copyists to assemble the richest library in Christendom.

Just as incunabula spoke to discernment, so did important libraries to reach. The 40,000 volumes shelved at John Thynne's Longleat House were much visited, and it brought attention to Bishop Stanislav Zaluski that the 200,000 works he assembled at Warsaw were catalogued in rhymed verse. Even after the Gutenberg printing press had enabled anyone anywhere to take all learning for his province, it distinguished Count Heinrich von Bünau to give Schloss Nöthnitz the day's largest private library, and advantaged the bookseller charged with locating a first edition or signed copy. Samuel Johnson spoke with veneration of "that generous and exalted curiosity which [bibliophiles] gratified with incessant searches and immense expense, and to which they dedicated that time and that superfluity of fortune, which many others of their rank employ in the pursuit of contemptible amusements or the gratification of guilty passions."

Academic cultures honored the written word differently. The Chinese lived and breathed poetry, coming together to recite verses and share texts. Those schooled by Confucius valued language for itself, holding precise usage conditional to wisdom. Their invention of paper gave the luxury reach. Paper provided the block-printed, 16-foot-long *Diamond Sutra* and the thousands of manuscripts lining the Mogao Caves. Paper gave Marrakesh a brisk bookselling trade and Timbuktu libraries that led the eminent scholar Ahmed Baba to hold his 1,600-volume collection paltry. Paper opened the Qur'an to manuscripts written in gold; conditioned the translations into Arabic that powered Harun al-Rashid's famed House of Wisdom; grew Persia's Grand Vizier Abdul Kassem Ismael's traveling library (carried on camels in alphabetical order) to 117,000 volumes; and enabled the 400,000-volume library that lifted Córdoba.

Japan zeroed in on calligraphy, prized for its unerring dexterity with the brush. Aside from a *koan* copied by an emperor, there was no more esteemed gift than one drawn by a master. Even decorative scrolls (the flung-ink *haboku* technique excepted) prioritized precision. Until shine mattered more: just as China had ceded the subtle calligraphy transcribing ancient sutras to Emperor Huizong's "slender-gold" style, Japan embraced a technique worked of shimmered silver-gold.

The Persians, too, engaged gold, though specifically for the Qur'an, until the great 15th-century calligrapher Mir Ali Tabrizi, told in a dream to imitate the flight of wild geese, transcribed his poetry in gold script. With shine become glory, gold served the Ottomans as an overall signifier—even to the arabesques applied to state edicts.

India's dual sensibility revolved even warrior courts around literature. Two millennia after the fearsome Chandragupta II had lodged the playwright Kālidāsa, Krishnadevaraya's law-by-killing regime harbored scholars whose writings lifted Vijayanagar to a cultural splendor "such that eye has not seen, nor ear heard of any place resembling on earth." In turn, Rajah Anup Singh stripped South India of Sanskrit manuscripts so revered that a dalit caught reading one had molten lead poured in his ears. Travelers descended on courts holding folios of the Mahābhārata, its 200,000 lines microscopically inscribed on a 300-foot-length of paper in colors extracted from minerals and, it was said, the urine of cows fed on mango leaves. They visited Shahjahanabad to view the *Gulshan Album*, its verse floated on gold, and Kuwait's House of al-Sabah for calligraphy spun like sugar.

A less tangible luxury but one valued across cultures was brilliant discourse. Until the advent of jesters, Europe's protocol-strangled courts sought out persiflage. It was completely without irony that Giambattista Manso founded, in early 17th-century Naples, the Academy of the Idle for intellectuals licensed to accomplish nothing, and that Cardinal Richelieu founded an academy to guard the French language. It gratified the Prince de Condé to form a salon around Molière, Racine, and La Fontaine. And it flattered Madame de Pompadour to lodge Voltaire—held a national treasure until his acidic tongue released him to Frederick the Great, himself a great wit.

More indulgent were private theatricals that paid many to pleasure a few. The English court loved a good masque, ideally starring the monarch and designed by the great Inigo Jones. Unfortunate that the production that hoisted the future Queen Anne and 12 heiresses into a gleaming gold shell alerted the London press to an abuse of the treasury: "their apparel was rich and the spectacle cost 3,000 pounds!" None upstaged the outlay that architect Sebastiano Serlio details at the court of François I: "Shepherd costumes made of golden silk lined with furs, fishermen with nets of gold thread, and shepherdesses and nymphs whose robes ignored cost." Louis XIV, uniquely adept at drawing advantage from opulence, personally supervised the ballets and funded 22 spectacles starring himself. For six ruinous years, La Pompadour quadrupled the budget for plays by Molière and Rousseau that entailed dressers, musicians, and the chief *perruquier* to ravish, for the most part, her relatives.

At once art form and aura, music proved more extravagant. To the east, song pervaded the air like a perfume. For the Umayyads, musicians formed a class apart:

the best were given a life stipend and, for a superlative performance, a silk robe. Through to the Nguyen dynasty, Vietnam's courts rejoiced in Royal Refined Music, lodging up to 200 musicians for daylong entertainments involving dancing, tea ceremonies, and lotus blossom displays. Mughal India's lavish patronage extended to full room and board and generous gifts for outstanding performances. Raza Ali Khan of Rampur, for one, spent "a great deal of money on keeping the musicians happy."

Feudal Europe's embattled courts held music but background, so passion built ground up. Secular works were not catalogued, church musicians not retained, and troubadours, although welcomed, not lionized. It awaited wealthy principalities to seek prestige from an orchestra's size and repertoire. Wondrous that 17th-century Germany counted 1,800 ensembles and that the Duke of Bavaria and Charles IX commissioned, from Orlando di Lasso alone, over 2,000 masses, requiems, motets, chansons, and magnificats! Arguably, the 36 vocalists and 74 instrumentalists retained by Charles VI in Vienna on double a colonel's pay, and the 60,000 florins he paid for a work performed only once, promoted the Holy Roman Empire, but the orchestra that brought Prince Joseph Franz Lobkowicz close to bankruptcy was for his pleasure alone. Mannheim's orchestra, too, like the buttons, paper, and gold wigs the small town produced, constituted a private luxury, "the chief and most constant of his electoral highness's amusements." For their circle alone were the traveling orchestra that accompanied Grigory Potemkin and, later, the full orchestra that Alfred de Rothschild maintained at Halton House, conferring with the conductor each morning on what should accompany dinner that night.

The very instruments grew opulent—medieval oliphants carved of elephant tusks, guzhengs tipped with gold, surbahars inlaid with silver, harps carved with nymphs, and harpsichords and clavecins painted by the likes of Nicolas Poussin. Organs aggrandized:

the one at Vilnius sprouted 2,200 pipes; the one built for the Chapelle Saint-Louis du Prytanée Militaire de La Flèche deployed so many moving parts as to occasion a pilgrimage. Indifference to acoustics gilded accordions, sculpted flutes, and inlaid with ivory the violins Antonio Stradivari fashioned to meet the king of Spain's request for the "very finest."

No diversion outclassed opera. Those staged in Italy impressed by the number of sets (none ever used twice) and the talent. The production inaugurating the Barberinis' splendid hall engaged the most eminent Cardinal Rospigliosi for the music and the most sought-after Bernini for the décor. Rococo sensibility waltzed the French court into the Great Age of Music, inflating theaters into palaces and opera into a logo of privilege—albeit not culture, since the aristocracy wandered around between arias. The curtain was brought down by the 1848 Revolution until raised again for the Second Empire at the sumptuous Opéra Garnier.

THE OPÉRA GARNIER, WHOSE OPULENCE WAS ORDERED BY NAPOLEON III TO RADIATE BONAPARTE GLORY.

Opera proved a cross-cultural signifier. Both Cairo and Beijing marked majesty with grandiose productions. In 1896, Brazil's newly flush rubber barons sailed Europe's chandeliers, staircases, boiseries, and 36,000 ceramic tiles across the Atlantic to give the remote town of Manaus a sumptuous opera house. To be seen at the opera so mattered to America's Gilded Age that William H. Vanderbilt's cronies, denied entry to New York's old-guard Academy of Music, erected the grander Metropolitan Opera House and launched it resoundingly with Gounod's *Faust*.

The only factor neglected was the musicians, hired and dismissed at the whim of the ruler. Philip V, to relieve his depression, had the great castrato Farinelli sing the same four arias every night for nine years. Bouncing between the courts of Sweden, Florence, and Naples, Alessandro Scarlatti garnered lucrative commissions (operas, cantatas, and for Pope Clement XI, a mass) but could not refuse them. Roman Emperor Joseph II famously replaced Christoph Willibald Gluck with Wolfgang Amadeus Mozart because he cost less. Only Joseph Haydn stood firm before royalty—orchestrating the *Farewell* symphony to let one player at a time leave the stage as a sign to his patron to send them home for the summer.

Message heard: thenceforth, composers were literally courted. Prince Nicholaus I lodged Haydn in Esterházy splendor as Kapellmeister of Eisenstadt, Ludwig van Beethoven's *Eroica* earned him a munificent stipend from Prince Lobkowitz, and for 20 years Franz Liszt vacationed luxuriously at the Villa d'Este, thanking the Cardinal with the lyrical *Jeux d'Eaux*. Johann Strauss was so cosseted at the court of St. Petersburg that he returned every summer, and Ludwig II tethered Richard Wagner to Bayreuth by funding his opera house.

More palpable display, the prestige collectibles first acquired for status by the Romans, surfaced again in the late Middle Ages when material value lifted a title above others. Goldsmiths doubled as purveyors, sourcing treasure from across land and sea. The wealthy rivaled for their services. To furbish his 19 castles with such empowering treasure as a solid-gold dinner service, Jean de Berry boarded over 100 artisans.

The cognoscenti sought out *spolia*, esoteric antiquities whose cultural lineage conferred standing and virtue. Habsburg Archduke Frederick III converted the medieval fortress of Ambras near Innsbruck for the purpose, forming the first Kunstkammer from the *naturalia* and *artificiala* that Renaissance reach had made fashionable. The 1565 edict issued by Duke Albrecht V of Bavaria to preserve for perpetuity the finest objects in his strongroom introduced the concept of "heirloom" now embraced by every dynastic house of northern Europe. So did Rudolf II, king of Hungary, Bohemia, and Germany, scour Europe for marvels his court couldn't

produce—a silver clock that paraded the goddess Diana on the hour, a narwhal tusk flashed with diamonds, an unguentarium carved on a Columbian emerald—which he would handle and study, then display at Prague Castle in a specially built wing.

Patrons supported workshops unstintingly, locking in competing craftsmen for ingenious curiosity cabinets. The high cost of these miniature palaces and the addiction that stocked them with geodes, gold-mounted ostrich eggs, brass astrolabes, automata, and artworks raked in from all over the globe, denoted infinite wealth and superior cognizance.

Painting took hold when burghers followed pope and monarch to commission a distinguishing portrait. After improved roads imported artists who had limned such as Philip the Good, nothing better raised profile than a likeness by Memling, Van der Weyden, or Van Eyck. From the Burgundians, too, came the notion of trophy art that would spin Italy's arriviste first families into full-blown collectors. Rivaling to assemble virtual museums, the Barbarigos culled Titian's estate; the Gonzagas accumulated 700 masterworks by such as Perugino and Tintoretto, and attached Mantegna for life; the Rezzonicos housed their prodigious collection under Tiepolo *père et fils* painted ceilings; and the Borgheses stocked their villa with a "collection of wonders."

None acquired art more promotionally than the merchant-banker Medicis who ruled Florence. If Cosimo the Elder was not the biggest spender he was the fiercest, promoting both the Republic and himself by advancing the careers of Ghiberti, Donatello, Masaccio, Fra Angelico, Filippo Lippi, and the brothers Della Robbia. Grandson Lorenzo rose to "Il Magnifico" for spending six times the city's annual budget on the talents of Verrocchio, Pollaiuolo, Botticelli, and da Vinci; for acquiring the best of Pope Paul II's collection (the Farnese Cup alone a sensation); and for funding the young Michelangelo.

Cut from the same brocade, Cosimo I opened his purse to purchase whichever masterpiece, on the order of Cellini's *Perseus Decapitating Medusa*, that stirred Florence. Climbing to the title of Grand Duke of Tuscany, he hired the day's talent to promote his "magnificenza"; Bronzino and Pontormo for his portraits, Giambologna to mount him on horseback, Vasari to emblazon the Uffizi for his art, and Ammannati to ornament the Palazzo Pitti for his residence. When Cosimo's attention turned to the new venture called Science, installing his palace with globes and Galileo with a telescope, son Francisco fatally reverted to

beauty—gazing for hours at pietra dura–inflected tapestries whose granulation suggested pictures within pictures—inured to the decline of the great house of Medici.

Led to Habsburg luxury by Charles V, Spain's Philip ll collected for glory and Philip III put out handsomely for promotional family portraits. Philip IV, however, loved art for its own sake. A painter himself, he retained Diego Velázquez, funneled much of the felled Charles I's fabled collection to the Prado, gladdened his private apartments with plump nudes by Rubens, and filled his spare-no-expense pleasure palace, Buen Retiro, with the 800 paintings that his astute ambassador, Count-Duke of Olivares, had drawn from Europe's cultural capitals—some delivered so quickly that they arrived wet.

France's aristocracy collected in the manner of their banquets, ordering up course after course of artful delights. Smitten for life, François I traveled around with his favorite paintings and after paying top price for Cellini's splendid saltcellar brought that along, too. Equally addicted was Jules Mazarin, whose fondness for master paintings extended to everything wondrous: "He had no greater pleasure," Colbert noted, "than arranging in glass cabinets his superb vermeil dinner service, his porphyry vases, his porcelains, his crystals, and a thousand other rarities that enchanted him." Feeling death near, the Cardinal toured his treasures one last time, sighing: "To think that we must leave all this!"

Ever keen to outshine, Louis XIV puffed collecting to vertiginous heights with works purchased abroad or commissioned from the battery of artists attached to his court. The king's fervor, however, was admittedly political: "The trumpet of art blows louder through time and space than any other trumpet." So much that was gathered was less longed for than marshaled—or endured, like the tsunami of thangkas that a 1686 embassy from the King of Siam had poured on Versailles. All knew that the royal mandate for splendor was to best an upstart minister of finance whose armorial

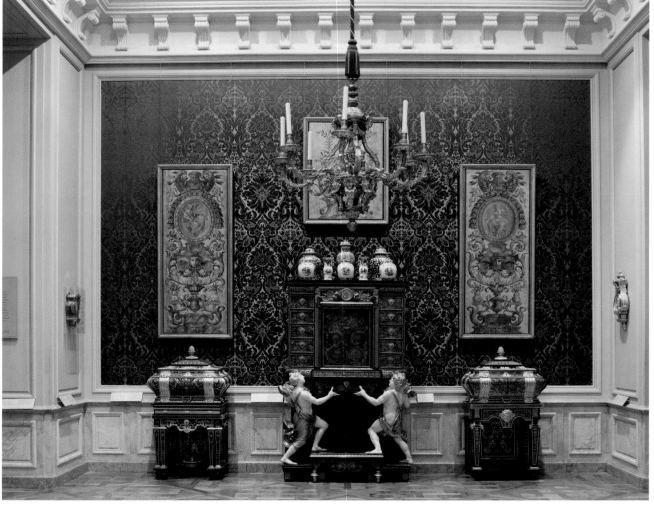

TOP THE VILLA BORGHESE: HOME TO THE ILLUSTRIOUS ART COLLECTION ASSEMBLED BY CARDINAL SCIPIONE BORGHESE.

BOTTOM INSTALLATION OF THE FRENCH OBJETS DE LUXE AT THE J. PAUL GETTY MUSEUM FEATURING A CABINET BY ANDRÉ-CHARLES BOULLE, THE ONLY ARTISAN PERMITTED TO CAST HIS OWN BRONZES.

motto was "What heights will he not scale?" It was annoyance, not distress, that the Sun King expressed on sending his solid-silver furniture to the smelter to replenish a treasury bled by war. It was to stun lesser courts that he assembled the era's best and largest collection of tapestries. It was to awe the dreaded public that he sweltered in ermine for sun-god portraits by Rigaud. It is difficult to find, behind *Sa Majesté*'s understanding of art's contribution to panoply, the same passion as for the music elicited from Jean-Baptiste Lully—so eager to please that he would fatally impale himself on his baton while conducting a *Te Deum*.

Not so, rival appetites. The fever of acquisition gripping Saxony's Elector August the Strong entailed debts far exceeding his revenue. The foresight that had attached the alchemist Friedrich Böttger for imparting how to fire white clay tipped to a "maladie porcelaine" that traded 600 dragoons to Prussia's Friedrich Wilhelm I for 151 of his Chinese vases. The elector's helpless obsession ordered every component of chapel, bell tower, and 20 rooms of his pleasure palace fashioned of the precious commodity and when his collection reached 20,000 pieces, sent the overflow to the Zwinger and the life-size figures to his gardens.

Lest Prussia's Frederick the Great become so afflicted, his father raised him to be frugal, a lack of parental insight that galvanized one of history's great spenders. Royal addiction bought or wrangled coveted objects—allegedly to the point of invading Saxony to attach Meissen's inventory and established the KPM manufactory for such domestic triumphs as Sans Souci's fabled dinner service. Extending his pleasures to literature, painting, and music, the king studied poetry, lodged a bevy of artists, and enjoyed a concert every night before dinner.

The Tsars went for broke. Having learned from Ivan the Great's return on displays of rich booty to promote his new capital with palaces stocked like department stores, Peter the Great developed a thirst for everything wondrous. The ruler who taxed everything—beards, bathhouses, beehives—to fund his campaigns readily paid out of pocket for "rarities of nature and art," which his developing aesthetic extended to fossils, Scytho-Siberian jewelry, chinoiserie, and ivory for a chandelier of his own making.

Her private purse could not slake the thirst of Catherine the Great; art coursed through her veins, sparking a spending spree that depleted the treasury. To ornament four palaces and jump-start the Hermitage, the empress transferred entire collections from high-profile reversals of fortune, draining the coffers for the works she had schooled herself in. Passionate for porcelain, Catherine commissioned from Sèvres an 800-piece dinner service inset with cameos, and from Wedgwood the prodigious Green Frog service depicting 1,222 of the structures and landscapes that she determined to replicate. Partial to French literature, she swept up even Voltaire

(who had declined her invitation to St. Petersburg) by acquiring his library on his death.

Nothing, not her clothes, not her fêtes, influenced Russia's princely families more than did Catherine's commitment to art, which drove the Stroganovs to underwrite icon painting, the Sheremetevs to attach artisans trained in Europe, and the Yusupovs to fill their palace at Arkhangelskoe with works boasting a provenance. Although none approached Catherine's trove—4,000 old masters, 10,000 drawings, 38,000 books, 10,000 engraved gems, 16,000 coins, and on, totaling 3 million objects—transfusions of art quickened successive generations of the Romanovs' thinning blood. Tsar Nicholas I expanded the Hermitage for acquisitions from such as the Barbarigo collection, and commissioned the Fabergé creations whose "dainty exquisiteness" came to symbolize the dynasty's downfall.

By then the English were flush and had come to collecting as they had to the Grand Tour—a little of everything exciting the visual palate. Secure in the favor of James I, the Duke of Buckingham had shopped freely, returning two Titians from a visit to Spain that would ignite in Charles I the resolve to buy art by the yard. Called by Rubens "the greatest amateur of paintings among the princes of the world," the king acquired over 2,000 masterworks (400 alone from the debt-ridden Gonzagas) whose cost, joined to that of the 143 solid-silver furnishings ordered up for his summer palace, sped his execution but set the bar for the Whigs' grand collecting.

Challenging the royals (George III and George IV collected avidly), an elite weaned on the new humanist philosophy that held man the measure of all things came to patronize the arts with an exuberance bankrolled by taxing their tenants. To form defining collections, they commissioned *en suite*—tapestries by the handful and settees by the dozen. They mined styles and materials—Roman, Oriental, Medieval, Renaissance, marbles, lacquer, ebony, giltwood—and gathered furniture signed Chippendale, Sheraton, and Hepplewhite. The dukes of Buccleuch filled Drumlanrig Castle with paintings, Lord Shelburne profiled Lansdowne House with statuary, and the 3rd Earl of Burlington lured William Kent from fashioning silver chandeliers for George II to refit Chiswick House as a showcase. To rival, the 1st Earl Spencer had the notable James "Athenian" Stuart overhaul his London mansion, while virtually next door the 6th Earl of Coventry charged Robert Adam to detail—inkwell to doorknob—a virtual palace. Furnishings followed fashion: after Pompadour-light who could retain ponderous Louis XIV? And mustn't voyagers return with the latest? Acquired as much for study as for show, theirs were the collections expected of affluent cognoscenti.

Unbridled accumulation was of a different order altogether—at once welcomed (the 10th Duke of Hamilton's vast collection passed at his death to the Rothschilds

A COGNOSCENTI, CONTEMPLATING YE BEAUTIES OF YE ANTIQUE: JAMES GILLRAY'S PUN ON LUST: SIR WILLIAM HAMILTON ON THE VERGE OF DISCOVERY THAT HIS PRIZED ART COLLECTION INCLUDES THE BUST OF HIS WIFE, EMMA, AND THE PORTRAIT OF HER LOVER, LORD NELSON.

and the Louvre), and derided (none crueler than James Gillray's spoof of son William's avidity). A triumph of connoisseurship that put surfeit in context, Regency architect Sir John Soane's London mansion featured a cornucopia of curiosities, antiquities, and painting-piled-on-painting that close curation had elevated from jumble to trove. Sir Hans Sloane's staggering collection of books, pictures, and relics stayed chaotic, but founded the British Museum.

Collections that couldn't get greater grew extreme. So did the precocious 19th-century sugar heir, William Beckford, (who had studied piano under Mozart at age five, acquired a taste for opulence before puberty, written his thinly-veiled autobiography in French, and traveled the world) raze his father's lavish mansion because its neo-Palladian proportions fatigued him and replace it with a splendiferous homage to pastiche. Twenty-five years in the making, Fonthill Abbey, with its 276-foot-tall tower and astonishing holdings, itself constituted an artwork hugely celebrated in its time. "Some people drink to forget their unhappiness, I do not drink, I build," the aesthete would say. Lifting collecting to obsession, his profligacy and insatiable longing to possess gathered in treasure from all periods and places. "Imagine the Cathedral of Salisbury," the artist John Constable wrote of it, "magnificently fitted up with crimson and gold, ancient pictures, in almost every niche statues, large, massive gold boxes for relics, beautiful and rich carpets, curtains, glasses." Searching out such rarities as a chalcedony cup mounted with coral and a nephrite

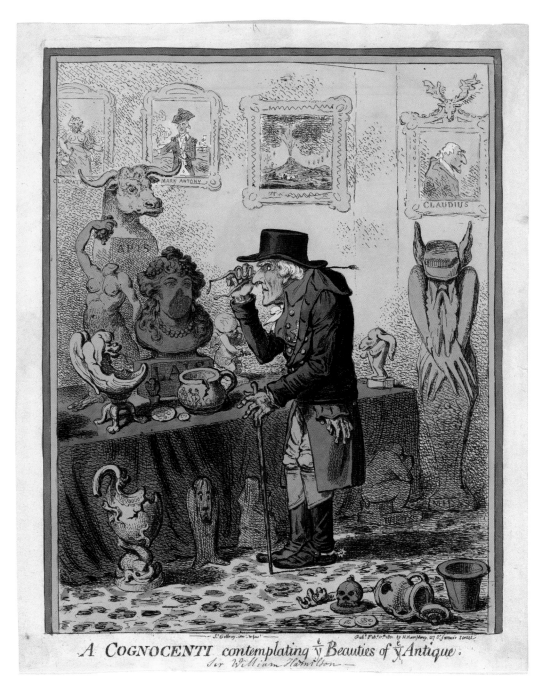

A COGNOCENTI contemplating ỹ Beauties of ỹ Antique.
Sir William Hamilton

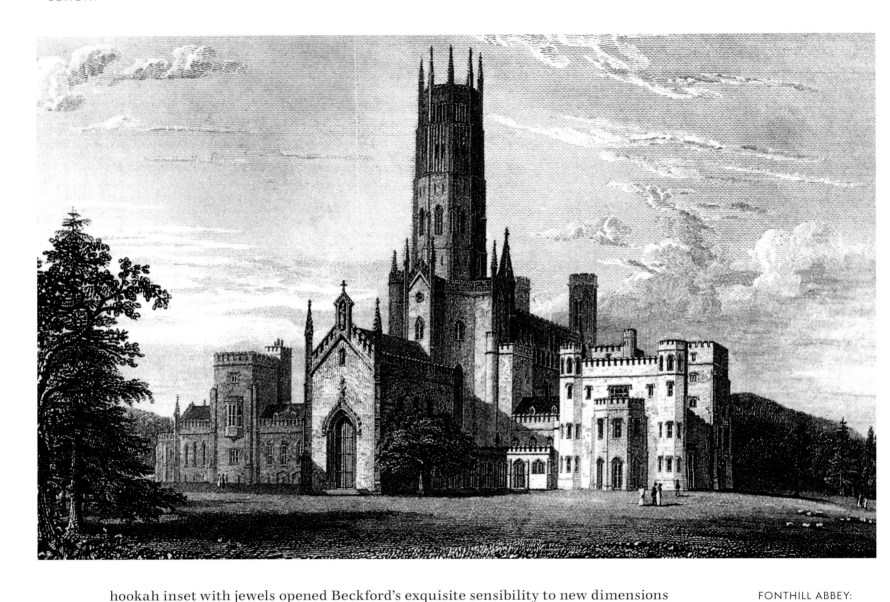

hookah inset with jewels opened Beckford's exquisite sensibility to new dimensions of desire. Infatuated with royalty, he visited Paris during the Revolution to buy up palace discards. With price no object, he paid an inordinate 1,200 pounds for a single stained-glass window and pounced on the ormolu-mounted porcelain trophy given by Hungary's King Ladislaus to Naples's Charles III. If Beckford could not locate just the thing, he designed it himself and found someone to produce it. Because what drove "England's wealthiest son," beyond even ambition, was a dream: "The painted windows of a hall high above in the Tower will gleam with the light of many tapers and summon us to our evening's repast. We shall ascend the hundred steps which lead to the spacious Hall, wainscoted with cedar, whose arched roof will be strangely sculpted with Gothic devices. The pavement is ruddy marble . . . the tall windows are crowded with gorgeous figures colored in ancient times. . . . The doors of old oak are large and folded; in the huge chimney . . . will be placed grotesque vases of antique china filled with tuberoses, and on the gallery you will find stout coffers of cedar whose laborious carvings will amuse you for some moments. Open them and you will discover robes of state, rich chalices and censers, glistening apparel, coral rosaries, and uncouth trinkets. . . . [Then] I shall call you to a table placed in the middle of the Hall, spread with embroidered linen that trails on the ground and loaded with choice viands in dishes of embossed plate. . . ." Alas, the tower collapsed and Beckford's fortune with it, remanding his dream house and its contents to a sale that was the

FONTHILL ABBEY: WILLIAM BECKFORD'S DREAM HABITATION THAT ELEVATED EXCESS TO MAGNIFICENCE.

We belong to our possessions

LORD MONTAGU OF BEAULIEU

talk of its day. Yet ruin gave the grand eccentric but the pause that refreshed his resolve to start over, with another round of pricey masterworks—this time for a castle near Bath. William Beckford closed the chapter on romantic aesthetes, but his role as tastemaker had reach. Thenceforth, addiction took on the éclat of heroic collecting that acquired and displayed the best of the most.

On the Continent, where Bonaparte had opened the door to unbridled assemblage, the Rothschilds' billion-dollar banking fortune now added savoir-faire. By 1885, servicing Europe's sovereigns had titled them in Austria, France, Prussia, Naples, and England, and funded a collective resolve to garnish over 60 palaces with the exquisitely curated appointments that placed "le goût Rothschild" in the lexicon. Baron James (titled by Balzac "Prince of Money") led off with Talleyrand's former residence at 2 Rue Saint-Florentin. Upon visiting, Disraeli thought it an "unrivaled palace with opulent furnishings, a great retinue of servants, and liveries more gorgeous than the Tuileries." In turn, Baron Ferdinand's Waddesdon Manor introduced England to a breadth of country estate acquisition that presented even the cows as collectibles. Comparison with the Medicis fell short only in that the Rothschilds were not patrons. Excepting James, who retained Rossini for operas and had Ingres paint his wife, the barons neither commissioned artists nor maintained them. Rather, they shopped with open wallets for treasures floated on the market. A diarist of the day observed of a purchase of drawings: "It's certain that if not restrained they will soon own anything beautiful that is still to be sold. . . . For there isn't an art object of any kind in any corner of the earth whose owner or dealer isn't trying to offer it to [Baron Édouard at] Rue Laffitte." That some works were of dubious provenance proved irrelevant, as any piece owned by a Rothschild conferred its own lineage.

In Italy, the gauntlet of vanity collecting flung by the powerful 19th-century banking Torlonias was taken up in the 1950s by Count Charles de Beistegui, whose Palazzo Labia in Venice (and, later, the Groussay in France) was so richly appointed as to occasion a record-sale auction. Objects the Count couldn't buy—most notoriously, Holbein's portrait of Henry VIII—he had copied, pronouncing the original a fake, and yet such was "le goût Beistegui" as to elevate even those.

All the while, to the east, cosmopolitans had been living like pashas. In the Levant, tax-exempt traders had built sumptuous dwellings—that of the Stanley Patersons was famed throughout Smyrna for its outsize chandeliers, forged-iron balustrade, and *four* grand pianos. Ottoman refulgence defined luxury living with finely glazed Iznik pottery, gold-threaded furnishings, and *saz* carpets layered to tabulate wealth. Travelers to 17th-century India reported gilded statues, latticed-stone screens, and

furniture inlaid beyond use with turquoise, copper, and jade. The Korean aesthetic, at once decorative and ceremonial, placed the cool perfection of a celadon bowl against a fiercely painted tiger or aligned rosewood carvings to guide the eye from smallest to largest. Their paintings on silk refined into paradisiacal views of snowy peaks and misted valleys, peaking with 18th-century Jeong Seon's coveted renderings of the Diamond Mountains.

Qing dynasty China valued quantity. The wealthy collected avidly, ceding first choice to the emperors, who justified as public policy an obsession that was personal. Passionate for the letters, Kangxi expanded the imperial collection to include 49,000 Tang poems, all expensively bound. Grandson Qianlong held collecting itself an art form. Whereas even the committed collector might be satisfied with a single scroll by a master, the emperor stamped his six-character reign mark on more than 2,000 such marvels. Passionate for all the arts, Qianlong personally vetted the artifacts skimmed from the trade routes, accumulated 30,000 jade works, and exacted top-quality domestic manufacture—gilded cloisonné vases, Coromandel lacquer screens, and cabinets of rare *huanghuali* wood whose carved elements were rendered twice to conform to the principle of paired opposites. Although the long-lived ruler's spending went virtually unchecked, intervals when even the fabled Qing fortune faltered drew public criticism—not for the quality, or even quantity, of his acquisitions, but because they were perceived to be for the pleasure of one person, Qianlong.

Not to be forgotten in all the hoopla were the artists, who were courted and fêted and bestowed their talents advisedly. To lure Giotto from Florence, the King of Naples titled him "first man" of the kingdom, extended a large stipend, and total artistic freedom. On acquiring the *Sistine Madonna* to backdrop his dais, Poland's August III dragged the throne aside himself, crying, "Make way for the mighty Raphael!" Titian was worshipped. Once, working on a portrait of Charles V, he dropped his brush and the emperor picked it up, bringing the artist to his knees: "Sire, your servant does not deserve such an honor." "Titian," replied Charles, "is worthy to be served by Caesar." Said Pope Paul III of his decision to let Cellini off a murder charge: "You don't understand, men like Benvenuto, uniquely talented,

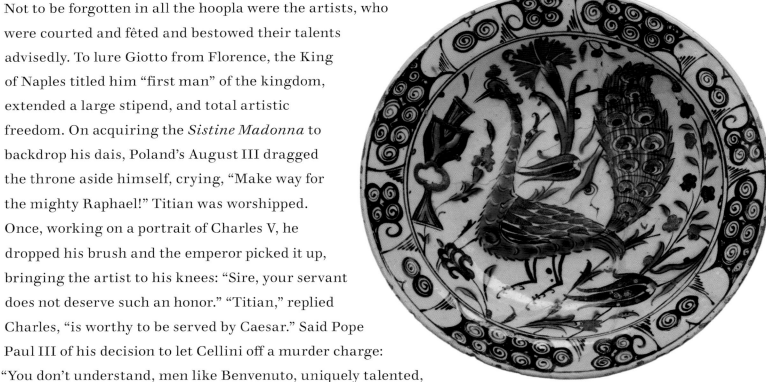

17TH-CENTURY IZNIK DINNER PLATE: OTTOMAN PRIDE OF CRAFTSMANSHIP EXTENDED TO EVERYDAY TABLEWARE.

are not bound by laws." And that Gianlorenzo Bernini had his mistress defaced did not affect Urban VIII's myriad commissions: "Your luck is great to see Cardinal Maffeo Barberini Pope, Cavaliere, but ours is far greater to have Cavaliere Bernini alive in our pontificate."

Flattery was a small price to pay for a swaggering portrait. As long as Charles Le Brun delivered glory, he had the run of Versailles. Bernini voyaged in the royal carriage and was given a life pension. Lacking the suzerain advantage of retaining the artist du jour, new money was wait-listed. The only way the Sforzas could lock in the likes of Verrocchio and Bologna was with back-to-back commissions and zero late fees. Even the Medicis scrambled: Michelangelo deserted Leonardo's patronage to accept Julius ll's offer of the largest paint job in Christendom—the Sistine Chapel ceiling. Imported talent cost more. François I overpaid Titian for a portrait and, despite having lodged the aging Leonardo, paid his estate handsomely for the *Mona Lisa*. None was more sought out than Peter Paul Rubens, who set a brush here and there to his veritable factory of orders while ferrying between courts as ambassador-at-large. He traveled grandly to France to design 24 tapestries narrating Marie de' Medici's rule as regent; to England to paint the ceiling of Banqueting House for Charles I (who titled him); to Spain to embellish a hunting lodge for Philip IV (who paid extra to join him on the scaffolding).

By 1800, England had knighted its own art stars—Thomas Gainsborough, Thomas Lawrence, and Joshua Reynolds. The latter, grown rich from painting anyone—prince, actor, prostitute—who could afford his exorbitant fees, rated a statue in St. Paul's Cathedral and a funeral procession that counted 91 carriages for the peerage alone: "Distinction," Reynolds noted, is "what we all seek after, and the world does set a value on." Such, too, was the prerogative of Ernest Meissonier, then Europe's highest-paid artist, that he could delay delivery of Bonaparte's urgent commissions for such imperatives as building a runway to sketch horses in motion. The impetuous Théodore Géricault, whose searing condemnation of France's slave trade, *Raft of the Medusa*, caused a furor at the 1819 Paris Salon, nonetheless was awarded the gold medal.

Still, for all the adulation, artists walked a fine line between ego and nest egg. Yes, the stars were indulged (Velázquez famously painted himself in the foreground of *Las Meninas* and the king as a reflection) and charged as they pleased (the portrait fees exacted by Largillière and Rigaud veered from 2,000 livres for the Prince de Conti to 13 times that for the King of Spain). And many were collectors in their own right: Mantegna and Titian gathered armor and textiles; Rembrandt moonlighted as a dealer, buying colleagues' work to flip for a profit; and Rubens lavished his mansion with tapestries and ivory-inlaid cabinetry. All, nonetheless, were in service—to

People with money already have the Guccis and the Puccis. Eventually you want a Michelangelo.

RAFAEL VIÑOLY

the guilds, to the nobles, and, ultimately, to King and Church. Excepting Albrecht Dürer (financially independent by controlling his print sales) they had to compete for commissions. Bernini famously edged out Borromini for the great Fontana dei Quattro Fiumi by sliding his model in front of the Pope. And even the masters were assigned trivia. Van Eyck was called on to paint an Easter candle for the sister of Philip the Good; Raphael, to limn Leo X's elephant; da Vinci, to "make something unusual" for François I's entry to Milan; Piero di Cosimo, to program a masquerade for Florence; and Jacopo Sansovino, to sculpt centerpieces from sugar. Catering to caprice, Verrocchio painted Lorenzo's mistress on the Medici standard, Bernini designed a coach for Queen Christina, and Inigo Jones fashioned a gown for the Countess of Bedford. Well into the Enlightenment, Antoine Watteau was diverted from his *fêtes galantes* to ornament ladies' fans, and François Boucher was pulled from his allegories to decorate Madame de Pompadour's doghouse. Payment was never certain; in 1771, the Prince of Asturias (later Charles IV) contracted Luis Meléndez for a series of still-lifes and after the artist had produced 37 annulled the commission.

To the east, the line also blurred. Whereas, despite the *Shahnameh*'s instant fame, the 11th-century Ghaznavid sultan Mahmud I poorly remunerated its author, four centuries later, Timurid Shahrukh pledged land to lure artists to Herat. Whereas Persia's foremost 15th-century calligrapher was careful to sign himself "the sinful slave Mir Ali," a Mughal master might garner his weight in gold, and Jaipur's artisans were given the city as a canvas. Japan qualified esteem, ranking artisans with merchants at the bottom of the Confucian four-estate system while rewarding top artists with special rights of depiction. It greatly honored Hiroshige, for example, to be sanctioned to paint the city of Edo.

China held artists in both admiration and thrall: a noted 3rd-century scroll shows Taoist poets escaping a stifling bureaucracy for discourse and song; another depicts the beheading of a painter who used a shade of orange reserved to the ruler. The revered Ming calligrapher Tang Bohu failed 70 attempts to correctly render a lake, yet was given free rein, whereas the eminent Ming artists Zhu Da and Zhu Ruoji escaped Manchu persecution only by becoming Buddhist monks. And although the emperors, generally themselves poets and painters, indulged esteemed artists, even an icon like Wang Hui might be restricted to landscapes. Only imported talent was coddled. The Italian Jesuit painter Giuseppe Castiglione, designer of the Old

THE SISTINE CHAPEL CEILING: THE GREATEST ART COMMISSION OF ALL TIME, IT BOLSTERED JULIUS II BUT COST MICHELANGELO HIS EYESIGHT.

Summer Palace, received up to eight imperial seals on a work, was honored with a Chinese name, and lodged richly at court. Should such bribery fail, imperial obsession did not balk at abduction.

The dynamic reversed forever when artists became idols. The papacy had orchestrated Raphael's obsequies, whereas celebrity drew two million fans to Victor Hugo's funeral and accorded him a lying-in under the Arc de Triomphe, burial in the Pantheon, and an eponymous street, which for years received mail addressed to "M. Victor Hugo, en son avenue." Collectors were toyed with. Witness the infamous affair of James McNeill Whistler and the *Peacock Room*. Hired by Frederick R. Leyland to refresh a dining room designed by the celebrated Thomas Jeckyll, the master took advantage of the shipowner's travels to create "something quite wonderful." The priceless Spanish leather was painted over, the precious porcelain

JAMES MCNEILL WHISTLER'S PEACOCK ROOM: THE INFAMOUS COMMISSION THAT INTRODUCED THE CONCEPT OF ARTIST PREROGATIVE.

A wonderful artist should charge highly for his art. No money is too much.

ALBRECHT DÜRER

was sidelined, and walls, ceiling, and shutters were lathered with peacocks—gold peacocks on blue background, blue peacocks on gold background, peacock eyes, peacock feathers, interlaced. To show off what he pronounced the greatest feat of decoration in all England, Whistler held a private viewing, sans client. "These people are coming not to see you or your house: they are coming to see the work of the Master, and you, being a sensitive man, may naturally feel a little out in the cold." All duly marveled excepting poor Jeckyll, who fled babbling incoherently and was hauled off to an asylum. Angered by Whistler's presumption and egregious invoice for gold leaf, Leyland fired him. Unrepentant, the Master returned, painted in his patron as a hectoring peacock, and sued for his pay: "You should be grateful to me. I have made you famous. My work will live when you are forgotten. Still, perchance, in the dim ages to come, you may be remembered as the proprietor of the *Peacock Room*."

The art stars postured on. Belying the "particular elegance" of his silver-tipped cane, Édouard Manet shocked Paris with his unclad *Olympia*. Paul Gauguin acted out the principle of self-sovereignty in Tahiti, Paul Cezanne subjected dealer Ambroise Vollard to 115 all-day sittings, Henri Matisse pawned his wife's emerald ring to buy Cézanne's *Three Bathers* then made her sit for him daily for months, and Claude Monet outbid a timber merchant to save trees he wanted to paint, saying: "Go higher. I'll pay the difference." While the third world's Diego Rivera ("giving rich people better work than they'll pay for") saw his controversial work for Rockefeller Center destroyed, society artist Maxfield Parrish charged John Jacob Astor IV a hefty $5,000 for a mural lampooning him as King Cole.

Performing artists were less exigent. At the height of their careers, Anna Pavlova and Enrico Caruso hired themselves out to Otto Kahn for his daughter Maude's coming-out party, and Paderewski performed behind a screen for only Isabella Stewart Gardner and a friend. By mid-century, however, their fees were substantial and their whims were indulged. Pianist Vladimir Horowitz toured around with his massive Steinway Grand and, for a dinner in Yorkshire honoring violinist Nathan Milstein, the Earl of Harewood flew in purveyor Arnold Reuben from New York with 110 of the maestro's favorite cheesecakes.

Artists-du-jour bypassed patrons altogether. London's cultish intellectuals plucked works off the walls of poet-painter Dante Gabriel Rossetti's mirrored mansion and from the studio that Frederic Leighton had lavished with Walter

Crane's Orientalist mosaics and William de Morgan's lustered tiles. Louis Comfort Tiffany's circle flocked to Laurelton Hall for its signature Favrile glass windows and translucent vases filled with exotica from his greenhouses. Patrons of Hudson School painter Frederic Edwin Church weekended at his Middle Eastern dream palace, Olana, whose 37 rooms—fashioned over 40 years with latticework, fretwork, stained glass, and a profusion of gilding—showcased his landscapes and such esoterica returned from his travels as iridescent butterflies and bronze ostriches mounted on turtles. Channeling the excess, contemporary artist Hunt Slonem bought two plantations in Louisiana to satisfy twin cravings for cypress and Spanish moss, and tailored each of his myriad mansions' rooms to a "life pursuit"—red-portraits, thank-you notes, butterflies, shells, and on.

Architects grew as exacting, demanding control over far more than the walls. In Brussels, Victor Horta designed every element, down to doorbell and spoons, of the Art Nouveau mansion delivered to the industrialist Armand Solvay. In Villefranche-sur-Mer, Ogden Codman Jr., forced by circumstance to rent out his famed Villa La Leopolda, rejected his famous lodgers' proposed adjustments: "I regret, but the House of Codman cannot do business with the house of Windsor."

Across the Atlantic, Frank Lloyd Wright subjected clients to a dictum of form over function. He answered Illinois mining heiress Susan Lawrence Dana's request for an extension to her prairie villa with a house-of-the-future displaying 250 leaded-glass windows and built-in

FALLING WATER: FRANK LLOYD WRIGHT'S IMMODERATE MASTERWORK, CANTILEVERED OVER A WATERFALL TO WRITE OWNER AND ARCHITECT INTO HISTORY.

J. PIERPONT MORGAN'S
PALACE LIBRARY,
BUILT TO HOUSE HIS
VAST COLLECTION OF
BOOKS, BINDINGS,
AND MANUSCRIPTS.

furnishings that upended architecture. He met Textile king George Fabyan's directive to "refresh" 600 acres of Riverbank with a lighthouse, Roman pool, Dutch windmill, and gardens calling on 100 workers to maintain. Crowned "The Master" after meeting Pittsburgh magnate E. J. Kaufmann's request for a quiet retreat with the revolutionary stone, steel, and glass Falling Water, improbably cantilevered over a waterfall, Wright answered to none. A complaint about water leaking through the ceiling reportedly elicited: "Why don't you move your chair a little bit to one side?"

Collector mania kept pace. Colonial America had indulged genteel acquisition. Leaving Martha to meet the Confederation's silver shortage with five-cent coins minted from their dinner service, George Washington sent off for Chinese export plates: "Pray let them be neat and fashionable or send none." Trace addiction to Thomas Jefferson, whose return from Paris with 88 crates of treasure instilled a passion for pewter-ware that by 1780 was importing 350 tons annually, and a fever for furniture skimmed from the French Revolution that led more than one hapless Bostonian to debtors' prison.

What might the Founders have assembled could they have accessed tycoon wealth! Between 1880 and 1929, art and antiquities sailed in from abroad on an imperial scale. Neither plunder nor tribute, they were the gleanings from a continent impoverished largely by cheap U.S. grain. At the ready were pre-income-tax millionaires, the so-called "captains of industry," Vanderbilt, Carnegie, Morgan,

LEFT HUNT SLONEM'S CORDTS MANSION IN KINGSTON, NEW YORK: AS VIVID AS THE ARTIST'S ACCLAIMED BIRD PAINTINGS, EACH OF ITS MYRIAD ROOMS WAS DESIGNED FOR A DIFFERENT PASTIME.

BELOW TITIAN'S *RAPE OF EUROPA*: ONE OF THE MASTERPIECES THAT ART-DEALER BERNARD BERENSON TRANSFERRED FROM EUROPE'S PALACES TO POLISH AMERICA'S GILDED AGE.

Rockefeller, Frick, Altman, Havemeyer, Mellon, Kress, Widener, and Whitney. At the time, Cornelius Vanderbilt controlled the nation's shipping and railroads, Andrew Carnegie furnished the steel, John D. Rockefeller supplied 70 percent of the world's oil, and banking titan John Pierpont Morgan, twice, bailed out the U.S. treasury.

Marshaling art as soft power, these Gilded Age barons turned salons into galleries, organized travel around art sales, and funded archeological expeditions to Egypt and the Orient. If buying was the high, the endgame was status. Beaux Art mansions, yachts, and country estates got attention, but culture conferred "class," and art with a provenance delivered a polished veneer. It was not irrelevant that by 1914 U.S. national income totaled $37 billion, more than triple the next-largest economies of Britain and Germany. Thus were Europe's domains stripped of entire interiors to furbish America's new courts. Virginia Fair Vanderbilt livened her Park Avenue triplex with an opium den from Shanghai; John W. Campbell transformed his office in Grand Central Station into a 13th-century Florentine palace; and Henry Clay Frick, on his way to a golf game in Paris, bought several works from the Richard Wallace collection. As competing obsessions built eponymous museums, collecting sped from a pastime to a round-robin race to buy at all cost. Altman vied with Havemeyer and Rockefeller for Qing porcelains; Mellon, Whitney, and Rockefeller challenged Havemeyer for Impressionist paintings; Frick beat out Morgan for the "Ilchester" Rembrandt; and Freer outbid Gardner for the *Peacock Room*.

None outbid J. P. Morgan, architect of U.S. Steel and the most influential banker of his day, who had still found time over 20 years to accumulate $60 million worth of art. What may have begun as a hobby surrendered to the need to rake in everything wondrous: ancient cylinder seals, amber, ivories, porcelains, furniture, rock crystal goblets, nautilus cups, majolica, Persian miniatures, Limoges enamels, Renaissance bronzes, and tapestries from the Royal Chapel in Granada. To complement his over 350,000 *objets de vertu*, Morgan brought his library to unrivaled heights with the very rich *Hours of Catherine of Cleves*, William Blake's *Book of Job*, Handel's *Messiah*, Milton's *Paradise Lost*, and *three* Gutenberg Bibles. Masterworks multiplied: a single day in 1901 relieved a Paris dealer of a Rubens portrait, a Titian *Holy Family*, and, for a hair-raising $400,000, Raphael's *Colonna Madonna*. On occasion, Morgan's obsession ("The three most expensive words," he would say, "are 'unique au monde'") overrode his famed business acumen. Hearing that he had fixated on replacing a missing cap from a ginger jar "even if it cost me a million dollars," an obliging dealer supplied one—from a jar Morgan had bought long before and never picked up. When his Manhattan mansion ran out of space, Morgan built another next door, yet another in London, sent the overflow to museums, and kept buying. His curator claimed that Morgan had "succeeded in acquiring all of the

world." Not quite. The titan was negotiating for the contents of the Forbidden City when he died.

The pace set, collectors vied to acquire the treasure that Morgan's death duties brought to auction (Joseph Widener alone purchased $1,750,000 worth of his prints, porcelains, and tapestries) and raced on. Feeding the frenzy were two worldly dealers, archrivals when not in collusion—Bernard Berenson and Joseph Duveen. There wasn't a painting Berenson ("B.B.") couldn't locate or validate or find clients for. Steering Isabella Stewart Gardner away from those "braces of Rembrandts" signing "any vulgar millionaire," B.B. stocked her Venetian-style palace with Giotto, Fra Angelico, Holbein, Raphael, and Vermeer. Had the Duke of Westminster changed his mind about selling Gainsborough's *Blue Boy*? B.B. would get her Titian's still pricier *Rape of Europa*. Might Italy block the export of the Count Chigi Botticelli he had set her heart on? B.B. had a copy made for the Count and filtered the authentic *Madonna* to Boston.

Cannier still, Duveen juggled masterworks like ninepins in the competitive air, sliding Morgan's Fragonards to Frick and selling Rembrandt's *Aristotle Contemplating the Bust of Homer* three times over—twice to the same client! The works that Duveen winkled out of Europe were its patrimony—Velázquez portraits, Gobelins tapestries, Clodion sculptures, and La Pompadour's Boucher panels. He even found the magic number ($728,800) to separate the duke from *Blue Boy*, dispatched to California to addict Henry E. Huntington to more bargains.

Collectors seeking instant gratification bought canvas by the yard. Merchant A. T. Stewart packed his 75-foot-long gallery so tightly with musts that Meissonier's sweeping *Friedland* ended up in a bathroom. Cotton king Thomas B. Clarke found himself mired in paintings, Greek vases, English furniture, and faience: "Once he started to collect," said a dealer, "it was like a disease that had to run its course." Joseph H. Hirshhorn darted around galleries saying, "I'll take that one and that one and that one," then advised his accountant "I've done some damage." There was no stifling the compulsion to outdo. Gertrude Vanderbilt Whitney vacuumed up enough artworks to stock four museums. Ogden Mills caught the Fine French Furniture bug from Carnegie and Frick to furnish five mansions—the one in Staatsburg alone held 74 rooms-full—and yet grandson Ogden Phipps, seeing how much Winston Guest's "FFF" fetched at Sotheby's, bought on, paying top prices for the best of Boulle, Gerard, Petit, and Tilliard.

Fatefully for the amateur, flipping for profit upturned collecting. Formerly a luxury, art became a commodity. Who could think acquisition indulgent after the Fragonard panels Morgan had purchased for $315,000 sold to Frick for $1,225,000? John D. Rockefeller Jr., desperate for a group of Chinese porcelains from said sale,

coaxed a million-dollar loan from his father by calling them an investment: "A fondness for these porcelains is the only thing on which I care to spend money. . . . The money put into these porcelains is not lost or squandered. It is all there, and while not income-producing, I have every reason to believe that . . . a sale under ordinary circumstances would certainly realize their full cost value, and as the years go by, more." Had Dad but known that a Qianlong vase was to sell at Sotheby's for $32.5 million!

Only the eccentric took no note of resale nor, indeed, of what anyone thought. France's freewheeling society cultivated singularity. The proudly impoverished composer Erik Satie agreed to take on a commission rejected by Stravinsky for its risible fee on condition he be paid even less, and at his death left 68 unopened umbrellas. Postman Ferdinand Cheval fashioned a dream palace in Hauterives from stones picked up on his mail route but couldn't afford water or heat, so viewed on its glory from the window of his shack. The auctioneer Maurice Rheims recalled an assemblage offered by a Monsieur Thiele of birdcages, brooches, corsets, and 4,000 keys; and another of 3,000 croissants gathered from the nation's best bakeries, displayed in humidified cases and willed to the Louvre. Marginally more sanely, oilman Calouste Gulbenkian, until building his eponymous museum in Lisbon, buried his vast art collection in his Paris mansion, shown to none but his staff.

America did not lack for singular profligates. There was the litigator John G. Johnson, owner of the Van Eyck that constituted the nation's costliest painting per square inch, who lambasted his peers' frenzied aggregation while building a second house for his own. There was the crotchety widower Grenville Lindall Winthrop, who kept his daughters locked up with his

"GOD OF WEALTH": ONE OF THE PRICEY QING DYNASTY PORCELAINS THAT JOHN D. ROCKEFELLER JUSTIFIED TO HIS FATHER AS A GOOD INVESTMENT.

art in cork-lined rooms that even the chiming of his 12 grandfather clocks couldn't penetrate. And the Baltimore railroad magnate Henry Walters, who chartered an ocean liner to import his purchases, including all he could find of an obscure *Quattrocento* painter, but never unwrapped.

It was not the accumulation that raised establishment hackles, but the tone. Whereas the mannerly Pittsburgh steel baron G. David Thompson didn't advertise his 100 Klees, 100 Kandinskys, and 90 Giacomettis, the arriviste chemist Albert Barnes, whose Argyrol patent had purchased 181 Renoirs, 69 Cezannes, 59 Matisses, 44 Picassos, 12 Modiglianis, and 7 Van Goghs, came on too strong for Philadelphia society. How arrogant to hire maestro violinist Fritz Kreisler to play for only him, his wife, and Leopold Stokowski! To buy 60 Soutines in one day! To put his collection on show, then limit attendance! Forgotten was Barnes's higher objective—to acquire the best for the purpose of educating. More genteel, the addiction of Electra Havemeyer Webb, which began as an itch ("Once you're a collector, you buy something, and you can hide it in a drawer or pack it in a trunk, and it doesn't matter, you know you have it"), but expanded with acquisitions too big for drawers. The Shelburne Farms inn, lighthouse, and railway station were but openers for the covered bridge, the pond built beneath it, and the steamboat *Ticonderoga*.

None outbought William Randolph Hearst, who stocked San Simeon with great and odd things, crammed his Riverside Drive penthouse with enough armor for a battalion of knights, and shipped the overflow to his castle in Wales. Hearst's haste to spend (saying he called a dollar "William" since he never knew it long enough to call it "Bill") bought such trinkets as a sawmill and installed 21 miles of railroad track to transport it—a labor of ten years—all to discover hoof-and-mouth disease in the packing crates, whereupon the whole thing was repacked and warehoused. Marking the apex of manic collecting, Hearst purchased a rare Georgian silver tankard listed by Sotheby's as "one of a pair, whereabouts of other unknown," and directed Duveen to locate the mate at all cost. Across years and continents, eager dealers searched in

PALAIS DE HAUTERIVES: THE IMPROBABLE PALACE BUILT BY AN IMPOVERISHED POSTMAN TO REALIZE AN IMPOSSIBLE DREAM.

vain. When at Hearst's death his warehoused goods were inventoried, the pined-for tankard was among them, acquired and packed away when he had been 21.

The Great Depression put a dampener on tycoon collecting but liberal tax breaks for philanthropy introduced a new luxury. Conspicuous giving married the age-old longing for status to the *elite oblige* precept outlined in Andrew Carnegie's "Gospel of Wealth," that God had ordained the wealthy to enrich the deprived. Leaving his employees to a grueling 12-hour-per-day, 6-day workweek, the steel baron had dedicated millions to civic improvement and embarked his peers on the supreme satisfaction of giving back. The Metropolitan Museum of Art's inestimable gifts from Havemeyer, Vanderbilt, Astor, and Altman (including over 40 of their famous Duveens) added masterworks that Henry Marquand had collected "not for himself alone, but for a whole people and for all the world"; a "series of items it could not possibly buy" from the round–the-clock-guarded trove that banker Robert Lehman was raised with; and more of the treasure J. P. Morgan would have deeded in full had the director agreed to the wing he'd requested. Uniquely American, exchanging benefaction for recognition stocked over 90 percent of the nation's institutions. Be it to cleanse soul or reputation, Henry Francis du Pont gave the nation his content-rich, 175-period-room, Winterthur mansion; Henry Walters left 22,000 works of art to the city of Baltimore; and Sears magnate Lessing J. Rosenwald gave the Library of Congress the spent fever of "a most virulent case of bibliomania."

What new fortunes most wanted on the wall was identity. Whereas growing intolerance of entitlement had induced Europe's giveaways, the gifts triggered by post-1952 tax incentives gave wealthy Americans the highest status-marker of all—bricks-and-mortar immortality. So did Kimbell, Hirshhorn, Sackler, and de Menil build eponymous showspaces, and entrepreneur Norton Simon allocate the remaining Duveens to a museum whose name changed to his. Oklahoma oilman J. Paul Getty gentled his profile as the world's richest person with a namesake $700 million approximation of Herculaneum's Villa dei Papiri, and publisher Walter Annenberg dangled his billion-dollar collection before several hopefuls before leaving it to an eponymous wing in the Metropolitan Museum. Although defined by philanthropy, Annenberg relished collecting ("an interest in art grows in you and takes you over") and, driven by one-upmanship, bought on. He liked to tell of the time he pounced on a Cézanne, *Mont Saint-Victoire*, that Robert Lehman was considering: "When he pleaded with me to sell it to him, I said, 'Bobby, you blew it!'"

Beneficence marks: altruism exalts. It stirred the heart that aluminum king Andrew Mellon gave the nation the National Gallery of Art, plus $30 million worth of artworks, $15 million outright, and a $5 million endowment—on condition that

his name appear nowhere. Rockefeller largesse reached another level altogether. John D. Jr. gave 400 pieces of his cherished porcelain to the Metropolitan Museum and threw in the Cloisters, a medieval glory of statuary and unicorn tapestries plus 11 miles of the pristine coastline it viewed on. He further gifted the nation with $94.9 million to restore colonial Williamsburg, funds to preserve western wilderness, and land for a Museum of Modern Art jump-started by wife Abby with works from her storied collection. When "you begin buying for yourself and then you just get too much," she explained, "you get out of collecting on a personal basis."

Son Nelson collected relentlessly before getting too much. When his Manhattan triplex ran out of walls, he gave his Pocantico Hills estate a 60-foot-long gallery. Even his brothers were impressed; touring the halls lined with Picassos, Chagalls, Motherwells, and Warhols, David sighed, "Only Nelson could live like this." After stocking five mansions, Nelson, too, embraced benefaction, donating and endowing a collection of primitive art, crowned by Henri Rousseau's *The Dream*, to a museum specially built for it. The happy fallout of beneficence was more space, which invited more buying, as on the evening that found David Rockefeller's wife Margaret at Parke-Bernet pursuing a Signac; asked if she'd been nervous she trilled: "Not at all, I just raised my hand until the other bidding stopped and the painting was mine."

Latter-day altruism inclined cosmetics heir Ronald S. Lauder to leave his name off the Neue Galerie—the glorious museum he founded to show Austrian and German art, crowned with a $135 million Klimt, and gifted to New York in a gesture he called "a unique luxury." Rating the three levels of collecting as "Oh," "Oh My," and "Oh My God," Lauder still goes for the latter, half-joking that only the Louvre could accommodate the art he has gathered. Brother Leonard A. Lauder followed with a billion-dollar gift of Cubist art to a wing of the Metropolitan Museum, which bears his name, and a further $131 million to jump-start the downtown Whitney Museum, which does not. Walmart heiress Alice L. Walton, "thinking this is something we desperately need," gave Bentonville, Arkansas, the $1 billion Crystal Bridges Museum of American Art, endowed it with $800 million and, for another $35 million, Asher B. Durand's iconic *Kindred Spirits*. They are not alone, noted White Cube gallery's Jay Jopling of the collectors who "want to leave something, a mark, a legacy, a contribution."

Artists marked differently. The climate of celebrity launched by Marcel Duchamp with the urinal he called art because it "created a new thought for that object" handed them a new trump card. James Rosenquist, offered a third more than the $60,000 asking price for his 86-foot-long diorama *F-111* from dealers planning to

As you know, it is my intention to have only important paintings in my collection

ALBERT BARNES

divide it, sold it for $30,000 to collector Robert Scull to keep it intact. Mark Rothko, on learning that paintings made for the Seagram Building were to backdrop people eating, reclaimed them. Olafur Eliasson, lest his Weather Project "slip from an artistic experience to mindless entertainment," denied the Tate's request to extend it. Exhibiting at Versailles, Jeff Koons faced his likeness on that of Louis XIV. Even Communist China found it politic to free the noted artist Zheng Shengtian, jailed for levity, to act as cultural ambassador, and to release the intractably subversive Ai Weiwei from solitary confinement.

Empowering too, the artist's license to brand. Carte-blanche fabrication made high art of product fashioned by assistants: "I don't design. I don't paint. I don't sculpt. I absolutely never touch my own works," pronounced Maurizio Cattelan of his retrospective at the Guggenheim with its solid-gold toilet "just waiting for you whenever you need it." Takashi Murakami created handbags for Louis Vuitton; Tom Sachs wrapped an Hermès store in its signature orange; Marilyn Minter designed Tom Ford's campaign; Kris Wu embroidered sportswear for Burberry; and Kehinde Wiley, traveling with his atelier in the manner of Rubens, created a shoe collection for Puma.

Collectors countered with star acquisitions, tattooing Stoschek, Falckenberg, Pinchuk, Brandt, Ullens, Hill, and Dokolo on eponymous museums. Mining magnate Bernardo Paz brought attention to a remote part of Brazil with Instituto Inhotim,

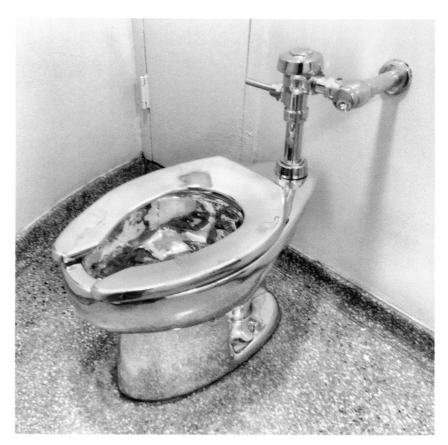

MAURIZIO CATTELAN'S *AMERICA*: INSTALLED IN MANHATTAN'S GUGGENHEIM MUSEUM, THE $4 MILLION, 18-KARAT, CONCEPTUAL UPDATE OF THE ONCE-PRICELESS SÉVRES COMMODE UPTURNED BY DUCHAMP'S URINAL AND RESTORED TO A LUXURY THAT LINED UP 100,000 VISITORS WHO HOPED TO USE IT—PLUS ONE (AFTER IT TRANSFERRED TO BUCKINGHAM PALACE) WHO STOLE IT.

built around 5,000 acres of man-made lakes and the world's largest collection of palm trees for such heroic installations as the 2,640-foot-deep hole that Doug Aitken lined with microphones to deliver Earth's inner rumblings. Professional gambler David Walsh promoted himself ("Turns out it ain't so great getting rich. . . . Better build a museum; make myself famous") with a $200 million Tasmanian showcase in Tasmania (MONA) landscaped for such fantastical installations as the human digestive system. Japanese billionaire Soichiro Fukutake purchased an archipelago in the Seto Inland Sea to explore art's relationship to nature with high-maintenance artworks on the order of Christian Boltanski's recorded heartbeats.

Obsession indulged, thirst still was not quenched. "I've got so much I've started putting it on the ceiling," said business titan William Koch of a collection overflowing such a "bloody big" house that he communicates by intercom. "It's an archetypal inner urge," noted entrepreneur Dimitris Daskalopoulos of collecting works so unwieldy they remain in crates. "It's about owning it, ingesting it. It's proto-sexual," observed auctioneer Tobias Meyer of the rampant desire for a Jeff Koons. Of mega-collector S. I. Newhouse Jr., fellow addict David Geffen remarked, "He would rather pay more for a painting than lose it," ignoring that he himself went for broke. "I was afraid I wasn't going to own it" explained Elaine Wynn's $57.2 million acquisition of a Francis Bacon triptych. "We couldn't stop" built a celebrated museum from a thangka that Donald and Shelley Rubin had purchased with half of their student savings. "Sometimes I think I'm completely crazy," exclaimed Mexican juice king Eugenio López Alonso of his Museo Jumex, inflated to the world's largest collection of Latin American art with found objects and bumper cars purchased up to twelve at a time. "Art is either our passion or addiction, probably both," offered philanthropist Eli Broad of his and wife Edythe's burgeoning collection

THE BROAD: THE NONPROFIT DILLER SCOFIDIO + RENFRO–DESIGNED MUSEUM BUILT BY ELI AND EDYTHE BROAD TO SHARE THEIR COLLECTION AND GIVE DOWNTOWN LOS ANGELES AN OVERNIGHT ART SCENE.

A month doesn't go by when we don't buy art

ELI BROAD

that stocked two Los Angeles museums before building theirs. "You don't need money, you need feelings," noted Dutch chemicals tycoon Joop van Caldenborgh of his 50-acre sculpture park in Wassenaar, which calls on steel plates to haul in the works, cranes to position them, and 20 curators. Of his similar effort in Oslo, Norwegian business mogul Christian Ringnes leaves wall art to millionaires since "sculpture is a billionaire's game because you need the space." Similar obsession led Philippine developer Robbie Antonio to have Rem Koolhaas design a 25,000-square-foot residence around 33 portraits of himself; entrepreneur Budi Tek to build a private museum in Jakarta and another in Shanghai; and real estate moguls Mera and Don Rubell to collect over 7,000 artworks and build a 100,000-square-foot Miami showspace to share them.

Reaching higher, industrialist Liu Wenjin gifted her Yinchuan Museum to the state to "improve the well-being of its citizens and China at large"; Swiss collector Maja Hoffmann devoted ten years and $182 million to converting a railyard in Provence to the 20-acre, Frank Gehry–designed, nonprofit, multi-disciplinary, Luma Arles arts complex; entrepreneur Dasha Zhukova founded the Garage Center in Moscow and an 8-acre "art island" in St. Petersburg to give Russia an art scene; and Mitchell and Emily Rales contoured hills, leveled mansions, and erected 12 pavilions to give their Glenstone museum in Potomac, Maryland, the 30-square-foot-per-visitor viewing space they hold optimum.

There is no end to the reasons for addiction and pursuit. "I've been there and done it" led investor Howard Farber to sell his large Chinese collection and start over with Cuban art. "Acquiring art is a very good exercise for me as a collector" made a museum of Miami developer Craig Robins's office building. "A collection dies the day you cannot add something to it" drove businessman Jean-Yves Ollivier's obsessive acquisition. "I just follow my instinct" justified e-commerce billionaire Yusaku Maezawa's record $110.5 million purchase of Jean-Michel Basquiat's *Untitled*. "I couldn't sleep anymore" explained mega-collector Artur Walther's up to 60 photographs at a time museum-founding purchases. "Quixotic" describes site-specific installations at Robert and Nicky Wilson's Jupiter Artland near Edinburgh, and at Steven and Nancy Oliver's Geyserville, California, ranch, that are too large to move, or, thus, sell.

Let cooler heads park art bought as an asset in Swiss vaults for resale, or rent masterworks to not have to insure them. The greater luxury is to build a collection that may not turn a profit, and the greatest, hands down, is helpless acquisition. As art advisor Philippe Ségalot said of François-Henri Pinault: "I've shown him work that he will look at for half an hour, then say, 'There is no choice. How much is this?'

*When you invite
a man to dinner,
never forget that,
during the short
time he is under
your roof, his
happiness is in
your hands*

JEAN ANTHELME BRILLAT-SAVARIN

THE PAMPERED PALATE

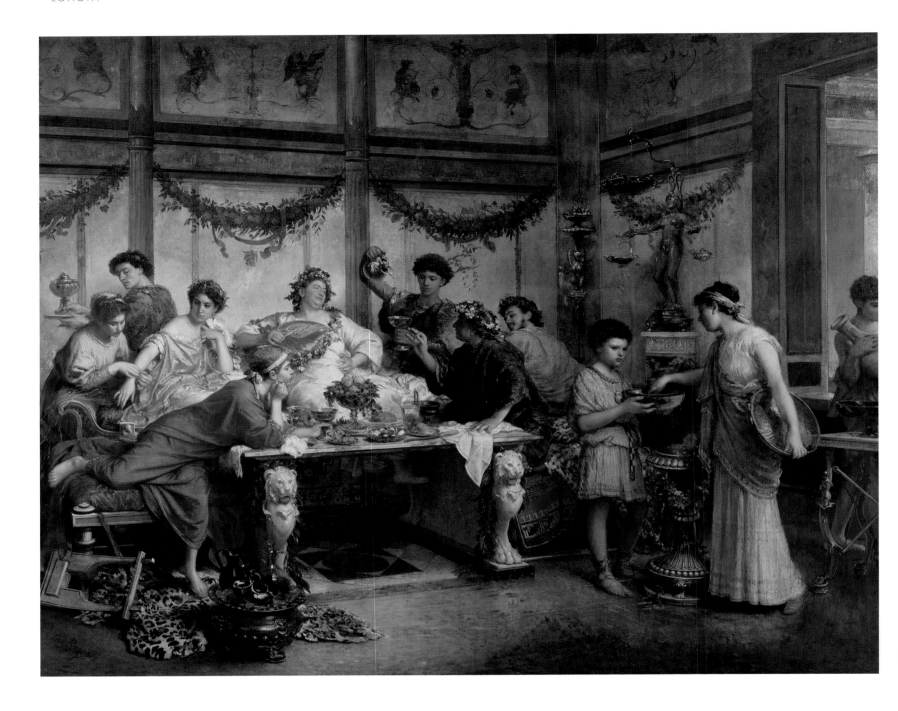

Seducers of the senses and symbols of prosperity, elaborate foods exceed the human need for survival. The Neanderthals enjoyed high-hanging fruits, roasted ibex, and delicacies culled from the sea. Agriculture introduced the luxuries of grapes, olives, stored grains, and (with farm animals) dairy. Clay vessels enabled cooked foods, trade routes delivered spices, and chefs furnished recipes. Imbibing added ritual: "Prince Hsiao Kang longs for longevity," wrote the poet Hsu Ling, "in crystal cups . . . with a jade spoon he mixes the Elixir." By the 5th century BCE, the fully indulged palate had raised taste to discernment, ingestion to gastronomy, victuals to delicacies, and beverage to ambrosia. Even today, a favorite dish betokens ultimate desire—"the luxury of thinking, in the last minute," said chef Éric Ripert, of the prisoner's last meal, "what is essential to yourself."

Early feasting impressed with abundance and reach; the banquets of Darius the Great served up a thousand animals along with sweet water from the mountains transported in silver carafes chilled with snow. Finer dining awaited exotic ingredients. The 4th-century BCE Greek hedonist Archestratus, known for "sailing the known world for the sake of his gaster and the parts beneath it," extolled grapes brought from Naxos, quince from Corinth, fowl from Ephesus, and dates from Phoenicia.

Rome's march to empire added vanities that approached the absurd. Leading the charge, that "most gluttonous gorger" Marcus Gavius Apicius praised the exceptional flavor of flamingo tongue, created a sauce for baked nightingales, and journeyed to Libya in search of an overgrown prawn. Virtually anything that moved, from grasshopper to sea snail, constituted an ingredient. One-upmanship sourced truffles from Africa, rabbit from Spain, pheasant from Greece, and peacock from India. Rivaling recipes stuffed figpeckers into peahen eggs, piglets into boar, and sea urchin into sow udders.

Imported fish was expensive—a 5th-century BCE text notes three days' pay for an eel—and passions ran high. A lover of sturgeon had them brought to the table with a 12-trumpet fanfare, Sergius Orata wept for joy when his eponymous sea bream was served up to him, and Servilius Vatia built a vast mansion outside Naples to live near the breeding ground of the bearded mullet he craved.

Imperial dining verged on lunacy. Domitian hosted in a mock cemetery, served black food, and seated each guest by a gravestone bearing his name. Caligula dissolved pearls in the wine and proffered meat cast of metal. Elagabalus may not, as alleged, have served lentils laced with onyx and depictions of meat stitched on napkins, but well-evidenced were his 22-course menus listing camel heels, mullet beards, ostrich brains, and hummingbird tongues.

Surfeit introduced gluttony—"Vitellius," reported Gibbon, "consumed in mere eating at least six million of our money in about seven months." Refined dining retreated to private estates offering fungi in fish sauce, apricots from Armenia, peaches from Persia, raspberries from Mount Ida, and cherries from trees imported from the conquered Kingdom of Pontus. It was the general in charge there, Lucius Lucullus, who famously rebuked his cook, on being served only three courses on a night with no guests: "Did you not know that tonight Lucullus dines with Lucullus?"

Feasting soldiered to the outer reaches of empire. Feudal barons consumed what the peasants provided and passed the remainder to the vassals. The Gauls, a rough lot, thrived off wild boar and venison. Even the courtly Merovingians, holding King Clovis's passion for plovers' eggs fastidious, sought robust fare—for the elite, farm animals, with beef outranking lamb, and lamb, pork, because the darker the flesh the more effort to produce it. Lean harvests brought famine: "Give us this day our daily

bread" prayed a people subsisting on grain. Catholic edicts reduced meat consumption, and waste was not tolerated.

Late medieval England fed heartily. With no notion as yet of "gourmet," magnificence relied on the spread. In 1243, Sanchia was said to have felt well married to Richard of Cornwall upon viewing the 30,000 dishes Henry III laid out at their wedding. Chaucer chronicled the 14th-century ducal table, when a roast pig cost three times a farmer's daily wages, groaning with meats that called on massive platters and tiered sideboards to display them. Centuries later, while the Flemish table spilled over with delicacies, the Tudors still feasted on haunches of venison roasted on spits rotated by specially bred dogs.

Thank improved navigation and roads for opening the table to cuisine. The chef known as Taillevent set down recipes, and developed party tricks like the *tourte parmerienne* (a sugar castle towered with gilded drumsticks) and a flame-spewing roasted peacock sewn up in its feathers. French pâtissiers perfected the mille-feuille and Dutch fisheries supplied freshwater delicacies (herring so coveted it was transported under armed guard). More critically, Catherine de' Medici introduced the truffle and *sauce béchamel*. So could a 1549 Paris banquet offer 13 capons, 13 partridges, 30 peacocks, 99 pigeons, 99 turtle doves, 156 chickens, 33 goslings, 33 pheasants, 33 herons, 33 ibises, 33 egrets, 9 cranes, 21 swans, 33 ducks, and 30 goats—each bathed in a fancy reduction.

Add seasoning to the luxury list when spices were found to liven dull fare. Only the wealthy could afford cinnamon from Ceylon, ginger from India, or saffron from Persia, extracted at dawn from the fussy purple crocus (4,000 blossoms delivering one ounce). Just as salt had constituted the Roman soldier's salary, pepper, too, served as payment. For the ransom of Rome, the Visigoth Alaric I exacted, along with 28 tons of silver and gold, a punishing 3,000 pounds of it, and King Ethelred II taxed in peppercorns any merchant doing business in London. When a pound of mace exchanged for three sheep, a pound of pepper was said to be worth a man's life.

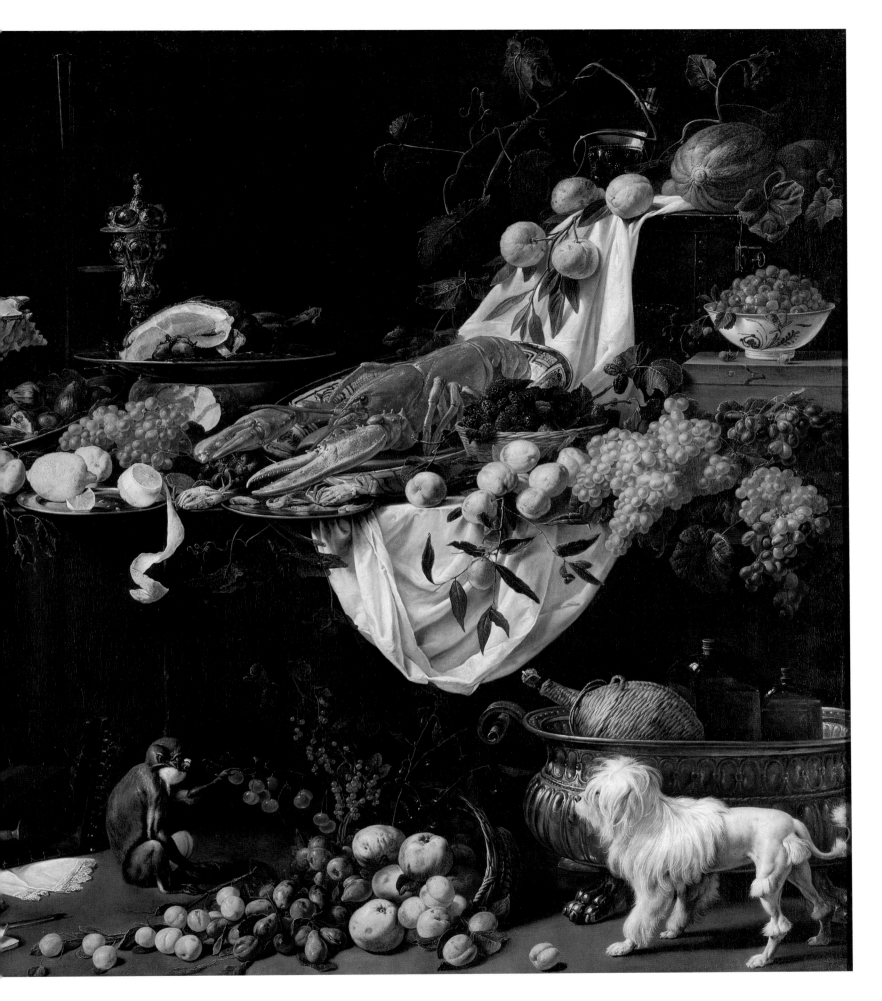

DUTCH TABLE DISPLAY
CODING BURGHER
WEALTH WITH IMPORTED
FOODS, ARTISAN PASTRY,
WINE CHILLED IN COPPER,
MANICURED PETS, AND
MUSICAL INSTRUMENTS.

Spices had been brokered over centuries, but it fell to Muslim traders to make them the first global currency, trekked in on an estimated 24,000 camels yearly. Europe's formidable fleets sourced them forcibly. To control the cloves from Ternate, the Portuguese assassinated its rulers: to secure the monopoly of nutmeg, the Dutch massacred every underage male in the Banda Islands.

Beverage added stimulant. The notion of imbibing together fueled Shang banquets and Dionysian bacchanals. Let abstainers denounce alcohol, there was no shortage of believers in its restorative powers: "When there is abundant wine, sorrow and worry take wing," observed Ovid of Rome's commitment to viticulture.

More bracing liquids sailed in from new worlds. We owe hot chocolate to Mayan cultivation of cacao—the bushes so closely guarded that the Aztecs went to war for them. Brought east by the conquistadors and sweetened with sugar from the Crusades, the libation gave Europe's courts a distinguishing beverage and, to confect it, a "chocolatier."

Coffee traveled from Ethiopia to Yemen and, via a long history of edicts and fatwas, to Versailles, with a bush given Louis XIV that was placed under guard. Taken up by Madame de Pompadour with a silver grinder and porcelain dispensers, the stimulant would have remained a court luxury had England's East India Company's steady imports not given the working class coffee houses—to such

MARY CASSATT'S PORTRAYAL OF THE UPPER-CLASS RITUAL OF AFTERNOON TEA (LIKELY IN HER PARIS SALON) TOOK CARE TO DETAIL THE SILVER AND PORCELAIN.

RIGHT ROMAN SKYPHOS: THE LAPIDARY SKILLS REQUIRED FOR THIS LEVEL OF CAMEO RELIEF RESERVED IT TO THE WEALTHY.

BELOW RIGHT PARTHIAN LION RHYTON: ON A VESSEL USED TO AERATE WINE, A SYMBOL OF BRAVERY RENDERED WITH GILDED SILVER AND GARNETS CONVEYS WEALTH AND STATUS.

BELOW LEFT HAND-RINSING AQUAMANILE: A BARONIAL SIGNIFIER BEFORE THE ADVENT OF DINING UTENSILS.

rousing effect that Charles I banned them. The elite transitioned to tea (one pound costing twice a cook's annual wage) prompting expeditions to Asia, fast ships, steep tariffs—even war. Compounding the luxury, Anna, 7th Duchess of Bedford, introduced the status signifier of afternoon tea, inserted between lunch and dinner to display dainty confections, delicate china, and monogrammed silver.

Precious liquids called on rich vessels. King Rehoboam of Judah quaffed his mighty wines from gold cups; Macedon's Philip II drank from silver rhytons ringed with lynxes; Pericles poured from kraters embellished by Euphronios, and Titus toasted from cameo glass chalices. It spoke to absolute power that Charlemagne imbibed from a solid-gold cup, and Jahingir from goblets cut from emeralds.

Food presentation, too, was pronouncement. King Ashurbanipal dined off gold platters; the Han elite, off glazed stoneware; imperial Korea, off celadon. Evolving mores gave Jeanne de Bourgogne gem-crusted dinner plates; Catherine de Bourbon, enameled bowls; and German nobility, bronze finger-rinsing aquamaniles. Table silver, the most scrutinized aspect of an aristocrat's wealth, marked by weight.

Medieval panache introduced the notion of décor. Charles the Wise commissioned a mechanized silver

centerpiece that enacted in miniature Godefroy de Bouillon sailing off to conquer Jerusalem. Philip the Good livened banquets with a singularly automated *mannequin pis*, and for the 1454 Feast of the Pheasant with a pie that disgorged a working replica of the Château de Lusignan. Renaissance banqueting called on tour de force vermeil. A Venetian ambassador described a "most sumptuous supper" at Hampton Court, with "huge vases of gold and silver," trumpets heralding each course, and "twenty-four dancers, all over covered with cloth of gold." The table at Fontainebleau radiated out from the Cellini saltcellar, and that of the Palazzo Aldobrandini flourished 12 tour de force tazzas, each depicting the life of a Caesar. French puffery commanded such massive gold platters that Louis XIII forbade them, then relented when none heeded, enabling the fated dinner service Nicolas Fouquet laid out for Louis XIV: "Remarkable plate" said the king; "Respectfully, Sire," corrected his host, "it is not plate, it is solid gold." "The Louvre has nothing like it," snapped Louis, and jailed his finance minister for life. Porcelain rivaled. Meissen delivered astonishing services—the 2,200-piece set commissioned by Count Heinrich von Brühl took five years to complete. Middle-class households settled for monogrammed cutlery, enameled beakers, and, for grand occasions, fine glassware— Murano goblets in such demand that glassblowers were retained with titles and land.

As elaborate as the *mise-en-place* was the protocol that codified it. Every advanced culture ritualized dining. The Inca

Emperor Atahualpa selected from a number of dishes and ate from a gold bowl his wives held up as they knelt. The Great Khan hosted banquets from a glittering dais, with his relatives seated at his feet and below them the barons, clad by edict in jeweled robes; at intervals, the lords poured rice mead from gold vats and milk-and-honey from silver fountains, falling to their knees when the emperor chose to drink.

Feudal Europe was mired in ritual, from the seating (above or below the salt) to the vessels and food. Vermeil was reserved to the nobles and exceptional dishes to the sovereign. Service was choreographed. When the Compte d'Amiens asked for wine, relates Gauthier's *La Chevalerie*: "A dozen servants ran to fetch it / Dressed head to foot in ermine / Among the guests a youth from Saint Eventin / Son of the count Palatin Herbert / Seized a golden goblet / Filled with fine spiced wine / And knelt to proffer it to the noble Raoul."

Louis XIV, addressing dining as he did everything else, with stage-managed excess, exacted *service à la française*—a form that overwhelmed function with elaborately penned menus, space between settings measured to the millimeter, and florid presentations. Each meal, from *la fête royale* through five variations of *le grand couvert*, offered eight courses of eight dishes each. The accompanying accoutrements imposed on the table engendered a fustian language of manners called "etiquette" that lined up over six forks and an arsenal of dessert spoons. The monarch's utensils nested in a small silver ship that the courtiers bowed to, whether the king was present or not.

To rival, Frederick the Great raised himself and his retinue on a dais and dined off a table dressed with a silver *milieu-de-table*, voluptuous porcelain tureens, and a conceit of no glasses that called on each guest's assigned server to hold them. At the court of the tsars, the kitchens were so removed that to keep the soup hot it was brought in on the run, entailing a change of livery between courses. Court gatherings ran late. An English collation might drag out until midnight and the Swedish court's *dîner intime* retained staff even later to dress the table and hoist it through the

ceiling. It's a wonder that anybody got fed. The historian Baudrillart details the numbing ritual that overtook Bonaparte's banquets; the Emperor and his entourage were seated at noon, followed by dukes and foreign dignitaries, then judges, lesser titles, the military elite, until finally, near midnight, the lesser officials sat down to the dishes that remained.

Happily, even as court protocol strangled formal dining, *haute cuisine* was reviving it. While France starved, the Sun King consumed at one sitting—along with four soups, pheasant, partridge, mutton, and ham—sundry of Varenne's 60 egg preparations. They arrived cold, but no matter, cooking was now an art, and the cook was a maître. Even as crop failures converted the Tuileries to potato fields, the Prince de Bourbon-Condé regaled *Sa Majesté* with a towering *ambigu* confected from ices and sculpted confectionary. Italy mirrored the disparity: in 1693, when the commoner was reduced to *pane*, pasta, and *fagiole*, Bologna's Senator Francesca Ratta gathered 69 eminents around a 22×60-foot silver centerpiece displaying an edible sculpture flashed with the Ratta coat of arms.

Upper-class consummation was not always enviable. Trace gout, the "disease of kings," to the liquor reserved to royal tables, and the profession of "taster" to food poisoning. Henry I choked on an overspiced lamprey, Clement VII succumbed to the death cap mushroom, and Charles V fell victim to an ill-prepared pie. Nor were the professions of chef and the newly featured maître d'hôtel without peril. In 1671, when François Vatel, superintendent of the prince's kitchens, was charged by the ever-eager Condé to coordinate three meals a day for the king and some 2,000 attendants, the roasts didn't make it to two tables, the fish course didn't make it at all, and Vatel, deeply shamed, threw himself on his sword.

OPPOSITE
SOUTH GERMAN NEF: PRINCELY 17TH-CENTURY TABLE ORNAMENT PURPOSED TO HOLD EATING UTENSILS.

TOP LEFT THE CELLINI SALTCELLAR: "THIS IS A HUNDRED TIMES MORE DIVINE A THING THAN I HAD EVER DREAMED OF," SAID FRANÇOIS I OF THE MODEL, AND HAD IT RENDERED IN GOLD.

TOP RIGHT THE ALDOBRANDINI TAZZA: ONE OF A NONPAREIL SET OF 12 EMBOSSED AND CHASED 16TH-CENTURY VERMEIL STANDING-CUPS DETAILING THE LIVES OF THE CAESARS.

The palate, meanwhile, was refining. Travelers returned with exotic new foods—the pineapple a showpiece—and elaborate recipes that gave dining the pricey new concept of gastronomy. The companion notion of "gourmet" produced culinary innovations that played out at a very high level: the Marquis de Mirabeau devised a choice garnish, Marie Antoinette introduced the croissant, and the Earl of Sandwich, not wishing to leave the gambling table for supper, invented the eponymous snack.

The 19th century brought the art of good eating to a pinnacle of profligacy. Both chef and epicure were now indulged and demanding. The art of *savoir-manger*, introduced by Brillat-Savarin in his seminal *Physiologie du Goût*, bade the world-class gastronome blow a fortune on his palate and deny his kitchen nothing. To wit, the tale of Charles, Prince de Soubise, on learning that his chef had ordered 50 hams for a small gathering: "Bertrand, you are a thief. Surely one is sufficient!" "Indeed not, my lord," protested the maestro, "although only one shall be served, the rest are essential to the coulis that will ennoble it. Grant me the other forty-nine and I will reduce them to an elixir that can be contained in a vial the size of your thumb." The prince acquiesced.

France's top chefs no longer copied a dish: they invented one, dedicated it to an illustrious patron, and guarded the recipe. They gave aristocratic tables chicken Villeroy, leg of lamb à la Mailly, tournedos Châteaubriand, eggs Sévigné, and quail Mirepoix. Their contributions to the Romanov court of Boeuf Stroganoff, Veau Orloff, and Charlotte Russe led Tsar Alexander II to have his own chef, Gouffet, create dishes that launched *cuisine russe*. The divas developed attitude. As had the great Antonin Carême, risen from royal *pâtissier* to service Talleyrand, the Prince Regent, Tsar Alexander I, and, finally, Baron James de Rothschild, they blithely left a rich employ for a richer one and measured a household's standing to its table. Reflected in the polished mahogany must be ormolu candelabra, silver sauceboats, engraved saltcellars, tableware for 12 courses, and a silver wine barge to roll down the center.

Carême's stated formula for Napoleon I's receptions set the bar: "The military trophies, the magnificent drapes, helmets, harps, staged entertainments; our exquisite new pastries, light-as-air tarts, soft-as-butter fruit jellies, cakes laced with jams. And the massive gold platters carrying braised turkeys and glazed hams, and the enormous fish entrées . . . all attest to the magnificence of a person of high rank and that's the effect that should be made by a great feast given by a nobleman committed to spending such a fortune on the luxury of the table." No less impressive, at a time when wealthy Parisians were hosting an average of two dinner parties weekly and a ball every month, were the menus. The one Carême designed for the

What would life be without coffee?

LOUIS XV

JOHN ROSE, THE ROYAL
GARDENER, PRESENTING
A PINEAPPLE TO
CHARLES II: TO GROW A
HOTHOUSE FRUIT VALUED
AT 3,000 POUNDS
EXALTED THE KING AND,
BY EXTENSION, THE
ROYAL GARDENER.

1816 ball given for the Royal Guard by the National Guard of Paris headlined—among the 250 roasts, 160 cold dishes, 250 side dishes, 600 desserts, and 200 platters of confectionary—his famed truffled veal, poularde à la Chevry, Charlotte à la Chantilly, and the sculpted chartreuse. For a military banquet in the Champs-Élysées, the master topped even himself, providing 10,000 revelers with 8,000 turkeys, 9,000 chickens, 1,000 pheasants, 500 hams, countless signature friandises, and 18,000 bottles of Macon.

Such culinary flourish survived the direst times. When the Franco-Prussian War drained the food supply, the noted Paris restaurant, Voisin, offered a repast of stuffed donkey's head, roast camel, kangaroo stew, leg of wolf, and *chat flanqué de rats*.

Only the mores relaxed. Cued by the Russian nobility's informal samovar-collations, the Proustian salon introduced the *buffet*—a casual form of entertaining that left the ladies seated and the gentlemen to forage from a copious spread, hat under arm. Intimacy called on a *souper* of Champagne and the small truffled birds Brillat-Savarin had held "such a luxury as only to be served at the wealthiest tables."

*I do hope you
like the wine.
It's homemade.*

BARONESS LILIANE DE ROTHSCHILD

Presentation remained artful, with animal displays carved from ice and sugar-paste centerpieces prettied with marzipan statuary. France's premier food chroniclers, the Goncourts, once visited the sculptor Emmanuel Frémiet to find him teaching the Rothschilds' maître d'hôtel how to model pastries in clay so that they could do it with dough.

Such auteurship did not resonate to the east, where fine dining involved skill and effort but not signature. Arabia, with its ready access to spices, had no need of celebrity chefs to lavish dining with sensuous sauces and scents, since every wealthy household from Baghdad to Isfahan employed cooks versed in infusions of rose petals and spices. Even for sophisticated Turkish cuisine, few (excepting the famed Sufi, Ates-baz Veli—his tomb still a pilgrimage destination) held celebrity-chef status. Ottoman palace hierarchy assigned the 200 cooks responsible for 4,000 meals daily to basic preparations of meats, fish, greens, and pastry; and 60 nameless chefs to the elaborate dishes tailored for the sultan, his wives, the viziers, and eunuchs, in four separate kitchens. A recipe for the royal table reads like the treasury: "Knead thirty pounds of flour with twenty-three pounds each of oil and sesame. Stuff lambs with meat fried with oil, sesame, ground pistachio, and spices like pepper, ginger, cinnamon, coriander, cardamom, and nutmeg; sprinkle generously with rosewater and musk, then upon them place ten fowl and seventy small birds, filled with eggs, meat, or lime-grape marmalade. Add a number of small pies filled with sugar and sweetmeats. Pile all in a pastry shell, sprinkle with musk, cap with pastry, add more musk and bake." As splendid was the glazed Iznik dinnerware that bore these creations: one example recently auctioned for $691,400.

The notion of cuisine permeated India's courts with subtly flavored regional recipes and class-marking gold leaf. Mughal majesty added ritual. Off-duty, Shah Jahan permitted only family and eunuchs to sit with him, nodded to select from the myriad dishes presented him, and made a production of drinking specially sourced Ganga water. When receiving on his throne, related a traveler, the emperor had it "brought to him on a gold saucer inlaid with gems, in a large, rock crystal cup, the cover of which was gold."

China went to the usual extreme, with the emperor's divine status exacting up to 3,000 dishes featuring choice delicacies—braised pork belly so prized it was rendered in jasper for the imperial collection. Through successive dynasties, even as the poor protested rice shortages, the rich enjoyed status-defining hummingbirds' nests,

shark-fin soup, dried lilies, and powdered bird tongue presented on lavish lacquerware.

Japan, holding collation an art form, drew on calligraphy and flower arranging to ornament *kaiseki*, fare that harmonized hot and cold, mild and spiced, silky and textured. Refinement pinnacled with the tea ceremony, perfected by the great 16th-century master Sen no Rikyū: procure a leaf from a high, foggy mountain before April 5 when the buds have but one leaf attached; brew in spring water over fire fueled by dry branches, and imbibe in a setting displaying a scholar's rock, a fine scroll, a unique bloom.

Pay great attention to the vessel—which clay best infuses the flavor? To the fragrance and implements—which distill the leaf to ambrosia? An artful tea ceremony must raise a utilitarian teapot to a cultural symbol and its presentation to the expression of civilization itself. Such were those offered in the 1930s by a Tokyo businessman whose estate enfolded a hill, forest, stream, and four lovely teahouses. Once a year, friends convened for a ceremony famed for its vessels, the geishas' apparel, and a subtle surprise. At one, fireflies were released from cages at dusk to take the guests' cares into the night; at another, 1,000 tortoises, padded with silk and mounted with candles, wandered through the gardens until dawn.

The least meal in Japan involved thoughtful presentation; foodstuffs were wrapped, bunched, tied, and laid out like landscapes. For business entertaining the price of each dish was announced—the more expensive, the more valued the guest. To this day, to be proffered Kobe beef (fattened on a diet of beer and massaged to the consistency of butter) is to be greatly honored. Missing, as in China, was the concept of auteur. Esteem for a sushi master apart, a collation's colors, textures, and arrangement were all noted but not its creator. Why single out the cook in a culture that holds all presentation an art form and all cooking cuisine?

ABOVE MING LACQUER DISH FOR PAVILION DINING, DETAILING A GARDEN SCENE WITH MOTHER-OF-PEARL.

RIGHT MOMOYAMA SAKE EWER: LACQUERED IN THE ORNATE KODAIJI-STYLE ORDERED BY WARLORD TOYOTOMI HIDEYOSHI TO REPLACE COURT TEA-MASTER SEN NO RIKYŪ'S SPARE AESTHETIC.

No such subtlety manifested across the Pacific, where Gilded Age dining had grown ever more gilded. Rough riders who had so recently lassoed their dinner were gathered to the tables of mavens whose efforts ranged from remarkable to ridiculous. Chicago's Mrs. Potter Palmer set the tone with a gold service for fifty. Newport looked to Mrs. Elbridge Gerry for her ten-course menus penned in French, monogrammed serviettes, and periwigged footman at each chair. Favor topped favor, inclining the old guard, on hearing that guests were receiving gold cigarette cases, to show up. The food, if abundant, was incidental, and of no interest at all was the intrusion on the barely acceptable buffet of packaged ingredients like Van Camp's Pork and Beans, launched the year after Auguste Escoffier had created the *Pêche Melba* at London's Savoy Hotel.

Imbibing, if paramount, was basic. What interest Colonial America had developed in taverns that doubled as town halls was for spirits, often distilled in a bathtub. Thomas Jefferson's private purse stoked White House gatherings with 20,000 bottles of French wine, but few could distinguish between labels. A century later, industrial barons railed west in their parlor cars to Mrs. Adolph Spreckels's high teas, noted for the silver teapot that dispensed a superior Ceylon neatly watered with gin. Leaving immigrant workers to brass-rail saloons, they stopped off at well-appointed establishments frothed with a pipe organ or, as at Erikson's in Portland, Oregon, a ladies' orchestra guarded by an electrically charged railing.

It was to attract international celebrities that America's hotels first featured cuisine. Chicago's swank Palmer House regaled Caruso, Kipling, and the Prince of Siam with pronghorn antelope and boned-quail-in-plumage. Foreigners frequenting San Francisco's Palace Hotel were amazed to encounter their native dishes.

Refrigeration introduced the luxury of perishables—plovers' eggs from Scotland, caviar from the Caspian Sea, and the yearlong summer fruits that prompted comedian Fanny Brice's famous line, "Order me anything out of season!" Every January, Count Pierre Apraxine descended upon the Hôtel de Paris, had 12 ripe strawberries sent to his suite at a cost of 12 francs apiece, crushed them with a fork to inhale their aroma, and returned them uneaten.

Not for long. World War I embargoed exotic comestibles and Prohibition sent spirits to speakeasies. In Europe, only grand establishments like Blenheim still seated five-course banquets, and only the wealthiest households kept a chef. A handful of fine restaurants soldiered on. The London Ritz still offered Escoffier's *darne de saumon Lucullus*—its recipe become legend ("skin one side of the fish, lard with truffles, and braise in Champagne")—while culinary excellence remained as crucial to French pride as the flag. At the Deauville Casino, Prince Alfonso of Spain and the kings of Portugal, Denmark, and Sweden convened for a wine-fueled collation of

If I can't have too many truffles, I'll do without truffles

COLETTE

caviar, oyster consommé, stuffed quail, pâté, and a bombe glacée, whose cost, though a fraction of that for Napoleon III's smallest suppers, totaled an impressive 400 gold francs. In Paris, while Germany's newly poor were trading pianos for eggs, those dining with Baron Édouard de Rothschild were enjoying two soup dishes followed by fish, game, cold meats, a salad, two desserts, cheese, fruit, and accompanying cuvées.

A Grand Cru was held a national treasure and Champagne a world wonder. Tsar Alexander had said of Veuve Clicquot 1811 that he would drink nothing else, and Count Otto von Bismarck disclosed that he had mapped his invasion of France to spare the great resource: "Gentlemen, patriotism stops at Champagne!"

The Second World War rationed food but not Europe's gilded *mise-en-place*. The day's must was Asprey's 18-karat gold twig for rating caviar. Emanuel Nobel themed a Russian banquet around Fabergé icicles and Aristotle Onassis slipped gold favors into the dinner napkins. The palate, too, was indulged. Extravagant, the effort given a new dish: the food writer Robert Courtine described weeks in Lasserre's kitchens devoted to perfecting *poularde au tilleul*.

The only excess not encouraged was gourmandise, the unbridled appetite that saw bon vivant Honoré de Balzac, the night that he dined at Véry with the publisher Werdet, down 100 Ostend oysters, Sole Véronique, 12 lamb chops, duckling with turnips, a brace of roast partridge, several entremets, and a fruit plate—hand Werdet the bill, and head off for a nightcap. The day the *New York World* headlined the cost of sirloin and pork as "Prices That Stagger Humanity," Diamond Jim Brady allegedly consumed at one sitting two servings of Sole Marguery, three dozen oysters, turtle soup, deviled crabs, a clutch of lobsters, a brace of fowl, a joint of beef, a 12-egg soufflé, and several slices of pie. "Whenever I sit down to a meal," he would say, "I always make a point to leave just four inches between my stummick and the edge of the table. And then, when I can feel 'em rubbin' together pretty hard, I know I've had enough."

Brady's dailies thrived on the excess, reporting breathlessly on William Hearst's impromptu four-chef picnics in the hills of San Simeon; on Mahomed Aga Khan's move from Venice's Grand Hotel to the Bauer so he could access the new Harry's Bar without crossing a bridge; on the Monte Carlo dinners Arturo López-Willshaw hosted aboard *La Gaviota*, which berthed two chefs, because "if I had only a French chef, my English crew would go on a hunger strike, and without a French chef *I* will die."

All the geniuses of the age are employed in designing new plans for desserts

HORACE WALPOLE

Remarkably, while glossy magazines touted the new wonders of sleek stoves and countertops, none in society cooked: Emily Post wrote her bestselling cookbook without ever setting foot in the kitchen. It did not help that the three-martini lunch produced health concerns. Waverley Root's dismissal of his doctor's injunction against buttery sauces had hastened the food critic's demise; determinist Julien Offray de La Mettrie met his end ingesting an entire truffled pâté; Khedive Isma'il Pasha breathed his last while trying to down two bottles of Champagne in one draft; and King Farouk, having dined on three dozen oysters followed by lobsters and lamb, exited this life from Rome's Ile de France restaurant wrapped in an Aubusson.

Like most latter-day intemperance, gourmandise went into remission. Known as the "Dior look," the thin silhouette of the 1950s championed a waist achieved by renouncing everything succulent. Strictures eased but temperance didn't. Social arbiter Amy Vanderbilt proposed the "ideal repast" as the American picnic, consisting of ham sandwiches, fried chicken, potato salad, loaf cake, peaches, and cherries. Happily, food arbiter James Beard reinstated delectation with his "Rich, Elegant Picnic for 10," listing Champagne, caviar, double consommé, chaud-froid chicken, baked ham-in-crust, tiny French rolls, frozen raspberry mousse, small cakes, and a demitasse. In 1975, when *New York Times* critic Craig Claiborne headlined a superior collation, courtesy of American Express, "Just a Quiet Dinner for Two in Paris: 31 dishes, Nine Wines, a $4,000 check," the Vatican labeled it "scandalous."

Regalement was restored with four-hour tasting menus, exotic ingredients, and tour-de-main food architecture. Chef Thomas Keller convoked diners to his Napa Valley French Laundry for lengthy presentations of veloutés, reductions, coulis, and fendants. London confectioners Bompas & Parr built jelly desserts into structures taking two weeks to mold. The table kept pace. The solid-gold Getty dinner service brightened Sutton Place entertainments, gilded Bernardaud tableware glittered super-yacht dining, and silver chargers engraved with the guests' names rang in party planner Colin Cowie's five-course millennium dinner for twelve.

Subsequent belt-tightening cut staff but not lust; the appetite for bluefin tuna that sent it to $75 a pound and, for pangolin, twice that, marked both for extinction. In Vietnam, where illegal meats constitute a great luxury, a newly prosperous middle class descended on Ho Chi Minh City's Thien Vuong Tuu for bear, bat, porcupine, and an endangered species of turtle. Meanwhile, in America, ecological concerns had refined a new palate. With beluga sturgeon fished out, indulgence shifted from

caviar to connoisseurship. Foodies committed to "buy local" sought out curated mushrooms, artisanal meats, and comestibles meeting the expectation of excellence that graded chocolate like fine wine and offered 220 varieties of cheese at their peak. Markets that stocked 5,000 items in 1945 now listed 40,000. Tomatoes were harvested at a precise time of day, olive oil invited tastings, mineral waters were rated, and ice was shaped, shaved, and presented as a delicacy. Bespoke coffee was delivered by a $20,000 "siphon bar" from Japan that brewed a "single origin, direct trade, or micro lot" bean whose flavor was released by a specially shaped paddle.

At his eponymous restaurant, chef Pierre Gagnaire created a *cuisine surprise* from edible twigs. At El Bulli in Catalonia, Ferran Adrià pioneered "molecular gastronomy" with 30-course "conceptual tastings" of preserved tuna-oil air, sous vide snails, spherical olives, liquid-nitrogen-foamed legumes, yogurt globules, and cooked egg-and-bacon ice cream. At Noma in Copenhagen, René Redzepi prepared cod's head with dips made from such delectables as wood ants. In New York, a *confrérie* of celebrity chefs feasted yearly on ortolons culled from the black market at $190 apiece. Michelin-starred chef Jean Coussau, for one, was unrepentant: "We could survive on nutritional pills if we had to. But if we go down that path, the notion of pleasure will disappear."

A BOMPAS & PARR
GLOW-IN-THE-DARK
JELLY DESSERT.

Venus herself as she drops her garments . . . leaves behind her on the floor every weapon in her armory by which she can pierce to the grosser passions of men

GEORGE DU MAURIER

RICH ALLIANCE

At its purest, love's luxury is free choice—its motive, guileless; its indulgence, helpless passion. The gainful agenda, in contrast, called on Cupid's full quiver of luxury. Romance was warming, but brokered nuptials opened worlds. At the least, a shrewd alliance supplied pretty things and pleasant days, while a brilliant one filled coffers, produced heirs, and shaped history.

The wrong arrow might misfire. Offered marriage to the daughter of Babylon's king in exchange for "gold in abundance," Amenhotep III, already steeped in gold, declined. To ally Alexander the Great, Darius III proffered a third of his empire and the hand of his daughter: "If I were Alexander, I'd accept," urged his general, Pausanias: "As would I, were I Pausanias," retorted Alexander, who wed happily elsewhere and opened his victorious campaign against Persia with a strategic mass wedding of Persian women and Greek warriors.

Surer aim empowered. Alexander's father, Philip ll, commanded the day's greatest army but grew the empire more expediently through his six foreign wives. The Jutes exacted a large slice of England from King Vortigern for the hand of Rowena: Eleanor of Aquitaine deeded Henry Plantagenet a big chunk of France. It was said of the Habsburgs: "Other nations go to war; happy Austria conquers through marriage." So did Mary of Burgundy bring Habsburg Maximilian I the wealth of the Netherlands, and so did their son Philip's marriage to the daughter of Ferdinand II of Aragon and Isabella of Castile produce Holy Roman Emperors Charles V and Ferdinand I, whose scions' alliances, in turn, attached half the continent and kept the Habsburgs in power for 400 years. Likewise, the Hesses, although minor nobility, brokered dowries replete with gilded coaches, 500-piece sets from Sèvres, and suites of Jugendstil furniture, into alliance with virtually every royal family of Europe. They were matched by the Medicis, who produced two future queens and solved a shortage of suitors for the daughter of Doge Vitale II Michiel by having a nephew released from a monastery long enough to sire 13 princely heirs.

The English excelled at the game. Marriage to Catherine of Portugal brought Charles II sugar, mahogany, the Seven Islands of Bombay, and the port of Tangier; George III handed sister Caroline to Denmark's Crown Prince Christian in exchange for shipping rights in the Baltic; and Thomas Grosvenor parlayed his wife's dowry of 430 acres in central London into a dukedom and the realm's largest fortune.

CHAPTER OPENER
THE KISS (LOVERS): PORTRAYING ARDOR IN A FIELD OF GOLDEN FLOWERS ELEVATED GUSTAV KLIMT'S REPUTATION AS A WOMANIZER TO THAT OF A PASSIONATE LOVER.

None, though, not even the astute marriages of Queen Victoria's five daughters, outpowered the web woven by the polygamous potentates of the East. Well into our time, the marriage of Princess Fawzia of Egypt to the Shah of Iran united two great Muslim lands, while King Ibn Saud's 45 sons from his multiple marriages took Saudi reach global.

Across cultures, a politically charged alliance was an expensive affair, exacting a rich dowry from the bride, a "bride price" from the groom, and nuptials reflecting their status. Outlay began with the courtship. Amenophis III wooed Gilukhipha, daughter of 14th-century BCE Mittani king Shuttarna II, with gifts of rubies, Chinese silks, trained horses, and slaves. Medieval Europe's negotiations of the import that pledged Anne of Bohemia to England's Richard II entailed gifts at the level of the three cities Charles the Bold bestowed on Margaret of York.

Most welcome were dowries that could be turned into cash. Florentine hope chests transferred so much treasure as to provoke sumptuary laws. Lucrezia Borgia came to Alfonso d'Este with 20,000 ducats worth of jewels sewn to her gown, and the fortune that Anna Maria Salviati, Italy's richest heiress, funneled to Prince Marcantonio III Borghese funded a magnificent art collection. More was exchanged for a crown. Catherine de' Medici promised France extensive land deeds, and to wed Marie Antoinette to Louis XVI the generally frugal Empress Maria Theresa pledged the equivalent of a grandee's annual income. It was, however, expected of all classes to come well endowed. The 800 working girls Louis XIV relied on to populate New Orleans had been sent off with substantial dowries. The gentlewoman's trousseau had to hold enough monogrammed bed linens to last through to laundry day, while the noblewoman entered marriage with a virtual emporium. To richly represent the great House of Spencer, Georgiana brought to her union with the 5th Duke of Devonshire multiple morning dresses, walking dresses, riding habits, visiting dresses, court dresses, ball gowns, hats, cloaks, wraps, shawls, 48 pair of stockings, 65 pair of shoes, 26 pair of gloves, and a trunkful of underclothes.

The contract locked in, the world must be told. A spectacular water carousel announced the alliance of Cosimo II de' Medici and Maria Maddalena of Austria. The purse opened wider for the wedding day. The treasure that Babur's sister Khanzada brought Uzbek Shaybani Khan was displayed in gold-tiled pavilions and distributed to the court, one roomful a day. To celebrate

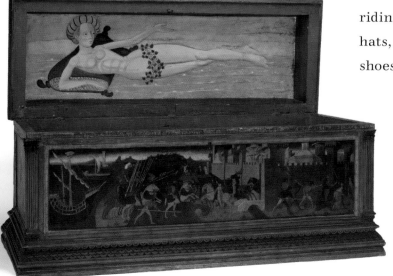

ONE OF THE RICHLY ORNAMENTED *CASSONE* (THIS ONE BY PAOLO UCCELLO) THAT PARADED BRIDAL DOWRIES THROUGH FLORENCE TO ANNOUNCE A POWERFUL UNION.

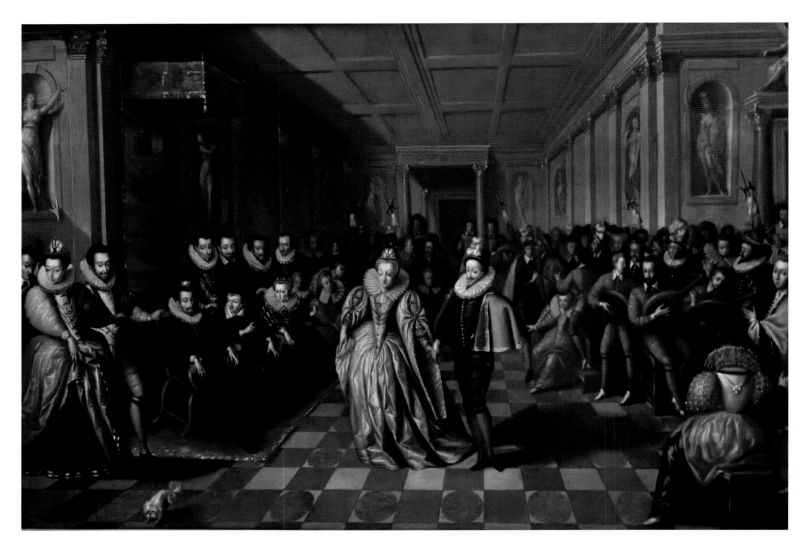

the marriage at Edina of Mehmed IV's daughter, Hatice, to Muhasip Mustafa Paşa, houses were leveled to widen the streets for 200 slaves to pull floats of acrobats, dancers, and musicians performing under colossal silver-leafed trees.

The point, throughout history, was to manifest enough reach to sear the collective memory. It spoke to consummate wealth that each of the hundreds of celebrants attending the nuptials of Alexander the Great received a gold vessel, and that the Frankish Prince Sigismer was wed in a "flamboyance of purple, a dazzle of gold, an eclipse of white satin." Thus did the Duke of Buckingham, sent by Charles I to marry by proxy Henrietta Maria of France, think to pulverize the Bourbons with a wardrobe of 27 silk suits laced with silver, two banquet suits laced with gold, and a gray velvet coat covered in pearls—had not the Dauphin pulled rank with a black-velvet outfit sewn with the crown jewels. All knew that the cost of the equestrian ballet that announced the betrothal of Anne of Austria to Louis XII had exceeded the archbishopric's annual income. And all heard of the Duc de Joyeuse's lavish wedding celebration: "Nothing in memory was more sumptuous," reported Pierre de L'Estoile of the unprecedented 1,200,000 écus poured on a cavalcade featuring illuminations and grand tableaux of sea creatures—not to speak of the jeweled wedding robes and 27 outfit changes asked of the court for the attendant ball and tournaments. What would the chronicler have made of the gift-laden procession attending the marriage of Poland's Jan Zamoyski to Griselda Báthory? An elephant

BALL GIVEN FOR THE MARRIAGE OF ANNE, DUC DE JOYEUSE, AND MARGUERITE DE VAUDÉMONT: THE ALLIANCE'S IMPORT CONVEYED BY THE RUFFS, JEWELS, SATINS, MARBLED HALL, AND ATTENDANCE (AT LEFT) OF CATHERINE DE' MEDICI AND HENRI III.

WEDDING PROCESSION
OF DARA SHIKOH:
BEHIND HIM HIS FATHER,
SHAH JAHAN, AND
ATTENDANTS BEARING
GIFTS, THE PRINCE FILES
THROUGH AGRA TO
MARRY NADIRA BEGUM.

carrying a tower spewing fireworks! Wedding gifts showcased on glistening floats representing War, Sun, Moon, and Venus! "An extravagance in matters of taste both material and psychological," sniffed another diarist about the royal couple's "obvious delight in the display and acquisition of valuable objects." Better received was the blowout marking Frederick V of the Palatinate's marriage to Elizabeth Stuart—a week of hunting parties and balls climaxed by a defilé through gardens planted overnight to view a staging of *The Tempest* directed by Shakespeare himself.

Wedding fever peaked in India, emptying coffers across time and class. Shah Jahan's sister had paid out of pocket to splendidly marry her nephew, Prince Dara Shikoh, to Princess Nadira Begum, but when more was at stake, the people bore the brunt. In 1939, the marriage of Cooch Behar's Gayatri Devi to Sawai Man Singh II of Jaipur swallowed half the state's annual revenue: nonetheless, all rejoiced. In 1970, when a worker's annual income equaled the hotel charge for a bottle of Champagne, the $8 million, six-day wedding of Crown Prince Birendra and Aishwarya Laxmi Devi Shah with its 50 costumed elephants, 10 bands, and 500 bearers proffering delicacies, almost bankrupted Nepal: and still, 500,000 Himalayans came to cheer. Ever paramount was the belief that the splendor signing majesty conferred blessings on the entire community.

The same held true, across cultures, for virtuoso commissions. The gold-threaded tapestry displayed in the street for Charles the Bold's grandstand wedding; *Eurydice* (the world's first opera) composed for the union of Henri IV and Marie de' Medici; and the Service de l'Empereur ordered from Sèvres for the wedding breakfast of Napoleon and Marie Louise, were exorbitant but supported the guilds. Enriching, too, were the exclamatory jewels launched by the first recorded diamond engagement ring—a pavé "M" given Mary by the future Maximilian I. Napoleon

*Love is like any other luxury. You have
no right to it unless you can afford it.*

ANTHONY TROLLOPE

OPPOSITE CONSUELO
VANDERBILT, ARRAYED
FOR HER ASCENSION
TO THE DUCHESS
OF MARLBOROUGH
IN A CORONET
BY BOUCHERON
AND PEARLS ONCE
BELONGING TO
CATHERINE THE GREAT.

BELOW BEDROOM OF THE
SAGREDO PALACE: THE
ROCOCO FLOURISH
OF HERALDRY AND
CUPIDS CROWNING
THE MARRIAGE BED
WED EROS TO STATUS.

Bonaparte sweetened the marriage of niece Stéphanie de Beaumarchais to the Duke of Baden with a mega-carat necklace from Chaumet. Princess Farah Diba exchanged vows with Shah Mohammad Reza Pahlavi under a dazzling two-kilo tiara from Harry Winston. Thought of as patrimony, they entered the state treasury, thenceforth only on loan to recipient and heirs.

The only factor neglected was Cupid. Until women joined the workforce, dependent girls were "placed" and rich ones fed to titles. Between 1870 and 1914, 454 American heiresses rescued Europe's national heritage. Collis P. Huntington's daughter transitioned to Princess von Hatzfeldt-Wildenburg with a dowry of $2 million in cash ($85 million today). Jennie Jerome eased the life of Lord Randolph Churchill with $50,000 upfront and a handsome yearly allowance. Vivien Gould revived the 5th Lord Decies with a stash of cash, a trousseau fashioned by 200 seamstresses, and a thousand-dollar wedding cake iced with the baron's coat of arms. Most famously, her mother's resolution to "produce me as a finished specimen framed in

a perfect setting" betrothed the supremely rich Consuelo Vanderbilt to the financially strapped 9th Duke of Marlborough with $2.5 million of railroad stock, a $100,000 annual stipend for each, and five roomfuls of bridal gifts. The bride herself was packed off to misery in a diamond tiara and the pearls of Catherine the Great.

Nuptials remained the ultimate potlatch. The gift-display at the Anne McDonnell-Henry Ford II wedding was assigned 16 guards, William Astor brokered son Waldorf's marriage to Nancy Langhorne with a tiara nesting the fabled "Sancy," and Anna Gould's ill-fated marriage to spendthrift Count Boniface de Castellane brought him a 200-diamond chain and $12 million in cash to subsidize his taste for bibelots from the Rue de la Paix—until Anna left him, for the Prince of Sagan.

Expectations had grown as big as the Ritz, or "the size of an egg," as Cartier captioned the matchless emerald (now in

THE JEWISH BRIDE,
ALBEIT DEPICTING
BURGHER LUXURY,
REMBRANDT VON RIJN'S
TESTAMENT TO THE
LOVE BETWEEN REBECCA
AND ISAAC REDUCED
VAN GOGH TO TEARS.

the Smithsonian) that Clarence Mackay handed opera singer Anna Case on their
wedding day. To romance the diva Ganna Walska, industrialist Harold McCormick
had 3,000 daffodils planted overnight outside her country château (which didn't
do it) and 100 McCormick reapers deposited on the lawn the next day (which did).
Eva Cromwell's marriage to Philadelphia banker Edward Stotesbury, "the most
profitable transaction I have ever completed," harvested two long ropes of pearls, a
diamond tiara, and $3 million in cash. On marrying August Belmont II, Eleanor
Robson traded her two-bedroom house for three mansions, each staffed by "sixteen
servants for indoor housekeeping, four men in the garage, three in the stables, and
several gardeners." Most famously, Elizabeth Taylor played out fourth husband Eddie
Fisher's assertion that a $50,000 diamond could keep her happy for four days by
raking in enough marital jewels from her fifth to warrant a book: foremost among
them, the King of Spain's "La Peregrina," which sold, after the star herself became
royalty, for a world-record $11.8 million.

Beauty is as beauty goes but status is forever. A "thoroughbred" could give a man
of substance international standing. Aristotle Onassis contracted an offer to Jackie
Kennedy of a $38,000 monthly allowance plus $10 million for each year of marriage
and $100 million more if they were still married at his death: should she leave him,
he had the Greek inheritance law rewritten to reduce her expectations to an annual
$250,000. Lucky the man whose spouse kept her side of the bargain! So could banking
baron Thomas Loel Guinness say of the trophy wife who smoothed his existence:
"I have houses in Acapulco, Normandy, Lausanne, and Paris. I have a yacht and a
plane, and because of Gloria I never have to worry about any of it."

What, then, did love have to do with it? Happily, a great deal. Many were the warm portraits and frilled marriage beds attesting to a blissful union. And generous have been the tokens of love. There was no finer testament to Flemish weaving than the *Allegory of Love*, and no richer example of German carving than on Renaissance love chests inscribed "path to my beloved," "declaration of love," and "exchange of kisses." Young passion wooed with painted fans, lacy handkerchiefs, jeweled combs, and wait-listed Castel Durante caskets holding bonbons and a brooch.

Through the ages it befell even the lofty to dote on a spouse. Nebuchadnezzar II put out royally for gardens to ease his wife's longing for her homeland. Seville's Abbadid ruler Al-Mu'tamid met his wife's nostalgia for snow by planting almond trees to whiten the hills with their petals every spring. Shah Jahan regaled his beloved wife, Mumtaz Mahal, with the three-inch-long "Pearl of Asia," a tendriled palace, and, in her memory, the carte-blanche Taj Mahal, which brought him to tears when the cost came in too low. Romanov ardor sustained Fabergé with the "Surprise" Imperial Eggs, each a year's labor, commissioned by Tsar Alexander III for the tsarina—an extravagance echoed by Nicholas II to convey his love to Alexandra. Corsican passion had Compiègne re-landscaped overnight to allay Empress Marie Louise's longing for Austria's open spaces. English sentiment inclined the blind King George V of Hanover to give his German queen a castle in Marienburg that he would never see; moved John Christie to answer his wife's wish for an opera annex with the glory of Glyndebourne; and led the eccentric surrealist-arts patron, Edward James, to win dancer Tilly Losch by founding a ballet company for her directed by George Balanchine.

Even America's ruthless barons opened their hearts to richly warm those of their mates. It was for his wife, not his standing, that circus magnate John Ringling

ABOVE GLYNDEBOURNE: THE INTIMATE OPERA THEATER, ENLARGED FROM THE ORGAN ROOM, THAT JOHN CHRISTIE CREATED FOR HIS BRIDE, THE SOPRANO AUDREY MILDMAY.

RIGHT THE FABERGÉ ROSE TRELLIS EGG: GIFTED BY NICHOLAS II TO ALEXANDRA FEODOROVNA TO COMMEMORATE THE BIRTH OF THEIR SON, IT OPENS TO THE "SURPRISE" OF A DIAMOND NECKLACE AND AN IVORY MINIATURE OF THE TSAREVICH.

175

gave the Saratoga shoreline a 30-room replica of the Doge's Palace in Venice. It was to keep the promise to his bride to give her, when he made good, "the best house in the world," that Nevada uranium king Charles A. Steen built a $12 million castle (dubbed "Steen's Folly" after a downturn returned them to eating beans from a can). Infrastructure won pharmacy heir John Seward Johnson three wives; a castle for the first, a sprawling farmhouse for the second, and for Barbara, 47 years his junior, the magnificent Jasna Polana—a $25 million, hand-cut stone palace near Princeton, whose indoor tennis courts, heated floors, orchid house, and $60 million décor eased her widowhood. Greater was the gesture of engineer Lynn Atkinson, who

PRAXITELES EXCHANGING HIS FAMED *CUPID* FOR ONE NIGHT WITH PHRYNE.

had secretly, over three years, built a lavish Bel Air mansion for his wife, drove her there when it was finished on the pretext of a party, and when she remarked on its vulgarity, said, "We don't have to go," turned the car around, and put it up for sale the next day.

Eros courted differently. To warm blood chilled by an expedient marriage, custom accommodated the seraglio, the concubine, the courtesan, and the mistress—all ruinous. The pure heart may be won with a rose, but the jaded expect more. Heady was the passion igniting the Kama Sutra, but high-profile seduction entailed pricier wiles. Judith beguiled Holofernes with gold bangles. Cleopatra ensnared Mark Antony with incense, harps, and love notes etched on black onyx. In China, women stirred sexual excitement with small fans; in India, with the jingle of gold anklets or with, as disclosed by the inventory of a dowager queen of Gwalior, an emerald lingam. Western inducement was equally explicit. Philip of Burgundy, Philip IV of Spain, and not a few popes, fleshed out private apartments with carnal depictions, and nude statuary was priced according to how much was revealed. Fans, watches, and

FRANÇOISE-ATHÉNAÏS DE ROCHECHOUART DE MORTEMART, AKA MADAME DE MONTESPAN: LOUIS XIV'S COSSETED MAÎTRESSE-EN-TITRE, WITH FOUR OF THEIR SEVEN CHILDREN.

tabatières opened to naughtiness, and each erogenous zone—throat, waist, shoulder, ankle, wrist, bosom, rump—called on a revealing garment or astutely placed jewel.

History records the cost to the besotted—those who fell hopelessly or serially in love. Offered any work in Praxiteles's studio in payment for her favors, Phryne had her servant tell him the studio was on fire and, told he had asked if the *Cupid* was safe, knew which to ask for. That Julius Caesar gave his mistress Servilia a pearl worth six million sesterces inflamed Suetonius: "The spoils of nations in an ear changed to the treasures of a shell." Lorenzo de' Medici shocked Florence by staging a tournament in his mistress's honor. Reckless, too, for the well-married Charles d'Orléans to have his latest infatuation—"Madame, je suis tout joyeux"—spelled out in pearls on his sleeve; for a giddy Sir Walter Raleigh to etch the queen's name on a windowpane with his diamond ring; for General Berthier to bestow on his mistress the exceptional diamond that Bonaparte had given him for his nest egg; and for Edward VIII to forfeit the throne for the divorcée he so loved.

More acceptable was the spoiling afforded a *maîtresse en titre*—an acknowleged gift from rulers to themselves for enduring arranged marriages that bored them. Whether plucked from the streets or the court, royal inamorata were subsidized by the treasury and tolerated by the nation until tossed out by the king. Favorites were greatly spoiled, enjoying the same consummate luxuries of ostrich plumes and embroidered mouchoirs as the queen. To the humiliation of Catherine, Henri II poured on Diane de Poitiers a vast quantity of jewels and had their entwined initials carved over Chenonceau's doorways. On the occasion of his entry into Paris, the very much married Henri IV bade Gabrielle d'Estrées ride before him "in a gorgeous litter so bejeweled with pearls and gems that she paled the light of the escorting torches." At her death he wore mourning—unprecedented for a mistress—and accorded her a queen's funeral. Henry VIII's same *droit du roi* made Catherine of Aragon cede crown and jewelry to the nubile Anne Boleyn, not incidentally imposing a new religion on the realm. Louis XIV went full out. His notion that "kings should enjoy giving pleasure" arranged a fabulous fête for Louise de la Vallière and wooed each

ABOVE LEFT PALAZZO CA' D'ORO: 15TH-CENTURY GRAND CANAL GILDED SHOWPIECE BOUGHT BY PRINCE ALEXANDER TROUBETSKOY TO GIFT TO HIS MISTRESS (WHO ALREADY OWNED THREE).

ABOVE RIGHT CHÂTEAU DE CHENONCEAU: GIFTED BY HENRI II TO DIANE DE POITIERS "IN FULL RIGHT OF OWNERSHIP" BUT RECLAIMED BY THE QUEEN AT HIS DEATH.

successor with a dedicated addition to Versailles's gardens. Françoise-Athénaïs de Rochechouart de Mortemart, aka La Montespan and mother of seven of the king's children, was unstintingly indulged: a duke's daughter, habituated to trysts with her royal lover in the Grand Trianon, she dismissed the lovely palace offered for her retirement as fit only for "a chorus girl" and commanded instead the far grander Clagny. Yet as long as La Montespan aroused him (it was she who introduced the negligée and eroticized the shoe), the Sun King funded her predilection for Gobelins tapestries, theatricals by Racine, and the 8,000 daffodils she had planted every spring, instructing his minister of finance, Colbert, to "continue to do whatever Madame de Montespan wants."

Plus ça change! Prince Alexander Troubetzkoy wooed the famed ballerina Marie Taglioni with the gift of the lovely palazzo Ca' d'Oro ("*si jolie!*"). Napoleon III seduced Marguerite Bellanger with a sumptuous villa—"The splendid tapestries! The elegant furniture! I especially remember a little room the emperor called his "Buen Retiro"; it was mirrored and paneled and exquisitely painted with flowers, fruit, and little gold cupids entwined in the branches. . . . The moment I entered this boudoir, I succumbed." Less happily, at the Tuileries Ball of 1863, the nubile Virginia Oldoini, aka Countess of Castiglione, danced as Salome before the emperor wearing only a veil, and was asked by the empress to leave.

Shame wasn't a factor. Retainers strayed openly and many an abbey accommodated loosely sequestered adherents. In her second career as the Abbess of Maubuisson, Princess Louise Hollandine bore 14 bastard children. Most notoriously, the storied Royaumont Abbey founded by Blanche de Castile harbored three princesses who had been impregnated, it was said, by the king.

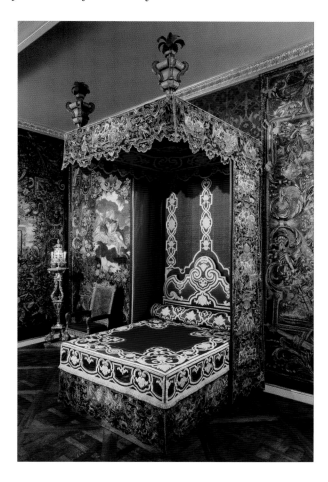

For the lowborn, pleasuring powerful men was a shrewd career move. Helena, the canonized mother of Emperor Constantine, had been a servant, Empress Theodora had started out as a belly dancer, and both Harun al-Rashid's mother and wife had been slaves. After giving Suleiman a son, the slave Roxelana was promoted to chief wife and accorded her own slaves, apartments, and, eventually, freedom.

Europe's rulers raised favorites just as high. A commoner of uncertain parentage, Jeanne

BED HANGINGS EMBROIDERED FOR THE PRIVATE APARTMENT AT VERSAILLES WHERE MADAME DE MONTESPAN RECEIVED LOUIS XIV.

Antoinette Poisson, aka Madame de Pompadour, who during her 19 years in favor dropped a stunning 36.5 million livres on amusing Louis XV, in turn charmed him into a lifetime of jewels, gowns, castles, and so much of everything from the purveyors she promoted that at her death the contents of Bellevue Castle alone took a full year to inventory. When Louis turned his attention to a 22-year-old milliner's apprentice, Jeanne du Barry, she was equally spoiled, though he died before Boehmer and Bassenge delivered the $15 million necklace commissioned "to surpass all others." Love won out in the end; after the perilous scheme that ensnared Marie Antoinette, the diamonds ended up on the décolletés of the Duchesses of Sutherland and Dorset, and the tassel on the lap of Lillian Russell.

Most remarkably, Catherine I embarked on her grand life as an illiterate peasant, was sold to Alexander Menshikov, and passed on to Peter the Great. In turn, Catherine II elevated her lovers. At a time when 1,000 rubles bought a serf freedom, Ivan Korsakov was given 150,000 rubles worth of diamonds; Alexander Vasilchikov received 7,000 serfs, 100,000 rubles outright, and 20,000 rubles yearly; Count Orlov (who likely fathered her son) rated a palace, 6,000 serfs, 150,000 rubles yearly, and a

Let me tell you, love without materialism is just a pile of sand

GUO JINGMING

pricey set of Sèvres; and Grigory Potemkin, for inciting a passion that elicited a cast of his defining sexual feature, was accorded the power of co-tsar.

In China, the luxury lavished on an imperial consort came at the hideous price of feet bound to fit in the emperor's mouth, but there was no limit to how high she could rise; the power that Tang Emperor Xuanzong extended to his startlingly corpulent paramour Yang Guifei almost cost him the empire. The mother of royal progeny, by extension, was held noble. Cixi, impregnated by the Tongzhi Emperor, was promoted to "virtuous imperial concubine," privy to 300 taels of silver and 70 bolts of silk, and later, as "Empress Dowager," to a retinue of 1,000 and her choice of 100 dishes at each meal.

In Japan, excepting notable favorites like Hideyoshi's Yodo-dono and those featured in Lady Murasaki's bestseller, concubines rarely made waves or rose to power, but they were greatly spoiled. In India, where marriage was contractual and wives held pride of place, court life centered on dalliance—lighthearted exchanges, enacted in plain view, between the lord and his richly maintained harem.

The homoerotic impulse was as profligate. The last emperor of the Han, wanting to rise from a divan without disturbing the lover asleep in his arms, sliced off the sleeve of his priceless dragon robe. Emperor Hadrian showered the young Antinous with silk tunics "sheer as the skin of a fruit," deified him at his death, and founded a city in his name. Edward II draped his male lover in jewels, fatefully angering his wife, Isabella of France, when she saw they were hers. James I marked with an emerald earring the courtiers he preferred to his wife ("I, James, am neither a God nor an angel, but a man like any other") and offered his favorite ("You may be sure I love the Duke of Buckingham more than anyone else") the crown jewels. Lesbian liaisons were less tolerated and sparsely documented. The women desporting on Athenian vases wearing little else than their jewelry, and the wealthy sorority ruling the island of Lesbos, left a small mark. As late as the 19th century, the amorous doings in the "Duchesse de C's" mirrored Paris apartment (a "chef d'oeuvre of coquetry") were evidenced only by the portraits of the ladies entertained there.

Once entrenched at court, a favorite's impact could be considerable (literally, as when Yang Guifei's girth launched a fashion for no waists). Wu Zetian, mistress of two emperors, murdered all she entangled in her intrigues, including a daughter and son, to rule as "Empress Sacred and Divine" and found her own dynasty. In turn, a lover's fall from favor might be precipitous. The Nizams of Hyderabad ended a liaison with the parting gift of jeweled slippers placed facing the gate. Emperor Xuanzong restored order by having Yang Guifei strangled, and the Yongle Emperor avenged a concubine's infidelity by "renting, splitting, tearing to shreds" all 2,800 unfortunates

*There are two things that
people will always pay for:
food and sex. I wasn't
any good at cooking.*

MADAME CLAUDE

in the harem. On the eve of the Boxer Rebellion, told that the Emperor intended to
flee Peking with his beloved "Pearl Concubine," Cixi had her tossed down a well.

The state of affairs in the West was *luxe* and *volupté* but not *calme*. Elizabeth I's
mercurial affections exacted of the Earl of Leicester a white satin doublet garnished
with rubies and diamonds; of the Earl of Warwick, a black velvet girdle holding
13 emeralds and pearls; and of the Earl of Essex, his head. At Henri II's death, his
aggrieved queen retrieved the jewels given Diane, banished her from the court, and
repossessed Chenonceau, ordering every "D" in the boiserie to be carved into a "C."
Even a popular mistress might be scuttled; on his deathbed, England's Charles II
begged his brother to take care of Eleanor Gwynn: "Let not poor Nelly starve!"
James II heeded, but removed her privileges.

Harlots had it worse. Ancient Greece, obsessed with virility, had held their service
essential, indeed, salutary. Lais parlayed her skills into a brilliant career (charging
even the philosophers) and founded the lucrative love academy that occasioned the
proverb: "Let Athens glory in the Parthenon, Corinth boasts the gardens of Lais."
But they were the exceptions. Egyptian temple paintings and Herodian texts relate
that "loose" women were forced into pleasuring the rich. Vulnerable, too, were the
naked dancers of Etruria and the streetwalkers of Ephesus who etched "follow me"
on their soles. A hotbed of vice, Rome developed a double standard: while the poems
of Catullus and Propertius lauded promiscuity, prostitutes were sequestered in
brothels, forbidden to take a carriage or wear jewelry. Even the bawdy Middle Ages
denied them the going luxuries of gold belts and furs. Still, given their number, the
world's oldest profession was thriving. In 13th-century Dijon, the clergy made out so
well from selling harlots salvation that whoring increased by 20 percent. In mid-17th-
century Rome, Pope Innocent X's sister-in-law, Olimpia Maidalchini, grew vastly
rich from a chain of brothels that serviced the cloth. By the 19th century, prostitutes
had risen from necessary evil to coveted plaything. Balzac wrote raptly of the
"putains" who romped from the arcades of the Palais Royale to the Emperor's whist
table, and Toulouse Lautrec limned their plunging décolletés at the Rue des Moulins.

More accepted were women vetted for childbearing and sheltered in a harem.
Solomon maintained 300, and Cyrus the Great, 3,000. Those pleasuring royalty were
pleasured in turn. Montezuma II's thousand ladies peeked through curtains woven
of feathers, and those kept by Akbar enjoyed luxuries calibrated to rank. In ancient

WOODBLOCK PRINT
BY UKIYO-E MASTER
UTAGAWA HIROSHIGE
OF A "FLOATING WORLD"
COURTESAN; HAIR,
MAKEUP, AND LOOSE
APPAREL CONTRIVED
FOR SEDUCTION.

times, though, such women were defenseless, their lot unpredictable. China's first emperor had his favorites immolated to service him in the hereafter, and those selected to pleasure Muslim rulers were kept enslaved for the purpose.

Things improved over time. Marco Polo described the ladies of Hangzhou as independent and accomplished: "they adorned themselves splendidly and had suites of servants." Precursor of the courtesan, this was a new breed of lover. Rarely wellborn and lacking instruction in the dress, walk, and speech required for presentation at court, but well versed in matters of seduction, they were decorative commodities that like a "morceau du roi" could be had for a price.

A few more centuries of polish produced the fully schooled courtesan, rigorously trained for pleasuring the elite. The *tayu* of South Asia and the *oiran* of Japan's "Floating World" were cultural celebrities given to entertaining lovers of their choosing on luxurious barges. Filtered to Venice, the courtesan held pride of show: in 1608, Margarita Emiliana received the English traveler Thomas Coryat amid perfumed textiles and gilded walls, "decked with many chains of gold and orient pearl like a second Cleopatra." Those aiming higher put out more: the French luminary Marie-Madeleine Guimard climbed to fame in a bed so fruitfully carved by Ledoux that she had him fashion a Temple of Love to accommodate 500 admirers. More brazenly, at a time when many were starving, the ravishing Madame Tallien, "cocotte de la Revolution," advised baths filled with crushed strawberries to give breasts the color of passion, and cruised the blooded boulevards in a crimson carriage wearing the 18 bracelets and toe rings that presaged the "need for the luxuries of elegance and wastage" later implicating Empress Josephine.

Become independent and worldly, the top courtesan now commanded top dollar. Paul Barras said of Josephine before she graduated to Bonaparte that she would happily drink gold from the skull of her lover. "Dame aux Camélias" Marie Duplessis raised the stakes: scornful of the money-wrapped oranges that a hopeful thought to score with, she sent her housemaid to their rendezvous. Listing among her conquests Franz Liszt and Alexandre Dumas, she advised a third: "Monsieur le baron, I realize that mine is a sordid profession, but I must let you know that my favors cost a great

CODED PORTRAIT BY RAPHAËL DELORME OF KING FAROUK'S MISTRESS, THE ONE DANCING IN THE BACKGROUND ALONGSIDE HIS YACHT.

deal of money. My protector must be extremely rich to cover my household expenses and satisfy my caprices." La Païva took note; holding Paris in thrall costumed only in parsley brought the Russian-born temptress a splendid *hôtel particulier* (now the Travellers Cub) and, when she married their owner, the famed Donnersmarck diamonds. In the first manual on the subject, the practiced Léonide Leblanc counseled: "If you have a heart, wrap it in a handkerchief and put it in your pocket and before acquiescing, exact 1) a pretty apartment 2) elaborate gowns 3) expensive jewelry . . . with one goal only, money, money, and more money."

Stakes for influence were high and blows struck for it low. In 1870, a lady of quality arrived at the theater to find Leblanc in the seat the Duc d'Aumale had assigned her: "I am dining with Monseigneur," sniffed the socialite, "and will tell him of this insult!" "You may be dining with Monseigneur, but I am sleeping with him," trumped the veteran. This was seduction at its most sophisticated, no holds barred.

JUAN AND MARIA EVA DUARTE DE PERÓN: ARGENTINA'S PRESIDENT AND HIS GLAMOROUS WIFE POSED FOR THEIR ONLY OFFICIAL PORTRAIT IN SATIN AND DIAMONDS.

Enter La Belle Époque—era of the *grande horizontale*, the cocotte, and every nuance in between. On the make were glad-time professionals who searched out men with money and drew on technique to partake of it. Returning their favors with jewels, furs, and mansions, were incipient heirs and blades about town. Playing rich admirers like a mandolin, a topflight demimondaine could man-hop to social security. The lubricious courtesan Liane de Pougy, diamonds fixed to her nipples, wielded racy charms for such as the globular pearl enticed from Lord Carnarvon, and ended up married to a very rich count. The irresistibly curvaceous Émilienne d'Alençon earned early retirement in an opulent palace received from an Arabian nabob. The actress Lillie Langtry lined her own nest. Her three-year affair with "Bertie," Prince Albert of Wales, provoked the famous exchange: "I've spent enough on you to build a battleship" / "You spent enough *in* me to float one." Assuring Prince Louis of Battenberg that he had fathered her daughter set her up nicely for life.

Weeklies like *Paris in Love* fed on the fallout. Coco Chanel recalled of heyday Deauville: "If a man went bankrupt, you knew a woman was the cause." Dismiss at your peril the demimondaines with their painted faces and "heads full of birds. . . . Every man kept a mistress, and not in a furtive backstreet manner; they lavished money on their *poule de luxe*. Their poor neglected wives couldn't possibly compete." Confessing to Salvador Dalí, "I was able to open a high-fashion shop because two gentlemen were outbidding each other for my hot little body," Chanel polished her own options into the fabulous Romanov pearls (from Russia's Grand Duke Dmitri) then turned down another duke ("there exists another Duchess of Westminster, but only one Coco Chanel") for fiscal independence. More pliant, Josephine Baker gyrated from *La Revue Nègre* into a roadster, a fully staffed castle in the Dordogne, the *légion d'honneur*, and material homage from such as Alexander Calder (who curved her into wire) and Adolf Loos (who modeled a house on her body). Shrewdest was Russia's prima ballerina Mathilde Kschessinska who, in costumes sewn with Crown jewels, segued from pleasuring the future Tsar Nicholas II to seducing his cousin, Grand Duke Andrei Vladimirovich, whom she wed.

Carolina "La Belle" Otero eclipsed all: a dancer of sorts, her charge to strip down totaled $25 million in cash, and her talent for rising in the altogether from a silver platter raked in jewels by the yard. She appeared at the Folies Bergère ringed in necklaces coaxed from three royal treasuries: the one gifted by Grand Duke Nicholas Nikolaevich had belonged to Catherine the Great, and the one received from William K. Vanderbilt had belonged to Empress Eugénie. "Ruin me but don't leave

BELOW LEFT CAROLINA OTERO: BELLE ÉPOQUE COURTESAN WHO DANCED HER WAY INTO THE AFFECTION AND THE JEWELS OF FOUR ROYAL LOVERS.

BELOW RIGHT JOSEPHINE BAKER: THE DANCE SENSATION OF PARIS, FAMOUS FOR HER LOVERS, HER BANANA ACT, AND ADDICTING THE JAZZ AGE TO BLACK EXOTICISM.

OPPOSITE TOP LILLIAN RUSSELL, THE BELOVED AMERICAN ENTERTAINER KNOWN FOR HER PLUMAGE, HEADLIGHT DIAMONDS, AND RICH SUITORS—MOST NOTABLY, DIAMOND JIM BRADY.

OPPOSITE BOTTOM LEFT MISTINGUETT: THE FRENCH PERFORMER WHOSE "COME-HITHER" DANCE ROUTINES SPED HER TO THE DAY'S HIGHEST-PAID ENTERTAINER.

OPPOSITE BOTTOM RIGHT ZSA ZSA GABOR: THE "HUNGARIAN BOMBSHELL" WHO CAME TO HOLLYWOOD TO WIN FAME AND NINE HUSBANDS WITH 21 SUITCASES, HAIR DYED BLONDE, AND A POODLE DYED PINK.

me," one royal lover had beseeched, and generally, as Otero said of Prince Pozharsky's offer of 5,000 francs for each day she spent with him, "I didn't refuse." Among the admirers gathered at the Café de Paris to celebrate La Belle's 30th birthday were King Leopold II of Belgium, Crown Prince Nicholas I of Montenegro, Prince Albert of Monaco, Grand Duke Alexei Alexandrovich of Russia, and Britain's future Edward VII, whose collective largesse kept Otero afloat through the most appalling reviews. Let society mock, by now every fetching performer had her protector. Romania's hip-swinging "Magda" Lupescu survived decades of scandal as King Carol II's doxy to end up as his queen. Argentina's Eva Péron rose from a struggling actress to Argentina's First Lady.

World War I darkened the scene not the spirit. Uncorked by peace, titillation bubbled through Europe to romp in the Aegean, splash in the Fontana del Tritone, stop by Nice for the Negresco's "naughty cocktail" (sparkling rosé

with strawberry nipples), skip to the Carlton in Cannes to watch Mistinguett dance on the tables biting a rose, and visit Paris to catch Annie Oakley shooting the ashes off playboys' cigarettes.

Like all things Parisian, *amour* sailed to America, where little more was asked of a blade keen on squiring a Gaiety Girl than to drink bubbly from her slipper. The nabobs were more discreet—Vincent Astor cavorted offshore on the aptly named "light of the harem" *Nourmahal*—but just as susceptible. The red-velvet-swing skills of chorus girl Evelyn Nesbit led her husband, coal baron Harry K. Thaw, to accuse Stanford White of seducing his wife and, to the tune of "I Could Love a Million Girls," shoot him dead.

The repeal of Prohibition lifted both feet off the brakes. The Jazz Age magnificos who survived the Depression drank hard, played harder, and thought squiring a dollypop around town the most daring thing they could do. They emptied their wallets at 21, and at Leon & Eddie's, whose sign read "Through these portals the most beautiful girls in the world pass out." They downed cocktails called Bunny Hug, Pink Lady, Between the Sheets, and Angel Tits. Ziegfeld Girls kicked it up for bracelets smuggled backstage in bouquets of roses, while girls on the make snuggled up to Big Spenders for the "oh my goodness" jewels that occasioned Mae West's quip, "goodness has nothing to do with it." The brooches that Diamond Jim Brady showered on Lillian Russell were as generous as her décolletage—the dogtooth pearls in the Tiffany chrysanthemum were incredibly rare at the time.

World War II recalibrated. Maude Burke, as had many, drowned her shady past on a crossing to England, wed Sir Bache Cunard, and titled herself "Emerald" after her favorite parure. The Gabor sisters crossed to America and between them clocked up 20 marriages. William Hearst parked his wife in New York and nested Ziegfeld's Marion Davies at San Simeon, thanking her for hosting guests she barely knew with a 110-room Georgian beach house where she could party as she liked. Raciest were the heiresses who consorted with a fast set of polo players, racing drivers, and dubiously titled gigolos. Doris Duke corralled Porfirio Rubirosa (whose last name, in Paris, still references a large pepper grinder) with a string of polo ponies, $500,000 in cash, a mansion, several sports cars, and a converted B-25. To her dismay he moved on to garner much of the same from Barbara Hutton, as would five of her other six husbands.

As weddings notched up, gossip columns thrived on the excess. Fabulous that Princess Elizabeth wed Prince Philip in a gown sewn with 10,000 pearls! That Grace Kelly had the House of Creed create "Fleurissimo" from scratch to perfume the bouquet for her wedding to Prince Rainier of Monaco! Tellingly, in 1949, when one house in four had no running water, 20,000 citizens lined Rome's streets to cheer Linda Christian, Tyrone Power, their dolce vita cortege of cardinals, divas, starlets,

socialites, and the dashing Count Rodolfo (Rudi) Crespi, from the church to their Champagne-floated wedding feast.

It fell to the hippie generation to revive romance. Love, taught the Sixties, was a poem, a song, and vows exchanged on the beach with a psychedelic décor. The romantic gesture took hold. Lady Antonia Fraser recalls Harold Pinter's courtship with prodigal arrangements of white flowers placed in the window, in the hall, on the mantelpiece, in the back room, on the stairs. "Is it for a party?" the florist had asked. "No," said the playwright, "it's for Sunday night."

Purveyors hastened to return love to commerce. Belying Diderot's conviction that *luxe* would never desert *eros* ("*C'est un vice si agréable!*"), truly big spending reverted to contractual alliance. Dating services charged up to $10,000 for introductions, and courtship and weddings were staged for promotion. For the rich but not famous, the Great Bridal Expo packaged Cupid as a "gifting experience" in a "romance environment." What did the trick? A $2,600 box of Knipschildt bonbons from Chocopologie presented at full moon. Such expenditure, noted economics professor Bradley Ruffle, shows that you care at a high cost to yourself. A diamond engagement ring may be "extravagant and wasteful" but signals serious commitment. Frilling the "proposal event" encouraged hopefuls to "pop the question" on Yankee Stadium's mega-scoreboard, or hire a World War II–era fighter plane to write, "Will You Marry Me?" in the sky.

Bespoke nuptials aimed higher: flowers ran to $40,000, lighting to $50,000, Champagne to six figures, and décor to the millions. High-profile daughters commanded still more. To sumptuously wed Marie-Chantal

THE FABLED 1956 WEDDING OF HOLLYWOOD'S GRACE KELLY (IN A DRESS GIFTED BY MGM) AND PRINCE RAINIER OF MONACO.

*Generally, women who are given
a necklace accompanied by a
letter find the letter too long
and the necklace too short*

VOLTAIRE

to Crown Prince Pavlos of Greece, duty-free king Robert Miller had designer Robert Isabell fabricate a Greek temple. To gladden Dylan's marriage to Paul Arrouet, Ralph Lauren indulged her three wishes—"feel like a princess," a "stunning and majestic" wedding gown, and an experience for her guests of "love, fun, magic, and glamour." Anything to delight: Bernard Arnault backdropped Delphine's wedding dinner at the Château d'Yquem with 5,000 roses. To ravish: philanthropist Ronald Davis's daughter, Lauren, married Andrés Santo Domingo in a Nina Ricci confection whose paillettes, vintage lace, white feathers, and silvered silk jacquard took 2,000 hours to assemble. To astound: had Veronica's Russian businessman fiancé flown the textile heiress over a beach to see 50 friends lined up to spell "Will You Marry Me?" Her father, Silas Chou, imported 1,450 more to a pop-up Russian palace wedding featuring Fabergé eggs and the Cirque du Soleil. To ace: steel magnate Lakshmi Mittal topped the $44 million wedding of Princess Salama to Sheikh Mohammed Al Maktoum with one for daughter Vanisha at Vaux-le-Vicomte that splashed $66 million on the décor, entertainment, and 5,000 bottles of Mouton Rothschild.

Expensive to get the girl? Ruinous to get rid of her! Few terminated a liaison as smoothly as had Gustav Klimt, with a fan he inscribed "Better an ending with pain than pain without end." Before the prenuptial, divorce had cost more than a limb. Should an alliance fail, the clever divorcée married up by exchanging a fat wallet for a bulging one. Foremost among her generation of women who wed well and divorced better was Mrs. Winthrop "Bobo" Rockefeller, whose exit two years after the "Cinderella wedding of the century" netted her six million 1950 dollars. Even prenuptials proved shaky. It stunned that Kirk Kerkorian's ex-wife exacted $6,000 a month just for flowers and that divorce cost Amazon founder Jeff Bezos $38 billion. Cheaper to keep her! The latest conciliator? A million-dollar "apology ring."

Progeny—When life was short and urgent there was no concept of childhood. Henry VI was crowned King of England at age six months, Ivan VI rose to Tsar at age two months, the Shunzi Emperor came to power at age twelve, and Alfonso XIII became King of Spain the day he was born. By age sixteen, Alexander had named a city for himself. By age fifteen, Clovis had unified Gaul. The daughter of Charles I wed William II of Orange at age nine and Isabella of Valois wed Richard II at age six. Across cultures, children of privilege were held assets, like collateral or promissory notes. "Be the heir of the father's possessions," counseled an African song of the Dema.

FASHION ICON LAUREN DAVIS, WEARING THE ONCE-IN-A-LIFETIME WEDDING DRESS CREATED BY OLIVIER THEYSKENS OF NINA RICCI FOR HER MARRIAGE TO ENTREPRENEUR-PHILANTHROPIST, ANDRES SANTO DOMINGO.

Strategically polygamous, Genghis Khan, Ismail Ibn Sharif, and Qianlong all bred copiously. King Rama IV's 32 wives gave Siam 82 heirs, and even India's judicious Mir Osman Ali Khan parted long enough from his 185-carat diamond paperweight to father 200 offspring. Western lords were hardly circumspect—England's King Henry I produced 24 children out of wedlock, and Poland's Augustus II, allegedly, 300. In turn, royal issue bred influence; three reigning cousins—Wilhelm II, Nicholas II, and George V—tied Germany, Russia, and Britain to the royal House of Hanover.

Royal progeny, nonetheless, were held property, deployed as pawns on a gameboard. To secure England, Ferdinand II of Aragon and Isabella of Castile, then Europe's most powerful alliance, contracted their daughter Catherine to Henry VIII, who in turn pledged sister Margaret to the King of France, and so forth, until bloodlines coagulated. Catherine de' Medici placed son Henri de Valois on two thrones, Maria Josepha of Austria bore three French kings, and many the princeling was anointed "Holy Roman Emperor." A male heir was so critical to legacy as to generally terminate the career of a queen who couldn't produce one. Henry VIII had

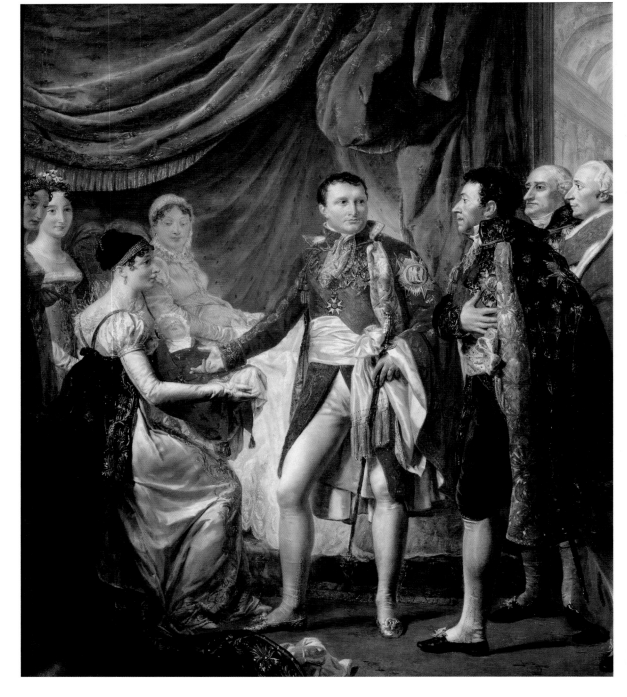

NAPOLEON BONAPARTE, EMPRESS MARIE LOUISE, AND THE KING OF ROME: THE MARRIAGE CONTRACTED TO ALLY A POWERFUL FAMILY AND SIRE AN HEIR.

a barren spouse beheaded and didn't hesitate over who should be rescued at Jane Seymour's difficult childbirth: "The infant by all means, for another wife is easily got, but not so another child." A successful delivery occasioned lavish commissions of a silver birth tray and serious jewels. Upon presenting Napoleon with an heir, Marie Louise received a diamond necklace that equaled the cost of her annual household budget. In gratitude for her first grandson, Catherine II gave his parents a lavish estate. Even lesser titles drew benefits. When, in 1704, ten-year-old Richard Boyle became the 3rd Earl of Burlington, he inherited vast tracts of Ireland and Yorkshire, a mansion in Piccadilly, and an estate in Chiswick.

Posters for legacy, heirs-presumptive greeted the world richly. Those born to Chinese nobility were bejeweled; those to Indian royalty were paraded. Napoleon II met the court in a gold-enriched cradle, the Leland Stanfords' infant son was presented to San Francisco society on a silver salver, and baby "Bubbles" Jaipur made

ABOVE THE VELVET AND VERMEIL CRADLE THAT WAS CROWNED WITH THE SOLID-GOLD IMPERIAL EAGLE OF "L'AIGLON."

BELOW QING DYNASTY JADE PILLOW IN THE SHAPE OF AN INFANT BOY: THE ANKLETS AND BRACELETS CONVEY BOTH HIS STATUS AND THAT BABIES WERE A BLESSING FROM HEAVEN.

his debut in a bathtub of Champagne. Bypassing childhood, Infanta Margarita Teresa was as richly dressed as her mother, and the young Louis XVI learned geography from an ormolu globe wrought by the great André-Charles Boulle. Rarely was the silver rattle warmed with a huggable toy. It's unlikely that Philip III had fun with the exquisite suit of armor gifted him at age seven. Did the son of the Duke of Bordeaux play with his music box by Giroux that sailed ships across a silver sea to the clapping of thunder? Could his sister cuddle her mechanical doll? Some warmed to luxury. The young Louis XIV was said to have doted on a little gold cannon drawn by fleas; the future Tsar Alexis was inseparable from the mechanical silver elephant received from his grandfather; the Princesses of Hesse played daily in a Jugendstil dollhouse furnished as richly as their palace; and Tsar Peter III so loved his army of almond-paste soldiers that he allegedly executed a rat who had dined on one.

Tellingly, the first luxury retailers were 18th-century toyshops offering articulated *objets de vertu*. Pre-World War spoiling was as lavish, but lost on progeny weighted by expectations for their future. How to embrace the three-foot-tall rabbit that FAO Schwarz shipped to young King Hussein, the marble playmates lining

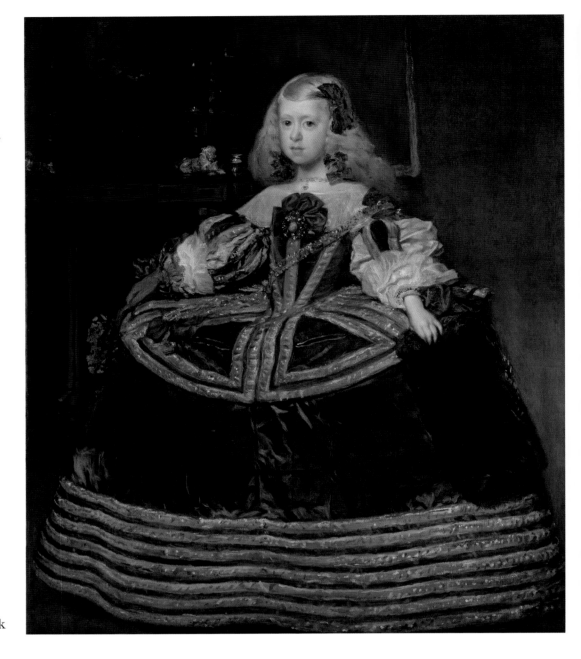

Marcantonio Colonna's palace halls, or the starched frocks offered on the shopping spree that London's Harrods had arranged for three-year-old Princess Gayatri Devi?

Princely indulgence wheeled the offspring of the Maharaja of Bikaner in a 10-foot-long vermeil chariot; gave five-year-old Pratap Singh Gaekwad of Baroda a locomotive to take him to school; and presented four-year-old Gaj Singh II with the city of Jodhpur, four medieval fortresses, five palaces, and terrain the size of England. Europe looked to the Rothschilds, who had each child brought to the bank with instructions to lift the heavy gold bar on the director's desk and, if successful, to take it home. Baron Robert returned once from London with a present "beginning with C" for whichever of his five children got it right, and handed Cécile, age thirteen, *Les Baigneuses* when she guessed "Cézanne."

INFANTA MARGARITA TERESA: GROOMED FROM BIRTH TO MARRY HOLY ROMAN EMPEROR LEOPOLD I, WHO HAD VELÁZQUEZ PAINT HER AT INTERVALS TO SHOW HIM HER PROGRESS.

American fortunes showered infant heirs with the likes of the mink coverlet given John Jacob VI. Evalyn Walsh McLean was regaled with a blue-and-silver Victoria to take her to school and in turn gave son Vinson a diminutive coach and an ermine outfit by Worth. Barbara Hutton received a Pullman car for her coming out, and Dolly Fritz was given San Francisco's Huntington Hotel for hers. Oil-tycoon Edward L. Doheny topped his son's graduation gifts with Greystone, a 55-room castle in Beverly Hills.

Such spoiling either stupefied or delighted. One Vanderbilt boylord summering in Europe was sent "a bewildering" 125,000 francs worth of toys insured against loss. Daughter Gloria, however, so cherished the playhouse that comedian Harold Lloyd had fitted with plumbing and electricity that she locked it up every night; Liza Minnelli treasured the pint-size party dresses reproduced for her from her

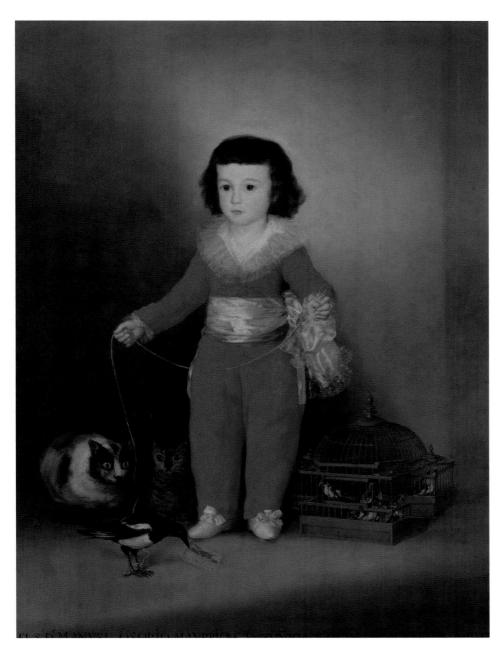

MANUEL OSORIO
MANRIQUE DE ZÚÑIGA
(AKA *THE RED BOY*): A
CHILD OF PRIVILEGE
WITH HIS PETS; DEPICTED
BY GOYA IN LACE,
SATIN, AND BOWS.

father's MGM films; and Beth Rudin DeWoody loved that her real estate-titan father thought the suggestion that he give her blocks for her birthday meant real-life Manhattan blocks. Tori Spelling never forgot her Beverly Hills birthday parties that turned up rare shells on a beach hunt, imported snow to simulate winter, and (for her tenth) met her request for songs by Michael Jackson with the performer himself.

Later expectations channeled Eloise—"one meringue glacé for me . . . charge it please." Top hotels stood at the ready to indulge nascent caprice—the little girl who ordered lobster tagliatelle at the Connaught would like it *sans* lobster? "Certainly, Madam!" Marketed as "investments," child-rearing luxuries included a toilet seat playing eight soothing songs and the $2,000 Maclaren Titanium Edition stroller made of the leather that lines fighter-pilot helmets. Spas for the tween-set offered "princess facials" and lotions smelling of candy. Websites delivered fairy-tale dreams of a $30,000 "Rapunzel" suite and a $47,000 Cinderella "Fantasy Coach" bed. Party fun inflated "Sweet Sixteens" into $100,000 "party concepts" and the "goodie bag" into a "Safari Package" supplying live animals, Veuve Clicquot, and a bow-wrapped Mercedes. "You do what you do for your kids," one mother told the *Hartford Courant*, "even if it means biting your tongue and spending the money." Retail king Sir Philip Green gave son Brandon an $8 million bar mitzvah; Hong Kong billionaire Joseph Lau gave seven-year-old daughter Josephine the $48.4 million "Blue Moon" diamond; Victoria Beckham took her three-year-old daughter (who already had her own blog) to fashion shows because "Harper is incredibly chic . . . a very stylish little thing with her own sense of how she wants to dress." Dairy-king Sergei Plastinin indulged daughter Kira (a fashion-store designer brand at fourteen) with her very own scent ("beachy") and horse—named "Baloven," which means "spoiled and treated too well."

*I do not live to play,
but I play in order that
I may live, and take up
life with greater zest*
PLATO

PRODIGAL PASTIMES

P_ets_—The very notion denotes privilege. _Homo erectus_ didn't pursue animals for cuddling. Before they were gentled, they served as either vittles or avatars. Testifying to their significance here and after, the Egyptians carved hippopotami into amulets, the Scythians embossed griffins on pectorals, the Chinese animated scrolls with the omnipotent dragon, and all took a quantity of creatures to the grave. Some were to feed the departed but spirit-animals like the dog Anubis were embalmed and worshipped for centuries. To splendidly bury the famed Apis Bull, Egypt's priests petitioned the Macedonian conqueror Ptolemy I, hat in hand. Household pets were held an extension of their owners. Cleopatra bejeweled her greyhounds, courtiers perfumed their cats, and their loss provoked intense grief. At the annual festival for the cat-god Bastet, the chorus mewed mournfully for all felines with perhaps the earliest perception of an animal's soul.

Horses, prized first as war machines, forged empires. "Next to God," Hernán Cortés's soldiers would say, "we owed our victory to the horses." Those brave in battle were honored and regaled. Alexander the Great named a city for his valiant

CHAPTER OPENER MERCHANT, DIPLOMAT, AND COLLECTOR PHILIPP HAINHOFER OF AUGSBURG GIFTING THE POMMERSCHE KUNSTSCHRANK—ONE OF HIS COVETED CURIOSITY CABINETS— TO DUKE PHILIP II OF POMERANIA.

BELOW THE ALEXANDER MOSAIC: THE CONQUEROR AND HIS BELOVED BUCEPHALUS CHARGING TO VICTORY OVER DARIUS III.

ZARAFA THE GIRAFFE,
CONSUMMATE
DIPLOMATIC GIFT,
EMBARKING ON HER
FAMED WALK FROM
MARSEILLES TO PARIS.

Bucephalus. Scythian warhorses were arrayed with embroidered blankets, and the samurais' noble Kisouma sported saddles inset with mother-of-pearl. China held horses central to both this life and the next one. Imported by the Emperor Wudi to battle the barbarians, the venerated Ferghana spoke loudest to power. The Tang owned over 700,000 of those magnificent animals, gilded their saddles, and held them divine: "He who rides upon the celestial horse will live for a thousand years," foretold the ancient text *Shan Hai Jing*. Taking no chances, Emperor Taizong had six carved on his tomb, and the Great Khans took the champions to the grave. Court life centered on ornamental animals—lions and bulls imported from a distance for the royal menageries. The big cats were collared with gold and paraded by eunuchs on a leash. The elephants, esteemed for their prowess and majesty, merited their own temple in the Elephant Quarter, the same remuneration as princes, and their orders read aloud to them by the emperor himself.

Mughal India's relationship to animals was both cavalier and sentimental. Warhorses were sent out to die, and parade horses to prance—their tails tinted vermilion, their haunches painted pink. War elephants were trained for staged fights to the death, but parade elephants were held sacred ("An elephant mounted by a king is radiant, a king mounted on an elephant is resplendent," reads a manuscript), given rubdowns, and bejeweled. The same nabob who arranged a high tiger count for a visiting dignitary might order, as did a maharaja of Rewa, a state funeral for his charger or, as did a nawab of Junagarh, a wedding feast for his dogs. Akbar had birds served up in the soup, yet created a vast bird park near Fatehpur Sikri and traveled around with 10,000 ornamental pigeons.

The West was as ambivalent. The first-ever-seen giraffe imported from Caesar's Egyptian campaign was displayed at the Colosseum and then fed to the lions. Spectators cheered the slaughter of a rare species of lion but erupted in fury when Pompey sent wailing elephants to their death. The generally sardonic elder Pliny wrote admiringly of an elephant that inscribed on the sand, "I, the elephant, wrote this," and of a raven that hailed the Emperor Tiberius every morning and occasioned, at its death, a solemn procession through Rome. Rare birds ranked. In 12th-century England, a specific breed of swan was—still is—reserved to the Crown. After

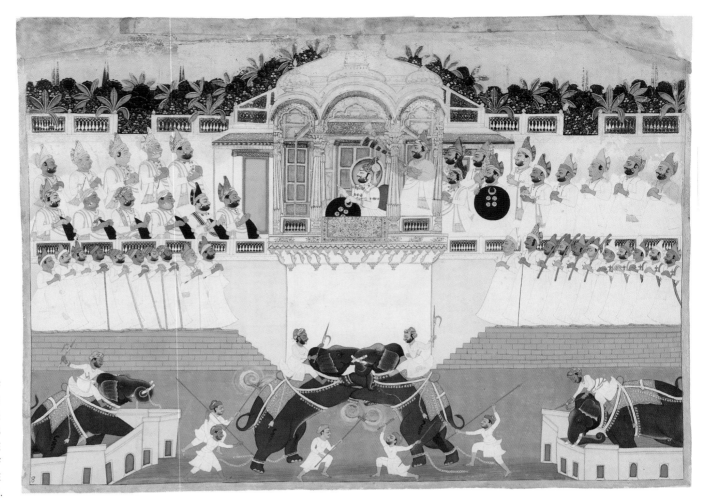

TAKHAT, MAHARAJA OF JODHPUR, ATTENDING AN ELEPHANT FIGHT: TRAINED ELEPHANTS WERE HELD THE EMBODIMENT OF MAJESTY, RESERVING THE DIVERSION TO THE RULER.

Marguerite de Navarre received the first turkey seen in Europe, there was no more coveted gift, until proliferation consigned them to the stewpot. Ostriches, displayed by Jean de Berry and the Emperor of Austria, so ennobled that fleeing Turks killed one they came upon lest it fall into Polish hands. Most exalting was an aviary, leading Holy Roman Emperor Frederick II to have his *rara avis* catalogued along with his art, Pope Julius III to have his winged trophies painted in trompe l'oeil on the Villa Giulia's outer walls, and Holy Roman Emperor Rudolf II to create pleasure parks for such rareties as the dodo bird.

Exotic animals distinguished by their reach. Hugely expensive to collect and maintain, they constituted living libraries. Billed as "attractions," the day's marvels were displayed to the public in zoos or on tours. Clara the rhinoceros garnered sensational revues and a portrait by Jean-Baptiste Oudry. A lucrative industry of animal sculpture produced snarling bronzes by Eugène Delacroix and Antoine-Louis Barye—200 accumulated by Brazilian engineer Eduardo Guinle to display in a specially built palace. During the short time that Empress Josephine could have anything, she formed an extravagant menagerie around a cheetah collared with diamonds, and hired the noted Redouté brothers to paint it.

The luxury going forward was a landed estate ornamented with roaming exotica. Poland's prodigal Count Joseph Potocki allotted 360,000 acres to curiosities obtained from one Carl Hagenbeck of Hamburg, who drove him around in a carriage drawn by zebras. King Farouk's gardens in Alexandria stocked 100 gazelles and iridescent birds from Sudan. Alexander Weymouth, 7th Marquess of Bath, roamed lions around

17TH-CENTURY DECCAN MINIATURE OF A LADY AND HER PARAKEET, THE STATUS-MARKING ORNAMENTAL BIRD THAT WAS HELD THE SYMBOL OF STORYTELLING.

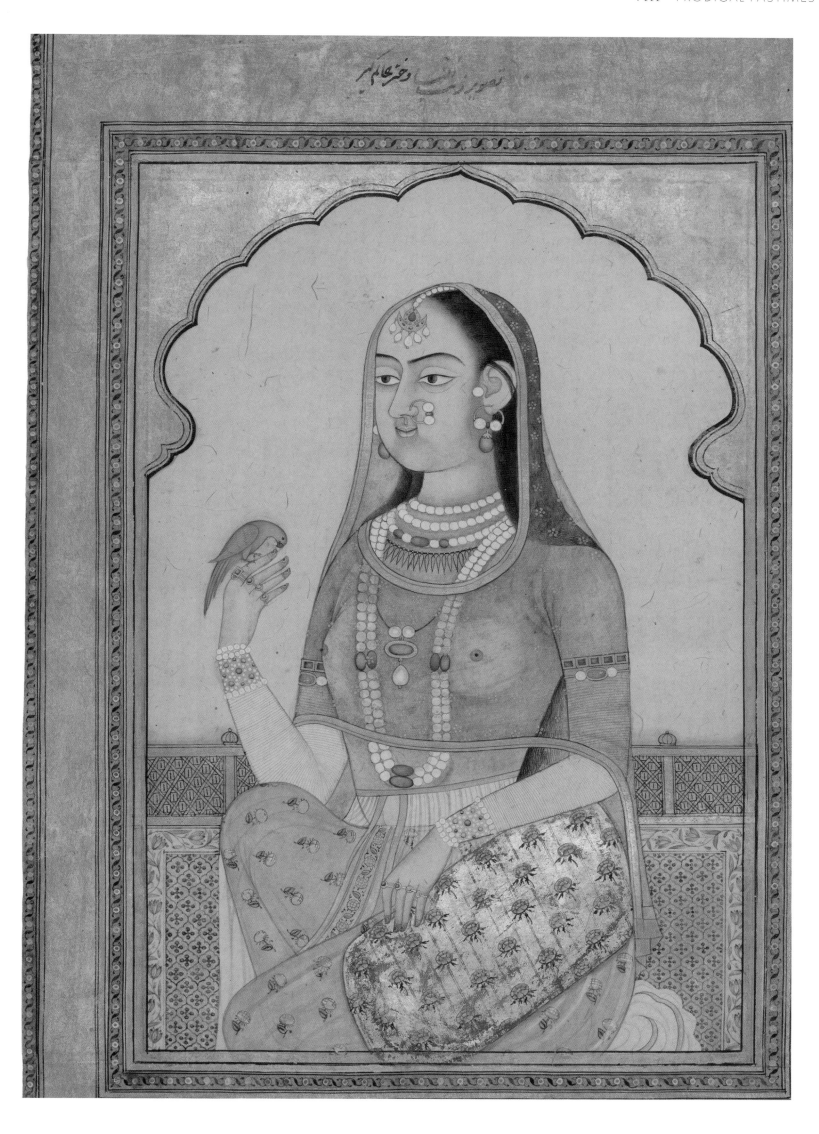

Longleat, until one escaped and wandered into town. America's nobs built private zoos: William C. Whitney's marked for its size; William Randolph Hearst's for the free-ranging buffalo, gnu, lions, and kangaroos that he called "San Simeon's "roving ambassadors."

Status pets led off with dogs, bred across time and cultures for performance and looks. Shi Tzu and Pekingese served Imperial China as accoutrements, trained to lift the emperor's robe as he walked. Each had its own servant, and any who stole one was executed. Japan favored creatures that could fit in a sleeve. Emperor Ichijō doted on bobtails—cats brought from Burma and coiffed to signal high rank—but purebred canines won out. Edo shogun Tokugawa Tsunayoshi, born in the Year of the Dog, maintained 50,000, issued edicts to protect them, and accorded them human funerals.

To the west, it fell to the monasteries to develop the small breeds taken up for the hunt and, later, for company. They appear in family portraits as individuals, with personalities and feelings. Court dogs were noble by extension, leading Louis XI to have Cher Amy collared in gold, Frederick the Great to build monuments to his greyhounds, and Charles I to take his namesake spaniels everywhere, even to his beheading. Spoiling grew outlandish: Henri II gave his dogs specially baked bread, Henri III de Navarre carried his favorite around his neck in a basket, and Madame de Pompadour commissioned a vermeil dog collar that cost the annual wage of a stonemason. The Victorians thought of canines as people. Francis Egerton, 8th Earl of Bridgewater, seated his greyhounds at table, each served by a footman, and Prince Albert fed his favorites from a monogrammed spoon. Royal pedigrees, such as the namesake that Charlotte of Pomerania introduced upon marrying George III, were themselves royalty. Edward VII had the collar of his wire fox terrier, Caesar, inscribed, "I belong to the King," and Elizabeth II still bestows royal favor with Black Labradors bred at Sandringham.

At their darlings' demise, the besotted went overboard. Peter the Great had his beloved Lizetta stuffed and displayed behind glass, and Napoleon Bonaparte had his stallion, Vizir, preserved for the nation. The absolute need for a souvenir engaged Gustave Courbet, then the most famous painter in France, to limn the dogs of the Duc de Choiseul, and brought George Stubbs to fame as the "thoroughbred master."

Horses with show potential were regaled. Louis XIV kept 800 at Versailles's Capitale du Cheval in quarters designed by Hardouin-Mansart, and Prince Louis-Henri de Bourbon, convinced he would return as a horse, had Jean Aubert build Chantilly's equestrian complex into a virtual palace. Few equaled the Potocki

stables at Łańcut, with its long gallery for ceremonial carriages and a room each for everyday-brown, formal-black, and gold-studded harness.

Indulgence turned eccentric. Lord Byron boarded a bear, Salvador Dalí kept an ocelot, Tallulah Bankhead housed a panther, and Erik Satie walked a lobster around on a leash. Both Robert de Montesquiou and Victoria Sackville-West owned a tortoise—the one gilded, the other crusted with diamonds—and Sarah Bernhardt lodged a live zoo in her flat and a dead bat in her hat. Marchesa Luisa Casati, ever on show, domiciled peacocks, took her boa constrictor to the Ritz, and paraded her cheetahs around Venice cloaked in little else than her jewelry.

Safety laws veered infatuation to $50,000 home aquariums stocked with sharks, ferrets displayed in jeweled cages, and $250,000 arawanas from Singapore privy to biannual eyelifts. None, though, would be more cosseted than the lapdog. Saks Fifth Avenue supplied cocktail-coats, Neiman Marcus provided ermine capes, and Paris offered Arf-Pette by Lanvin and Le Chien by Chanel. Gossip columns relayed that Edith Rockefeller McCormick's poodle sported a $1 million parure, Mrs. Howard Gould's dachshund wore a $15,000 Tiffany's collar, Geraldine Rockefeller Dodge's champions boasted their own Cadillac, and Mrs. Denniston Lyon had her Manhattan terrace refreshed with earth from Long Island because Peaches liked the smells there.

Latter-day spoiling involved detox wraps, "pawdicures," tummy tucks, members-only pet clubs, and doghouses inflated to the $325,000 mini-mansion modeled by Paris Hilton on hers. Seven percent of U.S. dog owners splurged up to $250,000 on "woof fêtes" lavished with sparkly wardrobes, biscuit-serving butlers, and (for Poodle Chilly Pasternak and Coton De Tulear Baby Hope Diamond) a five-tiered wedding cake. Pets that conferred status now possess it. Self-styled hotel queen Leona Helmsley deeded $8 billion for the welfare of dogs and indigent people, then deleted "people" and left $12 million to a Maltese called Trouble.

Diversions—Drones and robots constitute today's toys, but clever amusements have allayed boredom since articulated dolls beguiled incipient pharaohs. Shang Emperor Cheng Tang obsessed on a bamboo dragonfly helicopter, Harun al-Rashid commissioned

SALVADOR DALÍ WITH HIS OCELOT, BABU, WHOM HE INTRODUCED AROUND AS A PAINTED CAT.

a timepiece that spun out 12 knights, and Emperor Maximilian fixated on a mechanical fly. Called the father of robotics, Arabia's Ismail al-Jazari devised automatons on the order of a slave girl that, eight times an hour, delivered a glass of red wine.

Renaissance ingenuity engineered Curiosity Cabinets to showcase miniature worlds. At the touch of a Seychelles nut—itself a great rarity costing four times the price of a house—compartments of the *kunstschrank* fashioned for Duke Philip II of Pomerania sprang open to reveal models of every animal and plant in the duchy. Eighteenth-century diversion fixed on mechanical wizardry—celestial spheres spinning on cloisonné caskets, and vases that—presto—became candelabra. Roentgen's lifelike automaton of Marie Antoinette playing a dulcimer so spooked her that she packed it off to a museum. (She would have loved the intricate workings of the gold pocket watch commissioned for her from Abraham-Louis Breguet but not completed in her lifetime.) The 19th century

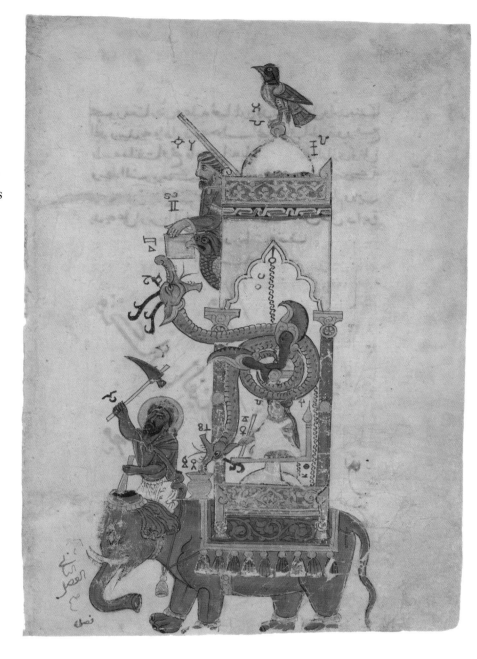

chimed status with magnificent standing clocks glossed with tour de force marquetry and gold filigree dials. Marvels, too, the clever timepieces that insinuated the Jesuits into Qianlong's closed court and galvanized artisans from every applied art to form an imperial collection that commanded its own palace. Marking Gilded Age status, Cartier's Mystery Clock, with its invisible mechanism magically floated in crystal: after J. P. Morgan acquired one, the King of Albania, the Queen of Spain, the King of Greece, and the maharajas of Jaipur, Kapurthala, and Nawanagar, joined the waiting list.

Addiction moved to the wristwatch—a subtle coat of arms invented to circumvent a Calvinist ban on jewelry. A famous rivalry between American moguls Henry

ABOVE ISMAIL AL-JAZARI'S WONDROUS WATER-POWERED ELEPHANT CLOCK, THE FIRST TIMEKEEPING AUTOMATON, MARKED THE INTERVALS WITH A CHIRPING BIRD AND A HUMANOID ROBOT.

LEFT CARTIER MYSTERY CLOCK: THIS SIGNIFIER ELEVATED DETROIT'S ANNA THOMPSON DODGE.

Graves Jr. and James Ward Packard, both avid collectors of Patek Philippe's bespoke marvels, led Graves to order an "impossibly elaborate" Supercomplication that would eclipse Packard's. By the time of delivery Packard had died and, in 2014, the trophy fetched $24 million. The true winner was Patek's Grandmaster Chime, sold in 2019 for $31 million, whose 20 complications took 11 years to develop. Shattering other records, the mechanical intrigues of TAG Heuer, Zenith, Girard-Perregaux, Jaeger-LeCoultre, Tissot, Audemars Piguet, and Vacheron Constantin engage moon phases, multiple time zones, perpetual calendars, solar power, multi-touch screen functions, tourbillons water-proofed to a depth of 3,000 meters, chronographs timed to 1/100th of a second, and minute-repeaters with 720 striking sequences. Far surpassing their function, these ticking miracles involve more elements than a car, parts finer than a hair, up to 36,000 beats an hour, and 5,500 operations worked by 20 different watchmakers.

Tobacco—An exotic addiction brought from the Americas to Catherine de' Medici by French ambassador Jean Nicot, and to the Tudors by court favorite Sir Walter Raleigh, the snuffing and smoking of tobacco leaf gathered a clubby elite. Credit the Tobacco College founded by Friedrich Wilhelm I for bringing the activity to the streets. First to inhale its revenue potential, Peter the Great canceled the penalty offing a transgressor's nose, slapped a hefty tax on imports, and pressured the clergy to take up smoking. Duly compliant, Benedict XIII lifted a papal ban on the practice and his blessing went viral.

The habit proved pricey—France paid Benjamin Franklin 2,000,000 livres for 5,000 hogsheads of Virginia leaf, effectively underwriting the American Revolution. Snuffboxes worked by such as Wenzel Jamnitzer and Johann Neuber into exquisite geometries of precious materials were the day's top collectibles. Frederick the Great accumulated over 300, sending a selection to await him when he traveled. The Prince Regent's insistence on a different one each day of the year furnished six cabinets. Their value conveyed value. Lovers exchanged *tabatières* painted by Greuze or enameled by Fabergé; those Catherine the Great gave her

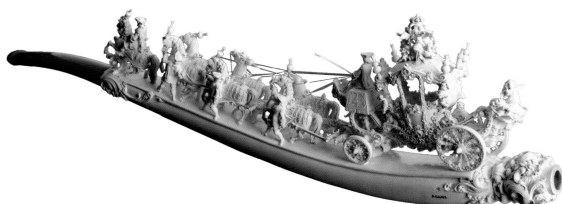

favorites were circled with diamonds. Sophisticates matched one to each outfit and showed them around, occasioning Beau Brummell's famous remonstrance to a boor attempting to pry one open with a knife: "Not all the world is your oyster, sirrah!"

Become status accessories, pipes and cigar holders were flourished into miniature sculptures—the lion's-head Meerschaum reaching staggering prices. Cigarettes occasioned pencil-thin Namiki lacquer holders and the sleek Dunhill platinum lighters designed for the likes of Frank Sinatra and Marlene Dietrich. In China, pushback against Ming Emperor Chongzhen's ban on tobacco produced wondrously carved snuff bottles, and Mughal India's involute hookahs ceded to princely cigar boxes passed down the table after dining—by the Maharaja of Gwalior on a small silver train.

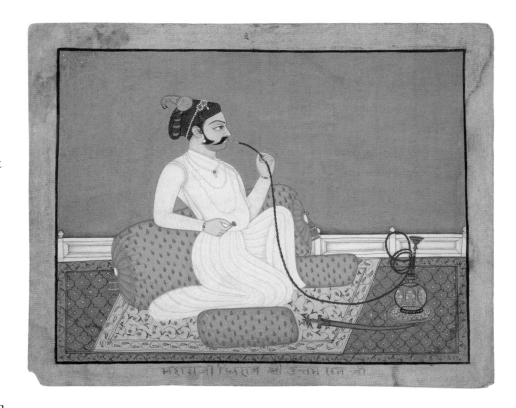

RAJPUT THAKUR UTHAM RAM AT LEISURE, SMOKING AN ORNATE SILVER BIDRIWARE HOOKAH.

Sports—Ancient contests had been largely ceremonial. Like the pre-Columbian ball games exacting combat to the death, Olympia's Panhellenic Games were first staged for the gods. But by 776 BCE the five-day event served more as a showcase for the mind-body-soul exercise informing the Athenian ideal of *arête*, attracting such crowds as to constitute the world's first sporting spectacle. Thenceforth, every

THE MAHARAJA OF GWALIOR'S BANQUET TABLE SET WITH THE TRACK THAT TOOTED A SILVER TRAIN AROUND CARRYING PORT AND CIGARS.

four years, muscled Greek youth competed for laurels inflated from a leafy crown to their likeness sculpted by Praxiteles and rations for life. A Laconian advised the day's hero: "Die, Diagoras, for thou hast nothing short of divinity to desire."

Leave it to Nero to define heroism as winner-take-all. Rescheduled to convenience him, the Olympics were transferred to Rome's Circus Maximus and staged for 250,000 spectators with events he could win. Tellingly, the heroic ideal died in translation. Although the patricians regaled the gladiators and the likes of the boxer Melankomas, they declined to compete, associating combat in the arena with slaves.

Battle-torn Europe held sports dangerous (Louis X had succumbed to pneumonia after a long match of *paume*) and, worse, distracting. Edward IV moved to protect archery (England's frontline defense) by banning all ball games, until Henry VIII revived them, albeit for the court only, with "real" (royal) tennis. A knightly obsession with pageantry embraced tournaments—combats that threw valuable horses at a confection of glory. A spectacle offered by the wealthy knight Bertrand du Guesclin laced the banners with gold and the field with 20,000 pieces of silver. In 1469, at the Piazza Santa Croce, Lorenzo de' Medici irradiated his opponent in a white satin cape, a plumed helmet, and a belt buckle flashing the Medici diamond. Thus did jousting rise to the fullest expression of gallant valor—until 1559, when Henri II, before the glittering court, was fatally wounded, effectively bringing the heroics to an end.

A more enduring luxury based on war, the royal hunt was held "sport of kings" for the land given it and the implication of a chase not undertaken for food. Idealized as the soul's pursuit of the gods, wild animal hunts were staged for bravura. Felled prey was honored—Hadrian founded a city to commemorate a she-bear. The Middle Ages worked the stag hunt into an alpha-male power display, reserved to the court until Louis XIII opened the sport to the gentry (famously titling an attendant "Duc de Saint-Simon" for devising a way to change horses without dismounting). Know the lords by the numbers: Gaston III, Count of Foix, maintained 1,600 hounds, the dukes of Bourbon stabled 240 coursers, and Louis XIV led a chase that by century's end entailed 2,000 horses, 3,000 trainers, and a bevy of grooms. The brinkmanship

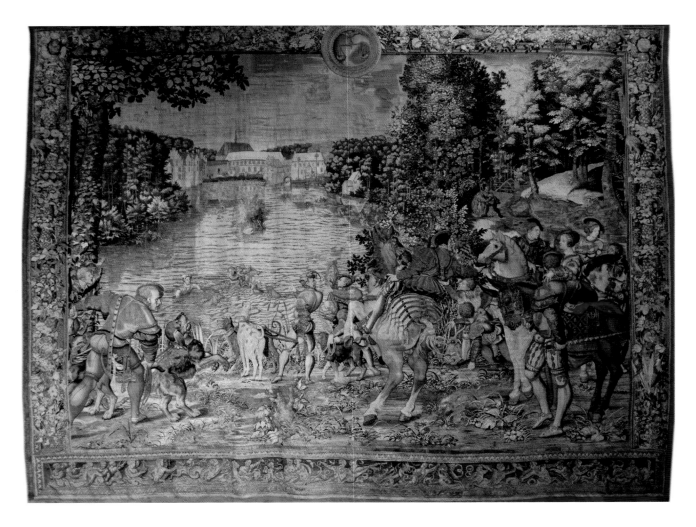

detailed in the 12 tapestries vaunting Habsburg prowess took a predictable toll— Emperors Theodosius II and John II of Trebizond, King Fulk of Jerusalem, Louis IV of Bavaria, and Poland's Casimir the Great all died at the hunt—but the enduring prerogative lathered Henri IV's Gallery of Stags with antlers, and the halls of Konopiště Castle with tokens of Archduke Franz Ferdinand's tally of 300,000 stag, boar, and bison.

Commoners enjoyed hunting privileges at the ruler's pleasure: in 1015, Doge Otto Orseolo exacted the head and feet of boar killed within his sphere of influence. Foxhunting was more accessible, but prohibitive (maintaining just the hounds cost half a family's yearly stipend) and the acreage allotted it was unconscionable: Soho (from the Norman call "SoooHooo") references the chunk of London reserved for the royal hunt. The ongoing move to ban the 400-year-old Beaufort Hunt was less about compassion for the fox than denial of public access to the duke's 50,000 acres.

The public be damned! Good sport made good show. Gleefully noted by a monk from Saint Gall, a delegation of Venetians rode out with Charlemagne in plumage that "heavy rain and the rigors of riding through dense forest completely trashed." Badges of sovereignty, Burgundy's kill knives were sheathed with ivory, Henry VIII's hawking glove flashed 52 orients, and Louis XIV's cormorants were collared with gold. Hunting motifs overtook everything, from the tablelegs at royal hunting lodges like Amalienborg and Stupinigi, to Empress Maria Theresa's Claude Du Paquier– gilded dinner service, the towels at Baron Ferdinand de Rothschild's Waddesdon Manor, and the carpets at Baron Eugène Roger's Château de Vouzeron.

The East rode the hunt to the pinnacle of glory. The Shang battled tigers from war chariots; the Tang shaped vast hunting parks around bosquets for deer to emerge through and created lakes to attract them to where the court paused mid-pursuit. The Great Khan closely guarded the prerogative, forbidding his subjects to hunt within ten miles of where small animals were trapped to feed the 100,000 raptors and 10,000 falconers brought north in winter. For big game, Marco Polo relayed, Kublai set forth with his family and attendants on pavilioned elephants, "enjoying himself to a degree that no person who is not an eyewitness can conceive; the excellence and the extent of the sport being greater than it is possible to express."

Persian miniatures depict Sasanian euphoria—the resplendent attendants, the caparisoned horses, the splash of flying fish, the swirl of lions and roebucks, the headlong rush of trained elephants driving wild boar to the king. The Ottomans staged elaborate hunts in stocked parks, while Mughal India grew the sport into a splendiferous testament to the ruler's control over nature. Shah Jahangir's *Book of the Chase* depicts the glory—emperor, retinue, and elephants at the charge in a plenum of silk.

Falconry, introduced to Japan in 359 by a Korean courtier, constituted a king's sport for the number of trainers and acreage allotted it. Taken up by Akbar, the luxury had presented most fully at Fatehpur Sikri until the Emirates opened the royal hunting grounds to wealthy enthusiasts. Jetted like movie stars to perform

THE 400-YEAR-OLD BEAUFORT HUNT, A CONTENTIOUS SYMBOL OF PRIVILEGE FOR ITS INORDINATE COST AND THE 750 SQUARE MILES OF DUCAL ACREAGE BARRED TO THE PUBLIC.

SHAH JAHAN HUNTING
BLACKBUCK WITH
CHEETAHS: PANOPLY
STAGED TO MANIFEST
MUGHAL VALOR
AND RULE OF THE
NATURAL WORLD.

at destination events, falcons constitute the UAE's national bird, enshrined in the contour of Abu Dhabi's Zayed National Museum.

Lesser fowl scored with tally. The duck shoots staged for British VIPs by the maharajas of Bharatpur were renowned for the count: in 1938, Lord Linlithgow bagged 4,273 birds. To show Sir Henry Wheeler that Bihar had the best shoot in India, the Tekari Raj directed: "Partridge shoot for Governor three months from now at all costs." Said governor brought down 500 of the imported 5,000 partridge in four hours and declared it the best shoot he'd had anywhere. The Maharaja of Orchha assured his own tally from a Cadillac V16 fitted by Pininfarina with gun compartments. In Hungary, a shoot arranged by Baron Maurice de Hirsch for the Prince of Wales downed 11,000 partridge in five days: another staged in 1932 by Count Elemér Lónyay felled 2,384 rabbits in six hours. Overriding all was the tiger shoot, a heinous exercise in brinkmanship that saw the Maharaja of Rewa rack up a total of 109 white tigers. The largest were reserved for visiting VIPs, all so keen on a trophy that drugged buffalo were left out for bait and tape measures given an 11-inch foot.

Tycoon America hastened to add hunting grounds to its toys; Alfred Lee Loomis bought Hawaii's vast Hilton Head for the purpose. Restless barons staged lavish hunting parties. Sir St. George Gore trailed 20 red wagons, 112 horses, 14 deerhounds, trainers, cowboys, and cooks across the Great Plains for two years, then offered the gear to Fort Union for a modest sum that the commander refused—so angering Gore that he incinerated the lot and sailed off to Ireland. Those seeking adventure went

SHAH JAHAN RECEIVING A FALCON FROM HIS SON, DARA SHIKOH: FALCONRY, AT ONCE SPORT AND STATUS EMBLEM, ENTAILED EXTENSIVE TRAINING, MAINTENANCE, AND LAND.

to Africa to bag the "Big Five." The 77 trophies racked up by Theodore Roosevelt and his 250 bearers anchor the collection of the Smithsonian Institution.

Concern for living dioramas was a wake-up call. Dwindling wildlife populations demoted the hunt from a metaphor for paradise to one for predation, and repurposed the big game safari. Laura Corrigan (the American arriviste known for agreeing to lease the Grosvenor Square mansion of King Edward VII's former mistress if it included the guest book) set off to Africa with a doctor, nurse, manicurist, hairdresser, dressmaker, two maids, two secretaries, and three waiters—and shipped her take to a zoo, along with $5,000 for food.

Commitment to conservation introduced the luxury of nature as Eden. Guests stayed at photo-op hunting lodges like Mombo, Serengeti, and Singita for their multi-course banquets, personal butlers, and tents fitted with Venetian chandeliers, content to return home with the Big Five on postcards. The likes of Texas billionaire Dan L. Duncan, who shot moose from a helicopter, were shut out; Juan Carlos I's African elephant kill occasioned an unprecedented royal apology; and the slaying of Cecil the Lion triggered world outrage. Mexico's once-bloody Charrería now rewards horsemanship, and Spain's once-glamorous bullfights have been sidelined.

Conservationists proffered new tallies. In Connecticut, Marcella and Peter Leone spent "many, many, many millions" on a nonprofit sanctuary for endangered wildlife. In Mozambique, Idaho entrepreneur Gregory C. Carr devoted much of his fortune to resurrecting Gorongosa National Park. In Gabon, London businessman Damian Aspinall purchased a million-acre habitat and bred lowland gorillas to repopulate it.

Climate change recalibrated recreation as decisively, discouraging even the status-ranking golf course. The masterfully designed one at the Annenberg

Sunnylands estate that had brought eight presidents to Palm Springs was rethought as a center for world peace. Taking over, extreme sports shifted the goalpost to "personal best" with records wrested from exorbitant hang gliders, carbon fiber bicycles, and fiberglass skis. Triathlons added the luxury of a coach, masseur, physical therapist, and chef. Competing at sea led Ernesto Bertarelli to block Lawrence Ellison's $10 million trimaran, *BMW Oracle*, from qualifying for the America's Cup—landing both egos in court: "The rational in me should have said this was nonsense," said the Swiss billionaire, "but you just get addicted." Today's jousting ground is the seabed. Blasting by director James Cameron's submarine dives to "deeper than anyone has been before," Google's Eric Schmidt bankrolls an oceanography institute and hedge fund titan Ray Dalio's OceanX is exploring the world's ocean floor.

Gaming—"I became very obsessed by the casino," confessed the artist Francis Bacon. He had company. Betting on odds and evens is innate observed 17th-century philosopher Thomas Hyde of a compulsion that dates to the first toss of a pebble. Unlike the professional bet that is based on studying the odds, the all-or-nothing wager, placed with a disregard that invites ruin, is a proven addiction. The argument against both, that money could be better spent, puts all forms of gambling squarely in luxury's lap.

Games of chance took hold early. The Chinese game of Go opened history, Queen Hatshepsut played a form of backgammon, and dominoes trace to Tutankhamun. Dicing gripped ancient Egypt, Greece, and India, and flamed Rome like a fever. Julius Caesar coined "toss of the dice" and "it's dicey," Claudius devoted a book to the pastime, and Commodus accorded it five rooms in his palace. Mesoamericans risked their worldly goods on one throw, Germanic tribes staked their liberty, and many a title lost castle and fortune. Even knights exacted a forfeit, except from the ladies.

RIGHT ACHILLES AND AJAX PLAYING A BOARD GAME.

BELOW SOUTH NETHERLANDISCH PLAYING CARDS, LAVISHLY ORNAMENTED, WERE DISPLAYED LIKE ARTWORKS BUT RARELY PLAYED.

The predictable edicts banning the "devil die" moved addiction to chess—a game-of-kings battle strategy filtered in from the East.

Bored courts embraced card games. Elegant, said Voltaire, that the Duke of Lerma, when entertaining the brother of Louis XIII, threw 2,000 gold *Louis* on the gaming table for the prince's attendants to wager with. Base, alleged Saint-Simon, that Louis XIV made gold the collateral for all debts but his own. Foolhardy, all agreed, of Holland's Count William IV to have wagered successfully against Hungary's Louis the Great, then embarrassed the king by giving away his winnings. Defeating a monarch was a delicate matter. When the Sun King rejected his offer of finely engraved Spanish pistols to settle a forfeit, Duc Louis de Rohan-Chabot tossed them out the window, crying: "Since your Majesty refused them, they are worthless." Duc Armand-Jean de Richelieu had to swallow surrendering 13 Poussin paintings to the king, and Marie Antoinette stopped losing 500 louis d'or nightly on faro only by taking up billiards, with a jewel-crusted cue. The queen best loved a good wager, famously betting that architect François-Joseph Bélanger couldn't erect a pavilion at Bagatelle in nine weeks—he did. Naturally, the veteran must appear blasé. Madame de Montespan once dropped 700,000 écus at *bassette* and recouped 20 times that without batting an eyelash.

A luxury for the solvent, gambling for others was a curse. So did the moralist Girolamo Savonarola fling gaming tables into his Bonfire of the Vanities, and so could the future George IV settle his gambling debts only by marrying the unlovely but wealthy Caroline of Brunswick. Catherine II banned betting on card games, saying, "The noble who loses his fortune gambling will have to sell his village, which fellow nobles may not be able to buy, so it will go to a merchant." Risk moved to Venice, sending the fast crowd to the Ridotto casino and society to high-stakes

*If you are first, it's a race.
If not, it's just sailing*

RICHARD BRANSON

casini, where, in one fateful card game, Tiepolo's wife wagered and lost the family home. Another cavalier bet cost the Barberini, the famed Portland Vase, owned by the family for 150 years.

A bagatelle for the English, who embraced all forms of chance to the brink of disaster. Between ages 21 and 24, the 3rd Duke of Bedford forfeited his fleet, two London boroughs, and more, until (happily for the lineage) he died. In 1719, a crippling gambling loss bound the 2nd Duke of Richmond to betroth his heir to the wealthy Earl of Cadogan's 13-year-old daughter. Robert Walpole relayed the gaming culture fostered in Bath by the racy Prince Regent, which led the ladies "to sacrifice the future of their children" on whist, a card game that "spread across the nation like opium." As dangerously thrilling were baccarat and the fast game of E-O that bankrupted Beau Brummell while leaving moderate players to cribbage, roly-poly, French ruff, faro, and lanterloo. Upon undertaking his dictionary, Samuel Johnson had to hire a specialist in "all words related to gambling and card-playing."

With no opportunity overlooked to mark status, gaming accessories grew opulent. The Romans played with dice cut of crystal, the Mughals favored Damascene-inlaid chessboards (excepting Akbar, who moved living men on a checkered floor), and the Russian court engaged carved ivory gaming chips (excepting Catherine II, who used diamonds). Hand-painted playing cards were a greater luxury. Charles VI owned a set that cost the equivalent of a coach. Furniture followed—card tables inlaid with porcelain and marquetry, and billiards tables carved of mahogany. Ingenious engineering supplied dice-throwing machines to rest the wrist, and intricate chess-playing automatons such as Wolfgang von Kempelen's tricked-out "Turk," which toured Europe for years, coming out of retirement in 1809 for Napoleon to defeat it in three illegitimate moves.

19TH-CENTURY GILDED-METAL CHESS SET, THE BOARD GAME EVOLVED FROM MILITARY STRATEGY AND PLAYED WITH PIECES RANKED AS ON THE BATTLEFIELD.

Addicts for speed, meanwhile, embraced everything swift; birds, ferrets, dogs. Baghdadi hotelier Sir Victor Sassoon assigned his racing greyhounds a cadre of groomers, trainers, and nutritionists. India's fanatics went all out: "Import the best dog," urged Kushaldeep Singh Dhillon, "and the best handler. It's not the dog competing; it's the man's

MOLLY LONGLEGS
WITH HER JOCKEY:
ANY WHO COULD
AFFORD A CHAMPION
THOROUGHBRED
COMMISSIONED GEORGE
STUBBS TO RECORD IT.

name competing." China besotted on racing pigeons, raising the price of champion
stock to $35,000. The Emirates backed pedigreed camels, symbol of Bedouin wealth
become trophy. Dubai's Crown Prince Sheikh Hamdan bin Mohammed bin Rashid Al
Maktoum paid $2.2 million for a champion.

Trace chariot races to the horses galloped to Rome from the steppes, and
flat racing to the thoroughbreds bred for speed 3,500 years ago by a Bedouin
sheik. Purses soared after Queen Anne sanctioned betting at Ascot, and inflated
beyond measure at Ferrières, Longchamp, and Chantilly, where Baron Édouard
de Rothschild and the Aga Khan had developed lavish stables. Track fever followed
fast money to Africa, Australia, and in North America went professional to give
barons a new marker. O. H. P. Belmont folded stables into the ground floor of his
mansion; Adolphus Busch gave his stables stained-glass windows by Tiffany; Alfred
G. Vanderbilt fixed solid-gold nameplates to the stalls, and Paul Mellon served dinner
off the gold plates his horses had won.

The rarified world of polo called on bottomless pockets. Sir Pratap Singh of
Jodhpur led with 150 pricey ponies until Argentina's Heguy clan gathered twice that,
at $250,000 each—a bar Adolfo "ten-goal-handicap" Cambiaso tripled. Champion
jumpers cost more—up to $500,000 each for those owned by Britain's royal family—
and there's no ceiling price for a thoroughbred. Dubai's Sheikh Mohammed bin
Rashid Al Maktoum invested over $250 million in three-year-olds that *might* win the
Eclipse Stakes.

To afford the luxury of losing is to invite the relish of winning. The Emirates Rugby World Cup purse exceeds $10 million. Greater still is the payout for auto racing—the juggernaut launched when the 9th Duke of Richmond careened a band of Lancia enthusiasts around Goodwood—reaching $23.6 million for the Nascar Daytona 500.

Entailing less maintenance but more nerve, high-stakes roulette trumped all. The Casino of Monte Carlo gathered the titled and thrived on their losses (a prince of Nepal parted with up to $20,000 daily). So did the principality's jewelers. Cartier, for one, supplied movie mogul Darryl Zanuck with a large enough diamond to reconcile ladylove Juliette Greco to the $200,000 he had gambled away.

The English preferred a good wager—it mattered little on what. Robert Walpole's grandson George wagered and lost Houghton Hall's historic stone staircases (whose removal bankrupted the winner). The working class was as prone; oddsmaker Ron Pollard's belief that "the public would gamble on absolutely anything" launched a lucrative betting industry. Charles James Fox introduced New York to "gentleman's bet" with a pledge in The Brook's betting book to seduce a pretty thing above the world's highest mountain. He took girl and witness into a hot-air balloon, and below the entry penned, "Won."

Colonial America had been risk averse. Even the genteel game of billiards had gone underground, until the respected Virginia planter William Byrd II displayed a fine table, moving the Van Rensselaers and their circle to join suit. Faster times took gamblers out west, to silver mining towns drunk on $10,000 cash bets. At Bowen's in Santa Fe, John Dougherty raised Ike Jackson's deed to his Texas ranch with one to the Territory of New Mexico that he made its governor sign at gunpoint. A game of five-card stud won Texan H. L. Hunt his first oil well, and Hollywood producer Jack Warner's poker debt released bankable Bette Davis to Sam Goldwyn for the Oscar-nominated *The Little Foxes*. Illinois barbed-wire salesman John W. Gates bet on anything (famously winning $50,000 on which raindrop would slide down a window first) and parlayed his poker skills into a $50 million oil company. Fools for chance still took him on. One fatefully called tails in a coin flip, to be known ever after as "the man who lost $40,000 in less than 10 seconds to 'Bet-A-Million' Gates."

The action moved to casino resorts rigged for addiction. The no-limit Texas hold 'em that placed all chips on one card brought even the seasoned gambler Major Riddle close to bankruptcy. High rollers embraced "high-minimum bet appeal" baccarat. Donald Trump's Atlantic City casinos let Akio Kashiwagi play $200,000 a hand provided he double a starting-stake of $12 million before quitting or forfeit all. The "whale" bit—"His nostrils were wide open; he was hooked and going down"—then bailed, but the establishment never pressed for payment, certain that Kashiwagi would return.

Sign Up, Play, Change Your Life

CITY OF DREAMS CASINO, MACAU

Las Vegas moved on to dress risk as a luxury brand, promoting itself as a "full luxury resort" with boutiques, museums, and fine dining. Steve Wynn crowned himself king of developers with a "sky's the limit!" eponymous hotel-resort evoking the Parthenon, and the refulgent Bellagio, whose dancing fountain Steven Spielberg called "the greatest single piece of public entertainment on Earth." Wynn compared his "wild ambition" to that of the emperors: "That we will be the most beautiful place in the world was in my heart every second of every day." Just as Egypt and Rome were the wonders of their day, "this is our time, our place." Annoying that archrival Sheldon Adelson had thrown $17 billion at an eight-hotel entertainment complex in Macau led by the world's "largest inhabited building." Said Adelson, of casinos projected for Singapore and beyond, "I would like to leave a visible footprint in history."

The 2008 recession hurt: the big players, nonetheless, followed Wynn's axiom of human behavior to "come back a week later." Billing the seeker of "life-changing money" as "king of players," "luck" as a mainstay of the American dream, and "risk" as a commodity, raised U.S. annual spending on gaming to $160 billion and, after digital sports betting elbowed in, to the stratosphere. A solitary affair, online gaming confirmed that gambling is ingrained. Fantasy baseball and football went viral, with fans wagering even on players out with an injury. Initially banned in the U.S., web casinos went abroad, spurring a cyber-bet jackpot syndrome said to equal trading stocks: "Trying to stop Internet gambling is akin to trying to hold a wave on the sand," cautioned MGM Resorts' Alan Feldman of the trillion-dollar industry built by electronic wallets. Just ask the Chinese, inveterate gamblers for 3,000 years, who toast not to health, but to luck.

THE BELLAGIO HOTEL, WITH ITS SIGNATURE DANCING FOUNTAINS, SET THE BAR FOR LAS VEGAS BLING.

CHAPTER IX

I suggested she take a trip around the world. "Oh I know," returned the lady, yawning with ennui, "but there's so many other places I want to see first."

S. J. PERELMAN, *WESTWARD HA!*

GRAND TOURING

The earliest voyagers were seekers of fortune and warlords scouting new terrain. Travel came to luxury with empire. The Parthians traversed holdings extending from Persia to the Indus River with 200 chariots for the court, 2,000 horses for the servants, 1,000 camels for the luggage, and 2,100 footmen for dominion. The Romans toured outposts as if on parade. Pulled by silver-shod oxen, Nero's chariot trailed 500 carriages, 1,500 acrobats, musicians, and attendants, and the ever-exigent Poppaea, with 300 mules for her baggage and 200 donkeys for her milk baths. Visiting far-flung possessions was costly. Emperor Harshavardhana toured North India with hundreds of attendants—all fed and lodged. The Great Khan trailed his entire household and carts carrying tents 20 feet in diameter that took two rows of 11 oxen to pull.

Voyaging, pre-photography, was deliberately promotional—a spectacle staged to attract cheering crowds. Imprinted on history is Catherine the Great's triumphal tour of the Crimea. In January 1786, the empress descended from her gilded coach and set out with her entourage on 150 gleaming sledges to check out Russia's annexed territory and impress her wealth and reach on the world. Micro-managing every stop, Potemkin had arranged for fresh horses (30 for Catherine's sledge alone) and had a mansion built or readied for the overnight stay. The royal coterie partied in Kiev waiting for the Dnieper to melt then sailed downriver with 3,000 liveried sailors in 80 vessels—those for the nobles included an orchestra. After stopping to view naval maneuvers at Kremenchuk, they boarded carriages to tour the villages Potemkin had stocked with waving peasants and fat cows to assure the empress, if none else, of her enlightened rule.

Even foot travel engaged luxury, most memorably when Empress Elizabeth of Russia undertook to atone for her sins by walking 60 miles, a resolve challenged by her corpulence until a compromise was reached that satisfied both God and ruler: trailed by her carriage, the royal penitent walked two miles, was driven back to the palace for the night's festivity, and returned the next morning to where she left off.

Empires shrank, but not vanity. Japan's 19th-century Princess Kazu toured with an entourage of 10,000—a full third at her expense—taking three days to pass through a town.

Europe's first recreational forays were exploratory, the urgent investigations of enlightened minds. Sir Francis Bacon's must-sees included "the courts of princes, treasuries of jewels, robes, rarities, masques, weddings, triumphs, feasts, and capital executions." Widening networks of paved roads introduced the pleasures of sightseeing. Leisured gentlemen would visit scenery theretofore bypassed on the way to a monument, probe ancient culture at Queen Maria Amalia's ambitious dig at Mount Vesuvius, and stop off at cozy inns for comfort fowl and fair.

Intrepid eccentrics ventured farther. In 1813, inspired by the 14th-century voyager Ibn Battuta, Lady Hester Stanhope sailed to Morocco, hired 20 valets, 12 bodyguards, cooks, grooms, 22 camels, and went to Palmyra to shop. First to cross the Sahara, Victorian trailblazer Alexandrine Tinné took along 36 trunks and a chambermaid to frill each campsite with lace tablecloths, silver dinnerware, a porcelain tea service, copper bathtub, and a library.

Far-flung travel entailed ranking accessories—monogrammed trunks, nécessaires fitted for toiletries, and matched luggage for the accessories (totaling 135 cases for the Windsors) that called on cadres of porters, and for such as Douglas Fairbanks and Mary Pickford, a second hotel room. Louis Vuitton encased everything—Madame Talon's postcards, Marie-Laure de Noailles's gloves, Jacqueline de Ribes's hats and, for Turkey's Youssuf Kemal, 216 sheaths for fishing tackle—which sank at sea and were re-ordered in full the next day.

High-profile transport evolved with the times but remained grandly promotional. The horse-drawn carriage, when no transport was swifter, flashed through the world's capitals as an extension of the ruler—literally, when Elizabeth I had the tails of her six Hungarian Greys dyed the same red as her hair. Long-distance coaches were upholstered into traveling thrones, and city equipage was puffed into high traps that "perforce," wrote a New York columnist in 1894, "let a gentleman look down on the commoner." One knew squires by their gigs and nobs by their rigs: that of Moritz, Prince of Hesse, was gold-leafed; the one parading Madame Valentin through Longchamp was of

ABOVE
LOUIS VUITTON LUGGAGE: NO SOPHISTICATE CROSSED THE OCEAN WITHOUT A SET INITIALED *LV.*

RIGHT SOUTH GERMAN *NÉCESSAIRE*: 18TH-CENTURY TRAVELING CASE FITTED WITH GOLD UTENSILS AND RUBY GLASS CONTAINERS.

porcelain; the lacquered affair trotting merchant John Hancock, his coachman, and two footmen around Boston was a bespoke shade of green. It was waiting list only for a Brewster & Company coach glossed with the family coat of arms, and there wasn't a Yankee gal who didn't hope to be driven to the races in a high-style Tally-ho.

Steam ushered in the glamour of express trains boarded from industrial palaces like the Yaroslavsky Terminal, Gare du Nord, Victoria Station, and St. Pancras—all so festooned with finials, gargoyles, chandeliers, and stained glass that restoring the latter would cost $1 billion. Rail cars, launched to take coals from Newcastle, had remained common transport, until James de Rothschild gave France a network of tracks and outfitted an entire train for himself. Overnight every crowned head in Europe had to have one. Become the new status marker, private rail was given right-of-way—until the fateful day Baron James was invited to Belgium to dine with the king. On vacation in the country, he had to take a regular train and was held up in Lille. Furious, he asked why. "Sir," cried the engineer, "told your personal cars were arriving from Paris, we held up the others," whereupon the baron's train barreled by with his valet in the smoking car, speeding to Brussels with his

MIDLAND RAILWAY, ST PANCRAS. The largest single span Passenger Station roof in the world.

A private railroad car is not an acquired luxury. One gets used to it right away.

ELEANOR ROBSON BELMONT

master's formal attire. The tails arrived in time; the baron did not, and never after was private rail granted priority.

There was no stopping America's parlor cars—customized by Pullman, they were the day's must. Railroad titan Cornelius Vanderbilt owned a complete train; others customized railcars. Adolphus Busch had his parlor car lined with mahogany and piped with chilled beer, Joseph Widener lined his dining car with gold sconces, and mining mogul James B. A. Haggin gave his a French chef. Lillie Langtry so weighted her blue Lalee with a moiré-padded salon, full kitchen, and overwrought guest suites that it had to detour to reinforced bridges. Fortunate the traveler who could afford the luxury of the Twentieth Century Limited's barbers, valets, maids, library, and copious buffets, but even lesser folk could access panoramic views from the Super Chief's astral dome, and stop off at any station on request. Travelers abroad railed from Paris to Istanbul in the mahogany-and-Lalique splendor of the Orient Express, or from Leningrad to Moscow in the velvet-seat, pink-lampshade elegance of the Red Arrow, along the ruler-straight line drawn by Nicholas I so that curves wouldn't trouble his sleep.

No form of transport was neglected. Venice ranked with gondolas lacquered for the elite and gilded for the doge. When bicycles were the thing, status was marked by the models and gear. Diamond Jim Brady asked Tiffany & Co. for a pair flashed with jewels, which the purveyor to royalty refused, so Brady ordered them elsewhere.

Luxury was better served with the motorcar. Shortly after the first lunatics careened along dusty roads in sheepskin and goggles, nothing ranked higher than a mansion on wheels—most visibly, a $4,000 Pierce-Arrow fitted with a brass-and-leather interior by Hermès. It fully distinguished that the Van Buren retreat in New Jersey garaged 70 automobiles, and that William Leeds's Long Island estate held 100 Lincolns. The 1957 Cadillac Eldorado introduced the luxury of "options." Chrysler weighed in with the "loaded" Imperial, pitched to Frank Sinatra by chairman Lee Iacocca as having "more luxuries standard than any car in America." (Sinatra's reply: "It looks rich.") Across the pond, Daimlers transported Kaiser Wilhem II, and Isottas, King Farouk. Ettore Bugatti produced limited editions of the Royale, reserving one for himself which, after he died, his son Jean wouldn't sell: "The boss is dead; the car is dead too."

A Rolls-Royce outclassed all. The activist-author T. E. Lawrence wrote in *Seven Pillars of Wisdom* that a Rolls in the desert was more precious than the most precious ruby. He was referencing a lifetime guarantee of repair and rescue that extended to the Sahara, and also its workmanship. Each car was detailed with walnut from a specific tree in the Caucasus that had been cured by exposure to salt air, split to match both sides of paneling, and stored for repairs. The body was painted 14 times

AIRFLOW EIGHT
6-Passenger Sedan

THE IMPERIAL AIRFLOW
COUPE: CHRYSLER'S
BID FOR AMERICA'S
CLASSIEST CAR.

over and slightly rounded in keeping with the Greek theory that flat surfaces appear geometrically incorrect. Rolls-Royce's bespoke policy supplied a mirrored interior to William Randolph Hearst, a gold-plated chassis for the Maharaja of Jodhpur, and, for the Maharaja of Nabha, a swan-shaped chassis. One-upmanship called for several. French decorator Jean Patou took two to the South of France: a white one for fair weather, chauffeured by a Moor, and a black one for rain, chauffeured by a Swede. To simulate carriage travel, the 12th Duke of Bedford kept four: one to start the short journey from London to Woburn, a "fresh" one to finish it, and two for the luggage. The 2nd Duke of Westminster owned 17, and Maharaja Bhupinder Singh, 27. The Nizam of Hyderabad favored his yellow one for its silver throne, gold rug, and lace curtains, but bought 49 others for variety.

Eastern potentates gathered cars like marbles—Fraschinis, Renaults, and Mercedes lacquered purple, bright orange, or sky-blue. Numbers still rate. Brunei's Sultan Hassanal Bolkiah is said to own over 7,000, including 604 Rolls-Royces, 452 Ferraris, and 21 Lamborghinis. Industrialist Yohan Poonawalla has lost count ("Anyway, I know I've got eight Rolls-Royces"), but so values the $949,000 Phantom engraved "Custom built for Poonawalla" that he had six chauffeurs trained to drive it, and another to trail it in something expendable—"My BMW maybe, or a Porsche." Poonawalla admits his collection is "all about attracting attention . . . people ask me where I plan to drive these cars, what I'm going to do with them. But driving them is not really the point. My passion is just for spending time with them on Sunday morning." Today's special editions, featuring painted interiors or monogrammed headlights, are available on request only. Vintage-car buffs join Jay Leno at the Pebble Beach Concours d'Elegance to parade trophies on the order of a $21.8 million 1956 Jaguar D-type racecar: "It's not a matter of 'I've got this, I've got that,'" noted an English restorer, "One is besotted."

Ambition is a dream with a V-8 engine

ELVIS PRESLEY

OWN A ROLLS-ROYCE WITH A PHANTOM IV ENGINE, AS DID LONDON BROKER JOHN DONNER, AND YOU JOIN A CLUB; PURCHASE SEVERAL AND YOU OWN THE ROAD.

Luxury afloat sailed Alexander the Great's generals in *thalamegos* embellished like palaces and led King Hiero II of Syracuse to build the world's largest ship—too long to berth anywhere, so he gave it away. Cleopatra's silk-shaded barges, replete with libraries, aquaria, copper baths, gyms, and gardens, informed the three infamous pleasure vessels Caligula built at Lake Nemi—each powered by 100 oarsmen and weighted with so many columns, bronze friezes, mosaics, and fountains that they eventually sank.

The advent of steam sped travelers to the colonies in "posh" (*p*ortside-*o*ut/ *s*tarboard-*h*ome) shaded cabins, and across the Atlantic in ocean liners tiered like wedding cakes. Those who could pay ten times a working family's annual income luxuriated in the SS *Kaiser Wilhelm II*'s baroque splendor, the RMS *Mauretania*'s 138-chef table, the SS *France's Beaux Arts* refulgence, or the prodigally reproduced Roman salon on the SS *Conte di Savoia*. None rivaled the 1940s églomisé-moiré Lalique glamour of the short-lived SS *Normandie*, but luxury's timeless metaphor remains the leviathan fashioned by 10,000 builders from Belfast. On April 14, 1912, the brand-new *Titanic* serenaded its A-listers through a Versailles-styled salon to a white-tie dinner offering oysters à la Russe, chocolate-painted eclairs, Champagne, wine, and spirits—then struck an iceberg.

Ultimate status mandated a large private yacht, raised to a floating salon from the Atlantic-racing monohulls that had pitted American magnates against the Earl of Crawford and the Kaiser. Shipping titan Cornelius Vanderbilt led off with the *North Star*, given a Louis XV décor to best Queen Victoria's twin-paddle steamer. Newspaper baron James Gordon Bennett Jr. upstaged with the $200 million turbine-steam *Lysistrata*, which boasted dressing rooms and a cow for fresh milk. Emily (Mrs. Richard) Cadwalader's record 408-foot-long *Savarona* floated gold-plated bathtubs

and an out-of-tune organ that took up half the
lounge. Marjorie Merriweather Post prettied the
"even the lifeboats have lifeboats" *Sea Cloud* with
marble tubs, canopied beds, and Sèvres dinnerware.
Defining the luxury, J. P. Morgan allegedly said
of his resplendent *Corsair*: "If you have to ask the
price, you can't afford it." Morgan did say, "You can
do business with anyone, but you can only sail a
boat with a gentleman"—though before William K.
Vanderbilt frilled the *Alva* for a nubile entourage
that did not include Alva.

For *savoir plaire* none bested the Greeks. To
host royalty, Stavros Niarchos had the *Creole* sailed
down to the Mediterranean and the *Gauguin* flown
in from New York. Archrival Aristotle Onassis gave
the *Christina O* an onyx staircase, a lapis-lazuli
fireplace, and an airplane: Richard Burton said
there was no "man or woman on earth who would
not be seduced by the pure narcissism floated on
this boat," and Jackie Kennedy proved him right:
"So this, it seems, is what it is to be a king."

Newer money blazoned. Arms dealer Adnan
Khashoggi had the $70 million *Nabila* painted
silver, and Mexican industrialist Carlos Peralta
ordered the *Princess Mariana* coated with crystals.
Had Roy Lichtenstein painted an America's Cup
sailboat? Greek financier Dakis Joannou had
his yacht dazzled by Jeff Koons. Did Paul Allen's
$250 million *Octopus* measure 414 feet? Lawrence
Ellison had the $300 million *Rising Sun* built
38 feet longer. "I'm a very private person," Ellison
told his designer, "But when I do go to port, I want
my presence to be felt through my boat."

Leaving hoi polloi to the trickle-down luxury
of the 16 restaurants, four swimming pools and
football-length amphitheater aboard the Royal
Caribbean's 18-deck *Oasis of the Seas*, billionaire
mariners competed for the most toys and footage.

*"Whose yacht
is that?"/
"The Duke of
Westminster's
I expect.
It always is."*

NOËL COWARD, *PRIVATE LIVES*

OPPOSITE TOP PARLOR OF THE
SS *KAISER WILHELM II*:
THE OCEAN LINER
DESIGNER JOHANN
POPPE'S SIGNATURE
MERINGUE OF STUCCO,
GILDING, AND VELOUR
THAT LAUNCHED
THE GREAT ERA OF
LUXURY AT SEA.

OPPOSITE MIDDLE
DAKIS JOANNOU'S
YACHT, *GUILTY*, DAZZLED
WITH ART STAR JEFF
KOONS'S TAKE ON
WWI CAMOUFLAGE
TO OBFUSCATE THE
TROPHY ART LINING
THE STATEROOMS.

OPPOSITE BOTTOM THE *OASIS OF
THE SEAS*: TRICKLE-DOWN
LUXURY OF A CITY
AFLOAT, INCLUDING, IN
THE ROYAL LOFT SUITE,
A GRAND PIANO.

RIGHT THE HUNT,
COMMISSIONED FOR THE
SS *NORMANDIE*: ONE
OF THE JEAN DUNAND
ÉGLOMISÉ PANELS
EXEMPLIFYING OCEAN
LINER MAGNIFICENCE.

Insurance mogul Peter L. Lewis rigged his 255-foot-long *Lone Ranger* tugboat with speedboats, a basketball court, a helipad, three staff to a guest, and enough fuel to circle the world twice. Roman Abramovich's 550-foot, $500 million *Eclipse* accommodated a crew of 70, two helipads, and a submarine. Distilling yachting luxury to its essence, Crown Prince Salman of Bahrain commissioned a $7 million Magnum 70 power yacht, lined inside and out with white leather, just to transport the ladies from the shore to his yacht.

Air travel, the innovation that, in 1783, hovered two men over Paris in a hot-air balloon, soared from the Wright brothers' improbable flying machines to the supersonic Concorde that sped the "jet set" to Europe with unlimited caviar. "Premium Class" travel offered Frette duvets (Qatar Airways), private suites (Emirates), and, on Etihad Airways, a shower and butler. Executive charters met elite flyer requests ranging from Dom Perignon to a patch of grass for the dog to "tinkle in nature."

Signature wings evolved from the upholstered Jodels that flew scions, white jacket under flying suit, across the Channel for an hour's gambling in Charbonnières-les-Bains, to the sky's-the-limit private jets that gave Elvis Presley's Convair 880 solid-gold bathroom fixtures, and Saudi prince Al-Waleed bin Talal's $300 million A380 Airbus two master suites, a concert hall, a sauna, a medical facility, and prayer mats engineered to always face Mecca.

Some hold flying itself the top luxury. John Travolta pilots a collection of seven jets and, for 21 years, King Willem-Alexander co-piloted a KLM Cityhopper monthly, incognito. Wenzhou's helicopter elite risked heavy fines to take off at will; said tycoon Guan Hongsheng, who owned three: "Secret flying is like secret love; you do it, you don't tell people about it." Aiming still higher, Cirque du Soleil's Guy Laliberté paid $35 million for a 12-day trip into space, and competing dreams wait-list passengers for Jeff Bezos's $50 million, microgravity Blue Origin flight and a rocket trip to Mars on Elon Musk's SpaceX BFR.

Every trip has a destination and grand touring called on sumptuous ones. To realize a hotel "without equal in the world," John Jacob Astor gave New York's Astor House 24-hour electricity, individual bathrooms, and $20,000 worth of table-silver—a splendor Henry James called "that new thing under the sun, 'hotel civilization.'" Family rivalry inflated William's Waldorf, John Jacob's Astoria, and their mutual, gargantuan, Waldorf-Astoria, into a top-this display of onyx, silvered ceilings, and mirrored tearooms. Top them Vincent Astor did, with the palatial St. Regis, whose gleaming amenities and skylight ballroom outshone even the Plaza, where Alfred Vanderbilt kept rooms—to rendezvous, it was said, with a pretty rider in the park.

THE FASTEST-OF-ITS-CLASS, $7 MILLION *MAGNUM 70,* COMMISSIONED BY SALMAN, CROWN PRINCE OF BAHRAIN, TO FERRY HIS RETINUE FROM THE SHORE TO HIS YACHT.

I want to build the world's most pretentious hotel

MORRIS LAPIDUS

For recreation, America's barons railed around with servants and luggage to take up residence for months at grande dame resort hotels. They stopped at Denver's lavish Brown Palace for the intimate suppers staged by Evalyn Walsh McLean, "waving," wrote a columnist, "the Hope Diamond she had bought from Cartier like a yo-yo." They visited Michigan's Grand Hotel on Mackinac Island for see-and-be-seen high tea on the 660-foot-long porch. They toured to the Broadmoor in Colorado for the racy doings around polo; descended on the Del Coronado in California for seaside bathing with celebrities; headed east to the Greenbrier for its restorative white sulfur springs; and motored down to Virginia for cocktails in the Jefferson's glass-domed Palm Court. Florida offered glamour: in Palm Beach, the majestic Royal Poinciana's 1,700 staff; in Coral Gables, the Biltmore's 250-foot-long swimming pool and 300-foot-tall replica of Seville's Tower of Giralda. Glamour met excess at Miami's Fontainebleau, outré designer Morris Lapidus's "too much is not enough" movie set of "tropical opulence and glittering luxury" wrought of 140 miles of electrical wiring, 25 miles of carpeting, 8,000 light bulbs, 2,000 mirrors, gold-painted statuary, and a photo-opportunity "stairway to nowhere." Taste be damned: "I wanted people to walk in and drop dead."

More thoughtful were the arrangements for personal guests. Bespoke hospitality lodged a tailor at J. P. Morgan's Scotland lodge to provide shooting outfits during grouse season, and made an airplane available at the Clint Murchisons' Mexican ranch to fly the Duchess of Windsor to a hairdresser. To host Queen Elizabeth II

THE GRAND SAN DIEGO DEL CORONADO HOTEL THAT HOSTED THE LIKES OF DOUGLAS FAIRBANKS, RITA HAYWORTH, AND THE NOBS WHO RAILED OUT WITH THEIR SERVANTS FOR THE SUMMER.

THE NEW YORK ST. REGIS: JOHN JACOB ASTOR IV'S BID FOR THE WORLD'S MOST GLAMOROUS HOTEL WITH CRYSTAL, MARBLE, MURALS, AND LOUIS XV FURNISHINGS.

in the desert, Ethiopia's Emperor Haile Selassie helicoptered the royal household to a rushing cascade ringed with air-conditioned caravans—each given a garden, chambermaid, mirrored bathroom, and lighted pathway to silk-tented dining on vermeil engraved with the Great Lion of Judas.

More subtly opulent was the sojourn that Stavros Niarchos arranged for Baron and Baroness Élie de Rothschild on his island of Spetsopoula. Transported from his DC-6 to the Creole in four Bentley Continentals, they found their baths drawn, cases unpacked, and every gown ironed to await Madame's choice. As they dined, all was repacked, sent ahead, and ironed again. Travel as usual for the Rothschilds—what marked was the shoot. In the middle of nowhere, wilted by the sun to a lethargy that even an island stocked with 10,000 Scottish grouse couldn't counter, they came upon the white-gloved majordomo holding the greatest luxury imaginable: a silver pitcher of ice water.

THE OBEROI UDAIVILAS, UDAIPUR: HOTEL BUILT FROM THE GROUND UP ON THE FORMER MEWAR ESTATE TO EVOKE THE MAHARANA'S FABULOUS PALACE, POOLS, AND GARDENS.

Public touring couldn't rival but with the *grand luxe* triad of fine dining, rich lodging, and stylish transport become the affluent voyager's baseline, even group tours sought to replicate the comforts of home. Thomas Cook of London sold out excursions to Greece that omitted notable sites so as to avoid rutted roads.

Predictably, elite travel winnowed out the merely affluent from the colossally rich. Yugoslavia's president-for-life Josip Tito descended from a white train fitted with Tanagra statuary, boarded his white yacht, and sounded a solid-gold bell to cast off for his private island of Brijuni. King Hassan of Morocco installed three floors of his habitual hotels with mattresses, carpets, and ten truckloads of food. Saudi Arabia's rulers took over entirely. Ibn Saud's sojourns at the Negresco in Nice exacted one floor for himself, three more for his household, a red carpet in the lobby, a throne in the elevator, and a bed modeled on that of Louis XIV. At summer's end, the king handed each of the staff a gold watch and boarded his Super Constellation with 440 pounds of strawberries and a cage full of canaries. Son Faisal learned well: disembarking the SS *Independence* in New York, he distributed $21,000 in gratuities—that to the steward could have purchased a Cadillac.

A new priority surfaced after one Jacques Pateille asked a Paris agent to reproduce Jean-Jacques Rousseau's walking trip from Geneva to Lyon. He could not pass a gas station, cross a paved road, or hear a phone, and had to bed down in barns and eat charcoal-baked bread. Peasants were hired to install antiques, hide devices, and mobilize a shepherd with flock to guide their client along three weeks of candlelit dining on remote country roads. "You wonder sometimes," mused Pateille beforehand, "what point there is to all the money you accumulate." He found out when the bill came. Rousseau's idyll of walking through untrammeled nature took hold, nonetheless, and remains a supreme luxury.

Bolder voyagers signed on to one-of-a-kind encounters with Amazonian tribes, or solo treks across desert trailed by a well-stocked conveyance. The jet set joined travel clubs to "collect" countries by setting down in as many as possible. Seekers of "experiential" luxury opted for an Abercrombie & Kent–designed "personal challenge adventure"—say, traversing the South Pole in snowshoes, trailed by a tent and gas stove. For its 150 by-invitation-only members, the London travel agency Earth offered a "luxury experience" too "stratospheric" to divulge.

The traveler who defined luxury, rather, as supreme spoiling sought out palace hotels—royal domains expertly converted to offer the full gamut of luxury, from being handed a key at the Aman Summer Palace to the adjoining Yuanmingyuan garden, to a double bed in Samode Palace's fabled hall-of-mirrors Sheesh Mahal. Grandest are Udaipur's heritage lake hotels that float Rajasthan majesty. Tata's lavish Taj Lake Palace still commands its own island, and the adjacent Oberoi Udaivilas reenacts Mewar glory with a marbled aggregate of terraces, pools, pavilions, and a three-acre garden paradise. Millennials seeking glamour coupled with internet connectivity descend on the $3 billion, gold-domed Emirates Palace for its "world's most expensive" $11 million Christmas tree, the "sumptuous service" of 2,000 staff, and "landmark gigabit wifi."

A new move to tailored luxury has immersed culturephiles in 6,000 artworks at the Omni Dallas Hotel; elitists in the grandeur of Schönbrunn's sole room for

THE EMIRATES PALACE: ABU DHABI'S BELLS-AND-WHISTLES HOTEL-RESORT, ORNAMENTED INTO AN "UNRIVALED ARABIAN FANTASY."

rent; and seekers of "identity refreshment" in Leonardo DiCaprio's "change the world" Blackadore Caye, the eco-resort built on artificial reefs to promote sustainability. Those wanting it all search out island hideaways fashioned by high-profile travelers Richard Branson, Helen and Brice Marden, Robert Oatley, and Julian Robertson to deliver the dream that floated a red balloon over Paris, and beyond.

A king without divertissement is a miserable man

BLAISE PASCAL, *PENSÉES*

FÊTES GALANTES

You're invited! The least gathering occasions anticipation—of hospitality, conviviality, what to bring, what to wear. Fireworks that lit the night, transformative masquerades, fancy-dress balls, all gladdened and marked. A fabulous fête entailed inordinate outlay, but draining the purse to give people who matter a marvelous time signed wealth and largesse. To revel was to defy death; to party was to fully live.

Party is a modern concept: early societies gathered principally to carouse. Queen Hatshepsut's annual Festival of Drunkenness was a ritualized orgy, and Sparta's bacchanals got so out of hand that Lycurgus declared them a public threat. The historian Strabo tells of Nabatean festivities where "no one drinks more than 11 cupfuls, using a different gold cup for each." Sophisticated entertainments awaited divan dining, introduced by the Athenians with music, fine wine, and boar stuffed with quail. Refinement suited Rome's Republicans—a sober lot who discouraged even dancing—but succumbed to the unhinged carousing of its dissolute emperors. In the reign of Claudius the calendar listed 159 holidays, fêted by libertines who ate until they retched and flogged their toy boys to death. Tiberius forced subjects to cavort naked at his banquets; Caligula did his own cavorting—with the wives of his courtiers.

Feudal diversion followed suit as the gentrifying hordes transformed Germanic fiefdoms into hotbeds of debauchery, and the Merovingian court, by all accounts, resembled a brothel. It awaited a lull in warring for the princely houses of Burgundy and Savoy to stage conviviality as we know it—a regalement of dining, décor, and

orchestrated amusements. The Valois scaled up, convoking up to 300 guests to banquets, theatricals, and, for grand occasions, a ball. Among those making history were the 1393 Bal des Ardents, where Charles VI and five courtiers tarred as wild men caught fire and perished (excepting the king, pulled to safety under the skirts of the Duchesse de Berry), and a much criticized affair in Fontainebleau's showy new ballroom that, for the flagrant cost of 60,000 livres, costumed the servants like the courtiers. Under the Stuarts England fêted more crassly, with exploding timbales, and pies disgorging live animals or, from Charles I's wedding cake, an 18-inch-tall dwarf.

BACCHUS, THE GOD OF WINE AND REVELRY, COMMISSIONED FROM CARAVAGGIO TO RELAY THE SAVOIR-VIVRE OF HIS PATRON, CARDINAL FRANCESCO MARIA DEL MONTE.

The court reverses the order of nature,
changing day into night and night into day

LUDWIG ERNST VON FARAMOND

I urge you to entertain

NAPOLEON BONAPARTE

ROMANS OF THE DECADENCE: THOMAS COUTURE'S PARABLE OF AN EMPIRE FELLED BY HEDONISM, EXHIBITED IN PARIS THE YEAR BEFORE REVOLUTION TOPPLED ANOTHER UNBRIDLED REGIME.

Europe's rising bourgeoisie marked by the food, a coarsening of society that in Paris moved Marquise de Rambouillet to dispatch the Marquis to the country and gather her circle to the first-ever salon. She would have adored Versailles: the entire establishment was a party space, its gardens prettied for the *fêtes champêtres* portrayed on its ceilings, and its ballroom mirrored to backdrop the 17 dance styles introduced by Louis XIV's Academie Royale de Danse. It was at such a festivity that Jeanne de Pompadour first met Louis XV, disguised as a hedge.

Rococo amusement called on overnight infrastructure—arches, mirrored pavilions, and, for Liechtenstein's princely parties, a garden folly whose cost, it was said, "could furnish twenty Turkish villages with good mosques." Italy went for glamour—the Venetians coding intrigue with jeweled masks worn only once—while Britain strove for the splendor of costumed quadrilles and chandeliered ballrooms. Imperial Russia pursued glory. The annual balls offered to the public of St. Petersburg by the great houses of Yusupov, Vorontsov, and Sheremetev— each calling on dress and ornament to evoke the year's theme—launched an industry that lifted the entire community. Skewed to vanity, the Romanovs' exorbitant 1903 Costume Ball, profiled by Tsarina Alexandra Feodorovna's $12 million jeweled gown, brought down the dynasty.

Those who are small in spirit,
who are mean, narrow-minded,
or timid, should leave
entertaining to others

MARIE-HÉLÈNE DE ROTHSCHILD

The East fêted differently. Ottomon entertainments, held a matter of honor, served to both divert and anoint. In 1582, Sultan Murad III celebrated his son's circumcision for 52 days in gardens fashioned of marzipan. An 18th-century account of two pashas disputing which hosted most memorably relates the sultan's proposal that each hold a banquet and he would judge: the first offered a magnificent feast, which the second simply replicated two weeks later in every detail of music, décor, and food—yet the sultan chose the latter, "for there is nothing more remarkable than re-creating a sublime experience." China's court festivities relieved routine ritual with dancing, boating through lotus blossoms, and "auspicious occasions" costumed for show. Emperor Kangxi's 66th birthday occasioned three days of banquets for 2,500 guests. India's diversions scaled up from hide-and-seek among the peacocks, and swinging together in air perfumed with rosewater, to sumptuous displays of food, décor, and gifting that joined taste and wealth to unassailable majesty.

Across the Pacific, America's fondness for spirits came to loosen the Puritan chokehold. George Washington was a prolific distiller, Thomas Jefferson's wine cellar held thousands of bottles, and communes too small for town halls conducted business in taverns. It was noted of the documents debated therein—the Declaration of Independence among them—that none had been conceived under the influence of water. So did bibulous gatherings mark many an historic moment, from Washington's stirring address at New York's Fraunces Tavern to Daniel Webster's resounding solution at a convivial dinner to the national debt: "I'll pay it myself," cried the senator, waving his wallet, "How much is it?"

The overnight wealth that had polished 19th-century arrivistes into gentry gilded their entry to more opulent affairs. To outdo the Henry Brevoorts' ball for 500, *the* Mrs. Astor gathered her exclusive "400" to tables set with $300 gold plates and reinforced to support massive orchid arrangements. Society columns detailed the ballroom acquired from the Château de Bastie for the blowout that opened William C. Whitney's 871 Fifth Avenue "palace of art," the trees sewn with 3,000 roses for the Virginia Fair–William K. Vanderbilt II nuptials, and the banquets boasting 2,100 pieces of Tiffany silver that established the Clarence Mackays in San Francisco. Evalyn Walsh McLean's entertainments were intentionally de trop. "*That* was a party," she recalled of the 4,000 yellow lilies shipped from London for a $40,000

OPPOSITE TOP THE 1745 FANCY BALL AT BUCKINGHAM PALACE GIVEN BY GEORGE II FOR THE DUKE AND DUCHESS DE NEMOURS.

OPPOSITE BOTTOM TAKHAT, MAHARAJA OF JODHPUR, ON A SWING WITH HIS LADIES—HAPPY INTERLUDE IN THE TEDIUM OF COURT RITUAL.

Existence is a party

ELSA MAXWELL

banquet: "It is only when the thing I buy creates a show for those around me that I get my money's worth." Newport one-upmanship disgorged jewels from a centerpiece that, at a signal, guests raked into silver pails, and anchored 30 white sailboats offshore for Mrs. Hermann Oelrichs's Bal Blanc. When the weekly working wage was $5, Vanderbilt Breakers–Marble House rivalry sent Alice's dinner guests home with 18-karat favors, and Alva's with keepsakes dating to Louis XV.

To own Manhattan, the tireless Alva splurged $250,000 on a costume ball ("the most expensive ever given," gushed the *New York Herald,* "unequalled in republican America and never outdone in the gayest courts of Europe") that incited Cornelia Bradley-Martin to her fateful apocalypse. The would-be mostest-hostess transformed two floors of the Waldorf-Astoria into a Versailles Hall of Mirrors featuring 6,000 mauve orchids, 50 liveried waiters, 60 cases of '84 Moët & Chandon ("most expensive wine in the U.S.," sniffed the *New York Times*) plus 400 carriages hired to transport the 900 costumed "nobility." Mr. Bradley-Martin appeared as Louis XV, and his wife as Mary Queen of Scots, wearing, because she owned it, Marie Antoinette's ruby necklace. The excoriating reviews ("half a million dollars [$12 million today] gone up in frippery and flowers to raise the hostess by her own garters to the vulgar throne of

FEAST OF THE PHEASANT;
THE BURGUNDIAN
BANQUET THAT
ENTERED HISTORY
FOR AMUSEMENTS
BUILDING TO A MOTET
PLAYED BY MUSICIANS
HIDDEN INSIDE A PIE.

vanity") so wounded the hosts that they decamped to London. Unheeding, Equitable Life's James Hazen Hyde gave a ball for 600 at Sherry's Hotel with a rumored outlay of $200,000 for the lobster, ham, pheasant, ices, Pol Roger '89, two late-night suppers, and a breakfast that elicited 115 columns citing (falsely) a misuse of the insurance company's money. Deeply aggrieved, the 29-year old scion sold his railway and 400-acre Long Island estate, sailed to Paris, and took up carriage driving.

The gilded set perfected the debutante ball. All on the guest list for the 1930 Mayflower Hotel debut of oil heiress Helen Doherty received a Ford Cabriolet—including the King of Spain, who had sent his regrets. Charlotte Ford's 1959 debut transformed the Detroit Country Club into a Loire château frilled with tapestries, $60,000 worth of flowers, and two million magnolia leaves. Gillian Spreckels Fuller

enjoyed debuts on two continents with two Arnold Scaasi–designed gowns before
waltzing into marriage with Lord Spencer Churchill.

Less exclusive was the cocktail party, a buoyant amusement masterminded by
gossip columnist Elsa Maxwell to divert and assimilate arriviste café society. One
such production matched the color of the cocktails to the gowns. Racier ones mingled
in perfumed goats and pink-tinted cockatoos.

Meanwhile, war-torn Europe was reviving. Buried with the silver had been
such productions as George Kessler's 1905 dinner that flooded the Savoy Hotel's
courtyard to dine 50 guests in a gondola manned by a full-throated Enrico Caruso.
Now England's great country houses reopened for coming-out balls, while London,
to the dismay of the formidable Margaret Greville ("One uses so many red carpets in

a season!") hosted immigrant royalty and the outré dinner parties of Maureen, Marchioness of Dufferin and Ava, featuring condoms in the serviettes, and if the Queen Mother attended, flowers in 43 of the 52 rooms.

Leaving carousing to King Farouk's Cairo revels, *l'art de recevoir* pinnacled in gas-rationed Venice. In 1951, when it took days to rail there, style-maker Count Carlos de Beistegui transformed his magnificent Palazzo Labia into an 18th-century "Fête de Fêtes" of fireworks, orchestras, and groaning buffet tables. Bedecked gondolas delivered the beau monde; Dalí and Dior costumed by each other, Barbara Hutton clad as Mozart, and couturier Jacques Fath so richly appareled as Louis XIV that he couldn't sit down. Artists stood by to sketch the gowns and hair architecture of such as Jacqueline de Ribes and my mother, who had lined up Alexandre and Balmain to out-feather-and-hoop Marie Antoinette.

Defining opulence, aesthete Baron Alexis de Redé's 1969 Bal Oriental piped *le tout Paris* through the opulent Hôtel Lambert, past huge porcelain elephants and bare-chested "Zouaves," to a candlelight dinner in the historic Salon d'Hercule. Also still in memory, Guy and Marie-Hélène de Rothschild's 1972 Surrealist Ball, staged at the Château de Ferrières for such as Princess Maria Gabriella de Savoie and Audrey Hepburn, with butlers costumed as cats, and centerpieces mingling fur-lined plates, broken dolls, and flaming Mae West lips.

Birthdays pulled out all stops. Prince Azim of Brunei's 25th flew in 500 guests for a weeklong celebration, and returned them with gift bags offering a Kenyan safari. Icelandic entrepreneur Thor Björgólfsson's 40th imported 120 friends to a remote island converted overnight to a nightclub. For Prince Johaness's 60th, Princess Gloria von Thurn und Taxis climaxed the weeklong festivity at their 500-room Bavarian castle with a million-dollar rock-and-roll cruise up the Danube. Of Saul P. Steinberg's million-dollar 50th, the business baron told his wife: "Honey, if this moment were a stock, I'd short it." Of the blowout in Paris for "King of Wall Street"

SUGAR HEIRESS GILLIAN SPRECKELS FULLER, IN ONE OF THE EXTRAVAGANT GOWNS ARNOLD SCAASI DESIGNED FOR HER BACK-TO-BACK DEBUTANTE BALLS; THE FEATHER-WORK ALONE INVOLVED MONTHS OF LABOR.

If you give a party,
you better give it right

ABY ROSEN

John H. Gutfreund's 60th (the cake flown in on the Concorde), his wife Susan noted, "It's so expensive being rich."

Recession dimmed revelry, but not see-and-be-seen celebration. Yammer founder David Sacks's 40th bannered a Versailles-themed extravaganza with "Let him eat cake." Blackstone CEO Stephen Schwarzman, known to "not like little things," threw himself a $10 million, Silk Road–themed 70th birthday blast featuring three-story-high golden temples, acrobats, camels, fireworks, and lobster salad folded into dragon-crested golden eggs. The down-keyed theme of "familiarity and comfort" proposed for the 2007 affair marking Valentino's reign as fashion's "last emperor" played out at a ball for 900 in Rome's Temple of Venus with the bacchanalian excess of embossed tablecloths, custom-made celadon plates, 2,500 bottles of Champagne, and 15,000 flowers flown in from Holland. "Parties," observed legendary Hearst gossip columnist Igor Cassini, "are inevitable."

ONE OF COLIN COWIE'S LAVISH WEDDING PARTY DESIGNS, CREATED FOR A BANQUET IN THE NEW YORK PUBLIC LIBRARY.

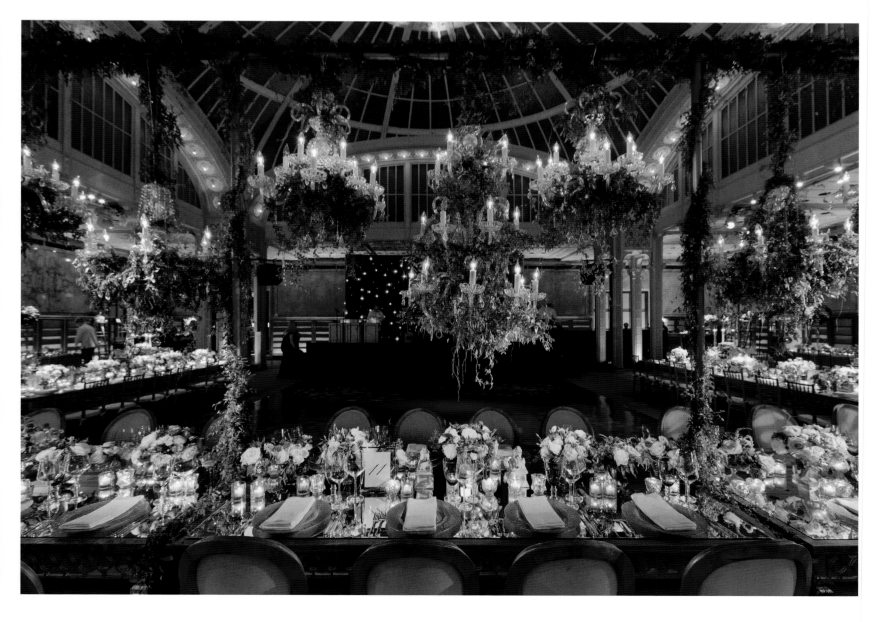

I don't do fashion,
I am fashion

COCO CHANEL

PRIVILEGE
PERSONIFIED

Driving luxury's story have been its protagonists, those holding luxury a birthright and those chasing it. All have aimed high but for different ends. Ambition for good or ill impacts equally but anecdotal history has favored the latter, those whose self-regard disregarded all else.

Such were the Imperious: Louis XIV, whose stringent command of Versailles extended from protocol ("you almost kept me waiting!") to procedure; "When His Majesty arrives by the pond road, the master fountaineer will be careful to turn on the water in the Pyramid, the Allée d'Eau, and the Dragon, and assure that these fountains reach their perfection at the moment they come into His Majesty's view . . . then stop the Pyramid after His Majesty can no longer see it, and switch the water over to the Pavilion before His Majesty comes within sight of it." Add Empress Elizabeth, who reproved a Russian ambassador's partiality to the Dutch by receiving him in a cabbage patch; Queen Christina, who summoned the aging Descartes to converse with her every dawn through a harsh winter until he died of pneumonia; and Marie Antoinette, who answered her mother's pleas for fiscal restraint with "Je suis moi."

The Snobs and Nobs: French finance minister Nicolas Fouquet, whose family motto fatally read, "What heights will I not scale?" Venetian merchant Paolo Labia, who, at an opulent banquet at his palace, flung his gold dinner service out the window, crying, "Whether I have them or don't, I'll forever be Labia!" George Khevenhüller of Aichelberg, Freiherr of Landskron, Master of the Horse to Emperors Ferdinand I, Maximilian II, and Rudolph II, who had all his titles carved on the walls of Hochosterwitz Castle "that it never pass out of the hands of my family." Prince Massimo, Rome's oldest title, who, asked by Napoleon Bonaparte if he was really descended from Quintus Fabius Maximus, said he couldn't prove it but the rumor had been around for 2,000 years. Well into the 20th century, Señora María del Rosario Cayetana Fitz-James Stuart y Silva, Duchess of Berwick, Alba de Tormes, de Liria y Jerica, de Arjona y de Montoro—known to society as the 18th Duchess of Alba— laid successful claim to a 57th title, Duchess of Almazan, whose holder had died heirless. She deferred only to the Rolling Stones' financial manager, Prince Rupert

I earned my money the old-fashioned way: I inherited it

JOHN REEVES RAESE

Loewenstein, descended via a 2,000-year-old pedigree from James I, Louis XIV, Dom Pedro I, Charles IV, and kings of Bohemia, Spain, and Germany.

The Haughty included Saxony's Frederick III, who descended grandly on Naples for a week to sell titles and charged its ruler, Alfonso II, 150,000 florins for his stay; the formidable royal mistress and thespian Mrs. Patrick Campbell, who berated the livid driver when her dog peed in his cab, "Nonsense, my dear fellow, it was I!" and Boniface de Castellane, whose funeral directive began, "Alert the kings and the Rothschilds!" Better remembered, Nathan Mayer Rothschild, who had underwritten Britain's victory at Waterloo and, told that the Bank of England had returned his check ("We don't cash the notes of private individuals"), dispatched nine clerks to keep turning in ten-pound notes for gold, deaf to the director's pleas: "Rothschild will continue to doubt the Bank of England's notes as long as the Bank of England doubts the Rothschild notes." Headlined, too, were financier George Jay Gould who, told that an error that had attached his Pullman car to the dining car would oblige the public to pass through, had his butler announce all who entered; William Waldorf Astor who, with "gold siphoned from New York as effectually as a ferret draws blood from a rabbit," bought Hever Castle (Henry VIII's gift to Anne Boleyn) to acquire the title Baron Astor of Hever; and author Truman Capote, whose Black and White Ball at Manhattan's Plaza Hotel sidelined food and flowers because the point was the list—those not on it left town.

The Debonair: Writer Sir Francis Bacon maintained an open table at his country estates, holding it noble to overlook that his servants were stealing from him. Abraham Crichton, Earl of Erne, at his barber's when his steward ran in crying, "Milord, your house has burned down!" sighed, "Well, build it up again." The English playwright Richard Sheridan, watching his theater go up in flames from a neighboring bar, mused, "Hard if a man cannot enjoy a glass of wine by his own fire." Newport's socially registered Colonel Malbone, told a fire had broken out at an event he was hosting, ordered the tables moved out to the lawn: "By God, if I have to lose my house, I shall not lose my dinner!"

The Spoiled: Apicius, down to his last 10 million sesterces (1,500 pounds of gold), deemed it insufficient for his standard of living and swallowed poison. Sui Emperor Yangdi, depressed by winter, had the lakes floated with silk blossoms and the trees sewn with hemp leaves. Japan's Emperor Komei, soothed by the sound of rain falling, had every palace rooftop expensively tiled. England's Queen Charlotte, offered a redo of Frogmore House, ordered up one that would provide her "fresh amusements every day." The 9th Duke of Devonshire, advised to economize by dismissing three of his pastry chefs, railed: "Can't a fellow even have a biscuit?" Vincent Astor came to breakfast in socks on butler's day off because he had never removed shoetrees.

The Cavalier: The Greek philosopher Diogenes, in his garden when Alexander the Great visited to ask if he wanted for anything, replied, "Yes. Move a little, you

But after all we can do whatever we like

ELISABETH OF AUSTRIA

are blocking the sun." Paris art dealer Ambroise Vollard, begged by client Louisine Havemeyer to postpone his nap as she had a boat to catch shortly, suggested she take the next one. Banker Andrew W. Mellon's diary entry on Black Thursday read: "Stock market crash in New York. Dinner Belgian Embassy."

The Jaded: Bored with convention, Grand Duke Nicholas Nikolaevich would urge fellow guests at Monte Carlo's Hôtel de Paris, to "drink Château d'Yquem with roast beef." Baron Édouard de Rothschild would whisper to his dinner partner, "I don't know if you agree, but I only like carp that is marinated for three days in spirits," and the Baroness would sigh to her butler midwinter, "Strawberries *again*?"

The Fatuous: New York maven Edith Goetz, congratulated one night on the wine—"very good, what is it?"—trilled, "Baccarat!" Florence Vanderbilt Twombly, resolved to attend her grandson's West Coast wedding but wary of kidnappers, set out in her violet Rolls-Royce sitting up front with the chauffeur, dressed as her maid, and sat the maid in the back, dressed as Mrs. Twombly. Bache heiress Mrs. Gilbert "Kitty" Miller, on acquiring Goya's *Red Boy*, had Van Cleef & Arpels reproduce it in rubies and told everyone how clever she was to have had a painting made of her pin. Edith Rockefeller McCormick, bored with a lifestyle that assigned four butlers to luncheons for six, and 100 footmen to serve guests off Napoleon's 1,000-piece solid-gold service, built a 40-room getaway outside Chicago that she never moved into: "My object in the world," she would say, "is to think new thoughts."

The Eccentric: Ludwig II of Bavaria slept under a mechanized moon, dined at Linderhof with three pretend guests, and was attended by two groomers: "If I didn't have my hair curled every day I could not enjoy my food." The 17th-century British trader Elihu Yale collected for his viewing alone, accumulating so many treasures that their sale, at his death, took 35 days. Self-taught Los Angeles artist Simon Rodia spent 33 years crafting the Watts Towers, gifted them to a neighbor, and moved north. Manhattan's wealthy Collyer brothers lived out their lives in a Fifth Avenue mansion with no electricity, no hot water, 25,000 books, 14 pianos, and 100 tons of old newspapers. Financier Hetty Green, America's richest woman, wore her one black dress to tatters, warmed her oatmeal on the radiator, and denied her injured son a doctor, which cost him a leg (a penury he avenged at her death by buying bejeweled chamber pots). Equally singular, Mir Osman Ali Khan, the wildly wealthy last Nizam of Hyderabad, enjoyed an opulent lifestyle furbished by 6,000 staff (38 assigned just to the chandeliers) yet owned only one fez, salvaged cigarette butts, and ate off tin plates.

Indulgent, too, the luxury of One-upmanship: the 3rd-century BCE Chinese merchant Shi Chong outclassed rival Wang Kai's 40-*li*-long silk-shaded garden path with one 10 *li* longer shaded with far costlier brocade. Beau monde Carolina "La Belle" Otero, mocked by archrival Liane de Pougy for piling on jewelry, appeared the next night at Maxim's without so much as an earring, trailing a chambermaid wearing

I dress for the image

MARLENE DIETRICH

her entire collection. Financier T. Boone Pickens countered Canadian rapper Drake's "the first million is the hardest" with "the first billion is harder" then proceeded to give it away.

The luxury of Prerogative: Ming Dynasty collector Wu Hongyu ordered that his fabled painting *Dwelling in the Fuchun Mountains* be cremated with him. George Granville, 1st Duke of Sutherland, cleared his lands of thousands of tenants to make way for sheep. Commodore Vanderbilt had four acres in downtown Manhattan leveled for a rail terminal marked by a 150-foot-long bronze relief bearing his likeness. The otherwise estimable J. P. Morgan slid countless treasures past U.S. Customs. They were after all, said his curator, like his yachts and his ladies, his "amusement." Henry Ford II had the M-35 routed around the hunting grounds of an old-guard club in the Huron Mountains he wanted to join. David Rockefeller, still a private in uniform, went to Van Cleef & Arpels for an engagement ring and, advised that Tiffany & Co. might be more in his price range, crossed Fifth Avenue and purchased Tiffany's largest diamond. Senator John McCain's mother, Roberta, told by an agent in Paris that her advanced age precluded renting a car, marched down the avenue and bought one. Collector Liu Yiqian paid a staggering $36 million at Sothebys for the fabled Meiyintang "chicken cup" then had them serve him tea in it. David Hockney declined an invitation to paint Queen Elizabeth II's portrait: "I told them I was very busy painting England, actually."

The luxury of Time led Prince Bada Shanren of the imperial Ming to feign madness and retire to a monastery for the life of an artist; enabled the prematurely widowed Mary Delany to cut and paste into ten volumes thousands of "paper mosaicks" reproducing the botanicals of the *Flora Danica*; and let Mary, Countess of Bessborough, devote 25 years to a petit point tapestry for Stansted's Great Hall and when it disappeared en route to the upholsterer, to start over.

The luxury of Self-regard moved Albrecht Dürer to sign even the nail heads on his *Crucifixion*, and Peter Paul Rubens to decline an alchemist's offer to share the accolades for discovering the philosopher's stone with "I've already discovered it!" Count in James Whistler, who, said Oscar Wilde, "spelled Art with a capital 'I'"; Marlene Dietrich, whose resolve to "dress for the image" entertained the troops in designer ballgowns; and Kim Kardashian West, whose 448-page photobook, *Selfish*, consists entirely of selfies.

The luxury of Disregard profiled Nubar Gulbenkian the night at Maxim's that he had a waiter ask a woman dining alone if he might join her after dinner. Yes, came

MARLENE DIETRICH: THE HOLLYWOOD IDOL WHO BURNISHED HER FEMME-FATALE REPUTATION ENTERTAINING U.S. TROOPS AND RETHINKING FASHION AS STYLE.

I could not stand to be bourgeois

FRANÇOIS PINAULT

the answer, if he brought her the ruby necklace in Cartier's nearby window. The magnifico roused the director from his bed to deliver it to her table; penned on the note she sent inviting him over: "I hate to be rushed, goodnight," and departed, never to address her again. Barbara Hutton, endlessly complimented on the luster of her Marie Antoinette pearls, would reply that on hearing pearls swallowed by birds came out brighter she had fed them to a goose. Coco Chanel, during World War II, would bring her maid to the bomb shelter carrying her gas mask on a cushion. Couturier Madame Courrèges, famously protective of her privacy but reluctant to refuse *Vogue* Editor Anna Wintour's request to stop by for coffee, received her politely, ordered coffee to be served, and exited, never to return.

Some splashed for Convenience: Diamond Jim Brady stopped by a Boston sweets shop, downed a five-pound assortment of the "best goddamn candy I ever ate," and left a five-figure check to keep him supplied. James Gordon Bennett Jr., finding no table free at his favorite eatery in Monaco, bought it on the spot and handed the deed to his longtime waiter, Ciro, with the proviso that his table should always await him. Olaf Hambro, dining at Wiltons in wartime London when a bomb exploding nearby

NUBAR GULBENKIAN WITH HIS BESPOKE AUSTIN FX4: THE FLAMBOYANT OIL MAGNATE WHO WAS SAID TO HAVE DAILY TIRED OUT "THREE STOCKBROKERS, THREE HORSES AND THREE WOMEN."

BARBARA HUTTON: THE DIME-STORE HEIRESS WHOSE FALLOUT FROM THE FAST LIFE TAGGED HER AMERICA'S "POOR LITTLE RICH GIRL."

inclined the owner to close the restaurant, cried: "I'll buy it, have it put on my bill!"

Others splurged out of Pique. The hunchback Principe di Palagonia lined his Sicilian villa with grotesque portraits of his enemies. Guy de Maupassant so loathed the Eiffel Tower rising outside his window ("a horrid affront to France's cultural heritage") that he dined nightly in its restaurant so as to not look out on it. Cotton king Marcel Boussac so hated the roar of lions near his penthouse in the Bois de Boulogne that he bought the zoo to have them removed.

America's titans learned fast. Asked to tone down the bronze doors of his Fifth Avenue mansion, traction-king Charles Yerkes had them coated in platinum. Denied membership in a golf club, financier Otto Kahn built Oheka Castle, the nation's second-largest residence, with an 18-hole golf course. Riled by a billing dispute with Houston Electric, Texas oilman James Marion West Jr. built his own power plant. Finding no room available at the Pierre Hotel, J. P. Getty bought it.

Arrogant? Feckless? Indeed. But not venal. Flip luxury's arc for the dark side. In the name of Britannia, the 8th Earl of Elgin, High Commissioner to China, had Peking's wondrous Old Summer Palace burned to the ground. To advance his career, Andrew Jackson led the Trail of Tears land grab that deprived Native Americans of a nation. Army officer Theodore Roosevelt's 1898 rallying call to America's "war of choice"—"Rough tough, we're the stuff. We want to fight and we can't get enough"— robbed Spain of the Philippines, Puerto Rico, and Guam. Naked corruption drained Haiti, bled Senegal, siphoned state treasuries to Mohamed Suharto, Ferdinand Marcos, and Mobutu Sese Seko, and added a billion-ruble palace to Vladimir Putin's yachts, jets, and $15,000 toilet.

Still all child's play compared to the hideous fallout of unbridled abuse. Conquest by slaughter reshaped the ancient world. The Homeric Ideal held Achilles a hero for destroying 23 cities. The 1st-century BCE Judaean king and high priest Alexander Jannaeus massacred 50,000 Pharisees and staged an orgy to view on the crucifixion of 800 more. Rome had an odious run: Elagabalus scuttled ships laden with food to demonstrate a "greatness of soul"; Tiberius used treason trials to eliminate opponents; Caligula's paranoia executed foes and allies alike; and Nero, though

cleared of debauchery, proved a serial murderer. Slaughter so cauterized the populace that, should a play specify a death, a slave was dismembered.

Even the convert Justinian, held a saint, had 30,000 allegedly disloyal citizens invited to a racing event, and slaughtered. Conversion didn't gentle Africa's Queen Nzinga, who thought it Christian to sell tribal chieftains into slavery, or the Frankish King Clovis, who sanctioned the proof-of-innocence-by-torture ordeal marking the Inquisition's ghoulish trials. Secular agendas enabled Henry VII to keep subjects "in danger at my pleasure"; Henry VIII to behead thousands of dissidents; and Elizabeth I to declare it a felony to cast her horoscope and a capital crime to foretell her death.

Absolute power empowered absolutely. Victory by slaughter entrenched the Ming with the massacre of 10,000 subjects the Hongwu Emperor thought disloyal, and so glorified the Mongols that Timur built a pyramid of the heads of Isfahan's 90,000 murdered citizens, and set his camels afire to take Delhi. Even the courtly Mughals reverted: Akbar ordered a surviving miscreant hauled back up to the roof to personally fling him to his death, and great-grandson Aurangzeb murdered his brothers and jailed his father, the great Shah Jahan. The Tsars refined cruelty. Any subject approaching Ivan the Terrible without doffing his hat had it nailed to his head; Peter the Great had his mistress executed and kissed the head before tossing it. Even Europe's Age of Reason tolerated despots. Frederick the Great ordered the peasants to plant potatoes or have their ears severed.

Most impacting were self-serving abuses of public trust. Cecil Rhodes used "blood diamond" profits from his Kimberley Mines to stamp his name on Zimbabwe and bring in Great Britain. Greed for the resources of a nation 80 times larger than Belgium drove Leopold II's private purchase of the Free Congo and subsequent massacre of 10 million Africans. "I'm a Renaissance type," crowed Hermann Göring of the 1,400 crates of art stolen from a civilization burned to ashes. Body count remains unbridled power's darkest avatar: Hitler scored 20 million, and Stalin twice that—because they could.

Flip the arc again to see how luxury has ennobled. At the spectrum's far end shone those of prodigal heart and warm gesture. Such was Euripides, the wealthy Greek tragedian who happily worked in a cave while helping others: "I care for riches, to make gifts to friends." The Duke of Northumberland who, on John Kemble's opening night, brought the 10,000 pounds bond loaned him when the Covent Garden Theater had burned down, and flung it into the fire he said the great actor's performance had ignited. Poland's Alfons Koziell-Poklewski, who addressed Edward VII's reproach that he had left the gaming table a pound short by sending it sealed in the

Everything was handed to me.
Looks, fame, wealth, honors, love.

ELIZABETH TAYLOR

lid of a gold-and-crystal Fabergé *tabatière*. And Leopold de Rothschild who, on the occasion of King George V's coronation, had orchids from his greenhouse delivered to Buckingham Palace in a Fabergé vase, together with a gardener to arrange them. And shipping magnate Aristotle Onassis, who found himself without cash one night drinking ashore incognito with five fishermen, and thanked them for seeing him home with enough to support them for the rest of their lives.

American gesture encompasses the cease-fire called by George Washington to let British General William Howe's dog, strayed into enemy lines, return to its master, and the Peace Ship dispatched by Gilded Age millionaires to end World War I. Of the private gestures that made headlines, Nelson Rockefeller, told that Manhattan's storied Knickerbocker Club was failing, purchased it outright and leased it back for a peppercorn; Marjorie Merriweather Post spent $10,000 to drill through her Mar-a-Lago dining room wall to an annex so that houseguest Madeleine

MARCHESA LUISA CASATI BY GIOVANNI BOLDINI: THE STYLE ICON AND MUSE WHO LIVED HER LIFE AS A PERFORMANCE.

Astor, in mourning for her husband, could dine with them, and yet, not; and William Randolph Hearst, whose driver had run over a goose outside Paris, sent the farmer another goose, together with the Renault that delivered it.

"Presentation," noted Walter Annenberg, "is everything." Picasso, offered by MoMA a major Cezanne in trade for one of two versions of his great Cubist *Guitar* sculptures, donated both outright. Willem de Kooning, apprised that Robert Rauschenberg would be requesting a drawing in order to erase it, told the upstart, "I know what you are doing. I want to give you one that I'll miss." When the IRS confiscated country-music legend Willie Nelson's possessions for auction, his friends purchased the lot and had it returned to him. When John Lennon and Yoko Ono wanted to surprise songwriter Sam Green with a better piano they had him invited out while it was hoisted through the window. Bunny (Mrs. Paul) Mellon's thoughtful gestures extended to sourcing a rare seashell to contain the Tiffany earrings she gave Jackie Kennedy, and flying vegetables from her garden to friends on the family plane.

The greatest gesture on record may be that of Charles Lang Freer, who had heard that James Whistler's ailing wife, Beatrice, longed for a lark, and promised to send one from his upcoming voyage to India. Plunging deep into the interior, Freer managed to locate a pair, one of which, at great

PARIS SOCIALITE DAISY
FELLOWES WITH A
PAGE, BOTH DRESSED BY
DIOR—AT CHARLES DE
BEISTEGUI'S VENETIAN
"PARTY OF THE CENTURY."

expense, made it to London. After Beatrice died, Whistler wrote to tell his friend how she had loved the magical bird: "And when she went . . . the strange wild dancing creature sang and sang. . . . A song of the sun—and of joy. . . . Peal after peal—until it became a marvel the tiny breast, torn by such a glorious voice, should live! And suddenly, it was made known to me that in this mysterious magpie waif from beyond the temples of India, the spirit of my beautiful Lady had lingered on its way—and the song was her song . . . and so was her farewell."

Tellingly, the columns preferred caprice and the fin de siècle insouciance that polished the bored and the hopeful into social gemstones. Holding with Oscar Wilde that the only thing worse than being talked about is not being talked about, they devolved into concepts. "I want to be a living work of art," exclaimed Luisa Casati, whose careening visibility exacted pageboys dipped in gold paint and an ensemble by Léon Bakst that had cost as much as J. P. Morgan's Rolls-Royce. So did Baroness

She delighted in everything but the commonplace

ROBERT BOIT, OF
MARY LOUISE CUSHING

ELSA SCHIAPARELLI,
THE VAUNTED FRENCH
DESIGNER WHO MADE
FASHION AN ART FORM,
WEARING ONE OF
HER COCKTAIL HATS.

Blixen (aka Isak Dinesen), even as her plantation floundered, voyage to Paris with two servants "regardless of expense" to buy a new wardrobe. Leaving "genteel" to fellow Bostonians, Isabella Stewart Gardner achieved what Henry James called a "preposterously pleasant career" walking lions on a leash and attending balls with an African page while building Fenway Court into a refulgent palazzo whose mantelpiece read, "C'est mon plaisir."

High society diluted as the Jazz Age unleashed a generation of blithe spirits for whom money bought happiness and too much was too little. Born to want what they didn't need and crave what they couldn't find, they bubbled fortunes into froth by the sophisticated alchemy of living too well. Among the rich expatriates spiking cocktails at the Crillon was social climber Kate Moore, who filled three loges at l'Opéra and left generous bequests to all who had smoothed her way up the ladder: "Departing this life," sniffed aesthete Robert de Montesquiou, "as she would from the Ritz, handing out tips." Lighting the Côte d'Azur were the dazzling Murphys (models for Fitzgerald's *Tender Is the Night*)—Sara, who held that the right way to drink Champagne was with eyes raised to the trees, and Gerald, who cultivated affect: "I've been discovered. What does one wear?"

"Not our class, dear" was the ultimate cut. "The bourgeoisie," noted the *Journal des Débats*, "isn't a class, it's a position. You acquire it, you lose it." Class was a birthright but could be joined by being intractably exclusionary and exquisitely extreme. When to be the height of fashion was the greatest thing possible, Aileen

Plunket, of the glamorous Guinness sisters, traveled to Paris to have Alexandre curl her eyelashes, and London's racy Daisy Fellowes (famous for seducing Edward VII) attended Lady Kenmare's Cap Ferrat gala wearing Potemkin's "*Tête de Bélier*" diamond nested in a necklace made of corks.

Bred of the social upheaval that divorced money from obligation, the American heiress devolved into a little-rich-girl pastiche. The press couldn't get enough of Mary Louise Cushing, who "delighted in everything but the commonplace"; Rita Lydig, whose shoetrees were fashioned from old violins; Thelma Chrysler Foy, who sported a 58.6-carat diamond cut from one of the Sun King's; Isabel Dodge Sloane, who imported pink sand from France for her tennis court; and Nica Hilton, who tore around Manhattan with Charlie Parker and a whiskey flask in a hollowed-out Bible. No whim went unrequited. "Richest-in-the-world" Doris Duke, unable to "go into a store and shop for things just as a girl," built a fantasy Shangri-La in Hawaii where she could live under the radar and spend to the rooftops. Standard Oil heiress Millicent Rogers perched a live monkey on her shoulder and gave herself seven dachshunds, five mansions, a custom-built Delahaye, and 48 identical blouses by Charles James. Artist-muse Peggy Guggenheim wore one earring by Tanguy and another by Calder to equally support surrealism and abstraction and, cued by the controversial icon she called "my uncle's garage," signposted her Venice palazzo with Marino Marini's tumescent horseman. The ultimate objective, to never be bored or average, was realized with superlatives. "For her," Guy de Rothschild wrote of the famously extravagant Marie-Hélène, "things were either exciting or odious, marvelous or abominable, thrilling or unbearable; people were either adorable or hateful, friends or foes, angels or monsters"—this of a wife who received in her bathtub and changed a gift's wrapping if it didn't match the décor.

The 1960s counterculture changed the tone, not the tenet. Model Mary Taylor marched with Martin Luther King in a suit by Christian Dior, while Andy Warhol's Factory socialites rebelled with no cause ("I would stop at Tiffany's," recalled Velvet Underground's Brigid Berlin, "buy some sapphire cufflinks, and toss them from the seaplane into the swimming pool. . . ."). A Manhattan couple who visited La Vieille Russie to make the next down-payment on a purchase, told they owed no more, left a check anyway, saying, "Don't worry, we will."

Even as inequality frayed the social fabric, the old guard fell back on lineage. Palm Beach's Lilly Pulitzer owed her fortune to a frock designed to sell juice at a road stand, but "the private-club culture prevails—if you don't believe me, try getting in." "The Spaniards in slippers and the king with 70 cars," penned a wag, as Spain

I don't get out of bed for less than $10,000 a day

LINDA EVANGELISTA

teetered on bankruptcy. "The best part about being a royal is getting pretty much everything you want," purred Princess Sikhanyiso of Swaziland. Prince William knows; he was given a key to Clarence house with the disclaimer: "just for fun, since there will always be an aide to open the door."

Players played on. Asked why she had her newspaper ironed every morning, artist Louise Bourgeois retorted: "Why not? It doesn't change the content." "There's nothing routine about her life," said her secretary of social whirlwind Brooke Astor, "except that it's booked." Clout still empowered. In the face of a drought that had moved Georgia's governor to ask God's forgiveness for the state's waste of water, investor Chris G. Carlos poured 14,700 gallons a day on his gardens, and mogul Steve Jobs parked in spaces reserved for the handicapped. Celebrity still entitled. Artist Tracey Emin selected her hotel by the sheet thread count; actress Sharon Stone had the Hôtel du Cap send up a Nebuchadnezzar of Champagne and a harpist; performer Jennifer Lopez, her body insured for $1 billion, would not enter a hotel room that was not painted white. Rocker Courtney Love made indulgence a refrain: "I want

VALENTINO GARAVANI, MAESTRO OF ITALIAN COUTURE, WHOSE TRADEMARK "VALENTINO RED" DRESSED LUMINARIES FROM BELGIUM'S QUEEN PAOLA TO JENNIFER LOPEZ.

to be the girl with the most cake." Designer Marc Jacobs shed obligation: "I can go wherever I want, I can be whatever I choose." Dakis Joannou skirted nicely—"I have one luxury in my life; I do whatever I feel like doing"—to furnish his New York apartment around tagger graffiti. André Leon Talley thinks of luxury as a house with four rooms—three allotted to clothes. For Valentino, life without frills is like a dress without ruffles: "Spare, spare, what is spare? I hate the word." For Michael Kors, bliss is "Capri in flip-flops, wearing ten-ply cashmere" while eating "caviar with potato chips." For Karl Lagerfeld, good fortune was leaving others to manage it: "The bottom line is that I don't deal with the bottom line. The luxury in my life is that I don't have to think about it."

The rest of us, reeling from recession, epidemic, and concern for a vulnerable planet, rethought fulfillment. No longer is luxury defined by the needs of Mona Williams, who wed America's richest man, hung a Goya in her living room, had Balenciaga tailor her gardening shorts, and vacationed on a $3 million yacht, yet met the question "Are you satisfied with your life?" with "Is anyone ever satisfied?" More compelling now is the bliss of Prince Alfonso zu Hohenlohe-Langenburg: "I have lived in castles, in Venetian palaces, and the world's finest hotels, I have watched the sun rise over the beaches of five continents, and I have looked into the eyes of the most beautiful women in the universe."

ABOVE LEFT ANDRÉ LEON TALLEY: FASHION ICON FOR HIS SARTORIAL EXTRAVAGANCE, SOCIAL FLAIR, AND UNERRING FINGER ON THE PULSE OF THE SARTORIAL ZEITGEIST.

ABOVE RIGHT WITH THE EXCEPTION OF HIMSELF, KARL LAGERFELD DIDN'T CREATE A LOOK, HE IMPOSED ONE, BURNING THROUGH GENRES TO BRAND FASHION ITSELF

OPPOSITE MONA WILLIAMS, AKA COUNTESS BISMARCK: THE KENTUCKIAN BEAUTY WHO HAD IT ALL—TITLE, FORTUNE, ART, DESIGNER CLOTHES, MANSIONS, A 98.6-CARAT SAPPHIRE, AND THE LARGEST YACHT AFLOAT—YET DECLARED HERSELF NEVER SATISFIED.

I have no intention of sharing my authority
LOUIX XIV

COMMAND AND CONTROL

*You own all that is
yours, but I own you*

KING CLOVIS

CHAPTER OPENER
CORONATION PORTRAIT
OF LOUIS XIV: SWATHED
IN ERMINE AND, AS
COMMANDED OF
HYACINTHE RIGAUD,
POSED TO PROJECT
ABSOLUTE MONARCHY.

A keen observer of human nature, Friedrich Nietzsche held that every living body strives to "grow, spread, seize, and become predominant." Unbridled ambition sought power without limit and influence to the rim of the world. Charlemagne's palace at Aachen held two silver tables etched with maps and a gold one depicting stars and planets. Just as power ordained luxury, luxury burnished power. "Who was king? Who was not king?" asked a Sumerian register; history's manual replied, "King is he who enforces rank, garners revenue, buys talent, builds big, reaches far, and manifests glory." Glory was both the duty and reward of unchallenged rule—a complex concept that, like magnificence, implied both preeminence and virtue.

What amazes is the drive—the relentless striving of Alexander the Great for the aura of Heracles, of Julius Caesar for the might of Alexander, of Napoleon Bonaparte for the triumph of Caesar.

What astounds is the reach. At their peak, the empire of Ramses II stretched from Nubia to Syria, that of Alexander from Macedonia to India, that of Rome from Scotland to Parthia. The Abbasids attached Europe, North Africa, and Byzantium; the Mongols controlled 11 million square miles; the Timurids burned through the Middle East to north India; the Ottomans ruled from the Caspian Sea to Peking. The sun never set on the empires of Portugal and Spain, and Great Britain, went the saying, ruled the world.

What dazzles is the outlay—how much was not enough. Animistic societies, lacking the concepts of ownership and prerogative, had no need for luxury. Revered and protected as long as they adhered to their role, tribal chiefs were hostage to the spirits. Anthropologist J. G. Frazer observed that on the island of Niue the monarchy almost died out for lack of takers. In contrast, the great dynastic kingdoms, dependent on awe for dominion, relied on the full arsenal of luxury. "Gold is as dust in your land, my brother," gushed Kadashman-Enlil I to Amenhotep III, then gilded all Babylon to rival him.

What stuns is the entitlement—how far the mighty ventured before felled by hubris. So did Cyrus the Great gouge 360 channels into the banks of the Gyndes for drowning his white horse; Xerxes the Great impose 300 lashes on the Hellespont for

Veni, vidi, vici

JULIUS CAESAR

destroying his bridges; and Qin Emperor Shi Huang dispatch his entire army in a quest to annihilate death. Subsequent rule was as brutal. Babur slaughtered captives, Humayun blinded rivals, and Napoleon Bonaparte spilled blood like water: "A man like me doesn't give a damn about the lives of a million men," said the self-declared emperor of his Russian campaign, and of another, "All human effort against me is useless, for I succeed in all I undertake. Those who declare themselves my enemies die."

What intrigues is the tipping point—how a program of luxury could advance an empire and then scuttle it. The Romans fell victim to boundless expansion, the Mayans to the complacency of a prosperous plutocracy, and imperial China to Qianlong's insular myopia. Vainglory, not honor, lost four empires to world war.

Rank was the first arrow in luxury's political quiver. Only the Inca Emperor wore clothing woven of vicuña, only the King of Benin carried an umbrella, all in the presence of the King of Dahomey had to bow when he sneezed, and none in Siam was permitted to hold his head higher than royalty. The more stratified the society, the clearer the markers of who sat where and wore what. Byzantium wrote the code: "The court looks to the prince, the city looks to the court."

Proximity to power ranked highest. A follower of Genghis Khan surrendered his infant son "that he may saddle your horse and open your doors." Even nobles commanding their own retinues vied to wait on the sovereign. And even Russia's loftiest aristocrat took care to record on an obelisk, not that he had gifted his mother with Crimea's highest mountain, but that "S.M. Emperor Nicholas I, LL.MM the Empresses, Grand Duke Nikolaevich, Prince Charles of Prussia, paid Prince Yussoupov the honor of dining at Arkhangelsky." The conceit persists: the 2017 obituary of Mary, Duchess of Roxburghe noted that at age 22 she had been appointed to carry the Queen's train.

Titles entitled. Alexander the Great asked India's vanquished ruler how he wished to be dealt with. "Like a king," replied Porus. "Nothing more?" exclaimed Alexander. "King says all," Porus replied, moving the Macedonian to restore all his lands. The embattled Empress Theodora chose her throne over fleeing to safety: "May I never not wear purple nor see the day I am not addressed 'Your Majesty'!" Tsar Ivan IV successfully petitioned Elizabeth I for the hand of her lady-in-waiting by listing his titles; "Son of Vasili of all Russia, of Volodimir, Misouia, and Nuooo, King of Cenan and Astrakhan, Lord of Pleskoy and Polotsk, Great Prince of Moscow, Sonolensko, Tver, Vgor, Perme, Vatka, Bolgar, Grand Duke of Meneeyoue, Razan, Rostoue, Yeroslaue, Belozer Uffand, Vdor, Obdor, Condence, and Commander of all Sibir." Peter the Great added "Emperor," created 2,000 princes, and assigned a fifth

of the population ranking uniforms. Titles could be bought—a source of revenue exploited by both James I and Louis XIV—or usurped, which was chancy but established legitimacy. Emperor Kangxi's fourth son, Yongzheng, for one, came to rule after unseating his brothers. Even atrophied honorifics distinguished. For 461 years England's rulers were nominal kings of France and to this day ex-royals from defunct principalities hold fast to their titles.

A new mindset, nonetheless, broadly called the Enlightenment, rose to question, among other entitlements, that of pedigree. Author Daniel Defoe cited Poland as a place where "this vanity of birth is . . . carry'd up to such a monstrous extravagance, that the name of gentleman and the title of a *Starost*, a *Palatine*, or a *Castollan* gives a man a superiority over all the vassals or common people . . . insomuch that they trample on the poorer people as dogs and frequently murder them, and when they do they are accountable to nobody." Outcry noted. Like mirrors that lost luster as they multiplied, titles diluted with every regime change.

Rank did not. Denoting class and station entailed visible markers, from dress and pecking order to fustian rites. Conceived to convey authority, they increasingly distanced ruler from ruled and when excessive fed vanity. Vanity inclined Alexander the Great to make all bow before him and to execute his friend Callisthenes for refusing. Vanity billed Rome's white-toga patricians "masters of the earth" and tripled the *lex oppia* that restricted the type and quantity of foods, fabrics, utensils, jewels, dwellings—even where and how often people could congregate. Vanity ranked Europe's rulers with medals and aureate heraldry.

Louis XIV imposed a puffery of state best exemplified by the morning's two-hour *levée*. His was the vanity of a fox: "Nothing," he wrote in his memoirs, "touches the worthy heart more than distinctions of rank . . . indeed one of the most visible effects of our power is to bestow, as we see fit, an infinite value to that which of itself is nothing." This from the man who had been kicked out of France as a child and knew to rescue his reign with vainglory. "L'État C'est Moi" assigned *Sa Majesté* five-inch carmine heels depicting his military victories in the full understanding that hype held a ruler aloft.

The East parsed more closely. Tulips, pomegranates, and gold-threaded brocade powered royal Ottoman robes. Imperial China assigned subjects a ceremonial bow behooving their station and allowed none to build higher than the palace or share the imperial emblems of red lacquer, black rice, sun, moon, phoenix, and dragon. Draconian sumptuary laws ranked by color (from imperial yellow to the officials' purple, vermilion, green, and turquoise, to the commoner's black or white) and even for the court legislated fabric, shape, border-width, and use of each garment. Transgressors were demoted, exiled, or even—like the hapless court painter who

SVLIMAN·OTOMAN·REX·TVRC· X·

FOUR-TIERED CROWN
OF SULEIMAN THE
MAGNIFICENT, SO HEAVY
THAT IT SAT AT HIS SIDE
ON THE THRONE.

rendered a commoner's skirt a forbidden shade of orange—executed. Imperial Japan's rigid rules restricted such luxuries as the twelve-layered *junihitoe* kimono, permitted only the samurai to wear two swords, and curbed even the once supreme emperor. On the pretext of his incarnation as the Sun Goddess, he must show his face only to his family, avoid contact with the court, be bathed as he slept, and since a deity needs no sustenance, eat in secret. In India, only a rajah's feet might be massaged through the night; in certain princely states the lower castes had to look away when the maharani passed by; a dalit was deemed "untouchable."

271

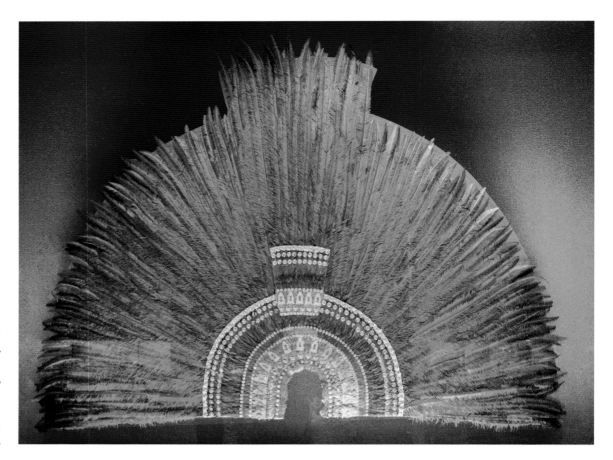

HEADDRESS OF EMPEROR
MONTEZUMA II,
MOUNTED WITH
GOLD, GEMSTONES,
AND 400 QUETZAL
FEATHERS: LIKELY
THE ONE HE WORE
TO MEET CORTÉS.

Vestiges linger. In Bhutan, the people cover their mouths when addressing their king; in Bangkok, any who slanders the royal family is jailed; and, throughout Europe, "class," subtly flagged by lineage, elocution, and the manner of wielding a fork, marks a social divide. Remarkably, Queen Elizabeth II's Lord Chancellor still leaves an audience walking backward, and only she, the crown jeweler, and the archbishop of Canterbury may touch the royal crown. As Her Majesty noted of Elizabeth Taylor's late arrival to a ceremony at Buckingham Palace: "What Miss Taylor failed to appreciate is that, in this instance, everyone had come to see me."

Display, luxury's banner, proved essential to dominance. The political aspirant began with his person—if clothes made the man, naked power richly garbed made him top man. Byzantine royalty signed with brocade, the Mayans with jade, and the Aztecs with quetzal feathers. Tellingly, even Genghis Khan, who had raided clad in hides, decreed opulence: "My descendants shall be robed in gold."

Europe's absolute monarchies engaged apparel as strategically (textile manufactories filled coffers) until vanity tipped policy to caricature. Henri III regulated finery then eclipsed a state affair trailing 400 yards of spun gold; Holy Roman Emperor Charles VI moved to reform Church excess then reserved red apparel to himself. Compliance wavered (it didn't sit well with the Venetian elite that the sumptuously garbed doges bade them hide their jeweled robes under cloaks) but Rank prevailed. As for File, a pox on the aspiring plebeian! The day's canard—"Now we have little need of brooms to sweep the filth from the streets because the side-sleeves of the grooms will do so"—had moved Elizabeth I to reserve purple silk to the nobility, size ruffs to the station of all entering London, and punish transgressors.

Only when the rising middle class was denied basic luxuries were sumptuary laws successfully challenged.

Surest to sign majesty was radiance. Gibbon faulted a diadem for seeding Rome's downfall ("Ostentation was the first principle Diocletian promulgated") but dazzle awed. Giving lie to the "Dark Age," Childeric held audience in a purple cloak sewn with gold-tipped garnet bees, Childebert I affected tunics nesting pearls, and Charlemagne met Harun al-Rashid's delegates in shimmering robes, his scepter topped with a gold apple that represented the world: "Until now we have seen only men of iron," they marveled, "but today we see one of gold!"

Luminous gemstones sheathed Tudor ambition like armor, studding Henry VIII's jackets and daughter Elizabeth's gowns until they stood on their own. Royal person and treasury were held one, until François I, inspired to assure a smooth transition of power by assigning the royal jewels divine right, declared his record-size diamond state property. Thus could Louis XIV, his person already awash in diamonds, profile the state with the 115-carat "French Blue." "The faltering economy gave him pause," recalled the generally prudent Saint-Simon, "but I urged him to take into consideration the honor of the crown." The headlight strained the treasury but, joined to an equally calculated wardrobe, blazed "Sun King" on the world.

Regalia, the emblems of authority, carried the most weight. For spirit societies, they represented the world order; a chief need only hold them to retain his people's allegiance since, in effect, the insignia reigned and the bearer represented them. A stick would have done the job. The secular ruler, however, knew power to be relative. He must draw on display to announce it and on ritual to exalt it. "A throne is just a bench covered in velvet," Napoleon remarked, then spent a fortune on the velvet.

A marking throne served across cultures. Those of the Arawak, the Asante, and the Inca were of gold; those of the tsars and the Mughals were bejeweled. Greater was the power logo of an eye-popping crown. That of Iran's long-lived Qajar dynasty bedded an egg-size carmine spinel; the Sasanians' was so weighted with pearls it hung over the throne from the ceiling; and the gem-studded, four-tiered affair that Suleiman bought in Venice all but crushed him. Best was a full flush. To eclipse Louis XIV, Catherine II plopped the 194-carat "Orlov" on her scepter and searched out "the grandest jewels in the world"—5 "matchless" diamonds, 28 "splendid" ones, and 4,903 others—to join 38 perfect pearls and a 398-carat red spinel for a crown weighing nine pounds. Queen Victoria outplayed her with a crown nesting the Black Prince's "Ruby," St. Edward's sapphires, Elizabeth I's globular pearls, the "Stuart," and the "Koh-i-Noor"; King Edward VII added two diamonds cut from the 3,106-carat "Cullinan." King Bhumibol Adulyadej of Thailand challenged with a scepter flashing the 545.37-carat "Golden Jubilee" but Elizabeth II's Imperial State Crown retained

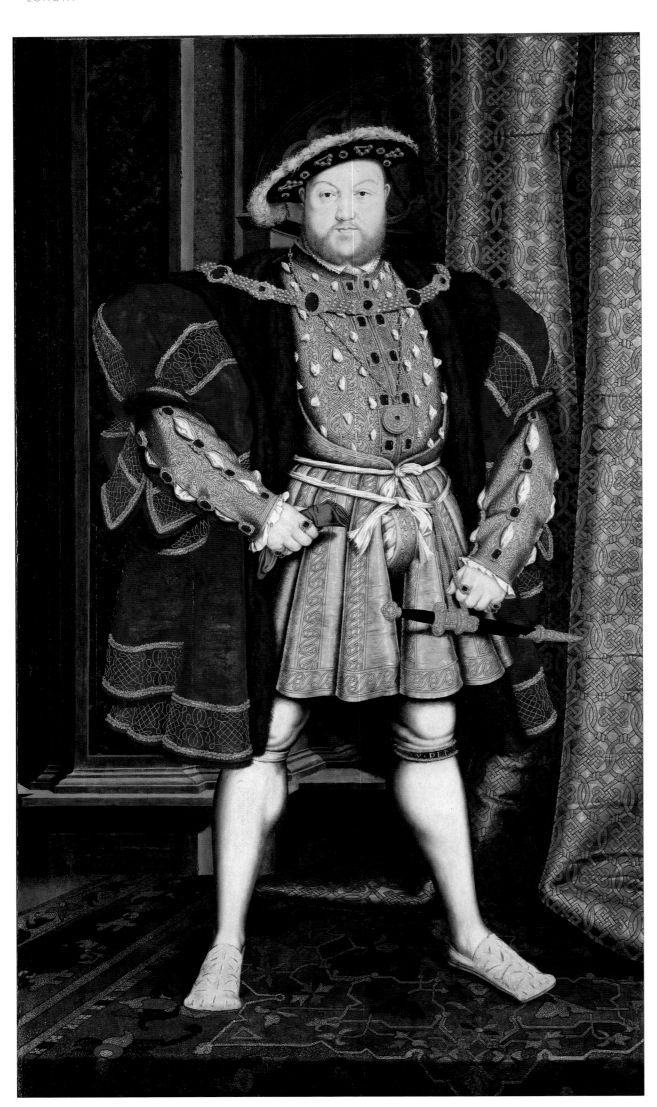

LEFT HENRY VIII:
BROAD-SHOULDERED
PRONOUNCEMENT OF
TUDOR PREROGATIVE.

OPPOSITE ELIZABETH II
CROWNED QUEEN:
ARRAYED WITH THE
ROYAL-FLUSH IMPERIAL
STATE CROWN, ORB SET
WITH 600 GEMSTONES,
SCEPTER SET WITH
THE CULLINAN I, AND
CORONATION DRESS
EMBROIDERED WITH
COMMONWEALTH
EMBLEMS OF SCOTLAND,
WALES, IRELAND,
CANADA, INDIA, CEYLON,
AND PAKISTAN.

bragging rights. As she said of her coronation gown whose jewels took eight months to attach: "I have to be seen to be believed."

The Arts—all aesthetics are political, observed French sociologist Pierre Bourdieu of art engaged as soft power. Sculpture ennobled, painting dignified, music aroused, and monuments awed. Playing out glory, the Palette of Narmer depicted the pharaoh as the slayer of evil; a frieze at Nineveh immortalized Ashurbanipal's defining battle with the Elamites, and the *Shahnameh* unfurled a storyboard of Persian heroics, retold and embellished over centuries.

Empires lacking a shared language harnessed superman portraiture. The colossal stone portraits of Amenhotep III and Ramses II guarding their temples portrayed them as invincible. The gargantuan Sphinx planting Khafre's likeness alongside Khufu's great pyramid ranked them as equals. Strongman depiction gave Queen Hatshepsut a beard to rule as pharaoh; entrenched Šuppiluliuma's command of the neo-Hittite kingdom of Patina with a 10-foot-tall avatar; proclaimed Olmec dominion with 50-ton basalt heads carved into a cliff-face; and imprinted Alexander the Great's profile on a battery of bronze coins by Lysippos. Throughout Africa, wrought by the Dahomey from brass, by the Asante with beaten-gold, and by the Mali with copper, the ruler's gaze embodied the very soul of power. Such was the impact of Montezuma II's likeness carved large into a rock-face at Chapultepec as to earn each of the stonecutters two slaves and a lifetime supply of cocoa.

Consular strut planted imperious busts on the Palatine Hill. The effigy Pompey paraded through Rome sent Pliny's famed irony into overdrive: "Such a frippery as pearls, oh great Pompey, to limn the visage of such a man as yourself!" Predictably, imperial vanity exceeded. Augustus had himself rendered crushing the Parthians, Vespasian

ABOVE QUEEN HATSHEPSUT WEARING THE FALSE BEARD ADOPTED TO RULE AS BOTH AMUN-RE AND PHARAOH.

LEFT *THE BRONZE HORSEMAN:* ÉTIENNE FALCONET'S EQUESTRIAN PORTRAIT OF PETER THE GREAT, MOUNTED ON THE LARGEST ROCK EVER MOVED BY HUMANS.

SCUOLA GRANDE DI SAN ROCCO: THE RENOWNED MEETING HALL, PRIDE OF VENICE, EMBELLISHED BY TINTORETTO.

topped the Colosseum with his 105-foot-tall likeness, and Constantine overlooked his capital sculpted as a supersized Helios.

Feudal rule engaged the arts indirectly. The Huns, although indifferent to possessions, looted rich works for leverage; Sicily's Roger II accrued *spolia* more for their aura than their material value; and the Normans fashioned the prodigious 224-foot-long *Bayeux Tapestry* more to document than trumpet their game-changing victory at the Battle of Hastings.

It awaited the Renaissance, crowning and deposing left and right, to deploy art strategically. Richard II hoisted the House of Gloucester on 2,300 enameled and jeweled articles; Rudolf II lit the Palatinate with the day's grandest *wunderkammer*; Archduke Ferdinand II's display of rare objects brought wide attention to Innsbruck; and the princely houses of Habsburg and Hesse surfed five centuries of upheaval on the Cranachs, Dürers, engraved silver, gilded bronzes, and delicate what-nots of conch-shell and crystal that they aggregated. Florence fell to the Medici under a volley of portraiture. Five by Agnolo Bronzino alone lifted Cosimo I to Grand Duke; a roster led by Botticelli, Verrocchio, and Ghirlandaio crowned Leonardo "Il Magnifico"; and 24 wall-length tableaux by Peter Paul Rubens recorded Marie de' Medici's trajectory from merchant's daughter to Queen of France. Venice posted

artworks like heraldry. "He who would make his
fortune must go there," had urged a 13th-century
poet, "for it's the source of all treasure." Lavish
commissions ennobled—none more promotional
than the Scuola Grande di San Rocco, founded as a
meetinghouse for a wealthy confraternity.

More purposefully, absolute monarchs
marshaled art for national glory. Obsessed with
magnificence, Henry VIII had Holbein the Younger
portray him in broad-shouldered brocade, Philip IV
asked Velázquez for a portrait in full armor, and
Gustav III posed for Alexander Roslin swathed
in ermine. None outdid the virtual Triumph
that Maximilian I, infatuated with splendor but
reluctant to appear in public after a dustup in
Bruges, had commissioned from Albrecht Dürer to
parade Habsburg glory—36 pulverizing 11-by-9-foot,
177-foot-long woodblock prints depicting a stream of
battles, tournaments, musicians, jesters, wrestlers,
buffalos, camels, and artillery, followed by the
dragoons, the marshal, the queen, and, finally, in a

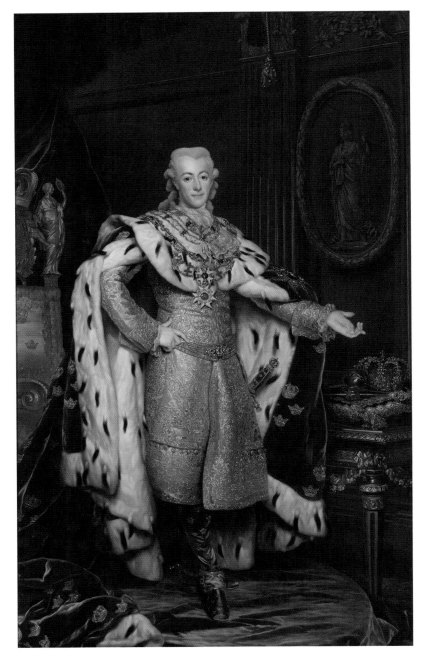

sumptuous chariot, the Holy Roman Emperor himself. Albeit on paper, the manifesto
was a palpable hit, prompting myriad editions and for Dürer a life stipend.

Paper would not have suited the Sun King. With all Versailles as his canvas
Louis ordered a commanding coronation portrait from Rigaud, a crowing Salon
d'Hercules from Lemoyne, and a dazzling Hall of Mirrors ceiling by Le Brun—all
to such stirring effect that Charles I would ask much the same from Van Dyck,
Margaret of Austria from Van Orley, and Ferdinand VII from Goya. More triumphal
proclamation raised Philip IV, Louis XV, Frederick II, José I, and Leopold I on very
high horses. Peter the Great was mounted on a 1,500-ton rock from Finland that took
400 workers two years to haul in.

Absolutism's signature logo was a gold-threaded tapestry. The preparatory
drawings alone for orders "en suite" (*twelve* for Charles V's coronation) kept artisans
backlogged; even Henry VIII found himself wait-listed for a Triumph by Pieter
Coecke van Aelst. No waiting for Louis XIV, who turned his *manie de grandeur* to
political advantage. The exorbitant weavings depicting his triumphs established the
nation's great manufactories—Gobelins, Beauvais, Savonnerie—as the go-to places
for lavish proclamation. It is difficult for a culture geared to imports to appreciate

CORONATION PORTRAIT
OF GUSTAV III, WHOSE
RESOLVE TO RESTORE
SWEDEN'S AUTOCRACY
LAUNCHED A PRODIGAL
PROGRAM OF MILITARY
EXPLOITS AND
PUBLIC BUILDING.

the advantage accrued from domestic manufacture. What admiration Grand Duke Ferdinand I reaped abroad from the pietre dure produced by Italy's Galleria dei Lavori! How it enhanced Saxony's August the Strong that Europe's first porcelain factory was his!

The porcelain moment said it all. Tagged the "jealous art," fired ceramics provided a surefire imprimatur. The royal one-upmanship that had lined Queen Mary II's Hampton Court dairy with blue-and-white Delft now filled entire porcelain rooms. To upstage the Habsburgs' mirrored-to-infinity collection at Schönbrunn, the Hohenzollerns fashioned one at Charlottenburg holding 2,700 pieces. Carlos III's rule over both Spain and Italy entailed one manufactory to supply the palace at Aranjuez with hand-painted figurines, and another to copiously tile the Royal Palace at Caserta.

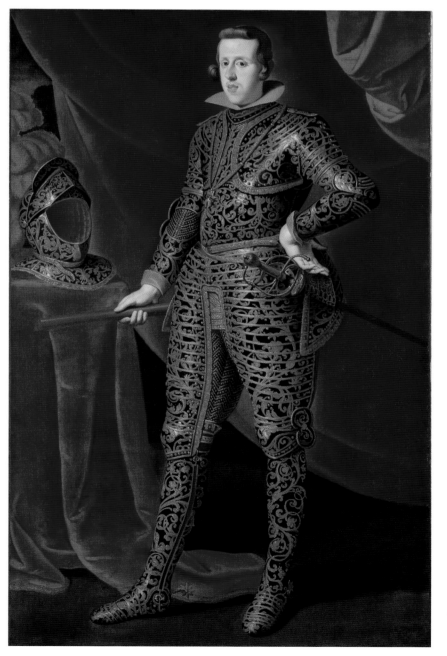

PHILIP IV IN PARADE ARMOR: PROFLIGATE SHOWPIECE BELYING SPAIN'S DECLINE.

Luxury on this level was straight-out propaganda, and contenders upped the ante accordingly. Charles V taught Spain the Habsburg tactic of strategic collecting, showcased by son Philip II at the Escorial with the rich objects of conquest and 45,000 books whose gilt-edges faced outward. Peter I sent talent abroad to study the arts and imported master artisans to design the salons that displayed them. Frederick II profiled the New Palace with Greek vases, Roman coins, Tangara terracottas, and 2,000 paintings. Queen Christina simply handed her army a shopping list: "Procure and send me the library and the rarities there in Prague." She seized the desk of the Duke of Lorraine "inlaid with hundreds of cameos and inset with jasper, agate, lapis, onyx, cornelian, turquoise, and myriad heads of emperors and of Roman gods"; and absconded, upon abdicating, with the nation's Veroneses. Her successors re-stocked with Dürers, Cranachs, and Tintorettos plundered from Lithuania and Poland.

A form of collateral, masterworks moved between nations like pawns on a chessboard. Philippe d'Orléans purchased Sweden's; Charles I acquired a defining amount from Mantua's

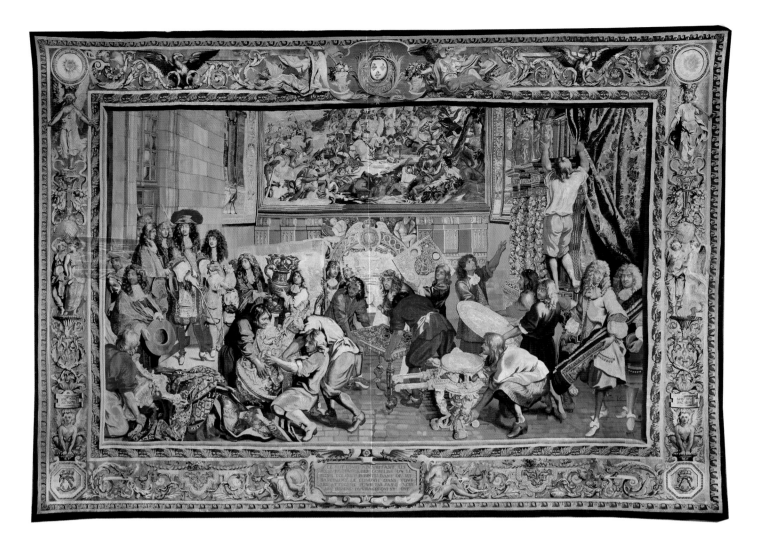

strapped dukes of Gonzaga; and the quantity that Denmark's Frederick V's victories accrued transformed Amalienborg Castle into a virtual museum. Catherine II raked in trophies like acorns. Resolved to out-collect Europe, the empress built the vast Hermitage and set out to fill it. Beginning with the fabled Gotzkowsky collection, she zeroed in at the first whisper of death or insolvency, relieving Paris of the Crozat collection, and England of its heritage—most of Robert Walpole's storied assemblage, which she sent a warship to collect. The ensuing outrage didn't faze her: "Never mind," she said: "When I've had an offer, and I want it, I never let go."

What wasn't purchased was plundered. Before designated a war crime at the 1814 Congress of Vienna, pillaging artwork was customary. Thus could Napoleon Bonaparte, history's greatest predator, hack Veronese's revered *The Wedding at Cana* from a monastery wall, transfer one of Luxor Temple's great obelisks to the Place de la Concorde, and transpose to the Louvre, from Cairo, Athens, Venice, and Vienna, the trophies announced on its cornice as "Les Fruits de Nos Victoires." His hair styled like Caesar's, the conqueror had himself sculpted in marble by Antonio Canova for the court, in bronze by Antoine Chaudet for his subjects, and on medallions for posterity. To model his coronation on the éclat of Charlemagne, the self-declared emperor bled the treasury of a stunning 100,000 francs for a vainglorious *Coronation* by Jacques-Louis David (without whom, it was said, there would have been no Bonaparte) that depicted his newly imperial self receiving God's blessing for his next power move.

WOVEN-OF-GOLD PROMOTIONAL TAPESTRY DEPICTING LOUIS XIV AND COLBERT VISITING THE GOBELINS MANUFACTORY.

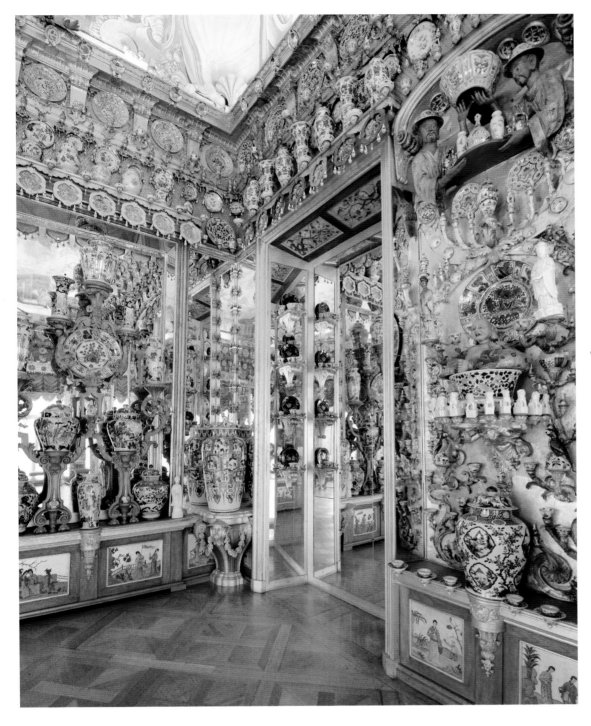

THE CHARLOTTENBURG
PALACE PORCELAIN
ROOM: QUEEN
SOPHIA CHARLOTTE'S
DAZZLING EXERCISE
IN ONE-UPMANSHIP.

Britain sowed glory the better to reap it. Queen Victoria professed moderation but knew to blind the world with the treasure pulled from her colonies. Once her ceaseless acquisition had filled Buckingham Palace, "the road of excess," noted William Blake, "leads to the Palace of Windsor."

To the east, where art informed everything, talent was bribed or abducted to record a great rule. Artists from Persia richly illustrated the Mongols' trajectory with the *Compendium of Chronicles*—the world's first complete history— and established the Mughal-defining atelier that exalted Akbar's reign with the poetry of Tulsidas and Jahangir's with an album of memoirs that titled master-painter Abu'l Hasan "Wonder of the Age" for its distinguishing frontispiece.

Imperial China breathed art. Just as the usurping Yongle Emperor had established the Forbidden City with one million objects, the Qing Emperor Kangxi knew to mark a long and victorious reign with tour de force artworks. More resolutely, Qianlong embarked on an extensive program of imports, commissions, and works confiscated from so-called inspection tours—some two million in all. The 145,000-page inventory compiled by the Jesuit Attiret comprised a trove beside which, said Victor Hugo, "all the treasures of all France's cathedrals would pale." These were but overflow from the Yuanmingyuan, which held 10,000 paintings in the Long Promenade alone, as well as 6,752 cases of manuscripts produced by 2,000 calligraphers and a staggering number of artifacts. "To convey," wrote a looter at their torching, "the splendors before our astonished eyes, I should need to dissolve

specimens of all known precious stones in liquid gold for ink, and to dip it into a diamond pen tipped with the fantasies of an oriental poet." There had been method to the muchness; for every object imported, two were exported to impress Qing wealth and artistry on the West. Determined that the world should never know greater glory, the emperor had thought his extravagance astute propaganda. Revisionist history holds that splendor extending to a 65-acre replica of Versailles's gardens sidelined the famine and drought that would fatally weaken China's defense against British invasion.

No such program crossed the Atlantic. Post-Revolution America looked to art for polish, not glory. A statue of George Washington rendered as Zeus reigned but fleetingly in the Capitol Rotunda, and the nation's museums would be stocked by private benefaction.

More modern agendas politicized unabashedly. Empress Dowager Cixi apprised the West of her five-decade rule with an exalting portrait commissioned for the 1904 St. Louis World's Fair, and a flurry of equestrian statues touted leaders past and present. New players posted top-dollar acquisitions: Sheikha Al Mayassa's resolve to "revise" Qatar's identity built a national museum and splurged $1 billion on masterworks. Tellingly, trophy art need no longer portray a ruler, a triumph, or anything at all—its market value suffices. A Jackson Pollock dribble, a Cy Twombly scribble, a Mark Rothko color field, a Yayoi Kusama dotted mushroom, or a Zhang Huan stuffed cow inflates national prestige nicely. Fully exploiting art's impact, Communist president Xi Jinping endorsed a buy-back of pillaged patrimony as "a foundation for China to compete in the world." "The message to the West is clear," Liu

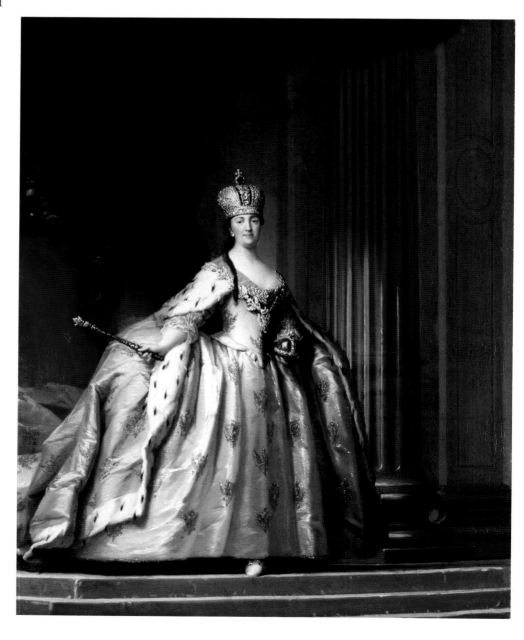

BELOW EMPRESS CATHERINE THE GREAT: MILITARILY EXPANSIONIST AND SOCIALLY ENLIGHTENED, HER BOUNDLESS REACH AND AMBITION EXPANDED AND WESTERNIZED RUSSIA.

OPPOSITE EMPRESS DOWAGER CIXI: PROPAGANDA PORTRAIT COMMISSIONED TO BROADCAST THE RULE OF THE CONCUBINE WHO HAD RISEN TO COMMAND EVERY LUXURY.

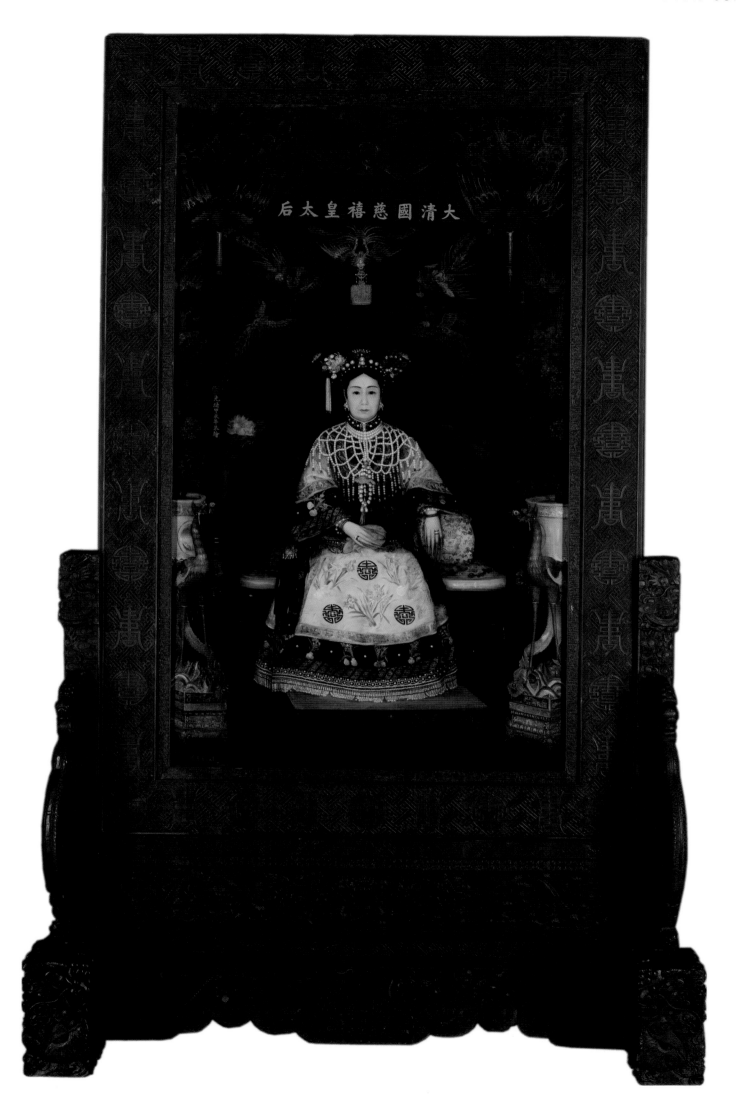

大清國慈禧皇太后

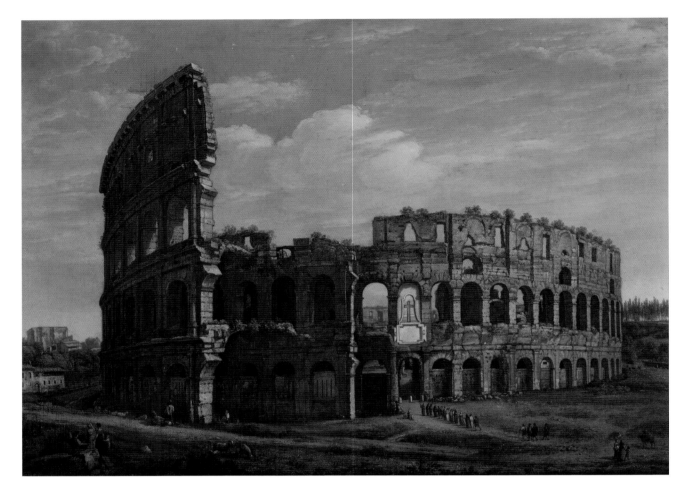

Yiqian stated of his newly acquired $170.4 million Modigliani, "We have bought their buildings, we have bought their companies, and now we are going to buy their art."

In the end, though, art and treasure are inert, their impact fleeting. Only direct enrichment earns fealty. Speaking to the bounty expected of a great rule, throughout the dry season Montezuma distributed food to his subjects, Emperor Harshavardhana left no petitioner empty-handed, and Shah Jahangir used auspicious occasions to disburse his weight in gold to the needy.

Rome's emperors diverted a restive proletariat with go-for-broke spectacles. The Colosseum boasted gold furnishings and a mechanism to sink ships that left the poet Martial dumbfounded: "But a moment ago, here was dry land!" The insatiable crowds were fed blood never-ending—9,000 animals slain to open the inaugural 100-day marathon, one million in all. Domitian's combats pitted women against dwarves and big cats against crocodiles. Probus ordered ravenous lions released in an amphitheater stocked with ostriches and wild boar—only to be dispatched there himself (by soldiers, not fauna). Best received were the gladiators, fiercely muscled, glistened with olive oil, and showered with honors, rewards, and female attention. Augustus engaged 10,000 over his reign—a bagatelle for Trajan, who hired 100,000 for a 123-day event proclaiming his conquest of Dacia. Never again, noted Gibbon, would so much be spent to divert the masses. But it was submission accomplished, supporting poet Juvenal's observation that those who once "bestowed commands, consulships, legions, and all else" now long for "bread and circuses."

THE TEATRO OLIMPICO:
THE WORLD'S OLDEST
INDOOR THEATER,
ORNAMENTED BY
ANDREA PALLADIO.

Theatricals, too, emptied of Greek tragedy's redemptive emotion of catharsis, were staged to divert. The Scaurus alone, a colossal, columned affair seating 84,000, flourished 3,000 statues and a surfeit of gilding. Medieval spectacles countered the liturgical gloom with a frisson of mechanical thunder and scenery propelled down actual canals. Renaissance exuberance staged explosions that brought down the backdrop—thankfully, cork. Topping the era's pyrotechnics, Palladio and Giorgio Vasari staged a scenario at the Teatro Olimpico in Florence that engulfed a gargantuan chariot drawn by buffalos in true-to-life lightning.

Thenceforth, no budget was too big for glory. China's allegorical plays entailed up to 450 lacquered masks and costumes as rich as the court's. The productions at Sweden's Drottningholm Palace featured special effects supplied by groundbreaking mechanics. Grandest was the bombast that met France's nostalgia for empire. At the Paris Châtelet, the notorious presentation of *Austerlitz* saw 30 actors exchange gunfire for ten booming minutes: for the *Battle of Marengo*, real cannons shot holes through the ceiling. Wilder still, an 1883 Opéra Comique production torched the drapes and scattered the audience, to disclose the next day that the blaze had been staged. Turn-of-the-century flamboyance underwrote 753 performers for Gustav Mahler's Symphony No. 8 in E Flat Major and for Serge Diaghilev's Ballets Russes the prodigious talents of Debussy, Ravel, Prokofiev, Stravinsky, Picasso, Matisse, Derain, Léger, Rouault, Tchelitchew, de Chirico, Bakst, Dobuzhinsky, Larionov, Soudeikine, Exter, Goncharova, Nijinsky, Karsavina, and Lifar.

Across the Atlantic, a rough-and-tumble America conjured wingding entertainments. P. T. Barnum's *Greatest Show on Earth* crisscrossed the country

in 65 railcars and packed 10,000 people around a three-ring
Roman hippodrome featuring clowns, beluga whales, Jumbo
the Elephant, and human oddities like 25-inch-tall "Tom
Thumb," whose marriage to the diminutive Lavinia Warren
was fêted at the White House by Abraham Lincoln. The
Ringling Brothers challenged with a caravansarai of tumblers,
animals, managers, 100 waiters, and an 18-ton tent—a feat that
by 1925 cost $15,000 a day yet provided two of the brothers a
bank in Sarasota, a million-dollar house, and toys on the order
of the museum that John Ringling stocked with $20 million
worth of art.

Colossal new entertainment centers borrowed the bravura
of Fair architecture. Madison Square Garden staged sporting
events under a first-ever retractable roof. The Atwood and
Hayden planetariums mounted vaulting displays of the heavens.
Xanadu movie palaces showcased D. W. Griffith's cast-of-
thousands *Intolerance*, Cecil B. DeMille's sweeping *King of
Kings*, Busby Berkeley's dancing-girls-on-a-cake *Footlight
Parade*, and David O. Selznick's $40 million, five-director,
15-screenwriter, *Gone With the Wind*. Deep pockets licensed
Charlie Chaplin's 342 takes of the *City Lights* flower-seller
scene and Howard Hughes's re-shoot of *Hell's Angels* (after four
stuntmen had died) because sound had come in. Oscar hopes
funded budget-busting authenticity—down to the buttons for
Peter Weir's *Master and Commander*, the 360-ton steamship
dragged through the jungle for Werner Herzog's *Fitzcarraldo*,
and the actual helicopters flown through a typhoon for Francis
Ford Coppola's *Apocalypse Now*. Star-power commanded
$14 million salaries and James Cameron's $235 million,
decade-in-the-making *Avatar*. Once again, regimes struggling
to provide bread proffered circuses—no cost spared for India's
flashy "Bollywood" fantasies and China's gold-drenched,
3-million-chrysanthemum, 20,000-extras, *Curse of the
Golden Flower*.

Panoply—Nations bent on glory extended the set to the
streets. The secular ruler, his throne ever in play, had to parade
the full gamut of splendor. Birth might advance him, the gods

might endorse him, but only pomp and circumstance could uphold his authority. The ancient world filed out days-long processions and Rome perfected the triumph, introduced by Aurelian with 200 wild animals, 1,600 gladiators, and a trail of captives from Palmyra led by Queen Zenobia, bound with gold chains.

The goal was to pulverize. The Emperor Theophilus impressed Byzantium's wealth on Baghdad by scattering 36,000 gold coins in the streets "like the sand of the sea." Montezuma received Cortés in full regalia, trailing 200 richly arrayed lords and 4,000 retainers. Well into the Renaissance, the belief that acting out majesty achieved it wrote resplendence into history. Henry VIII drained the treasury to summit with François I in a setting of a splendor that tagged it the Field of Cloth of Gold. Holy Roman Emperor Charles V countered with a reception for the French king that drew on six state coffers. Italian obsession with *magnificenza* bordered on swagger. Milan's Duke Galeazzo Sforza descended on Florence with 500 infantry,

GRAND CELEBRATION STAGED IN LONDON'S HYDE PARK, THEMED TO HANDEL'S ROYAL FIREWORKS TO MARK THE 1748 PEACE TREATY OF AIX-LA-CHAPELLE ENDING THE WAR OF THE AUSTRIAN SUCCESSION.

100 men-of-arms, 2,000 retainers, 50 valets, and 1,000 dogs. Catherine de' Medici imprinted her proxy rule for son Charles IX on Spain with an island banquet at Bayonne remembered for the 61 tables overflowing with delicacies and prodigal tableaux staged at sea. Thinking to stun Venice with a splendiferous entrance, Henri III was outmatched by 360 silver-clad delegates, led under overnight arches painted by Tintoretto and Veronese, entertained at a banquet featuring centerpieces of spun sugar, and—to drive the point home—taken at dawn to the Arsenale to see a warship laid out, and back the same evening to find it completed.

None more declamatory than the Royal Entry, a pronouncement of unassailable monarchy achieved with tableaux vivants and a triumphal arch. For her entry into Paris, Isabeau de Bavière arranged to be met by citizens on horseback dressed in her colors. Marie de' Medici entered Paris to marry Henri IV in shimmering silks and a crown so weighted with jewels she had to keep halting her cortege to adjust it. Charles V's flamboyant Entries—five into Genoa alone—established him as Europe's most powerful monarch. An exemplary entry equally elevated the host: in 1515, Giuliano de' Medici greeted the newly crowned François I in Lyon with a mechanical lion fashioned by Leonardo da Vinci to puff open its chest and proffer a cluster of lilies.

Impressive, too, the celebrations searing milestones into memory; the banquet that welcomed the Peace of Aix-la-Chapelle with Handel's *Royal Fireworks* and volleys of gunpowder; Verdi's *Aida* staged with live elephants to premiere Cairo's new opera house; Mozart's promotional *La Clemenza di Tito* ordered for Leopold II's coronation.

Investiture presented the ultimate look-at-us opportunity. Europe's frequent realignments held accession pivotal. Frederick Barbarossa impressed his sons' crowning on the Great Diet of Mainz with an extravagant pageant. Queen Christina flourished her coronation with forty warships, three triumphal arches, and a carriage fitted with brocade three years in the making. British investiture radiated out from the richly gilded four-ton palace-on-wheels built for George III to the breath-stopping panoply of Edward VII's coronation, flashed by so many diamond tiaras as to establish Cartier in London.

Outshining all was the folderol commemorating a long reign. Queen Victoria's 1897 Diamond Jubilee flooded London with well-wishers. Crown jewels! Cortege! Fireworks! "No one ever, I believe," crowed the sovereign, "has met such an ovation as was given to me."

None, that is, in the West. Persia had long before set the stage. Xenophon detailed the crowning of Cyrus II, garbed in royal white and purple, preceded by his cavalry and followed by 6,000 lancers, 200 horse-drawn chariots, a string of sacrificial bulls, and an elite corps of 10,000. Abbas the Great's celebrations featured tournaments, banquets, and displays of wild animals collared with jewels. The Ottomans rivaled: "A more beautiful spectacle has never been presented to my gaze," wrote a Holy Roman ambassador of the procession that opened a three-week festivity extolling Suleiman the Magnificent.

THE BRITISH CROWN'S GOLD STATE COACH, FASHIONED FOR GEORGE III WITH FOUR TONS OF GOLD—ITS INORDINATE COST JUSTIFIED BY ITS USE FOR SEVEN CORONATIONS.

LEFT SHAH JAHANGIR IN DURBAR: ANNUAL CEREMONY WHOSE SIGNIFIERS—COSTUMED ELEPHANTS, CAPARISONED HORSES, RICHLY ROBED RETINUE—SPOKE TO A MAGNIFICENT RULE.

OPPOSITE SHAH JAHAN HOLDING COURT ON THE PEACOCK THRONE: RESPLENDENT SYMBOL OF ABSOLUTE RULE WHOSE TRANSFER TO PERSIA WAS SAID TO HAVE DEPLETED HALF THE TREASURY.

Even this puffery deferred to Mughal ostentation. Emperor Humayun's succession had already entailed weeks-long festivities that filed over 12,000 attendees past a numbing tribute of riches, but Shah Jahangir's accession topped it. Setting out in procession he was the embodiment of majesty: "On one side hung a ruby uncut, as big as a walnut," gushed the diplomat Thomas Roe, "on the other side a diamond as great, in the middle an emerald like a heart. His sash was wreathed about with a chain of great pearls, rubies, and diamonds and about his neck he carried a chain of the most excellent pearls, three double, so great I never saw, at his elbows, armlets set with diamonds . . . and on almost every finger a ring." Reported, too, the surrounding misery—the lame, blind, and beggared.

Not understood, like the nimbus representing him, was the layered symbolism of a bejeweled lord in procession. The fully realized pageantry of caparisoned horses, adoring subjects, and the raja enthroned on a war elephant leading his costumed retinue to a magnificent durbar, spoke to the prowess and virtue expected of a great rule. Likewise, Shah Jahan in state on the Peacock Throne—the power logo involving a labor of seven years and set with gemstones that cost twice the Taj Mahal—constituted, not a frivolous extravagance, but the sacred seat of sovereignty.

Mughal decline ceded empire to Great Britain and regional rule to the maharajas. At once compliant and defiant, they readily added Victoria's medals to their ornaments but when forbidden to wear crowns had them attached to their turbans. Posturing on, Ram Singh II had the entire city of Jaipur painted pink to royally welcome the Prince of Wales and received him later as Edward VII, reported Sir Stanley Reed, with "a quantity of bullock-pulled palanquins . . . turbaned runners and kettledrums announcing Sirdars on frothing stallions, camel drivers mounting blunderbusses, and apparitions by the score, gorgeously dressed, of orange-robed messengers, spearmen by the hundred, and match-lock men in olive green. Through this fascinating throng drove his Highness the Maharaja, in a carriage, to receive his royal guests, and he alighted at the station to the braying of war-horns and the strains of a most original anthem."

The world realigned and air-shuttle diplomacy shut the show: in 1971, Shah Mohammad Reza Pahlavi gathered 250 world leaders to a last-hurrah, five-day, $200 million tented banquet in Persepolis proffering a barbecued camel, peacock stuffed with foie gras, and 25,000 bottles of Champagne from Maxim's, to proclaim himself "King of Kings," heir to the Achaemenids, Darius, and Xerxes.

Ultimately, panoply is but packaging. Lasting pronouncement entails statement infrastructure. "For those who shall see my monuments in years to come and speak of what I have achieved," Hatshepsut erected skyscraping obelisks. "To draw the

admiration of all peoples," Nebuchadnezzar II gave Babylon a spectacular portal. A 108-foot-tall bronze Colossus lifted Rhodes, a 1,000-foot-long tunnel enriched Megara, and the Mauryans' wondrous Trunk Road gave 1,600 miles of North India shade trees and wells. Credit Rome's relentless advance to its stadiums, bridges, aqueducts, and the "Queen of Roads" Appian Way, and Inca ascendancy to a 14,300-mile network of roadways.

Waterworks were surefire signifiers. Rule the elements, history taught, and you rule the world. "I made the rivers flow where I wanted," boasted an epitaph at Saqqara, and Angkor Wat's walls exalt the king "who made water flow where it had been scarce . . . a basin lovely as the moon to refresh us and to drown the ambition of all other rulers." To master the desert was the boldest of undertakings. Only unchallenged authority could have sacrificed 2,900 lives to build the 19 BCE canal at Mahmoudia, and another 120,000 to link the Nile to the Red Sea. Roman engineering gave the capital 11 aqueducts and vaulting underground sewers—the Cloaca Maxima so accomplished that the workers signed the pipes. China's mind-bending efforts shored up the roiling Yellow River and accessed Peking with the 1,104-mile Grand Canal, opened by the Yongle Emperor and his entire flotilla, pulled along it by maidens harnessed with silk ropes.

Water's greatest glory was a garden. First evidenced at Thebes, royal gardens served as political cannonades. Those at Versailles challenged the world with a stunning geometry of canal and parterres angled from the royal bedchamber to infinity. St. Petersburg weighed in with 40,000 trees and a canal plumed with more fountains than the Sun King's. The manicured gardens of Dresden's Zwinger Palace constituted a manifesto of nature-subservient. Even small courts pronounced—at Wilhelmshöhe with a garden cascade that bankrupted the treasury and left two-thirds unrealized.

The more durable power move was a marking domain—autobiography writ in stone to amaze and proclaim. Every Bronze Age palace posted power: those at Karnak with heft, that at Pylos with ornament. The Sumerian palace at Mari stretched to eight acres; the Shang palace at Yingxu rose on gigantic stone columns. Trade routes supplied the special effects—for King Solomon's dwelling, crystal ceilings and a profusion of gold; for Nebuchadnezzar II's domain, every luxury obtainable: "I rebuilt the palace, my royal residence . . . on massive foundations of brick and mortar. I brought in great cedars of Lebanon for the roof and inlaid the precious wood with bronze for the thresholds and hinges. I embedded the portals with gold and silver and precious stones, with everything costly and beautiful, and filled the palace to overflowing with princely wealth and goods." At Susa, Darius I reached farther: "The

materials I used for my palace came from a great distance. Babylonians dug up earth and piled up gravel. I had cedars from the hills of Lebanon hauled to Babylon by my countrymen and on to Susa by conscripts. I had the teak brought from India, the gold from Sardinia, the lapis lazuli from Samarkand, the lead from Egypt. The ivory too came from India, and from Ethiopia. The stone was quarried in Cairo by stonecutters from Syria and Lydra, and the metal-smiths came from Egypt." Hear this and quail! So would Diocletian's massive white limestone palace-complex trumpet Rome's dominion to the empire's perimeter, and so did King Khosrow I lift the Sasanians with a radiant palace in Ctesiphon that vaunted a 110-foot-high audience hall and the miraculous "Winter Carpet."

Didn't have one? Better hustle! Harun al-Rashid ruled from a pleasure-palace in Baghdad adorned with 9,000 cushions, 8,000 pillows, 2,500 carpets, and 640 gold and silver vessels looted from Asia—a conversance with luxury that placed court and caliphate at Arabia's epicenter. Al-Mu'tasim gave Samarra a palace of such splendor that an envoy from Constantinople urged Emperor Theophilus to outbuild it, which he did. The Nasrids outshone. A great swinging ball lit the famed inscription on the Alhambra's gold-and-silver gateway: "Give me charity, lady, for there is nothing in life like the pain of being a blind man in Granada."

Shine ceded to majesty. Philip II aggrandized the monastic El Escorial into a 2,700-window monument to Spanish dominion. François I countered with Chambord, a grandiose proclamation of primacy that triggered Henri IV's 2.5-million-livre expansion of Fontainebleau—the largest sum a French king had ever spent on a home. All paled before Versailles, palace-building's defining monument. Inflated from a hunting lodge positioned safely outside Paris, the megastructure was conceived to eclipse all that preceded it. Mirrors reflecting a bottomless purse, a commanding façade, and numbing square-footage anchored the hub from which radiated the power and the glory of France. The labor alone defied reason. Between 1670 and 1684, 6,000 horses and 22,000 soldiers diverted the river Bièvre, dumped earth into marshland, and hauled in cartloads of furnishings. Louis XIV used the public treasury as his personal bank to provide everything constituting an interior— boiserie, marquetery, orfèvrerie—and not just a piece of furniture here and there. The myriad salons swallowed matched sets, several ordered in triplicate. Yet even as war debts sent the solid-silver chairs to the smelter, the king's spending went unchecked because it so palpably promoted the state.

Just as royal commissions vastly expanded the manufactories (252 weavers alone for tapestries supplied by Savonnerie, Aubusson, and Gobelins), the embellishments

that soared Versailles's cost to a stunning 100 million livres proved a propaganda bonanza. "To the Glories of France" its portals proclaimed. All Europe knew the numbers: 700 rooms, 2,153 windows, 352 chimneys, 28 acres of roofing, and 35,000 workers. Astounding, the space allotted the Place d'Armes (60,000 square meters) and the two approach avenues (94 and 78 meters across), given that Georges Haussmann would later be vilified for widening the Boulevard Sebastopol to 30 meters. Wondrous, the gilded Hall of Mirrors, with its 357 mirrors, 17 glass doors, 30 ceiling paintings, and 84,000 square feet of parquet flooring. Even Bonaparte, when asked to restore it, replied, "I dare not."

Vanity or strategy, Versailles's effective return on excess wrote palace-building into monarchical economics. The glory the Sun King had emblazoned on France inflamed Europe's rival rulers with an "I'll have what he's having" attack of *style solaire* palaces with long façades, lavish ballrooms, and a killer Hall of Mirrors. Copenhagen's Charlottenborg was modeled directly on Versailles, as was Würzburg's Residenz, Kassel's Wilhelmshöhe, and the Bonchida in Transylvania. The Zwinger's Baroque splendor and the Green Vault's refulgence entrenched August the Strong's four-decade rule and elevated the Dresden court to the most brilliant in Germany.

THE ALHAMBRA: GRANADA'S PALACE-FORTRESS, EMBELLISHED AS "PARADISE ON EARTH" TO IMPRINT MUSLIM GLORY ON IBERIA.

The gauntlet flung, Frederick II profiled a new Prussia with a palace in Berlin that outstretched Versailles, and Maria Theresa gave Schönbrunn 1,440 rooms, 139 kitchens, a mirrored ballroom, and a signature yellow façade exceeding the Sun King's. Austria's Prince Eugene of Savoy answered the rumored was-he-wasn't-he son of Louis XIV with *four* treasure-stuffed palaces and had himself limned as Apollo in the Belvedere's Hall of Mirrors. Portugal's House of Braganza rose on a radiant library wrought of gold from Brazil; although built for learning, it was inscribed to dominion: "In this regal portrait see how much this palace comprises / All that is majestic is displayed / made possible by João V / Eternal Be it / like the name of the prince, his work."

England weighed in slowly, although those thinking her reticent hadn't seen Inigo Jones's heroic new Banqueting House—its ceiling flamed by Rubens—which even the caustic Horace Walpole, lord of the splendiferous Strawberry Hill, called "the most beautiful fabric of any kind in Europe." Nor had they followed William III, whose consuming hatred of Louis XIV resolved to outbuild him with a Nottingham House modeled on Versailles, a "Petit Trianon" annex to Hampton Court, a magisterial Royal Bank, and the splendid Royal Naval Hospital whose dome depicted the Protestant king stomping on his Catholic nemesis. Appalled by the cost, Parliament cut the royal right to tax, leaving fire, not royal decree, to reshape London and raise Christopher Wren's 52 churches through the ashes.

Undaunted, King George III ordered a lodging whose "vast and expensive design should be at once an object of national splendor as well as convenience." With "an eye to the Ornament of the Metropolis; and as a monument of the taste and elegance of His Majesty's reign," Somerset House was extended to the Thames and given six acres of gardens. Alas, vanities like Greek columns shot the cost to 500,000 pounds, delaying completion until after the architect had died. It fell to George IV, envious of *le style Bonaparte*, to achieve a glory intended to "quite eclipse Napoleon's" with court architect John Nash's lavish redo of Buckingham Palace and, at Brighton, a gilded meringue of Anglo-Indian minarets.

Rivaling in splendor, Poland's dynastic ambition profiled, not the king (Sobieski III's residence was modest) but its powerful nobles. Staggering monuments to unchallenged oligarchy, the palaces of the Potocki at Łańcut, the Krasicki at Krasiczyn, and the Czartoryski at Pulawy, enfolded libraries, chapels, theaters,

SCHÖNBRUNN: EMPRESS
MARIA THERESA'S
SUMMER RESIDENCE,
EXPANDED FROM A
HUNTING LODGE TO
UPSTAGE VERSAILLES.

and, for the Branicki Palace at Bialystok, an opera house. The princely Radziwills surpassed only in real estate, amassing 10,053 villages, 2,032 estates, and 423 palaces.

Russia's imperial dwellings outscaled them. Already in 1668, on grounds that called on nine hamlets to maintain them, Tsar Alexis had given the Kolomenskoye Palace the blinding luxury of 3,000 windows and "a profusion of gilding so brilliant," trilled a visitor, "it seems to have emerged from a jewel box." Peter the Great's domains lined the Neva with pink marble from Finland, and all the malachite, lapis lazuli, and rich trappings the treasury could fund. A genetic disposition to pronouncement moved daughter Elizabeth to repeat the whole effort. "For the glory of all Russia" the empress imported Rastrelli and three colleagues to overhaul five palaces she thought unacceptably outdated. Her call for 100 kilos of gold leaf to relieve the monotony of snow at Tsarskoye Selo's Catherine Palace rattled even Catherine II, no slouch in the building department: "It was the work of Penelope," she wrote of the "whipped cream" confection. "What was done today was destroyed tomorrow . . . the sum of 1,600,000 rubles was spent on its construction." Doubly egregious, "the Empress spent much out of her own pocket without ever counting." Her composure recovered, Catherine had Rastrelli's masterpiece reworked with an opulent neo-Palladian décor, and the gardens with eight follies.

Ostentation signed Ottoman ambition with extravagant palace-complexes extending through circling courtyards to gardens planted with the rarest of tulips and exotic botanicals; that of Topkapi exacted, by Suleiman's reign, 3,552 indoor staff and 5,000 gardeners. Luxury in the service of majesty strung out Rajput palaces like necklaces and lit Mughal domains with an excess of tilework, metalwork, murals, stained glass, and patterned marble born of Babur's horror vacui. The maharajas kept the show going through British rule in palaces glittered for status with gilded throne rooms and mirrored sheesh mahals.

Remarkably, even those marvels paled before China's imperial dwellings. Fashioned to represent the celestial universe, they inflated to compounds as large as

state parks and as peopled as cities. The Upper Woods of the Wei (Shanglin), built for China's first emperor, radiated out from his principal residence—itself a complex of palaces—to paradisiacal gardens, forests, lakes, and 300 more palaces. By the time of the Ming, "palace" had transcended the emperor's personal galaxy to constitute a metaphor for heaven. Although his father had grown Nanjing to the world's largest city, the Yongle Emperor ordered up a sprawling compound in Peking to reflect his wider worldview. One million workers hauled in marble, brick, and the land's tallest cedars to give the Forbidden City 980 buildings and 8,728 rooms so richly appointed as to almost bankrupt the dynasty.

Reconfiguring an entire landscape bordered on hubris. Nebuchadnezzar II engaged "bronze, gold, silver, rare and precious stones" to convert all Babylon into "a gold cup that made the whole world drunk." Pericles advanced self and Athens with a pulverizing complex of temples, theaters, and parade grounds—fashioned, grumped the historian Thucydides, "from a superfluity of marble." That just the vestibules of the Acropolis cost more than the capital's annual revenue rendered him apoplectic: "The Greeks must be outraged when they see that with their own contributions extorted from them . . . we are gilding and beautifying our city as if it were some vain woman decking herself out with costly stones and statues and temples worth millions."

Judea arose on the vanity of Herod the Great. Building to a glory that outlived his cruelty, the king molded barren desert into the new city of Jericho and a commanding hill-fortress at Herodium. Seizing on the innovation of concrete, he flattered Rome with a shining city named Caesarea and himself with a compound of palaces improbably terraced 300 feet up the cliffside of Masada.

More enduring was the showplace achieved by the world's then richest man. Boasting that he had found a city of brick and left one of marble, Augustus played with Rome as with blocks, deploying newly mined marble and the innovation of the arch for a model of power-building that profiled "empire" for centuries. In turn, Hadrian's brilliantly engineered Pantheon (its 150-foot-high dome stretched to the same width without buttressing) equated him with the gods, and Trajan worked slaves round the clock to build bigger baths, a longer aqueduct, a victory column circling 2,600 figures, and yet another marble forum, dedicated to himself.

Marble was but backdrop for the jeweled cities of Arabia. "He who has not seen Cairo has not seen the magnitude of Islam," wrote the 13th-century historian Ibn Khaldun, "for she is the capital of the world, the garden of the universe, the assembly of nations, the beginnings of Earth, the Origin of Man. . . ." The same agenda of opulence shaped India. Had the Gujarat Sultanate converted all Ahmedabad to

OPPOSITE TOP THE CATHERINE PALACE: OVERHAULED BY FOUR ARCHITECTS TO GIVE EMPRESS ELIZABETH A RESIDENCE RIVALING VERSAILLES.

OPPOSITE BOTTOM THE BRIGHTON PAVILION: MOORISH/MUGHAL WHIM, CONVERTED FROM A FARMHOUSE TO PROVIDE THE PRINCE REGENT A MARKING RESIDENCE BY THE SEA, ROUNDLY CRITICIZED AS A "MASTERPIECE OF BAD TASTE."

ST. BASIL'S CATHEDRAL:
NINE REFULGENT
CHURCHES BUILT AS
ONE—THE TENTH ADDED
TO HOUSE THE SAINT'S
RELICS AND VAUNT
IVAN THE TERRIBLE'S
GAME-CHANGING
DEFEAT OF THE KHANATE.

a showcase? The Hindu Emperor Krishnadevaraya would give Vijayanagar 900 monuments, magnificent gardens, and dwellings carved of ivory. To the north, the Kremlin buried Ivan the Terrible's brutal attachment of one-sixth of the world under a flurry of new palaces and the glorious St. Basil's Cathedral.

Renaissance Europe found its stride with urban renewal. The 1532 overhaul of Naples ranked it second only to Paris. Paris itself was a grand work in progress. Henri IV contributed the Marais, Place des Vosges, and Pont Neuf, and Louis XIV ordered the majestic Champs-Élysées, Invalides, Tuileries, and Place Vendôme. "All you see everywhere is masons at work," griped *Le Mercure*, ignoring that theretofore the city had been dank, dirty, and dark—just the cost of providing drinking water, let alone sweeping the streets and lighting them with 5,000 flares, was an expense

PERSEPOLIS: DARIUS I'S EMPIRE-DEFINING PALACE COMPLEX, BUILT FOR RITUAL, TRIBUTE, AND AWE.

that lesser courts could afford only later. Rival rulers raced to keep up. The number of projects undertaken by Denmark's Christian IV tagged him "the builder king," and so elegant was Archduke Franz-Joseph's scheme for Vienna that when the Secessionists built modern headquarters facing the palace, Franz Ferdinand refused to use his front entrance.

Arguably, the Bonapartes were the last to deploy the full battery of luxury. Sidelining industrial innovation, Corsican strategy relied on pomp, edicts, and an empowering aesthetic. Ordering the Rue Napoléon (now Rue de la Paix) made the "most beautiful in Paris," and a street named for his victory at Rivoli to sell only luxury goods, Napoleon imprinted his new empire with Roman monuments and pharaonic furnishings. The ploy was pragmatic but the endgame was quixotic; to revive the radiance for which English has no word—*la gloire*—a crimson carpet rolled out from ornament to dominion. As it happened, the self-styled emperor tripped on his vanity, thwarted in his plan to build Paris into "the most beautiful city that has ever existed" by a series of disastrous campaigns. With half the vision and twice the ego, nephew Napoleon III overtly harnessed infrastructure to power, marshaling Haussmann to raze half the capital for boulevards widened to accommodate marching armies. Only his misjudged forays into Mexico, and, fatally, Prussia, brought an end to it.

More conducive to absolute rule was a capital built from scratch. To command the manpower and source the materials took inordinate effort (Assyrian Ashurnasirpal II committed 70,000 laborers to build just the walls circling Nimrud) but such dominion was marking. Sargon II fashioned Dur-Sharrukin (Khorsabad) into a beat-this proclamation: "Sargon, king of the universe, has erected a city . . . in

it he built a palace without rival." Son Sennacherib countered with a new capital at Nineveh whose "palace without rival" boasted 30-ton colossi and 160 million bricks.

The Achaemenids signed in stone. Imposed by Darius I to entrench his rule, the gigantism of Persepolis—a labor of 57 years—established the prototype of official architecture. Rising on 10 million cubic feet of polished limestone, the entire palace-city functioned primarily as a proscenium for tribute to sovereign omnipotence: "One King of many, one Lord of many . . . the great King, King of Kings, King of the countries possessing all kinds of peoples, King of the great earth, far and wide."

Alexander the Great pushed for legacy. To own the Mediterranean he stamped Egypt with an eponymous capital whose Wonders—a library containing 70,000 scrolls, and the soaring Lighthouse of Pharos (the world's tallest structure for 1,200 years)—spawned 17 more Alexandrias. Diocletian took up the gambit, but his plan for four regional capitals at the frontiers of an empire grown unwieldy proved ruinous. Constantine reaped the glory, with an overnight capital whose fresh take on luxury shifted the imperial seat east. First to subject infrastructure to a scheme, Constantinople formed the template for gilding the lily. The lavish materials (a fortune for the gates alone, marveled Gibbon), statuary imported on a scale not seen again until Bonaparte, and the opulent detailing, informed Yeats's dreamy evocation of "hammered gold and gold enameling / to keep a drowsy emperor awake."

Africa's young empires, if less worldly, pronounced boldly. Walls 17 feet wide circled Zimbabwe's Great Enclosure, and the 19,000 miles of walls guarding Nigeria's Benin City still constitute the world's largest earthworks.

Mesoamerica shot past them in Peru with the miraculously engineered Machu Picchu and, in Mexico, a capital modeled on paradise. Bernal Díaz del Castillo gazed down in wonder on Tenochtitlán's "great towers and temples rising from the water" that dwarfed any city in Europe: "We saw the three causeways which lead into Mexico . . . and the bridges and temples and oratories all gleaming white . . . the soldiers among us who had been in many parts of the world, in Constantinople and Rome, said that so large a marketplace and so full of people and so well arranged they had never seen before." This was the splendor Cortés razed for Spain to impose a new metropolis on its ruins.

Post-feudal Europe was shorter on land but longer on planning. In 1492, pioneer urbanist Duke Ludovico Maria Sforza leveled Vigevano for a strategy of parade avenues radiated out to columns and arches that informed urban design for the next 300 years. Rival ambition led the dukes of Tuscany, Lorraine, and Mantua to each build a grander capital—Livorno, Nancy, Charleville—and to each claim victory with balls and parades.

Competition did not factor up north, where Peter the Great profiled empire with the most wondrous capital ever wrested from wasteland. In the service of reform, St. Petersburg proved a triumph of arrogance, an effort Dostoevsky called the most premeditated in the world. To address mud and flood, vehicles were charged an entry fee of building-quality stones. To drive pilings, level hills, and dig canals, 40,000 workers were press-ganged from all Russia, hauling dirt in their shirts until they dropped dead. Imperial decree whipped hell into heaven. A glittering network of palaces, fountains, spires, and bridges linking one hundred islands gave Peter his "Eden," his "darling," and taught that edict could subjugate nature. Relocating the nobles from Moscow was a snap—they were ordered to. Stocking his new capital with treasure was elementary—a limitless budget. Assuring its supremacy entailed only forbidding any other Russian city to be constructed of stone.

THE PETERHOF COMPLEX: PETER THE GREAT'S CHALLENGE TO THE SPLENDOR OF VERSAILLES.

For maximum statement, look east. Arab Muslims had so distrusted the refulgence of Ctesiphon, capital of the Persian Empire for 800 years, that in 651 they destroyed it. Yet just a century later Abbasid Caliph Al-Mansur entrenched Islam with a capital built to obliterate. Ringed by massive walls, Baghdad radiated out from a palace of unrivaled splendor to reign for 200 years as the world's largest and wealthiest metropolis. Revitalized in Córdoba with 1,000 mosques, Umayyad aspiration fashioned the capital into "the brilliant ornament of the World." Six centuries later, Safavid Shah Abbas united 21 kingdoms with one religion, one language, and a capital flourished by a network of trade routes into Islam's political and cultural epicenter. The marvel of its blue-and-gold domes, bustling caravansaries, and ornamental gardens, was seen to constitute "half the world," inspiring André Malraux's famous adage: "Who can claim to have seen the most beautiful city in the world, who has not seen Isfahan?" As reported by an envoy, across a river cut through mountains; past a wondrous 33-arch bridge, shaded boulevards, and mansion-lined Naqsh-e Jahan Square; past the sprawling Maidan-i-Shah agora lit by 30,000 lamps, and the Imam Mosque built of 18 million bricks and 472,500 tiles—stood a magnificent palace. There, bathed in the light streaming through polychrome glass, sat Abbas the Great, "on splendid cushions, a rose in his hand."

Mughal India transcended. Megasthenes had held Pataliputra, seat of the Mauryan Empire, the world's greatest city for its theaters, racetracks, bazaars, ornamental lakes, lavish palace, and 1,150-mile approach-road lined with 50-ton pillars that had called on 8,400 laborers to position. Muslim fervor outbuilt it. Timur had led off at Samarkand, adding so many structures so quickly that several collapsed. Inheriting his ancestor's vision and poor engineering, Akbar created a lake and ordered huge blocks of sandstone hauled in and chiseled like lace for a resplendent capital city intended to unite Muslims and Hindus. Fatally, the water proved toxic, so the marvel of Fatehpur Sikri that had taken 15 years to create was abandoned. Delhi, in contrast, was pressed ever more grandly into capital service. The invader Sher Shah Suri had enlarged it "that my name might remain honored upon earth until the day of resurrection." Now, Shah Jahan renamed it Shahjahanabad and aggrandized the Red Fort—a palace-complex large enough to shelter 50,000 of his subjects and display enough treasure to dazzle them. The 50-foot-long white marble Audience Hall flashed the fabled Peacock Throne, a ceiling inlaid with silver, and imagery worked of cabochons that linked him to Solomon.

Hindu pride held its own. Two centuries after Sultan Muhammad Quli Qutb Shah had modeled Hyderabad on Isaac, that his capital might be "unequalled in the world and a replica of paradise itself," Rajput maharaja Sawai Jai Singh II surpassed

THE RED FORT: SHAH JAHAN'S PALACE COMPLEX, ESSENTIALLY A DEFENSE SYSTEM, BUT PRODIGALLY EMBELLISHED TO RADIATE MUGHAL RULE.

it with a capital built from scratch; "I doubt there were many cities then could compare with Jaipur," a traveler reported of the engineered symmetry and walls inlaid with lapis lazuli.

Even realms on the move learned to build for advantage. To entrench the Yuan, Kublai Khan fashioned a capital at Xanadu that left Marco Polo breathless: a "city of cities" ringed with a moat four miles long "around which eight palaces held his war gear . . . inside it another moat, another eight palaces. The walls of the great palace at the center and the rooms are all covered with gold and silver and painted with dragons, birds, and horsemen. The great hall is so large 6,000 people can dine comfortably." In winter, the court moved south to a string of new palaces at Dadu (Beijing). Their opulence, together with 16,000 acres groomed to accommodate exotic game for the hunt, established the Great Khan, the first Mongol to rule all China, as "the most powerful man in people and lands and in treasure that ever was in the world."

China's agenda of blistering infrastructure traces to Xia dynasty king Jie, whose legendary Tilt Palace enfolded multiples of palace-strewn pleasure grounds. A millennium later, Han Emperor Gaozu erected a largest-ever 4.8-square-mile palace-city, and yet imperial vanity built on. Although Sui founder Wen-ti had grown Diaxing to 33 square miles, son Yangdi threw two million workers at a new capital at Luoyang. In turn, the Song grew Hangzhou to the world's largest metropolis, held by Marco Polo "beyond dispute the finest and most splendid city to be found in the world, where so many pleasures may be encountered as to think oneself in Paradise."

For resolute glory, though, nothing rivaled Yuanmingyuan, the summer capital of the Qing and the most splendorous architectural complex the world would ever see. Emperor Qianlong had already taken luxury in a fiercely new direction, combining his passion for artistry with an open strategy of spend-to-astonish. Over his 60-year reign every admired structure and landscape was replicated—palaces, pavilions, temples, hills, lakes, bridges—for a supreme resolve to outdo that proved absolutism's last idyll.

By the mid-19th century, the rest of the world had come to a realpolitik reassessment of glory. Africa was rising up, New World profits were winding down, the East India trading companies were dissolved, and the Mughal Empire undermined. Reduced to a diorama of land, seas, and stars, the entire planet had been mapped. All that remained was to bilk it.

Revenue—Replenishing the exchequer proved empire's constant challenge. Darius I exacted tribute of goods and services. The province of Farsishan brought Baghdad 30,000 bottles of rosewater. At the height of his power, Montezuma II received from the provinces of Tochpan and Tochtepec 7,848 piles of garments, 20 sacks of feathers, 16,000 balls of rubber, 24,000 bundles of parrot plumes, two gold collars, three jade-and-turquoise collars, and a diadem. Unchallenged prerogative freed Croesus to tap Lydia's gold deposits, licensed Periander of Corinth to assassinate rivals and strip the widows of their gold-threaded robes, and let Lucius Mummius destroy Corinth, carry off its treasure, and sell it at auction. Accountable to none, Julius Caesar attached silver from Spain's mines and pearls from Scotland's rivers. Mindlessly cavalier, Richard the Lionheart conquered Cyprus and sold it off to the Knights Templar. Wittingly arrogant, Henri III accepted the French crown and relinquished Poland's after extracting the diamonds.

Feudal transition from barter to cash enabled direct taxation—tolls, tithes, tariffs, fines, the irksome lottery tax, and the punishing inheritance tax. Become monarchy's bread and butter, arbitrary taxation caused dreadful hardship. In the 17th century, Poland hiked taxes 50 times, reducing tariffs on the wealthy as it raised those on the poor. Lucrative, too, were returns on the day's luxuries. France taxed salt, England taxed clocks, Russia taxed tobacco, and the Elector Karl Theodore drained Bavaria annually of 58,000 gallons of wine—while Venice, noted Wordsworth of the riches exacted from Byzantium, "did hold the gorgeous East in fee." Eastern agendas extorted as unduly. Onerous taxes gilded the caliphate's mosques, Emperor Monmu attached Japan's coffers, and Ming exploitation of the peasantry sparked the rebellion that brought in the Qing.

Delivery was ever a hassle. Before wire transfers, revenue had to be physically hauled in, with each handler taking a cut. Ships provided surer return. The

commodities sailed across the Mediterranean vastly enriched the Minoans, Phoenicians, Babylonians, and Romans. Vasco da Gama's sea route to India vastly enriched Portugal, spurring England, France, and the Netherlands to seek cash cows of their own. It mattered little that competition for monopoly wiped out the indigenes. England's nutmeg revenue from the Banda island of Run added "King of the Run" to James I's titles. (High irony that the tiny outpost would be exchanged to the Dutch for, among other trinkets, Manhattan!)

Expeditions to the New World, the day's euphemism for pillage, sailed adventurers styled as explorers to source greater treasure. Vasco Núñez de Balboa, Ferdinand Magellan, Juan Ponce de León, Bartolomeu Dias, Francisco Vázquez de Coronado, and Henry Hudson returned gemstones, precious metals, and beaver pelts. Spain funded Christopher Columbus: "Humanely if possible," Isabella and Ferdinand had directed, "but at all costs get gold." To attach Inca coffers (*valer un Perú* means "worth the world"), Francisco Pizarro captured Atahualpa, reaped a ransom of 24 tons of gold, and killed the proud ruler nonetheless. "Do you have more gold?" Cortés asked Montezuma, "because my men suffer from a disease of the heart that can be cured only by gold." The disease was greed and the Aztec Emperor its victim. Become a global power, Spain pressed on, exploiting Potosí's silver mines to hoist itself on the petard of a cupidity grown so reliant on the returns from the Flota de la Plata treasure fleet that the capsize of ten of its galleons in 1715 all but collapsed its economy.

Turning to land grabs for steadier revenue, Britain's dashing privateer Martin Frobisher delivered a chunk of east Canada, and Captain James Cook bagged New South Wales. Seasoned explorers served up more; Douglas Mawson claimed Antarctica for Australia, Henry Morton Stanley handed Belgium a large part of the Congo, and Pierre Savorgnon de Brazzà gave France the rest. Once the choice bits had been gobbled up, the game of Manifest Destiny launched a scramble for the North Pole. In less than 300 years, the European powers had swallowed 85 percent of the globe and by 1900 Queen Victoria ruled a quarter of it.

Diplomacy—the art of interstate negotiation to win ally or favor relied on rich gifts and skilled ploys, politely called embassies. How the Queen of Sheba must have stunned when she arrived on an ostrich-plumed elephant to assess the might of King Solomon, her cavalry clad in green, her arms circled in ebony, trailing camels bearing offerings of gold, jewels, frankincense, and the greatest quantity of spices Jerusalem had ever seen!

Calculated largesse could obtain a great deal: the right to levy taxes, to negotiate, to court. The Roman general Mark Antony wooed Cleopatra with the great library of Pergamum, part of Crete, and much of the Phoenician coast. In turn, Egypt's queen

lavished Rome's centurions with tapestries, horses, jewels, and slaves. Gifts of mutual recognition, reported Gibbon, could be modest: "the most opulent kings of the earth were gratified with such trifling presents as could derive value only from the hand that bestowed them, a garment of purple, an ivory chair, a piece of plate." Petitioners must put out more: "It is customary for those who wish to gain the favor of a prince to endeavor to do so by offering him those things which they hold the most precious. . . ." So did Don Pedro of Castile present England's "Black" Prince Edward the 174-carat ruby spinel that first headlined the royal collection. Peter the Great both gave and took grandly, parting with the iconic Safavid "Emperor's Carpet" to ally Leopold I, and enticing from Frederick William I the world-wonder Amber Room panels.

Points, too, for living marvels exchanged to mark reach; the elephant presented to Charlemagne by Harun al-Rashid; the camel a Sultan of Egypt caravanned across 3,000 miles as a gift to Timur; the tortoise given the King of Tonga by Captain Cook (surviving until 1966); and Hanno, the Asian elephant that Portugal's King Manuel I sailed over to Pope Leo X (who wept when it died).

Giving of this sort was quantified flattery but as nations grew competitive global exchange verged on showbiz. Louis XV challenged the Qing Emperor with a battery of Sèvres vases and the salvo "Don't think you make the best porcelain, I do!" Spain's Philip III engaged Persia's Shah Abbas I with arms, spices, silver, and a very large dog. Courting the tsars drained all purses. London merchants proffered huge vermeil flagons, paraded through Moscow on wagons to the firing of cannon. Christian VII had Royal Copenhagen fashion the 1,802-piece Flora Danica dinner service for Catherine the Great that took 12 years to complete—by which time she had died. Napoleon sent Alexander I a Sèvres dinner-service for 66 and a 22-foot-long silver centerpiece by the great Vivant Denon. In turn, Nicholas II offered Paris the Pont Alexandre III.

Not all scored. The rulers of Siam dismissed unwanted envoys with the high-maintenance gift of an albino elephant. The Yongle Emperor returned a fine bowl to a minor province saying his porcelain was finer. Suleiman the Magnificent, whose munificence extended to solid-gold caskets containing the first tulips seen in Europe, lamented the reciprocally gifted silver flyswatters piling up in his treasury: "Oh that these could be *used!*" Misjudged liberality could flounder in translation. England repeatedly tripped on its ignorance; Ahmed I felt so outclassed by the magical clock-organ sent by Elizabeth I that he smashed it, and the Macartney mission to the Qing court failed because its emissary refused to perform nine

head-knockings and three kneelings before an emperor resolved to subject Britain to the Sinocentric world order.

Better welcomed, a great jewel. "It's a great advantage for the republic of Genoa," wrote *Le Mercure* of the historic pearl sent the French crown, "that one of its subjects could give a gift so well received by the king." Nizam Ali Khan ingratiated King George III with the "small diplomatic gift" of the 101-carat "Hastings"; the Transvaal acknowledged Britain's assent to self-government with the miraculous "Cullinan"; and the deposed Duleep Singh of Punjab survived by surrendering the "Koh-i-Noor." The fabled Topkapi Emerald Dagger gifted by Mahmud I to Nadir Shah returned only because the sultan was murdered before it arrived.

CALIPH HARUN
AL-RASHID, REIMAGINED
BY LAWRENCE
TALMA ALMEIDA,
RECIPROCATING
CHARLEMAGNE'S
DIPLOMATIC OVERTURES
WITH GIFTS OF
GREATER SPLENDOR.

Exchange at this level was carefully tabulated. The Republic of Venice recorded a gift to Niccolò d'Este of a palazzo on the Grand Canal and a bribe to the ambassador of Parma of a 130,000-livre diamond-crusted snuffbox by Massé. France established a ministry to list distributions that by 1789 filled 63 registries with such puffery as the 2,000 pieces of Sèvres thanking the 4th Duke of Bedford for negotiating the Peace of Paris, and the twelve armchairs, two sofas, and four tapestries by Gobelins recognizing George Washington's presidency.

Industrial prowess enabled monumental recognition. Paris gifted America with Lady Liberty, and Egypt shipped the Temple of Dendur, in 661 crates, to the Metropolitan Museum of Art. Boldest was Winston Churchill's post-war gesture to align Saudi Arabia. Alerted that President Roosevelt had sent over a C-47, the Prime Minister resolved to top Ibn Saud's 500-car collection with a bells-and-whistles Rolls-Royce—then remembered he had ordered the factories retooled for aircraft engines. Declared top priority, a floor-model Phantom III was refitted for gifting with a gunrack, searchlight, siren, copper washbasin, electric fan, and a brush whose bristles, respecting Muslim strictures, were fashioned of nylon.

Rich overture persists. In return for signed photos of herself, Queen Elizabeth II receives solid-gold palm trees and sapphire parures, while Russia's high-level officials, noted antiquarian Alexander Khochinsky, "are buried in gifts." None, though, approaches the power exchange fiercely practiced in the Pacific Northwest by the tribal peoples of the Pacific Northwest: "All the zest of life lay in the giving away of goods," anthropologist Ruth Benedict observed of the potlatch ceremonial, "the object of the contest was to glorify oneself and humiliate one's opponent."

War, the ultimate power move, proved nation-building's greatest indulgence. Alliance and compliance supplied the hooks and fasteners of acquisition, but war, not peace, shaped the globe. Look to Livy for motive: "Rome's first aim for which she counted no sacrifice too costly was empire." Should annexation prove resistant to treaty, the classic option was coercion. Through to our era, those who wouldn't be commanded were controlled through slaughter, conscription or the divide-to-conquer technique of "decisive surgery" broached by Frederick II, mastered by Catherine II, and refined post-war by the four superpowers into lucrative "spheres of influence."

Elective war put ambition on fast-forward, providing at a time of short lifespan the swiftest conduit to dominion. "He cannot rest content with what he has conquered, he is always taking in more," Demosthenes noted of Macedon's Philip II. In just over a decade, son Alexander conquered from Anatolia and Egypt to Central Asia and the Punjab; in less than that, Qin Shi Huang pushed east and north to unify China, wasting all before him "like a silkworm devours a mulberry leaf"; in just short of a decade, Umayyad Al-Walid I established the caliphate across Persia, Iberia,

I do three things that
sit ill with avarice:
I make war, love,
and palaces

HENRI IV

North Africa, Anatolia, the Balkans, Central Asia, and North India. It took but seven years for Attila to extend Hun dominion from the Baltic to beyond the Caucasus, and just over twice that for Genghis Khan to attach the largest contiguous landmass ever ruled.

With victory came opportunity. "The empire," historian Mary Beard wrote of Rome, "created the emperors." Thutmose III advanced New Kingdom influence to Syria, Sargon of Akkad rose from a foundling to become "King of the World," and Cyrus II united two kingdoms to found the Achaemenid Empire. Firearms delivered more. At age 21, Sultan Mehmed II defeated Constantinople to form a vast land empire, and, for the 49 years that Aurangzeb ruled over 1.2 million square miles and a quarter of the world's population, the Mughal Emperor was the most powerful being on earth.

More lastingly, Europe's strategy of coercive expansion re-scrambled the map. Inside of three centuries, the king of England was German, the king of Denmark, half-Polish, the king of France, half-Italian, and the king of Spain, French. Already heir to the houses of Habsburg, Valois, Castile, and Aragon, Charles V fought and bought his rise to Holy Roman Emperor and control of Germany, Flanders, and Austria. Already king of Spain, Portugal, Naples, Sicily, England, and Ireland, Philip II attached Brazil, Guinea, Goa, Madeira, Malacca, Macau, and the Philippines. In turn, the House of Hanover stamped English culture and language on the largest number of possessions ever assembled.

The blood of revolution fed itself. Joseph Stalin didn't serve Communism, he decreed it: "Whoever occupies a territory imposes on it his own social system, as far as his army can reach."

All-out war entailed a staggering outlay, from the number of combatants to the construction and maintenance of equipment and infrastructure. To cross the 30-foot-deep Rhine, Julius Caesar erected in ten days at the edge of the known world a bridge the length of four football fields. Each of Admiral Nelson's battleships, built to deploy the firepower of a land army, consumed 75 acres of oak. Still, might was all, and to rally the troops and vanquish the enemy engaged the full battery of luxury— the arms, armies, and fortifications that either made or broke the regime bent on destroying another.

You own what you can defend and defense strained the budget. The Mycenaeans relied on 10-foot-wide battlements, the kingdom of Benin on 66-foot-high walls,

HIMEJI CASTLE: OPULENT
FORTIFICATION BUILT
IN 1346 BY AKAMATSU
SADANORI TO WARD
OFF RIVAL SHOGUNS
THEN FURTHER
EMBELLISHED TO SIGNAL
CLAN SUPERIORITY.

the Rajputs on miles-long ramparts. China's vast expanse exacted colossal defense systems: to circle Nanjing, a 30-mile wall; to protect the Forbidden City, a 170-foot-wide moat; to stave off northern invasion, the 3,914-mile, world's-longest, Great Wall, whose 40,000 towers garrisoned one million soldiers.

The last line of defense, palace-citadels consumed as much food, water, and manpower as a town—Moscow's twenty-towered Kremlin constituted a virtual city. The push to embellish them spoke to war as an ideal, a bid for glory that ennobled both ruler and community. Even Japan's combative culture gilded its strongholds— Himeji, Nagoya, and Toyotomi Hideyoshi's opulent Osaka Castle, erected by 30,000 workers with matching stone sailed in on 1,000 boats.

Arms upped the cost by their number and materials. At a time when iron was valued over gold, Assyria's Sargon II possessed 200 tons of iron weapons. By the 15th century, payout for weaponry consumed a third of Spain's revenue. Still, arms delivered. Bronze axe heads provided Egypt's victories; feather-light chariots won the Hittites the decisive 1600 BCE battle of Kadesh; a massive siege tower calling on 3,400 men to position advantaged Athens; rifles felled Europe's flanks, and Rajasthan's 50-ton Jaivana cannon, which took four elephants to swivel, leveled everything.

Beasts of war proved more costly but critical. With 500 elephants, Macedonia's Seleucus Nikator won the decisive Battle of Ipsus. With 50,000 warhorses, Korea's Gwanggaeto the Great conquered the rival kingdom of Baekje. With armored Molossers (canines bred to a height of six feet), Atilla routed the Romans.

CHÂTEAU DE CHAMBORD:
EXPANDED FROM A
HUNTING LODGE TO THE
FORTIFIED CASTLE THAT
EMPEROR CHARLES V
CALLED "THE SUPREME
EXAMPLE OF HUMAN
ACHIEVEMENT."

War's greatest expense was an army—for an empire, one comprising scores of footmen, a cavalry, and engineers and masons to build forts and bridges. All, plus the captives (one million taken by Julius Caesar), had to be clothed, lodged, and fed. Louis XIV's standing army, numbering 300,000 strong, was "an effort," said Voltaire, "that bankrupted France." The Ottoman army's daily consumption, reported an envoy to the Siege of Vienna, totaled 52,000 pounds of meat and 95,000 loaves of bread. To replace the felled, battle-ready soldiers were leased-out: "Your men don't die easily," Prussia's Frederick II admonished an ally: "Remember, my coffers are empty." Autocrats bled their own; as late as the 20th century, field marshal Kemal Atatürk told his troops: "I do not order you to attack, I order you to die."

Whatever the cost, a large military assured victory. Tuthmose III sustained 100,000 fighting men, King Solomon swept all before him with 1,400 charioteers and 12,000 cavalry, and Xerxes called on a fighting force exceeding 500,000 men. Annexing terrain called on more. The Qin vanquished the all-powerful Chu with one million conscripts. India's widening army—Emperor Krishnadevaraya's was reported to number 703,000—came to comprise its most numerous class.

Forming a class of their own, free agents sold their services dearly but delivered. Without them Julius Caesar would not have triumphed, Elagabalus would not have been proclaimed emperor, and Alexander Severus could not have survived. Loyalty was well rewarded. "Liberality," counseled Machiavelli, "is very necessary to a prince who marches with his armies and lives by plunder, sack, and ransom, and

is dealing with the wealth of others, for without it he would not be followed by his soldiers." Professional hitmen were further enriched lest, like Alaric, they defect to the enemy. Some grew seigneurial; Pio Enea degli Obizzi of Padua gave himself a marking "castle of wonders." Top brass was compensated beyond measure. Emperor Valerian accorded a valued tribune 50 pounds of engraved silver, three gold-and-silver buckles, a gilded helmet, a jeweled ring, two hunters, a cook, two women, a groom, an architect, a secretary, a water boy, and a pastry chef. The Tang made General Guo Ziyi a god for the states he delivered. John Churchill's victories earned him a dukedom and a palace that exceeded the king's. Chambord was twice proffered in recognizance—first by Louis XV to Maréchal de Saxe, and then, by Napoleon, to Maréchal Berthier. Wellington's game-changing rout of the Bonapartes brought him a dukedom, the palatial Apsley House, a Velázquez, and, from Portugal's prince regent, a 1,000-piece table service that took 120 metalsmiths four years to complete.

Whatever the cost, too small a coin could lose all, as when the senator Didius Julianus purchased Rome for 300 million sesterces then lost it to Septimus Severus, whose soldiers had been paid twice that to march through the night and retake it; and when Kublai Khan's hurriedly built, flat-bottomed ships foundered, aborting his invasion of Japan. So did the underfunded Thirty Years' War weaken the Holy Roman Empire and cede Spain's centuries-long dominion to France. So did the attrition of the Seven Years' War flip large chunks of India and Canada to the British and lose France her supremacy. And so did a taskforce too small to defend Constantinople surrender 1,000 years of Byzantine rule to Ottoman cannon. Most fatefully, China's heedless insularity felled the world's oldest empire, and the assassination of an expendable Archduke inflamed the vainglory that scuttled four empires.

Even winning might miscarry. "Another such victory," cried King Pyrrhus, of his costly triumph at Asculum, "and we are ruined!" Hannibal trekked 38,000 infantry, 8,000 cavalry, and 37 elephants across roiling rivers and the icebound Pyrenees to defeat Rome for just a day. And even the mighty paid dearly. Forced to hand Prussia six billion francs plus most of Alsace and much of Lorraine, the French protested that the indemnities had been calculated from the time of Jesus—unmoved, Bismarck rejoined that his financier had begun the reckoning at the Creation.

Should the money run out, monarchs put their kingdoms in hock. England never forgave Charles II for backing Louis XIV in exchange for 6,000 fighting men, an annual 60,000 pounds, and a clutch of commodes by André-Charles Boulle. Enter the moneylender. Luis de Santángel loaned Isabella de Castile the wherewithal to finance Christopher Columbus, Jakob Fugger underwrote the army that sustained Charles V, Richard Whittington bankrolled Henry V for the Battle of Agincourt, Jacques Coeur backed Charles VII's conquest of Normandy, and Italy's prolific powerbrokers—the Bardi, Peruzzi, Frescobaldi, and Lombardi—funded centuries of cavalier wars. Few,

however, survived sovereign default, and social acceptance awaited the ancien régime's end. Initially derided as *nouveaux riches*, financiers came to constitute a formidable new class, took up residence in the Place Vendôme, and shored up the French Revolution. Mayer Rothschild's son James, leaving brother Nathan to fund the Duke of Wellington's peninsular campaign, rescued Portugal with a $25 million loan and founded the Paris bank that enriched Leopold I and earned the family a baronetcy.

Sea power, although as critical to war as to peace, proved a prodigal undertaking—a single sortie of the Sicilian Expedition cost four times the Parthenon. Egypt had boasted the first sailing vessels but their reliance on imported lumber surrendered command of the Mediterranean to the triremes of forest-dense Athens. Alexander the Great finessed the strategy with 800 ships, and Rome trumped it with a fleet large enough to render the Middle Sea theirs. In turn, Arabia's vessels reduced *mare nostrum* to a tributary.

The king reigns but the bank rules

JAKOB FUGGER

Asia thought of water as terrain. The Han's 600-square-foot castle-ships patrolled the Yangtze River, and Ming admiral Zheng He's 400-foot-long "treasureships" accessed Zanzibar's gold. A fleet's perceived strength alone proved advantageous. Pisa's perpetual shipbuilding kept Genoa in check, Venetian galleys locked in trade with Byzantium, Portugal's caravels secured Asia, and Spain's mighty Armada owned the Atlantic—until Britain's prodigious Royal Navy took control of the globe.

At sea as on land, ends justified means. Just as returns from the New World jeweled the crowns of Portugal and Spain, so did sanctioned piracy glitter England's. Francis Drake was knighted for intercepting the gold that funded its golden goose, the East India Company; the profits that privateer Henry Morgan filtered to Charles II titled him governor of Jamaica; and the plundered bullion paraded on 32 wagons to George II bought Commodore George Anson a lucrative baronetcy. The Dutch, at a time when Europe's combined fleets counted 20,000 ships, launched a stunning 16,000, empowering the trading company that sailed the Netherlands to the world's greatest economy. Said one Beylant, an Amsterdam merchant: "If there was a profit to be made, I'd sail through Hell to get it, even if it scorched my sails." Not tabulated was the risk. Before sextant and chronometer, only luck and good weather stood between smooth sailing and the loss of ships, crew, and cargo to a watery grave: a Mali emperor who braved the Atlantic with 4,000 pirogues never returned.

Still, to rule the seas was to own the world. Irrelevant that new technology shot the cost of dominion to the stratosphere. Luxuries all, the ironclads, destroyers, and Rolls-Royce turbine engines, were held essential: "I have not become the King's First Minister in order to preside over the liquidation of the British Empire," Churchill thundered. Tellingly, though, the world-largest Nimitz battleship, the carrier *Enterprise* that cruises for years without refueling, and the $3.5 billion nuclear submarine *Jimmy Carter* that zaps a target from halfway round the world—like the boondoggle $412 million F-22, a fighter plane too advanced for its mission—have become testaments to a swagger that could be collapsed by a hacker.

With so much at stake, it is remarkable how much attention was given to appearance and the bella figura resolve to replicate civilian luxury on the battlefield. One didn't hide from the enemy, one paraded—the richest armor, the brightest uniforms— unconditionally. Style at sea sailed Francis Drake down the African coast with a tailor, a shoemaker, an apothecary, and a trumpeter. Style on land gilded Persia's battlefield banquets—a vanity that led Sparta's general Pausanias to commend the plain meal he'd set out: "Countrymen, here you see the folly of the Persians, who, living so luxuriously, came to Greece to rob us of our poverty"—and led his men to favor the opulence.

Arms ornamented beyond need served as heraldry. Skills since lost embellished Sumer's copper spears, Ugarit's iron hatchets, and the Yue dynasty's bronze swords. Ornate shields burnished the warriors of the Zanda, Mali, Tanzania, Uganda, Sudan, Nigeria, and Congo; jeweled daggers distinguished the Mughal elite; and Japan's tamahagane steel swords, fired, hammered, layered, and polished to neatly sever a head, marked rank with handles that were lacquered and gilded.

The flamboyance was calculated. What a sight they must have made, those Celts fighting naked but for gold helmets and shields, and the Anglo-Saxons wielding gold-etched scabbards led by the fearsome Raewald in a helmet of consummate craftsmanship! The Mongols swept all before them in sable-lined coats sewn with peacock tails, Ming and Qing rulers rode out in steel helmets etched with gold, and samurai heroics called on armor formed of up to 4,500 lacquered-iron scales laced with 250 meters of silk thread.

The theater of war had become precisely that. "We are at their doorstep," cried Umayyad Caliph Muawiya I, "and I want to best the enemy in finery and pomp that they may be awed by the prestige of Islam." The field was ever a stage. Saladin had reclaimed Jerusalem waving a gold-incised scimitar, Bijapur's cavalry sported jeweled saddles, and Suleiman led the Ottomans into battle wearing silk robes sewn with tulips—greatly annoying the Venetians: "They go to war as to a wedding!" Exactly!

Greatest was the outlay for knighthood, the feudal vanity that assumed the chivalric ideal like a cross. At a time when a helmet was worth three oxen, and a horse twenty cows, induction entailed a page, a groom, several horses, and a full suit of armor. Holding sword, shield, and helmet an extension of self, Bertrand du Guesclin rode out in the 400 gold kilos worth he held the price of his ransom. Maximilian I held armor so exalting that he went into debt to splendidly outfit self and horse. Investiture into such as England's Order of the Garter or the Burgundian Golden Fleece upped the cost of induction but ennobled beyond measure. Count Geoffrey Plantagenet of Anjou recalled no finer moment than when he received in Rouen the jeweled sword and gold spurs of his knighthood.

TOP SET OF MUGHAL DAGGERS, HILTED TO RANK AND SHEATHED WITH GEMSTONES TO CONVEY THE VIRTUE EXPECTED OF A GREAT WARRIOR.

RIGHT EDO SAMURAI ARMOR: ITS CRAFTSMANSHIP AND EMBELLISHMENT CONVEYED CLAN, RANK, AND A PERSON OF HONOR.

317

Outfitting an entire fighting force entailed more. Waving luxury as a badge of honor, Marquis Philippe de Gentil de Langallerie arrayed self and regiment: "To justify my standing with my troops, and not be neglected or despised, I must make an impressive show." Madame de Sévigné's rebuke to her grandson for heading to war with 4,000 francs worth of silver and a retinue "already too big" fell on deaf ears. Status called for a porcelain dinner service, carved ivory oliphants, gilded drums, and a lacquered *nécessaire* fitted with perfumes and pomades. Royal signifiers drained the treasury. The gold bodysuit made for Henri II, the burgonet Filippo Negroli sculpted into a portrait of Charles V, the shield Caravaggio embossed with Medusa for the Grand Duke of Tuscany, and the gold-and-jewel-handled sword crafted for Maximilian II, are today's museum pieces. The advent of firearms introduced new vanities—Peter the Great's gunpowder flask crusted with 294 diamonds, Kaiser Carl VI's rifles inlaid with cameos, and, just yesterday, flashed by Muammar Gaddafi as he was flushed out of a culvert, a gold pistol.

The conceit, through to modern times, was battlefield as self-portrait. Feathered helmets ranked Bourbon generals: brass miter caps classed the Prussian grenadiers. The future Duke of Marlborough, arrayed in gold braid and lace, had his field table set out nightly with the family silver, and Napoleon famously quaffed Champagne from a crystal goblet on the eve of each battle—excepting, fatefully, Waterloo. In 1794, the Nizam of Hyderabad and a caravan of elephants set out from Bidar with his bejeweled harem and a female infantry clad in British-style red coats. In 1839, 21,000 British soldiers were dispatched to Afghanistan with 30,000 servants, canteens fitted by Hermès, and 300 camels to carry the wine. Edwardian bravura sent troops in chainmail into torrid Khartoum, holding camouflage demeaning. France's war minister, Eugène Étienne, said it best: "Eliminate our red breeches? Never! The red breeches, they are France!"

Such strut was expensive, but to the victor the spoils. From ancient times, war was an open bank and luxury was the business plan that kept monarchy afloat. A 3,000-year-old tablet records King Lugalzagesi's raid on Lagash: "silver and gold they grabbed. . . ." The treasure looted from Solomon's Temple was by biblical accounts blinding, and it took three full days to parade Pompey's vast haul of artwork, crowns, jewels, and "finest and richest" enemy armor.

BURGONET: SO MASTERFULLY CRAFTED BY COURT ARMORER FILIPPO NEGROLI THAT HE SIGNED IT.

With fame, even if I die, I am contented

BABUR

Vainglorious, no question, but booty ennobled. Beyond paying the bills, to attach a state's treasure was to assume its splendor. It had exalted the Sasanids that Khosrow I plundered Byzantium. It had glorified the Ghaznavids that Sultan Mahmud looted northwest India of 6.5 tons of gold. An overnight game-changer, acquisition became policy. "Man's greatest good fortune is to chase and defeat his enemy and seize his total possessions," declared Genghis Khan on snatching Merv's treasure and leaving 1.3 million dead in the rubble. "I have indeed succeeded him," crowed Poland's John Sobieski III on routing the Ottomans' formidable Kara Mustafa Pasha at Vienna, "for the greater part of his riches have fallen to me." "Wondrous," an historian called Prince Eugene of Savoy's victory at Zenta that returned the sultan's full wealth—treasury, cannon, camels, and harem. "Calamitous," wrote another of Nadir Shah's sack of Delhi that transferred to Persia the entire Mughal treasury with its fabled Peacock Throne; "the accumulated wealth of 348 years changed hands in a moment." Accountability? It mattered not to the Duc de Richelieu that his township was bought with ill-gotten booty, or to Napoleon that his raid of Venice left half its citizens to beg in the streets.

Foot soldiers held war a shopping spree. Let Plutarch extol the "majestic and terrible sight of the Spartan army marching to the attack to the sound of the flute," Pausanias knew that what drove them was not music but license to remove gold-hilted sabers from the dead. Alexander the Great abjured luxury but let his men strip Persepolis of all that 2,000 mules and 6,000 camels could carry. Even disciplined armies looted: the Zhou general Xiang Yu could halt his soldiers' retreat across the Yangtze by burning their ships, but only the prospect of booty moved them forward.

Conquest achieved, victory was writ large. A 170-foot-tall

ARCH OF TITUS: VAINGLORIOUS VICTORY MONUMENT COMMEMORATING THE PLUNDER OF JERUSALEM.

bronze Colossus posted tiny Rhodes's defeat of Cyprus, the great Arch of Titus proclaimed Rome's sack of Jerusalem, and the arcaded Gloriette marked Empress Maria Theresa's dominion over Prussia. Bonaparte imprinted his victories on Paris with the Arc de Triomphe and a column cast from the bronze of 1,200 cannon.

Brief splendor. With national interests growing global and sovereign entitlement refining into the contracts and alliances of international cooperation, terrain was now a commodity more expediently negotiated than snatched. Thus was France's 827,000-square-mile Louisiana Territory sold to America. Even as Napoleon III sacrificed an empire to forays abroad, and Britain played out the last hurrahs of imperial aggression, the great engines of steel, steam, coal, and petroleum were shifting manifest destiny from conquest to commerce. Her reach become global, Queen Victoria's was a rule now led by a passion for progress, a push for law over custom, and a civilizing mission that ran colonies like shopping malls—all better supplied by free trade than by arms.

Entitlement had by no means been mothballed. The U.S. attached one-third of Mexico, Leopold II bled the Congo, and, while Britain's tea consumption scuttled China, her high commissioners ran South Africa, her overlords controlled Egypt, and the Raj ruled immoderately over Victoria's crown jewel, providing to civil servants the lifestyle of princes, to the queen a lavish durbar, and to the viceroy a New Delhi palace with a 180-foot-high copper dome.

CRYSTAL PALACE: PRINCE ALBERT'S 1851 "WONDER OF THE WORLD" GREAT EXHIBITION HALL, ERECTED TO SHOWCASE EXCEPTIONAL WORKS OF CULTURE AND INDUSTRY.

I just think that everything in the White House should be the best

JACQUELINE KENNEDY

A new social order, nonetheless—born of the stock market, commerce, and Rousseau's "Rights of Man"—was divorcing affluence from aristocracy, refining spoils into profits, equating power with knowledge, rewarding merit over birthright, and holding nations accountable. What had flattered now condemned. Blazonry burnished by glory ceded to medals tarnished by grief. Napoleon's visionary Egyptian campaign now was deemed a fiasco.

Taking over, science and industry moved luxury's gambit to soft power. Laboratories replaced battlefields; the victory column now served as a gift of goodwill; and monuments once lauding despots now honored the fallen. The Era of Progress still sought dominance, but *patria*, albeit sporadically flourished at gunpoint, shifted to steel showcases—long tunnels, wide dams, swooping bridges, vaulting rail stations, and, most promotionally, international exhibitions on very large stages.

Conceived as a display case, the World Fair (in essence a potlatch) flaunted superior goods and breakthrough technology. The Great Exhibition of 1851 announced British excellence with the dazzling Crystal Palace—24 acres of glass framing a "world's largest" structure, which introduced six million consumers to modern commodities that spoke to modernity. Its every aspect would be copied—in Manhattan to the very name for a showpiece that capped Bryant Park with 15,000 panes of glass and a 100-foot-high dome. In turn, the Paris 1867 Exposition Universelle lit a furor for all things French with Lalique's patterned glass, Peter Carl Fabergé's shimmered enamels, and a 3'9" tall Sèvres vase—the largest porcelain piece ever fired. With such wonders baiting the hook, luxury now presented as product. Like Europe's glass-roofed arcades—essentially department stores—its World Expos shifted aspiration to consumption, and luxury to commodities that, while pricey, were attainable. Buy labels like Tiffany and Baccarat, these rich displays promised, and you too will matter. Marketed as must-haves, luxury goods signed new wage-earner status.

Industrial firsts flamed America. The 1893 Chicago World Fair stunned 750,000 visitors with an edifice large enough to enfold the Great Pyramid, St. Paul's, and a General Motors pavilion displaying a functioning assembly line: "Make no little plans," overseer Daniel Burnham had directed, "they have no magic to stir men's blood."

As the business of nations veered to business, the captains of industry harnessed glass, steel, and elevators for the penultimate logo of a skyscraper. In 1913, five-and-dime titan Frank W. Woolworth gave Manhattan a world's tallest namesake

GOLDEN GATE BRIDGE:
THE INDUSTRIAL AGE'S
LONGEST MAIN-SPAN
SUSPENSION BRIDGE,
BUILT TO LINK
SAN FRANCISCO
TO THE WORLD.

building, dubbed "Cathedral of Commerce" for its copper roof, swimming pool, and Italian-glass ceiling. Tycoon rivalry shot two egos higher. Resolved to canonize his trajectory from a journeyman-mechanic to *Time*'s "Man of the Year," Walter Chrysler poured millions into a metal-clad "monument to me" bid for the world's highest man-made address. Told that banking "kid" George Ohrstrom was taking 40 Wall Street higher, the motorcar baron had a 185-foot spire secretly assembled in the airshaft and hoisted at night, handing the Chrysler Building a 1,046-foot-tall world record. A year later, Governor Alfred Smith climbed the Empire State Building four dizzying stories weekly to a 1,250-foot trophy comprised of 365,000 tons of steel, stone, and brick, 70 million rivets, 60 miles of water pipe, 1,860 steps, 72 elevators, and 6,500 windows—a testament to "American exceptionalism" that garnered fame as the eighth wonder of the world, and immortality as "Al Smith's Last Erection."

Fortunes indebted to the public gave back. Mid-Depression, Milton Hershey's concern for the workingman built two model towns, and the $86 million that John D. Jr. diverted to ornament Rockefeller Center—largest real estate project since the Pyramids—created thousands of jobs. Commitment to beauty led the Beinecke family to fund architect Gordon Bunshaft's vision for Yale University's rare-books library (an extravagance that discarded whichever pricey sheet of marble he said marred its translucence) and moved the Bronfmans to underwrite Mies van der Rohe's exorbitant scheme for Seagram's Manhattan monument to whiskey (a bronze facing that must be oiled by hand annually, fountains heated in winter to create mist sculptures, and a public plaza that swallows half the footprint).

Chauvinism scored higher with industrial feats. America's bridges set awesome records with the first steel-cable suspension Brooklyn Bridge, the world's-tallest

Golden Gate, and the longest-span Verrazano. Its continent-spanning highways headlined the daunting 1,500-mile Alcan. Its concrete dams weighed in with "the biggest thing on earth" Grand Coulee, which boasted twice the hydraulic pressure of Niagara Falls and enough concrete to circle the equator twice. Most ambitious was the "greatest project of all time" Panama Canal, which took untold workers' lives but handed Ronald Reagan the slogan that sped him to the White House—"We built it. We paid for it. It's ours." Global presumption built India's 16-mile-long Hirakud dam; the record-length Trans-Siberian Railroad, whose cost approximated the military budget of WWI; and the Seikan super-tunnel, whose cost far exceeded its return. Boring 35 miles through the Alps, 20 years and 8 deaths in the making, the Gotthard Base Tunnel is still held heroic.

National pride got the most bang from architectural bling. France's Eiffel Tower topped the Washington Monument by 429 feet; Australia's Sydney Opera House headlined 1,400-percent-over-budget concrete sails; Spain's Guggenheim Museum countered with a cloud of titanium; and England boasted the vaulting Millennium Dome, built to display who knew what. Brasilia, constructed miles from nowhere to give Brazil a marking capital, was held lunatic, and yet the world marveled.

More thoughtful were state gifts to the public, such as Moscow's crystal subway chandeliers and the Paris Metro's extravagant Art Nouveau portals. Most prodigal was the acreage that America gave over to beauty. It would have been difficult, claimed landscape architect Frederick Law Olmsted of the rock bed he wrestled into New York's glorious Central Park, to find a site with fewer "desirable characteristics,"

SYDNEY OPERA HOUSE: VAUNTING CIVIC PROCLAMATION UNDERTAKEN TO "HELP MOLD A BETTER AND MORE ENLIGHTENED COMMUNITY."

King Abdullah is the ruler.
If he wills it, it will be done.

PRINCE TALAL BIN ABDULAZIZ AL SAUD

or land "upon which more time, labor, and expense would be required to establish them." When open terrain was held private property to the point of just 100 men owning over 17 million acres of California's arable land, Congress designated 58 national parks, 51 bird reserves, 100-plus forests, the vast California preserves of Yosemite and Sequoia, Crater Lake in Oregon, Yellowstone in Wyoming, Glacier National Park in Montana, and the six-million-acre Adirondacks Park. Their maintenance is an unqualified luxury: Florida's current effort to sustain the Everglades constitutes the world's loftiest project.

As quixotic is the resolve to preserve cultural patrimony. Mind-boggling, the effort by local conservationists and the Getty Foundation to rescue Tintoretto's *Last Supper*; Leipzig's $74 million resolve to restore 62,000 fire-ravaged books from the library founded by the Duchess Anna Amalia of Saxony-Weimar; and the World Monuments Fund's 2,000-artisan, 15-year commitment to restoring Qianlong's private garden.

The charged 1980s "me" economy reverted patria to promotion, moving newly minted nations to create marking logos. None outpaced the Persian Gulf fiefdoms, whose fortunes of state and ruler are one. Kuwait, synonymous with the House of al-Sabah, had long lit the region with a palace watchtower roofed with pure gold and a collection that built to 33,000 precious objects. A century later, Saudi Arabia, its kingdom on steroids from $2 billion-per-day revenues, regaled Mecca with the "world's biggest" Abraj al-Bait towers, and green-lighted Mohammed bin Salman's improbable impossibly "world's-largest" $500 billion robot-manned NEOM giga-city. Gas-fueled Qatar preempted with three instant cities boasting 40 palace hotels, an $8 billion research hospital, a sprawling education center, the water-themed Aqua Park, and a proposed "world-first smart island" designed to operate every function by remote. Reframing art as an asset, the House of Al Thani underwrote Sheikh Hassan's "sky's the limit" agenda to transform a desert peninsula into a "cultivated country" headlining an Arata Isozaki–designed library and starchitect museums by I. M. Pei, Jean Nouvel, and Alejandro Aravena. If Sheikh Saud's purchase of a $125,000 tile was held frivolous, not so Sheikha Al Mayassa's acquisition of a $300 million Gauguin.

THE CHRYSLER BUILDING:
FEAT OF ENGINEERING
THAT RAISED THE
SPIRE OVERNIGHT TO
(BRIEFLY) CLAIM THE
TITLE OF THE WORLD'S
TALLEST BUILDING.

ABRAJ AL-BAIT TOWERS: SAUDI ARABIA'S $15 BILLION POLITICAL MINARET—A STATE-OWNED COMPLEX BOASTING THE WORLD'S LARGEST CLOCK, THE WORLD'S TALLEST HOTEL, AND PRICEY SUITES VIEWING ON MECCA'S GREAT MOSQUE.

The Emirates signed disproportionately. Even tiny Ajman built an international airport, a complex of skyscrapers, and a nine-mile beachfront. Oil-rich Abu Dhabi, posting solvency with an ATM machine that dispenses gold bars, imported 40,000 workers to fashion Yas Island into a pleasure-ground featuring a roller coaster, water park, movie park, indoor theme park, and "world's-fastest" Formula One circuit. On nearby Saadiyat Island, a wasteland the size of Manhattan sprouted a world's-largest culture center headlining a Norman Foster showcase for national history, a Jean Nouvel iteration of the Louvre, a Zaha Hadid performing-arts center, and another Frank Gehry take on the Guggenheim Museum. For bragging rights, Crown Prince Sheikh Mohammed bin Zayed al-Nahyan bought New York's Chrysler Building, commissioned Christo's "world's largest and costliest sculpture," and unveiled the projected $22 billion, "world's first sustainable," Masdar City.

With less cash but more flash, Dubai turned "a patch of worthless sand" into an instant megapolis promising a can't-top-it leisure "experience." Playing out ruler Sheikh Mohammed bin Rashid Al Maktoum's mantra—"The word impossible is not in the leaders' dictionaries"—is an underwater hotel, an artificial coral reef nesting actual World War II planes, and a three-mile-high man-made tornado. Two self-sustaining cities view on the $2.5 billion Dubai Mall, a "world's-largest" entertainment complex that offers a beach cooled by underground pipes, and a 1,300-foot indoor ski slope. Mere openers for Falconcity of Wonders, a shopping nirvana shaped like the national bird and themed with replicas of the Eiffel Tower, Leaning Tower of Pisa, Taj Mahal, Hanging Gardens, and *two* Central Parks. Across from the 370-acre "world's-largest" Norman Foster–designed airport, the sheikh had an archipelago modeled on a map of the world, and villas laid out to spell lines of his verse. Whatever was presented to him, relayed his architect, "he said to make it bigger." How many customers could possibly return these wild investments? It turned out, not enough; the archipelago began sinking and the oil market too. Still, the last chip is not played; newly introduced passenger drones blazon Al Maktoum's resolve to "overcome the impossible."

No less declamatory, a renascent Asia gave Bahrain a world's-largest underwater theme park, and Kazakhstan a "world's-tallest" Norman Foster tensile structure. Japan's deepening pockets built a "world's-longest" suspension bridge, and billed Seoul "World Design Capital" with a Zaha Hadid plaza and Daniel Libeskind–designed business district.

Communist China's imperial agenda replaced Mao's "Look to the Future" with "Look to the Money" schemes that uprooted entire communities for the "largest windfarm," "fastest intercity train," "longest bridge," "highest bridge," the "biggest-ever-construction-project" Three Gorges Dam, and the "unprecedented project in the history of mankind" railway linking Beijing to Lasa that remains unaffordable for the worker. The Beijing 2008 Summer Olympics saw entire neighborhoods leveled for the "incalculable cost" of name-architect superstructure. Steven Holl, Norman Foster, Paul Andreu, Herzog & de Meuron, and Rem Koolhaas answered "Can it stand?" with the triumphant "Yes" of a hybrid eight-towered palace, a vaulting $3.8 billion airport terminal, a floated National Theater, a steel-ribboned National Stadium, and the humungous CCTV headquarters. Shanghai weighed in with a "largest-ever" World Expo 2010 featuring a $270 million sports arena, a $700 million riverfront promenade, the $2.4 billion, 2,073-foot-tall Shanghai Tower, and the $5 billion, "world's-biggest" Disney Resort. Tellingly, even Xi Jinping's austerity program displaced 9,000 villagers for a "world's-largest" radio telescope.

Rival egos short on land built up. By 2010, the race for a "mega-tall" had climbed Taiwan's Taipei 101 to 1,671 feet and Dubai's Burj Khalifa to a record 2,717 feet. Saudi Prince Waleed bin-Talal countered with the yet unfinished 3,281-foot-high Jeddah Tower, and Dubai announced the "visionized" 4,600-foot-tall Nakheel Tower, whose

THE BIRD'S NEST: THE ELABORATELY ENGINEERED HERZOG & DE MEURON 91,000-CAPACITY STADIUM COMMISSIONED FOR THE 2008 BEIJING OLYMPICS.

elevator will soar through five different microsystems, and the "conceptualized" two-kilometer Vertical High.

Such are the dreams. Ultimately, though, economic disparity, climate change, and now, pandemic, may crush them. Manhattan's record high-rise casts a shadow that has deflowered a mile of Central Park, India's recent launch of 104 satellites orbits dangerous debris, and plastics are choking the oceans. Revisionist history pairs excess with decline; the fall of Rome, Mughal India, and imperial China are all attributed to insatiable appetite. So did economic meltdown leave Europe shaken, the U.S. a debtor, and Dubai the victim of—a recent book title suggests—"the Vulnerability of Success." "Building beyond possibilities," reads a billboard announcing Sheikh Sulaiman al-Fahim's aborted Hydra Village.

Pushing back, in 2007 the Royal Canadian Mint created a $1 million gold coin; in 2011 Cape Canaveral shot the Curiosity Rover to Mars; and in 2019 Singapore profiled its new airport with the world's tallest indoor waterfall. And ever the panoply: King Salman bin Abdulaziz's 2017 tour of Asia called on six Boeing jets, a military transport aircraft, a fleet of Mercedes, electric elevators for his personal use, and 1,500 attendants and 572 handlers for the luggage. Xi Jinping's overreach may tank China's economy but his Belt and Road Initiative remains boundless: a circumnavigating bridge-and-rail-scheme, new ports, new islands, 100-plus cities built from scratch, and the $110 billion, zero-pollution eight-square-mile, four-island, Forest City in Malaysia that "will alter the world map" with technology promising a no-privacy "dream paradise for all mankind."

Servitude—The ineluctable subtext of dominion is subservience. There is no ruler without subjects, no commander without subordinates. The pharaohs didn't own slaves because in effect they owned everyone, ruling a static society that was

THE BURJ KHALIFA:
RAISED TO 2,717 FEET TO
GIVE DUBAI THE WORLD'S
TALLEST STRUCTURE.

One death is a tragedy; a million deaths are a statistic

JOSEPH STALIN

beholden for water, for life itself, to the gods and, by divine association, to them. Absolute power exacted absolute servitude and expectation of service beyond death entombed scores of the living. Introduced when people were first captured, bought, and sold, slavery constituted the commodity that most urgently defined privilege. Across millennia and continents, the triremes, monuments, mines, and armies that conditioned magnificence were built and sustained by forced labor. The Athens of Pericles presented as a democracy, yet a third of Attica was enslaved, and the Roman conceit of freedom was just that—thralls who were freed only at the owner's discretion. No peoples were safe. Rulers sold subjects, warlords enslaved captives, and from Persia to the Far East, wealthy households indentured the Slavs ("slaves") peddled by Viking invaders. Rousseau's "Men are born free" curtailed bondage but not entitlement, leaving servants prey to whim and abuse. So could Friedrich Wilhelm I shoot a bullet through the wig of a lackey who rattled the plates, and Poland's pious diarist, Jan Pasek, order a keeper caught snaring a rabbit to eat the creature alive.

When ships opened new worlds, Africa supplied chattel to exploit them. In the Caribbean, where slaves were cheaper to replace than to support to maturity, Louis XIV's Black Codes worked them to an early death. Critical to the revenues from sugar, cotton, and hemp that sustained empire, the slave trade itself became a lucrative commodity. Even the evolved kingdoms of Kongo and Asante trafficked in slaves, and even the righteous Black Jacobin Toussaint Louverture, who led Haiti's 1791 slave revolt, later owned them. By 1807, the quantity shipped to Britain's colonies outnumbered settlers by three to one.

Numbers counted. Whether conscripted or hired, a great ruler's workforce must be marking. The pharaohs commanded hundreds of thousands of servers, 20,000 sustained imperial Rome, the Great Khans maintained twice that, and Montezuma II held over 6,000 in bondage. Medieval Europe lived off its vassals and Renaissance courts commanded a profusion of ill-paid servants—169 women waited on Catherine de' Medici, and over a dozen tended just to Elizabeth I's wardrobe. For centuries, serfdom sustained Russia's courts and, worldwide, reform notwithstanding, the indentured count remained high.

So did the cost. Even with wages not a factor, service entailed outlay. The 100,000 workers conscripted to build the walls of Baghdad, the 165,000 drafted to extend the Sui Emperor's Grand Canal, and the 1,200 slaves, 60,000 servers, and 200 porters who accompanied Emperor Mansa Musa's *hajj* to Mecca—had to be fed, clothed, and lodged. Turkey's Sultan Mahmud II boarded over 5,000 servants in Constantinople—935 coachmen and grooms just for his 635 horses. A bagatelle for Qianlong, who sustained all who serviced the Forbidden City and Summer Palace, plus cadres of imported artisans.

Dieu et Mon Droit

RICHARD THE LIONHEART

THE GOD STANDARD

T he ancient world, born of the sun, prey to the elements, and ever reliant on bounty from sea and land, turned for favor and succor to the spirits who controlled them. More sophisticated belief systems, shaped by thoughts of eternity, summoned up powerful gods for protection in this life and safe passage to the next one. To ally them called on superlative artistry: *ikat* ceremonial robes woven from individually dyed threads, Ardabil paradise carpets tied with 30 million knots, Sufi begging bowls worked with silver, African ritual masks pieced with ivory, and Mayan priest-jackets wrought of tiny feathers because small birds flew close to the gods. Ultimately, though, life everlasting relied on monetary outlay. Across millennia, every luxury— fragrance, art, and treasure—was pressed into service. Sanctuaries were scented, altars carved, bodhisattvas adorned. In dimly lit times, a flash of revelation was just that—fervor set alight by a gilded Shiva, a gleaming menorah, a gilded Qur'an, a jeweled Cross. Whether to flatter the gods, ward off evil, buy immortality, or cushion the hereafter, the path through this life to the next was visibly opulent.

Human inclination to anthropomorphism gave the gods our desires. Egypt's Mentuhotep III sent an expedition 3,000 men strong across the Red Sea to source aromatics for his temple to Montu. Ramses II regaled Amun: "I've immolated 30,000 steer for you with all the sweet herbs and costliest perfumes." Every temple built for Babylon's myriad gods was infused, Marduk's was drenched: "I had incense and perfume mixed into the bricks," read Nabopolassar's inscription. Little changed but the god. Hindus burned fragrant resins for Brahma, the Prophets offered sweet spices to Yahweh, and the Christ Child was regaled with frankincense and myrrh. Scarce aromatics were expensive—the price of those Mary Magdalene poured on Christ's feet, alleged Judas, could have fed a thousand poor—but cost measured devotion.

Pleasing the gods called on the most precious materials; copper for its malleability, bronze for its burnish, silver for its gleam. Gold, for its durability, set the gold standard. The collars circling the deity figures found at Ugarit, the ritual knives of the Chimú, the Druids' ceremonial scythes, the talismans buried with the Scythians—all were gold.

Arguably, human sacrifice presented an ordinate offering by removing a community's major resource, but catastrophe must be averted. Transfixed by the supernatural, Mesoamerica held its rulers only semi-divine—avatars at once empowered by the gods and beholden to the people, who sought to pacify the underworld with the blood of virgins and captives' beating hearts. Material riches, nonetheless, ornamented the entrails of worship; Andean high priests presided in hammered-gold shirts, Mayan death masks were carved of jade, and the bloodthirsty Aztec war-god Huitzilopochtli, said Bernal Díaz, was girdled with "so many precious stones, so much gold, so many pearls, and huge snakes made of gold and precious stones."

It was not the gods who commanded such luxury, but their spokesmen. Whereas tribal cultures, believing the spirit to reside in nature, had no need for intermediaries, worldly societies lifted gods above mortals and charged living avatars to represent them. So could Sargon of Akkad, held a demigod, unify diverse peoples into history's first empire, and Queen Hatshepsut, self-styled "God's Wife," justify an exorbitant expedition for myrtle trees: "I made his garden into the image of Punt, as he asked me to."

Assuming divinity entailed greater outlay. Planting his magnified likeness at Abu Simbel conjoined Ramses the Great and all-powerful Amun. Building a city for Aten proclaimed Akhenaten god incarnate. Empires stretched thinner could only allege divine sanction. Darius I brandished a solid-gold block engraved with the names of the 20 nations he ruled: "I am Justice and have been asked by God to promote happiness." Rival deities differed, inviting Macedonian takeover. "I accept Asia from the gods," crowed Alexander the Great, self-crowned Pharaoh of Egypt, cutting the Gordion knot to imprint his godhood on the coinage of his realm, but dying too young to invite the fate of his father, Philip II, murdered for claiming kinship with Zeus.

The Hellenes, weaned from cult-worship by a philosophy that brought the gods down to earth, had no direct pipeline to eternity. Lacking a Creator, supreme

ABOVE BEGGING BOWL: BELYING SUFISM'S PROFESSED DISREGARD FOR LUXURY, THIS HUMBLE VESSEL WAS FASHIONED OF SILVER, TURQUOISE, CORNELIANS, AND A PRICIER-THAN-GOLD SEYCHELLES NUT.

TOP RIGHT AMBON OF HENRY II: GILDED PULPIT INSET WITH GEMSTONES AND *SPOLIA*, GIFTED BY THE OTTONION EMPEROR TO THE PALATINE CHAPEL.

RIGHT CHALICE OF ST. SUGER: FAMED ALEXANDRIAN SARDONYX VESSEL, MOUNTED BY THE ABBOT WITH GEMSTONES AND GOLD TO GLORIFY GOD.

judge, and clergy, they transformed sacred to divine, destiny to tragedy, miracle to marvel, the afterlife to the immortal soul, and fearsome idols to fickle deities whose strengths and weaknesses mirrored theirs. All could be bribed, allied, or mollified with sculpted heroics and temples wrought of white marble. Idealized statuary filled the sanctuary of Delphi, Olympian gods battled along the great altar at Pergamon, and it mattered not to Athena that an agnostic detailed the Parthenon—Phidias was the best sculptor around. Ever pragmatic, the Romans attached the same gods and let imperial agendas assume kinship. In turn, the divine sanction claimed by Augustus stamped Caligula's divinity on the coinage and diverted 7.5 tons of war-booty gold to Aurelian's temple for a sun god topped with the emperor's likeness.

Asia conflated sacred and secular more organically. China's priest-emperors ruled with an express mandate from heaven, licensing the Shunzi Emperor to meet with Tibet's Dalai Lama "as deities at the center of the celestial Palace of the Mandala." Japan's emperors, descended from a sun goddess, ruled by celestial command, waited on hand and foot long after the shogunate leached their power. India's early rulers assumed divinity like autobiography, representing its myriad deities in a nimbus of splendor: the King of Malabar appeared in public with prayer beads composed of 304 giant pearls, one for every god he acknowledged. Such opulence greatly burdened the community but was held essential—a ruler fully ornamented was fully enabled, a powerful interlocutor to the gods for the people.

RAMSES THE GREAT: THE REMAINING TWO OF FOUR STONE PORTRAITS PLANTED OUTSIDE HIS TEMPLE AT ABU SIMBEL TO PROCLAIM HIM GOD AND KING.

Enter the One God, announced by spiritual leaders pledged to austerity—until they, too, were aggrandized. Siddhartha Gautama, having abandoned princely riches to seek Enlightenment through detachment, self-defined as a teacher, yet Mahayana Buddhism would regale him like a god: "All those who fashion images of Buddha out of gems, copper, bronze, lead, iron, clay, stone shall be rewarded with Buddhahood." Embellishing the teachings—in India with gilded stupas, in China with bronze reliquaries, in Japan with lacquered shrines—indeed earned spiritual merit. Less so, the agendas that magnified them. Disregarding his injunction against idolatry, the Buddha would be ornamented beyond measure, with temples clad in gold and relics flashed with gemstones. In 643, related the scholar Xuangzang, Emperor Harshavardhana, robed as a dharmapala, scattering pearls, and trailing a motley flock of Buddhist monks, Brahmins, rajahs, and elephants, undertook a costly pilgrimage to the Ganges to erect 100 stupas and bedeck an already bejeweled bodhisattva.

The prophets of Judaism, too, had abjured luxury and yet, beating God's drum—"Whether gold, silver or jewelry, who among you would pledge it to Yahweh?"—King David pulled in 100,000 darics, 5,000 gold talents, 10,000 silver talents, 18,000 bronze talents, and 100,000 iron talents from the children of Israel. Gold chandeliers lit Solomon's Temple—built 20 stories high with forced labor and cedar exchanged for 20 towns of the Galilee. Believing that Yahweh deserved nothing less, an enriching Jewry commissioned extravagant Judaica.

VENETIAN TORAH CROWN: RICHLY ORNAMENTED AND INSCRIBED "CROWN OF GLORY AND DIADEM OF BEAUTY" TO EXALT BOTH OWNER AND YAHWEH.

Hanukkah lamps were wrought of gold, tzedakah boxes carved of rare woods, Passover goblets emblazoned by Herend, and textiles for the Torah scrolls, richly embroidered. Most wondrous were the prodigally illuminated manuscripts on the order of the Mishneh Torah and the Rothschild Pentateuch.

The prophet Jesus, in turn, announced a God whose kingdom was humble and acolytes charitable. Through centuries racked by war, plague and famine, disciples had faithfully practiced austerity and transcribed the Lord's teachings. Yet by the

OPPOSITE THE ROTHSCHILD PENTATEUCH: THE GOLD-ILLUMINATED HEBREW MANUSCRIPT HELD THE PINNACLE OF MEDIEVAL ARTISTIC ACHIEVEMENT.

RIGHT *THE HOURS OF CATHERINE OF CLEVES*: 15TH-CENTURY ILLUMINATED DUTCH MANUSCRIPT, SO MASTERFULLY EXECUTED AS TO DESIGNATE THE ARTIST "THE MASTER OF CLEVES."

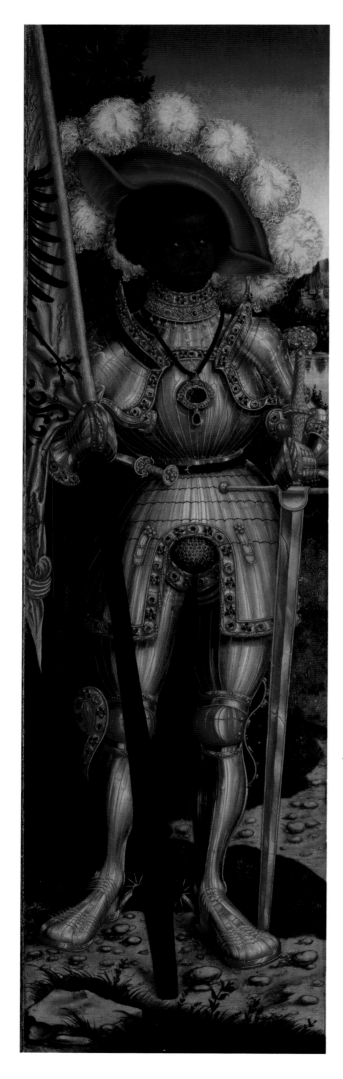

late Middle Ages, as the monasteries came to interact with prosperous courts, they conflated divinity and luxury. Christ's crown had been of thorns but the Cross of St. Eligius marked His wounds with rubies. Convinced that "the dull mind rises to truth through that which is material," 12th-century Abbot Suger gave the Basilica of Saint-Denis an effulgence of stained glass and a 23-foot-tall gold crucifix. While pilgrims crossed hundreds of miles on their knees to worship a shroud, priests officiated from gold altars. So did the Holy Grail, alternately a precious jewel, plate, and cup, come to signify divine Grace.

Credit fervor, nonetheless, for their artistry. The wages were good but devotion embellished God's regalia. It took a full year to illuminate Ireland's *Book of Kells* with a single-hair brush; ten for the 157 miniatures given *The Hours of Catherine of Cleves*; and 27 for the three-ton gilded Gates of Paradise doors commissioned from Lorenzo Ghiberti for the San Giovanni Baptistry. Marvels, too, the boxwood prayer beads opening to minuscule tableaux; the painstakingly gold-stitched *opus Anglicanum* chasubles; the Alexis Master's immersive stained-glass windows ornamenting Canterbury Cathedral; the altarscreen crafted for Chartres Cathedral by three generations of woodcarvers; and Andrea Amati's masterful violin, inscribed "By this bulwark alone religion stands and will stand." *Si Christus videre potuisset!* The sublimity of tracery, gilding, painting, and needlework that consumed the eyesight and health of so many for so long—all these Christ surely saw, and as with Mary Magdalene's lavish gesture, found good. Good, too, the light cast by the mighty; the

LUCAS CRANACH THE ELDER'S PORTRAIT OF SAINT MAURICE, THE LEGENDARY EGYPTIAN COMMANDER OF ROME'S THEBAN LEGION, MARTYRED FOR REFUSING TO SLAUGHTER FELLOW CHRISTIANS: REPRESENTED AS A KNIGHT BY ORDER OF FRIEDRICH II AND, IN A GESTURE TO THE SAXON ELECTOR'S DIVERSE COURT, AS BLACK.

FOLIO FROM A
LAVISHLY ORNAMENTED
NASRID QUR'AN.

jeweled pulpit given Germany's Aachen Cathedral by Henry II, the ornate portrait
commissioned by Saxon Elector Friedrich II to honor the martyr Saint Maurice, and
the 20 tapestries by Rubens that Infanta Isabella Clara Eugenia lavished on Madrid's
convent of Las Descalzas Reales.

Such luxury did not sit well with Muhammad. Yes, Jesus was a messiah and would
return, but plainly garbed and on a donkey. The Five Pillars of Islam required no
embellishment, and the devout need only observe daily prayer, Ramadan, and the
annual Hajj. Still, Allah must be praised. Shia split from Sunni to burnish the
Prophet's sayings into gilded arabesques, and Allah's revelations into extravagant
objects—scrolled incense burners, lustered ceramics, and glistening Qur'ans. The
10th-century Blue Qur'an stuns for the abundance of silver applied to indigo-dyed
vellum. Prodigious, too, the 1,000-page Qur'an ordered by the Ilkhanid sultan
Uljaytu from the great Baghdadi calligrapher Yaqut al-Musta'simi that measured 40
by 28 inches—each surah illumined with gold.

Of the four, Christ's teachings were the most susceptible to luxury. Overriding vows
of poverty, the Knights Templar siphoned enough treasure from Solomon's Temple
to "defend the Faith" with the opulent Chastel Blanc chapel-fortress, a slew of castles
in Syria, sumptuous chapels in Malta, and a flurry of Gothic cathedrals modeled on

Chartres. Heeding Pope Urban II's call to rescue Jerusalem from "infidel" Islam, the Knights Hospitallers took over the formidable Crac des Chevaliers and led an army of hooligans into ruthless Holy Wars—a centuries-long slaughter that proved ruinous. To transport and garrison 4,500 knights, 20,000 horses, 9,000 squires, and 20,000 foot soldiers during Innocent III's ill-advised Fourth Crusade, the Republic of Venice charged a staggering 94,000 silver marks.

Closer to home, the Roman Church, grown worldly after centuries of monastic seclusion, licensed abbots to don the luxury of court life and the clergy to join a pampered hierarchy that opened the best and brightest to the surefire advantage of a high-ranking ecclesiast. So could Cardinal Wolsey, son of a butcher, parlay a string of favors at home and abroad into a fortune poured so richly on Hampton Court that the king took it over. The Cardinal's "Ego et Rex Meus" vanity bade servants kneel before him, bishops tie his shoes, and dukes hold up a basin while he washed. His inordinate enrichment from a lord chancellorship, an archbishopric, England's wealthiest abbey (St. Albans), and the dioceses of Bath, Durham, and Winchester—not to mention the

ST. JOHN'S CO-CATHEDRAL IN VALLETTA: GLEAMING TESTAMENT TO THE RICHES GATHERED BY THE KNIGHTS OF MALTA.

CRAC DES CHEVALIERS:
THE FORMIDABLE
CRUSADER CASTLE IN
SYRIA THAT ANCHORED
THE KNIGHTS
HOSPITALLERS' HOLY
WAR AGAINST ISLAM.

pensions extorted from Charles V and François I—gave Henry VIII the pretext to sideline Rome and, finally, bring Wolsey down.

On the resolutely Catholic Continent, the papal agenda attracted aristocrats challenged by the rise of absolute monarchy. Prince-Bishop Clemens August flourished his palace in Würzburg with a caryatid stone staircase that took 25 years to complete, Prince-Bishop Johann Philipp von Walderdorff furnished a palace in Trier with works by Roentgen that cost the equivalent of a mansion, and the Cardinal de Rohan commanded a palace that rivaled Versailles.

Advancement could be purchased. In 1541, when 2,000 ducats was the average annual wage, 80,000 ducats assured the position of Archbishop of Mainz, and twice that titled Charles V "Holy Roman Emperor." Courts could be manipulated. Armand-Jean du Plessis de Richelieu rose from the provinces to the all-powerful Cardinal who directed the policy of Louis XIII, stocked the Palais-Cardinal with art that later founded the Louvre, and introduced the Roman triumphalism that set the direction for Louis XIV. His successor, Jules Mazarin, was fast-tracked to Cardinal and the queen regent's first minister to become the most powerful figure in France. Only hubris brought him down. Directing policy to fund the Sorbonne and a weekly gazette may have been the Lord's work, but besting the Crown's art with such nuggets as Poussin's *Triumphs of Bacchus* and *Pan* clearly was not, since they, plus the 55 carriages that Mazarin exacted for an entry into Brussels, incurred the divine retribution of bankruptcy. It speaks, nonetheless, to both luxury and art's imprimatur that Bonaparte's otherwise frugal uncle, Joseph Fesch, during his tenure as Cardinal acquired more than 17,000 paintings.

None proved more self-serving than the papacy—the beneficent office that Gregory VII had incrementally politicized as he deposed a Holy Roman Emperor, formed an army, and established reforms that empowered the clergy. To the papal tiara, Gregory's successors added the imperial crown and ill-gotten revenue. By the early 13th century, the collection plate was but openers for a corrupting campaign that enriched the Vatican from holdings in France, England, and Scotland, onerous levies (a tax on *butter* to restore Reims Cathedral!), and threats of excommunication that left many unable to marry, hold services, or even bury the dead. Profitable, too, were psalters given ghoulish iconography to elicit lucrative penance, and the medieval invention of Purgatory that drove the sale of indulgences—Albert, margrave of Brandenburg, said he had bought enough to reduce his soul's stay in limbo by 39,245,120 years.

POPE CLEMENT VIII (IPPOLITO ALDOBRANDINI): THE STRATEGIST WHO RECONCILED HENRY IV TO THE CHURCH, ABETTED THE INQUISITION, AND REINVIGORATED THE JUBILEE.

There was protest. The Barberini popes were sued for embezzlement, and it was widely observed of popes fattening on tribute that the supreme pastor was supposed to shepherd his flock, not fleece it. The papacy doubled down with a bread-and-circus agenda of miracle and mystery plays staged to stir emotions that could be gainfully manipulated.

Nothing, though, equaled the traffic in holy remains. Rivalry for relics brokered a lucrative trade—even God-sanctioned theft—of arms, busts, and skulls, all showcased with a jaw-dropping extravagance of precious metals and jewels. The more body parts the more pilgrims. The gleaming reliquaries encasing the Arm of St. John the Baptist and the Bust of St. Ludmila hoisted Prague, the remains of St. James and St. Martin built the colossal basilicas of Campostella and Tours, the skull of Saint Yrieix named a town, and the body of St. Mark lifted Venice with the richest reliquary in all Christendom. Thanks to serial exhumation, Saint Teresa of Ávila kept on giving—her jaw to Rome, her heart to Alba de Tormes, and, to General Franco, her right hand. Only souvenirs of the Holy Family raked in more: the

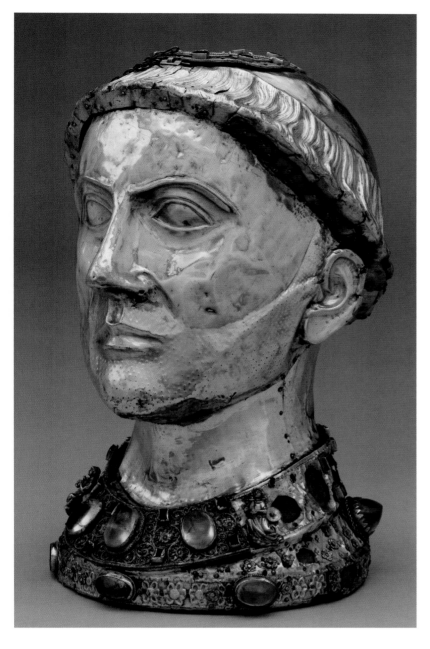

BUST OF SAINT YRIEIX:
THE VERMEIL AND ROCK
CRYSTAL RELIQUARY
ENCASING THE SACRED
HEAD WAS PARADED
ANNUALLY THROUGH
THE STREETS OF LIMOGES.

requisite pilgrimage to view the robe of the Virgin Mary shot Vézelay to Burgundy's second-wealthiest abbey, and the shroud bearing Christ's image still enriches Turin. Offer a relic of the Passion of Christ and be canonized! So did Louis IX's purchase of the Crown of Thorns and a fragment of the True Cross, for three times the price of the church built to house them, buy him sainthood.

There were setbacks. Payoff for royal obeisance could be generous—the wealth of the papal court at Avignon under John XXII reached a staggering 25 million gold florins—but not every game plan went smoothly. The pope, by God's will, ordained the powers-that-be, but monarchs periodically challenged. Pope Leo I strong-armed Attila into withdrawing from Rome, but Charlemagne made Leo III grant him sovereignty over four papal lands. King Louis the Pious played along, Michael VIII Palaiologus did not, and Holy Roman Emperor Frederick II ignored three excommunications to rule grandly in Sicily. Posturing on, Urban VI misguidedly excommunicated Joanna l, Queen of Naples, Sixtus IV shortsightedly excommunicated Lorenzo the Magnificent, and Pius IV imprudently accused Jeanne de Navarre of heresy. Stronger popes crowned Henri IV Holy Roman Emperor only after he declared Paris "worth a mass," and made it contingent on their public conversion to entomb Queen Christina in St. Peter's Basilica, and enthrone August the Strong as August II, King of Poland.

Well after the Age of Enlightenment had leached excommunication of its impact, king and pope jousted on. Whereas Louis XIV could order the congregation to bow to him, not the altar, lesser rulers wooed the papacy with whatever it took—church building, pilgrimage, Holy War—to win the title of Holy Roman Emperor that gainfully linked them to both Church and Caesar. Even as God came to be viewed more as a constitutional monarch, after crowning himself, Napoleon knew to kneel before Pius VII, trailing brocade and ermine like a bridal veil.

Ever at stake was the nest egg of Western Christendom itself, the large congregations and rich realms that kept the papal enterprise afloat. Veiled by elaborate ritual and rich trappings, the Church fine-tuned the Inquisition, toppled kings, and launched wars. In the course of transfiguring Rome with magnificent

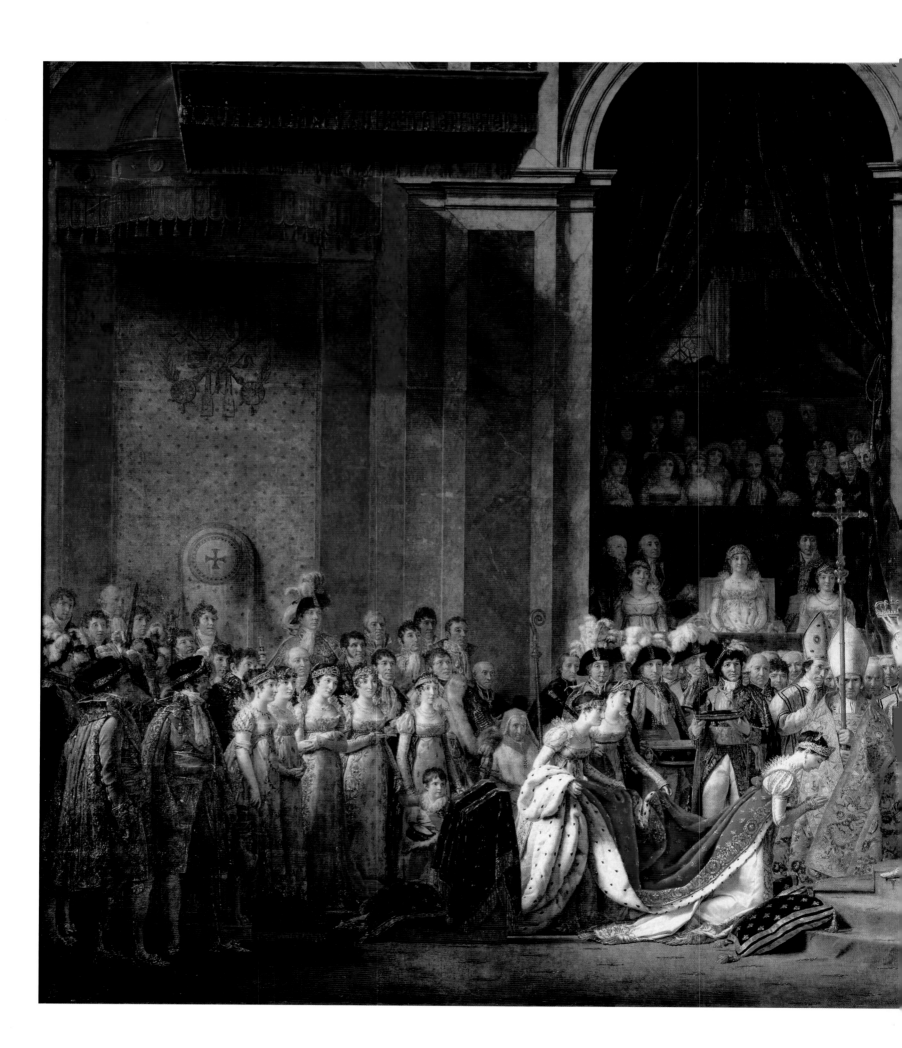

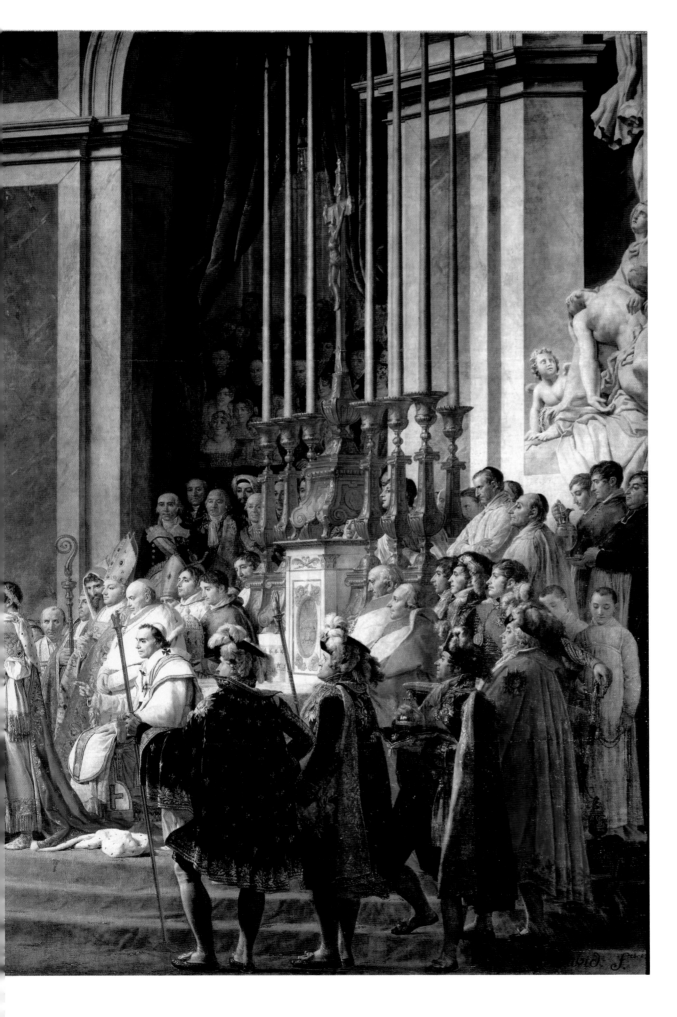

THE CORONATION
OF NAPOLEON:
JACQUES-LOUIS DAVID'S
DEPICTION OF THE
CEREMONY STAGED
AT NOTRE-DAME DE
PARIS TO EMPOWER
THE CONCORDAT.

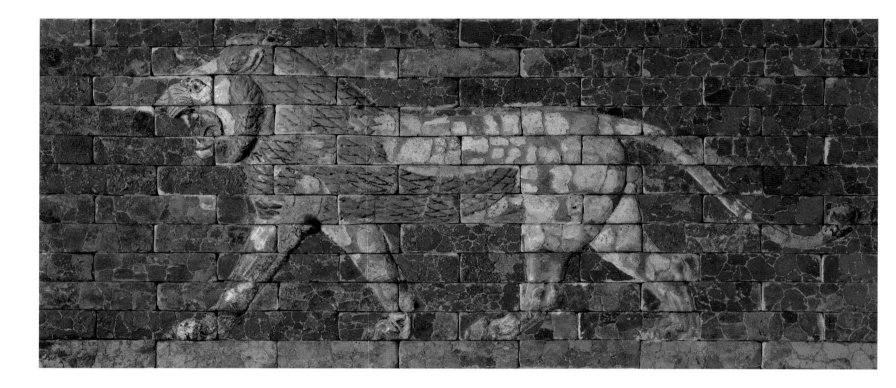

to Nabu at Borsippa climbed to a record 160 feet. Babylon's myriad deities received 53 temples, 955 sanctuaries, and 372 altars—a strategy Nebuchadnezzar II politicized with a grand processional way embellished to link king and gods.

Let the kings claim the kudos, the burden fell on the people. The Horus Papyrus lists the resources pulled in from 169 communities; 15 percent of the arable land, half a million cows, 88 ships, 53 workshops, and, for a balance to weigh the sacrifices offered the temple of Heliopolis, 673 pounds of gold and silver. An inordinate number of workers were assigned religious duty. Eight thousand of Seti I's subjects tended just the temple gardens at his summer compound. The construction of Solomon's Temple dispatched 30,000 laborers to Lebanon for the cedar, 150,000 to the hills for the stone, and an army of artisans to gleam every visible surface until, relayed a chronicler, "the entire Temple was covered in gold, absolutely the entire Temple." King Herod diverted 10,000 laborers and 1,000 chariots to rebuild Jerusalem's Second Temple into "a Mount of alabaster topped with golden spires." If the message of such massive conscription was glory, its subtext was a populace too subjected to protest.

Leaving the Greek deities to the lilting symmetry of Paestum's cult temples and the sublimely proportioned sanctuaries of Delphi and Athens, Rome lodged its gods in imperial splendor. Domitian's Temple of Jupiter was held "Best and Greatest on the Capitoline" for its variegated marbles and roof lavished with a staggering 12,000 talents worth of gold. Septimus Severus built such a grandiose temple at Baalbeck that three centuries later Justinian had its columns transferred to Constantinople and, post-conversion, threw 10,000 workers and mega-kilos of gold and silver at a cathedral for Christ that became a template for all time. The length of three-and-a-half football fields, Hagia Sophia irradiated 12,500 worshippers with three million glimmering tiles, a 55-foot-tall solid-silver iconostasis, and a gem-studded altar. Pushed too high and too fast, its octagonal dome succumbed to an earthquake but was instantly rebuilt, remaining the world's largest for nearly 1,000 years and

THE LION OF BABYLON, THE LAVISHLY TILED SYMBOL OF RULER AND ISHTAR, STRIDES ALONG THE ENTIRETY OF NEBUCHADNEZZAR'S PROCESSIONAL WAY.

the model for church-building everywhere. Mission accomplished for Justinian I, conqueror of the Vandals and the Persians, of Africa and Italy, who had given Byzantium a trophy for the ages: "Solomon, I have surpassed thee!"

There was no turning back. The Byzantine aesthetic, meant to be experienced more than contemplated, had irretrievably glittered worship. Forevermore equating illumination with the Spirit, Hagia Sophia's incandescence radiated out to the pearly-glass mosaics glinting Ravenna's churches; to the gold-ground mosaics gleaming St. Mark's Basilica in Venice; to the vivid marble inlay ("the like of which," wrote a pilgrim, " no man has ever seen") ornamenting Palermo's La Martorana; and to the 148 stained-glass windows lighting Sainte-Chapelle in Paris. Even the secluded Monastery of St. George Mangana built for Constantine IX's retirement

HAGIA SOPHIA: CONSTANTINOPLE'S SPIRITUAL BEACON, BUILT TO RADIATE CHRISTIAN WORSHIP THROUGHOUT BYZANTIUM AND BEYOND.

gleamed like a "vault of heaven," as the historian Michael Psellos said of its "golden stars . . . fountains that filled basins of water; gardens, some hanging, some sloping to level ground, and a bath that was beautiful beyond description."

Such was the glory that Islam aspired to. Although Muhammad's call to prayer had exacted nothing more than prostration facing Mecca, his descendants built to fame with mosques that shone as brightly on ruler as on God. Umayyad Abd al-Malik replaced Jerusalem's Temple Mount with the radiant Dome of the Rock, and Abd al-Rahman I so richly detailed Córdoba's Great Mosque that even Catholic zealotry left it standing. Such effulgence was seen to lift both Allah and—absent a priestly caste—Caliph. "I mean to build my mosque the like of which my predecessors never constructed and my successors never shall," crowed Al-Walid I, and lavished the Great Mosque in Damascus with a world-record surface of gold tile. Asked why his son had diverted funds allotted to roads to give Samarra the world's largest

TEMPLE OF AMRITSAR: SIKHISM'S SACRED PILGRIMAGE SITE, ALREADY A GLORY OF MARBLE, WAS THEN CLAD IN GOLD.

was the beauty of Mahabalipuram's 8th-century Shore Temple that rival gods left it standing. And such, wrote a scribe, was the glory of Krishna's temple at Mathura that "people believed it not built by men, but only the angels." Displacing the Vedic gods, Vishnu romped across the massive Ranganathaswamy Temple at Srirangham and drew $26 billion worth of treasure to Kerala's Sree Padmanabhaswamy Temple. Shiva animated 85 temples at Khajuraho and at Somnath commanded 14 golden domes, 56 bejeweled pillars, and 2,000 Brahmins sustained by revenues pulled from 10,000 villages. Even Waheguru, Sikhism's ineffable god, exacted a Golden Temple at Amritsar coated with 1,650 pounds of gold.

The Hindu push to monumentality called on herculean labor: 2,700 workers to haul the marble across Rajasthan for Mount Abu's nonpareil temple carvings, and 1,200 to fashion Konark's immense Sun chariot speeding Surya through the sky that dazzled the poet Rabindranath Tagore—"Here the language of stone surpasses the language of man." The Virupaksha Temple at Hampi marked by its myriad reliefs—no two the same—and the Meenakshi Temple complex at Madurai by its 4,500 pillars, 14 gateway towers, 1,500 polychrome statues, and a columned hall housing parrots trained to say "Meenakshi." The granite analogue of a divine city, Thanjavur's looming Brihadisvara Temple flourished multiple sanctuaries, gargantuan pillars, an 80-ton monolith, and a two-story lingam. None surpassed Angkor Wat. A 402-acre architectural masterpiece built by King Suryavarman II as a simulacrum of the Hindu universe, the Khmer capital constituted the world's largest spiritual monument. Rising 1,640 feet to an opulent temple, the entire complex functioned as a

MEENAKSHI TEMPLE COMPLEX AT MADURAI: HISTORIC PILGRIMAGE SITE FOR THE RIOT OF STATUES, 15-STORY-HIGH GATEWAY, 1,000-PILLARED HALL, AND PARROTS TRAINED TO SAY "MEENAKSHI."

Make offerings to the Sangha

THE BUDDHA

ANGKOR WAT,
CAMBODIA: HIGH
POINT OF KHMER
ARCHITECTURE, BUILT TO
SERVE GODS AND EMPIRE.

sacred city. Each sanctuary harbored 18 high priests, 2,700 officials, 2,200 assistants, and 600 dancers—all living off the pearls, silks, gold vessels, and provisions drafted from the surrounding villages, until King Jayavarman VII, believing Hindu gods had failed him, converted the vast complex to Buddhism.

It had taken six centuries to aggrandize the Buddha. Apart from the 3rd-century BCE Mauryan Emperor Ashoka, whose ecstatic conversion had allegedly built 84,000 stupas in one day, his acolytes had advanced humbly. By the 2nd century, nonetheless, the quiet teachings were writ large. Every place the Buddha had graced was augmented, every body part exalted. In Peshawar, for a reliquary holding unspecified fragments, the Kushan Emperor Kanishka climbed a jeweled stupa to an astonishing height. In Sri Lanka, for a belt fragment, King Mahasena grew the Jetavanaramaya Stupa to the world's largest brick building. In Bangkok, the Wat Traimit Temple was given a solid-gold Buddha weighing five and a half tons. Such opulence, if prodigal, was devotional, offered to accumulate virtue on the road to Enlightenment. Burma's disciples earned merit from gilding Bagan's 1,000 golden pagodas—a sight Marco Polo called "the most beautiful in the world." Devout, too, were the retreats scaling vertiginous heights. In Llasa, Tibet, from his 1,000-room, 13-story Potala Palace, the Dalai Lama viewed on a valley 1,000 feet below: in Bhutan, the Taktsang hermitage perched 2,938 feet higher. A still greater effort built India's temples: at Ajanta, cut deep into a rock face; at Ellora, the world's highest rock-cut monument.

Broader agendas, though, politicized meritmaking. Kashmiri King Shankaragaurishvara gave his name to a vast temple built for Shiva. Thailand's Wat Mahathat Temple was given a record-tall reliquary and placed by the palace. Java's 9th-century monumental Borobudur Temple displayed among the 2,672 reliefs of bodhisattvas one of King Samaratungga holding court with his subjects. Sacred structures supplied political logos. Had Korea's Hwangnyongsa Pagoda topped Xian's 210-foot-high Big Goose Pagoda by 14 feet? The Yongle Emperor raised Nanjing's Porcelain Pagoda 36 feet higher.

China had started out cautiously. Han Emperor Ming, sensitive to a cult of ancestor worship sustaining 400 shrines, 45,129 guardians, and 12,147 priests, had introduced Buddhism with the modest White Horse Temple. Sharing Taoist and Confucian precepts of benevolence and modesty, the teachings took hold, but inflated as the practice evolved. Monasteries built to dispense charity swallowed whole forests. Xuanzang bewailed "mountains stripped bare by the felling of trees, roads choked with carts hauling in earth, and still not enough to make the pillars and walls. The main hall of just one of them is twice as large as that of an imperial

ABOVE LEFT TAKTSANG: VERTIGINOUS 8TH-CENTURY HIMALAYAN PILGRIMAGE SITE NAMED FOR THE FOUNDING DISCIPLE SAID TO HAVE ARRIVED THERE ON A TIGER.

LEFT BOROBUDUR, INDONESIA: THE WORLD'S LARGEST BUDDHIST MONUMENT, COMPRISING 28,760 SQUARE FEET OF CARVED STONE RELIEFS.

OPPOSITE TOP THE SHWEZIGON PAGODA: FIRST AND MOST SACRED OF BAGAN'S MYRIAD TEMPLES, LATHERED WITH GOLD TO HOUSE THE BUDDHA'S RELICS.

OPPOSITE BOTTOM THE POTALA PALACE, FORMERLY THE DALAI LAMA'S WINTER RESIDENCE: ITS GOLDEN STUPAS HOUSE THE TOMBS OF EIGHT PREVIOUS DALAI LAMAS.

palace and immeasurably more luxurious. Their wealth is seven or eight times greater than that of the entire empire." Dunhuang enriched from taxes that forced serfs to sell their children and from the thousand caves of Mogao, lavished with silk banners, precious scrolls, and colossal stone statues—the world's largest collection of Buddhist art. Wu Zetian seized on their propaganda potential to mark her rule as China's first (and only) empress regnant with a cave-temple at Longmen displaying her magnified likeness as the Vairocana Buddha. Rivals took note. The Northern Qi's Xiangtangshan grottoes held 20-foot-tall bodhisattvas. A pavilion erected in 775 for just one of them devoured 974 acacia trees, 746 pine trees, 2,478 gold nails, and 8,000 meters of silk.

Japan's early rulers, finding Buddhism in harmony with Shinto beliefs, embraced the teachings as richly. Nara's 8th-century Tōdai-ji Temple floated a 49-foot-tall Buddha on forty-eight 90-foot-tall cypress pillars—an effort entailing 917 builders, 1,438 laborers, 1,000 cooks, a quantity of bronze that almost felled the economy, and so much lumber that, although now much reduced, it remains the world's largest wooden structure.

OPPOSITE THE MING DYNASTY "WORLD WONDER" PORCELAIN TOWER OF NANJING: RESTORED WITH A $156 MILLION CONTRIBUTION BY BUSINESSMAN WANG JIANLIN—CHINA'S LARGEST-EVER DONATION.

BELOW TŌDAI-JI TEMPLE: MONUMENTAL BRONZE STATUE OF THE BUDDHA VAIROCANA, FLANKED BY THE BEJEWELED BODHISATTVA OF WISDOM, MEMORY, AND FULFILLER OF WISHES.

Ming wealth surpassed with the resolve to fashion heaven itself. In 1406, acting out the belief that the imperial palace represented the celestial order, Zhu Di ordered up the largest sacred residence ever built. Over one million workers hauled in logs, bricks, and marble to site the 70 palace compounds of Peking's 178-acre Forbidden City along an axis angled to the polar star. At its center reigned the Emperor, the self-appointed Son of Heaven, orbited by 10,000 eunuchs fed and clothed at the community's expense that they might craft such imperial delights as robes threaded with silver waterfalls and golden dragons chasing pearls.

By the 15th century, every major belief system bathed in luxury, its temples rich as banks. Halfway across the world, the Aztecs had built the Great Pyramid of Cholula into the world's largest monument; the Mayan temples at Chichén Itzá hid so much treasure that the conquistadors thought looting it more exhausting than war; and the riches given the Inca Temple of the Sun daunted even the rapacious Hernando

TEMPLE OF KUKULCÁN (EL CASTILLO): ONE OF THE NEW SEVEN WORLD WONDERS; SURVIVING GLORY OF THE MAYAN CITY OF CHICHÉN ITZÁ.

de Soto: "Over nine hundred men and three hundred horses could not together have carried off all the pearls in the temple."

Still, attach them Christianity did. Globally, no religion more gainfully monetized faith. Africa's system of ancestor worship was deftly converted to ornament Jesus—in the kingdom of Kongo with magnificent altars, and in Ethiopia with 11 astonishing churches that King Lalibela had wrested from rock for a city modeled on Jerusalem. Missionary zeal adorned churches in the Philippines, Indonesia, and Malaysia. Seeing that gaudy spoke to the pagan soul, New World evangelists glazed Peru's alcoves, columned Colombia's naves, tiled Brazil's bell towers, and erected gleaming cathedrals on the ruins of Mexico's trashed temples. Seven tons of gold beatified Quito's Compañíia de Jesús and a profusion of stained glass irradiated Nicaragua's Catedral de León. On its march south, the Catholic Church was said to have embellished so many sacred spaces as to change the direction of South American art.

QUITO'S IGLESIA DE LA COMPAÑÍA DE JESÚS: SUCH WAS THE SPLENDOR GILDING NEW WORLD CONVERSION.

Medieval Europe saw no end to the splendor. Just as commerce succumbed to fashion, so did God. A prosperous bourgeoisie rethought the virtuous life as the good life. Romanesque façades like that of Notre-Dame la Grande in Poitiers, richly sculpted in the belief that God resided in the stone, ceded to the decorative tracery lavished on Reims Cathedral to backdrop coronation. Plump putti displaced crucifixion, breviaries displayed family crests, and rich burghers exchanged altarpieces floating the Virgin to Heaven for a Hans Memling Nativity displaying their portraits. Italy's merchant class blazed the chapels of Florence with Della Robbia majolica, and Genoa's Ciesa del Gesù with a busy altarpiece by Rubens. Portugal's colonial revenues tiled the Jerónimos Monastery and gave Lisbon's Church of São Roque an altar fashioned of gold, silver, and agate. Spanish plunder underwrote the Churrigueresque convolutions of a cupola in Salamanca, the marble, jasper and bronze altar in Segovia, and Toledo Cathedral's monumental gilded altarpiece. Even the somber Escorial preened: "Its ornaments are sewn with pearls, its chalices are all jeweled, and the lamps and chandeliers of solid gold," marveled the historian Baudrillart: "There are forty chapels and forty altars, each dressed differently daily . . . a single container of precious objects far outshines those of St. Mark's Basilica." And even Germany's stolid churches—Ottobeuren, Steinhausen, and Wies—surrendered to rococo frescoes ringed with cupids.

Civic pride funded record-breaking construction. Spain marked the Moors' ouster with a refulgent cathedral built atop Seville's mosque. France gave Amiens Cathedral the nation's highest nave, and to Beauvais Cathedral the world's tallest tower. Italy raised the cupola of the Duomo in Florence to a record 375 feet, and the Duomo in Milan to the state's largest cathedral. Norman conquest flourished Westminster Abbey with England's highest nave, raised Lincoln Cathedral to the world's tallest building, lavished Canterbury Cathedral with record-high stained-glass windows, and gave York Minster a world's-largest expanse of stained glass.

Monuments built for such wonder called on generations of devotion—643 years for Cologne Cathedral. God understood that civic pride was at stake; some doubted, however, that He had ordered the bishop of Paris to outclass the bishop of Chartres with a cathedral so immense that both died before its completion. Notre-Dame's transept measured the length of a football field, its walls rose 100 feet, and its pioneering buttressing gave the West Rose Window a record diameter of 42 feet. And yet Chartres surpassed it, with a record-tall bell tower, inordinate buttressing, and boundless ornament: "The wild height of naves, their interminable length, their useless width, sumptuous decoration, excessive paintings," Bernard of Chartres could swallow, "but what justifies the grotesques, the bizarre bric-a-brac, and foreign

OPPOSITE THE NORTH ROSE WINDOW: MARVEL OF STAINED GLASS GIVEN CHARTRES CATHEDRAL TO OUTCLASS NOTRE-DAME DE PARIS.

OVERLEAF, LEFT PAGE RETABLE OF TOLEDO CATHEDRAL: LAST FLOURISH OF *CHURRIGUERESCO*, ITS GILDED, CONVOLUTED, FIVE-STORY-TALL DETAILING IS HELD CATHOLIC SPAIN'S MAGNUM OPUS.

OVERLEAF, RIGHT PAGE NOTRE-DAME DE PARIS, GIVEN 20 BELLS, MYRIAD SCULPTURES, AND RECORD-HIGH VAULTING TO OUTCLASS CHARTRES CATHEDRAL.

carte blanche to level Constantine's church and all else in his way for a statement basilica. Leo X named Raphael "Commissioner of Antiquities," charged with erecting a new city from the chalk of felled buildings. Let the populace rail! Urban VIII's directive to Bernini for a yet grander basilica taught that moderation was not in God's interest. Still, it did not go down well that St. Peter's was given the world's highest dome, 284 columns, a baldachino fashioned of bronze stripped from the Pantheon, and a 75-ton obelisk that took 907 men and 75 horses 17 months to install. Abetted by four pampered architects and the sale of indulgences, a string of unbridled popes took religious building off the charts with the insouciance that had inflamed Martin Luther ("St. Peter's is built with the skin and flesh and bones of its lambs!") and unleashed the devastating retribution of the Protestant Reformation.

If reform was inevitable, its foothold proved slippery. After the Great Schism of 1054, the Catholic Church had bloated from a cross to an empire. Dissenters were strung up and heretics burned. Let the pure heart find grace in devout altarpieces and J. S. Bach's throbbing oratorios, the Vatican conditioned the forgiveness of sins on donations—in one famous instance, for rebuilding the Speyer Cathedral. Luxury was no longer ornament but vital to worship—the Word become gold. Long after Christendom had embraced ecumenism, the Gothic enterprise exalted. Christopher Wren pushed the dome of London's St. Paul's Cathedral to a height the city council said (wrongly) wouldn't stand. Antoni Gaudí gave Barcelona's Sagrada Familia a soaring cupola and embellishments that exhausted several purses and all patience but his: "My client is in no hurry," he would say of the project that absorbed him for 42 years, and remains uncompleted.

Even puritan America underwrote excess—most famously, with New York's St. John the Divine. When such strut as a dome that could shelter the Statue of Liberty ground work to a halt, Senator Daniel Moynihan fumed: "After twenty centuries of Christianity, we conclude in a moment of moral doubt that we have to stop construction on the most glorious cathedral this city has ever conceived. The retreat from magnificence has lasted long enough." Indeed. Ninety years after breaking

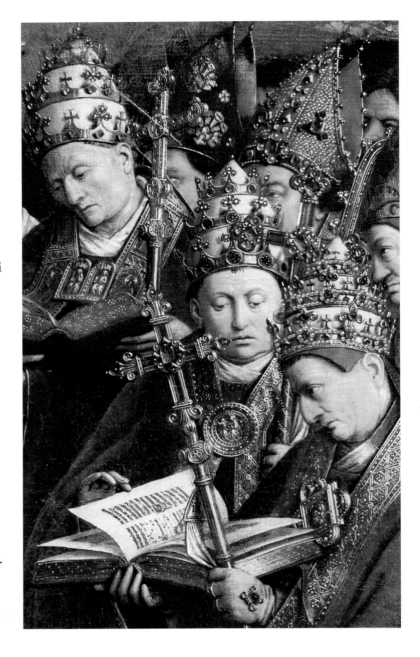

ABOVE THE GHENT ALTARPIECE: CENTRAL PANEL DETAIL OF JAN AND HUBERT VAN EYCK'S MASTERWORK RELAYING THE CLERICAL OSTENTATION— ROBES, JEWELS, REGALIA—ATTENDING THE ADORATION OF THE LAMB.

OPPOSITE
LA SAGRADA FAMILIA: ANTONI GAUDÍ'S PRECOCIOUS, 140-YEARS-IN-THE-MAKING BASILICA, WHOSE SCHEDULED COMPLETION IN 2026 WILL RAISE IT TO EUROPE'S TALLEST RELIGIOUS BUILDING.

Still more sumptuous was the casing; for Seti I fashioned of alabaster, for the Nubian kings of patterned faience, and for Tutankhamun (his rule nascent but supremely powerful) both an inner coffin of pure gold and that spectacular death mask. Speaking to concern for status in this life over transport to an eternal one, the animist ruler Attila the Hun exacted a boxed set of gold, iron, and silver coffins. As marking was the workmanship; to wondrously sculpt a Tang marble sarcophagus, to paint a Josean dynasty wooden bier so finely as to preserve it for future burials, or to masterfully weave a royal Ottoman covering, artisans were bribed, forcibly retained, even captured.

Fully distinguishing was the treasure that surrounded them. Ancient cultures postulating an afterlife furnished it like the present one, with every available luxury. Shang queen Fu Hao was interred with 195 bronze vessels: her successors added chariots, crossbows, silks, ivories, and 20-foot-long painted scrolls. The Scythians found at Tuva were circled by over 5,000 gold artifacts; Korea's Silla royal tombs in Gyeongju held shimmering glassware and gold crowns; and the quantity of gold leaf, lacquer, pearl-inlay, and metalwork attending the Fujiwara clan's lacquered corpses lists the Konjiki-dō Temple a national treasure. Halfway around the world, Inca rulers were buried enthroned with all they held precious, and, given the number of goods interred with Mississippian Indian chiefs, tent cultures, too, sought to take it all with them. Even, for a powerful rule, to service everlasting. A queen of Uruk took her musicians to the grave, a king of Cush took 400 courtiers, and the Pharaohs brought along their most accomplished retainers. To attend them in the next world, the Bactrians interred cooks, bakers, and concubines, and the Vandal chieftain attached, among other treasured possessions, his wife.

Greatest, the fortune poured on housing. Giving name to the conceit, the columned, stepped mausoleum of 4th-century BCE Achaemenid Satrap Mausolus at Halicarnassus was listed a World Wonder and that of Hadrian at Castel Sant'Angelo constituted Rome's tallest structure. The vanity best suited the Renaissance. Maximilian I gathered the era's top artisans for a no-contest cenotaph whose dynastic statuary portrayed the kingdom, not of God, but of Austria. Italy's banking families sought to evade the hellfire promised moneylenders with mortuary chapels embellished to evoke "heaven's gate left open on earth." The Strozzis' was given murals by Filippino, Ghirlandaio, and Benedetto da Maiano that cost five times a year's average wage: that of the Medicis featured their portraits in stone, Lorenzo II's spectacular tomb, and Ferdinando I's armorials emblazoned with pietra dura. Papal vainglory moved Julius II to ask Michelangelo for a commanding sepulcher,

TUTANKHAMUN'S SPECTACULAR GOLD DEATH MASK, ORNAMENTED FOR THE AFTERLIFE WITH THE FALCON HEADS LINKING HIM TO HORUS.

Urban Vlll to order a grander one, and Alexander Vll to have Bernini outdo both. Hubris proved a poor endgame, for such was the ego of both artist and patron that often both had died before the undertaking was ready for occupancy.

Exposed encasement did not suit religions whose provisions for an afterlife exacted infrastructure everlasting. In 2670 BCE, with the most limestone ever quarried, Egypt's great architect Imhotep stepped King Djoser's mausoleum above Saqqara's brick mastabas to an unprecedented 205 feet—a status logo that induced a rash of pyramids in the neighboring kingdoms of Nubia and Kush. Grandson Khufu outbuilt them at Giza with the largest engineering enterprise ever seen. In the heat of the desert, 2,500,000 stone blocks were hauled in (enough, judged Napoleon, to build a 10-foot-high wall around France) and—using only chisels, sand, rope, and planks—were cut, polished, and raised to a height of 482 feet. The number of workers diverted to the Great Pyramid's decades-long construction courted ruin,

THE DECLAMATORY CENOTAPH OF MAXIMILIAN I, SO DELAYED BY ITS EMBELLISHMENT THAT IT WAS NEVER OCCUPIED.

374

but established the Fourth Dynasty as the most advanced civilization on earth, constituted the world's tallest building for 3,800 years, and flagged immortality for all time.

Thenceforth, statement entombment signed indelible power. So did Palmyra's Valley of the Tombs bury the elite in massive towers; Korea's King Gwanggaeto extend his tomb's base to a declamatory 254 feet; and Emperor Nintoku stretch his Daisen Kofun tomb-complex in Osaka to Japan's largest.

Islam's empowered caliphate built large but prioritized visibility. Whereas Muhammad had discouraged memorials, politicizing agendas embraced them. In Merv, Seljuq Sultan Sanjar's turquoise-domed tomb manifested such "other world" tilework as to declare it a pilgrimage site. In Cairo, the intricate stone carving on Sultan Qaytbay's three-story mausoleum rewrote his history from Mamluk slave to Allah's acolyte. Glory begot glory. The mausoleum of Ilkhanid ruler Öljeitü boasted a record-size dome challenged only centuries later by the one (largest in all India) given Mohammed Adil Shah's Gol Gombaz mausoleum. The Timurids' breathtaking tomb-complex in Samarkand, lavished with an azure dome, onyx paneling, blue-gold reliefs, and a gravestone carved for Timur of a single piece of jade, formed the template for the "heart-delighting" mausoleum that marked Mughal Emperor Humayun's passing. Finest was Shah Jahan's memorial to his queen. A cloud of white marble inlaid by 20,000 workers with the entire Qur'an, the Taj Mahal's size and splendor deified majesty, though it launched a statement-tomb industry that relied on the neighboring villages to maintain.

Only China had outbuilt them. Han Emperor Wu's Maoling celestial palace, 50 years in the making, had absorbed a third of the taxes but enfolded temples and housing for thousands of people: still more elaborate, that of the Eastern Qing in Zunhua covered 30 square miles. None, though, topped the effort to immortalize Shi Huang, the self-anointed First God of the Qin. Through to after his death, 750,000 conscripts had fashioned a 38-square-mile necropolis near Xian with no expense spared for the emperor to preside as richly in the next life as in this one. There were bronze chariots to transport him, a life-size terracotta army to guard him, and a bevy of dancing girls, acrobats, and musicians to amuse him. To assure perpetuity, 500 tons of liquid mercury were kept flowing down 100 bronze riverbanks by a mechanism designed to never wind down, and all of the workers were buried alive. Such, though, is luxury's fleeting glory that the dynasty that built an empire and the world's largest tomb endured only 15 years.

Much endgame effort was insurance. Retribution and vandals aborted many an afterlife—even Herod's fortified tomb would be smashed to smithereens. "I am

Cyrus," read the inscription on Cyrus II's multi-tiered tomb at Pasargardae, "who founded the empire of Persia and ruled over Asia. Do not grudge me my monument." Yet all that survived of its glory was the coffin—sans body. Backbreaking precaution tunneled New Kingdom tombs into sand and those of the Song into hillsides. Alaric I's body and treasure remained under a river in Calabria that was allegedly diverted for their burial then returned to its course. Genghis Khan's tomb remains on the missing list because all knowing its location were eliminated.

Evolving ideas of the afterlife and what could not be taken to it prioritized status in this one. Victorian England's high-end family vaults stipulated fancy masonry: Paris burial alongside Chopin and Balzac at the Père-Lachaise cemetery called on marble statuary. Gilded Age America frilled Woodlawn Cemetery's mausoleums like their mansions with columns and Tiffany glass—those at Forest Lawn with marble fountains and replicas of Michelangelo's *Pietà*, and those on San Francisco's Millionaires Row with renditions of Greek temples. Even agnostics wanted in. The famously impoverished iconoclast poet Walt Whitman ordered up a pricey mausoleum, invited friends to the groundbreaking, and handed them the bill. As graveyards reached capacity, a prime site became a luxury good. One John Schiffeler sold the family vault for $250,000: "Most distasteful," he agreed, "but one has to live." No price buys burial in Westminster Abbey, soon to admit only monarchs for lack of space.

More attainable, a plush casket with a "polished finish" and shirred velvet lining: the blanket was extra—$4,000 for one sewn, like Irving Berlin's, with gardenias. Cue the hairdresser, makeup artist, estate jewels, and designer gown. Elizabeth Arden told Oscar de la Renta, at a fitting for a gold lamé dress: "I'm saving it for a special occasion"—her viewing.

Gangster swagger surpassed. Mexico's Jardines del Humaya immortalized narco-status with stained glass and gilt statuary, and New York mobsters bid farewell to John Gotti with large floral replicas of a martini glass, a racehorse, and a Cuban cigar. Celebrities aced. The ashes of gonzo journalist Hunter S. Thompson, LSD guru Timothy Leary, and literary lion George Plimpton were shot to the stars: those of architect Luis Barragán were pressed into a diamond. Latter-day strategy preserves the whole body at 320 degrees below zero for eventual rebirth or for travel to paradise on the $180 million Timeship—a six-acre "Noah's Ark" outfitted for 10,000 resurrected corpses, animals, and plants. Those left behind can find consolation in Funeral Home, a memento perfume formulated by Demeter Fragrance to evoke an oriental carpet and white flowers.

THE TAJ MAHAL: SHAH JAHAN'S NO-COST-SPARED MONUMENT TO MOURNING, HELD THE GREATEST ACHIEVEMENT OF INDO-ASIAN ARCHITECTURE.

*Ultimately,
it is the desire,
not the desired,
that we love*

FRIEDRICH NIETZSCHE

LUXURY REDUX

P ursued across time and place, luxury is as old as the hills and as new as the morning. Rivals raided coffers because armies could, hearts wooed with treasure because lovers would, and rulers measured wealth in iron, salt, nutmeg, and land when each was held dearer than gold. To own the day's luxuries was to matter. The Epicureans, relayed Plutarch, craved "gold, silver, jewels, purple garments, houses built of marble, groomed estates, caparisoned steeds." Gilded Age New York, noted Cleveland Amory, aspired to "a château by Hunt, a box at the Metropolitan, a pair of opera glasses by Lemaire, a C-spring carriage, a pair of spanking bays to drive through Central Park, a yacht with rosewood paneling, and marble pilasters in the saloon."

In our nanotech era of mind-bending possibility such satisfactions may seem quaint, but if the desirables changed, desire did not; turn up the volume and luxury was marching in step, still chasing the best and the most. Even as aspiration collided with the top 1 percent owning 45 percent of the world's wealth, some 600 billionaires and 20 million millionaires poured into the 21st century on a tsunami of cash that consumed one luxury after another. That the ensuing recession didn't curb appetite confirmed that luxury is hardwired into the human pysche and that Veblen had it right: strivers consume conspicuously to manifest social status. African mines churned out "blood diamonds" and Nevada's open-pit goldmines disgorged 200,000 tons of toxic waste daily, yet few settled for an aluminum wedding ring. Thus could time-share tycoon David A. Siegel build his fortune on selling low-income families the American Dream: "Everyone wants to be rich, and if they can't be rich, the next best thing is to feel rich, and if they don't want to feel rich, they're probably dead."

Feeding desire raised "don't put off to tomorrow" from aphorism to mantra. Baiting luxury's lure with "you can't afford not to buy it" opened wallets to commodities sailed over on container ships the width of the Panama Canal. Relentless branding produced a glut of allure—too much bespoke chocolate and regional cheese; too many perfumes, designer shoes, bottled waters, and summer berries in winter. The luxury of surfeit, nonetheless—those 22 varieties of baked beans sold by a supermarket in Rockville, Maryland—had become a societal expectation.

Less welcome, the backlash. Hopefully gone forever is unchallenged entitlement—the "fierce passions of a luxurious aristocracy" noted by Henry James that had eased Baron Alexis de Redé into the life of a latter-day Pompadour and let Lady Annabel Goldsmith cushion a North Ireland childhood with grooms,

gamekeepers, gardeners, footmen, valets, butlers, ladies maids, cleaners, chauffeurs, a bagpiper, a trained nurse, and a telephonist. We no longer think to sample Caspian caviar from overfished waters or to skin wildcats for their fur. There is no joy in such feckless fantasies as the 2,600-acre Neverland, whose zoo, serpentarium, railroad station, theater, and 16 amusement park rides entailed a staff of 150 and an annual $5 million upkeep for the pleasure of, essentially, Michael Jackson. "To get rich is glorious" is no longer China's mantra, and mogul intemperance—flagged by Dennis Kozlowski's $15,000 umbrella stand and John Thain's $35,000 commode—has become a cautionary tale.

None, though, threw out the Tesla with the tiger rug. The press still reported on glittering

doings and fabulous acquisitions, and only those with no access asked "to where?" or "for what?" Even after the recession of 2008, did we not see many a reprise of Elizabeth Taylor, wearing the Krupp diamond, folded into a jade-green Rolls-Royce with her bodyguard and Paris coiffeur Alexandre, for a luncheon just two blocks away? Achievers still overdressed to be seen and overspent to be known wherever dressers, handlers, and bloggers publicized such as Kimora Lee Simmons ferrying her daughter and a Louis Vuitton shopping bag to inspect a $500,000 parure at Chopard that she found "very reasonable." After President George W. Bush prescribed shopping as a physic for 9/11, living on the edge was deemed politically correct, and corporate overreach, patriotic. Bankruptcy, in American parlance, had created an opportunity to begin spending all over again. At the ready were new flashy new logos self-branded as luxuries.

In that new gilded age, track the Millennial's wonder cabinet to know the day's dreams. Acquired with the high-limit Amex Centurion Card were the $1.3 million, edition-of-three, diamond-studded GoldVish Le Million cell phone; a $61,000 Louis Roederer Cristal methuselah that takes two to cart home; a price-on-request, edition-of-one, Dolce & Gabbana confection; *the* shoe—Louboutin's $3,095 crystal-flashed, Sexy Strass pump; *the* bag—for day, a wait-listed Nile crocodile Birkin and for evening, a $11,500 Delvaux grip the size of a card deck; and a $300,000 "executive protection" dog with Navy Seal training. Watch-lust eyed a price-on-demand Patek Philippe "first series" Calatrava. Car envy attached a $3.4 million, 750-horsepower Lykan HyperSport flashed with diamond-crusted headlights. Rounding out the must list; 1,000-thread-count sheets, a $2,000 stationery "wardrobe," a $20,000 Keith "Bang Bang" McCurdy tattoo, an indoor pool floating $18,000 Dale Chihuly glass waterlilies, and, sustainably sourced from the Himalayan Changra goat, a ME&K *kani* shawl that takes up to 18 months to weave.

Luxuries once elitist now signed attainment. Distinguishing to decant a 1945 Romanée-Conti and to offer a cup of $1.4 million-per-kilo Ming dynasty Da-Hong Pa tea. Enhancing to display Dior's gold-monogrammed jar of L'Or de Vie skin cream heightened with extract of Château d'Yquem or, encased like diamonds, Estée Lauder's formula-guarded, 21-day intensive beauty treatment, The Essence. Gratifying to payroll a high-profile chef, retain a wellness guru, own a helipad, a submarine, a VistaJet Bombardier Global 6000, and an escape haven in New Zealand.

Auction houses became luxury's playground, smashing records with $1.2 million for a 1927 movie poster of *Metropolis*, $1.9 million for a bottle of 1926 Macallan Valerio Adami whisky, $2.2 million for Nicolaus Copernicus's *On the Revolutions of the Celestial Spheres*, and $450 million for Leonardo da Vinci's *Salvator Mundi.*

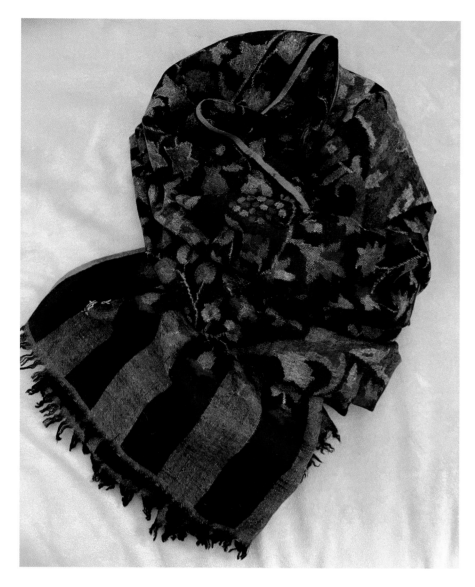

KANI SHAWL WITH CHINAR LEAF PATTERN; WOVEN OF THE FINEST PASHMINA USING A 15-STAGE PROCESS OF SPINNING, DYEING, WEAVING, AND FELTING TO CREATE THE DESIRED MOTIF.

Not all headline acquisition spoke to luxury. Filling a space in his 62-year-old stamp album qualified "million-dollar-shoe designer" Stuart Weitzman's $9.5 million purchase of the 1856 One-Cent Magenta, but of such binge-bids as $7.6 million for one of 12 extant 1933 U.S. double eagle gold coins, a cooler head noted that outlay once considered a hedge against inflation now reflected "a slightly irrational desire to own the item."

Buying status, however, anointed, as evidenced by strivers bidding up to $4.5 million to lunch with Warren Buffett. Anyone could go to Jaipur, but an extra $3,000 obtained a visit with the maharaja, and $40,000 bought a trip to the Himalyas that stopped off in Malta for dinner with a countess. Exalting, too, the record bid conferring name recognition. What did the public know of asset manager Julius Gaudio before he paid $300,000 for a round of golf with Bill Clinton? Or of Mexican financier David Martinez before his $140 million purchase of Jackson Pollock's *No. 5, 1948*; of WeatherTech founder David MacNeil before his $70 million acquisition of a 1963 Ferrari 250 GTO; of Ukrainian steel magnate Victor Pinchuk before he traded $3.3 million for a photograph by Andreas Gursky? Etching Russia's new oligarchs into memory, Roman Abramovich bought the Chelsea football club, Mikhail Prokhorov bought the Brooklyn Nets, Dmitry Rybolovlev bought the Monaco football club, Viktor Vekselberg paid $100 million for the Forbes collection of Fabergé Imperial Easter eggs, and Maxim Viktorov exchanged $3.9 million for a Guarneri del Gesù violin that he won't play because it "cannot bear any agitation."

For some, luxury is cumulative. "We have, I think, twelve houses all over the world," relayed Philippe Starck, "and all of them have the same equipment." Jerry Seinfeld built a 286-car collection including 40 Porsches, Ralph Lauren maintains 70 of the world's scarcest vehicles in running condition, and architect Rafael Viñoly's "fanaticism" for pianos assembled 11. For others luxury is exclusive. Ringo Starr had Asprey cast a gold and silver chess set from his fingers; Leonardo DiCaprio had Urs

Fischer sculpt him as an actual candle; and Lego Group chief Kjeld Kirk Kristiansen had British artist Jeremy Dickenson portray his collection of cars stacked on top of each other. Buying into history motivated Indianapolis Colts owner James Irsay's $2.4 million purchase of the 120-foot-long, too-fragile-to-unroll manuscript of Jack Kerouac's *On the Road*; Santiago scion Jorge Yarur Bascuñán's $52,000 acquisition of Madonna's bra and bustier; and South Korean poultry tycoon Kim Hong-Kuk's $2.2 million payout for one of Napoleon's bicornes to adopt the Bonaparte adage, "nothing is impossible." For its provenance, mega-jeweler Laurence Graff calls his $24 million purchase of the King of Bavaria's "Wittelsbach" diamond the "pinnacle" of his career.

More marking is the outlay that buys influence—the "chump change" of $5 billion that handed Rupert Murdoch both the *Wall Street Journal* and the Dow Jones to effect an unprecedented media synergy, the $500 million that gave biotech mogul Patrick Soon-Shiong the *Los Angeles Times*, and the $250 million that bought Amazon's Jeff Bezos *The Washington Post* to "conquer the world."

More salutary is the judicious giveaway—the "satisfaction return" of such "win-win" philanthropy as Mexican media tycoon Carlos Slim Helú's $8 billion handouts that left the world's seventh richest man with a comfortable $51 billion. Sharing wealth bestows a "social and psychic benefit," noted the Carlyle Group's David M. Rubenstein, who paid $21 million for the last available copy of the *Magna Carta* to display it in perpetuum at the National Archives. The gifts of $100 million carving "Stephen A. Schwarzman," "Henry R. Kravis," "Ronald O. Perelman," "Sanford I. Weill," and "David Geffen" onto Manhattan landmarks functioned as flattering selfies. "I wanted to do something big," said Steven A. Cohen of the $350 million donated to address veterans' post-traumatic stress disorder, "something that was all mine." Signature giving moved Swiss art scion Nicolas Berggruen to offer an annual million-dollar prize for the "advancement of humanity," and Mark Zuckerberg and Priscilla Chan to pledge 99 percent of their Facebook shares to maximizing "human potential."

More redemptive is the magnanimous gesture. Led off by Indianapolis heiress Ruth Lilly's $100 million bequest to *Poetry* magazine to "discover and celebrate the best poetry," Home Depot's Bernard Marcus gave Atlanta the world's largest aquarium; Target retail-legend Robert J. Ulrich gave Phoenix a world's-largest museum of musical instruments; philanthropist

MADONNA'S CONICAL BRA BUSTIER: FASHIONED BY JEAN PAUL GAULTIER FOR THE QUEEN OF POP'S 1990 BLONDE AMBITION TOUR.

ROY LICHTENSTEIN'S *MASTERPIECE* EXCHANGED IRONY FOR GLORY WHEN PHILANTHROPIST AGNES GUND SOLD IT FOR $168 MILLION TO FUND CRIMINAL JUSTICE REFORM.

Agnes Gund sold a $160 million Roy Lichtenstein masterwork to fund prison reform; and private-equity billionaire Robert F. Smith pledged $34 million to wipe out the debt of Morehouse College's 2019 graduating class. Giving back, roofing-billionaire Diane Hendriks bought up Beloit, Wisconsin, building by building, to revive the blighted town where she and her husband got their start, and Douglas and Kristine Tompkins plowed their windfall from North Face clothing into a million-plus threatened acres of Chile's wilderness and handed them back for a national park. Going forward, the tradition launched with Andrew Carnegie's "He who dies rich, dies disgraced" $350 million giveaway has committed 200 American billionaires to donate half their wealth in their lifetimes, and projects wealthy Americans giving $28 trillion to charities by 2060.

Disproportionate giving tipped the scale. We have come a long way since dynamite-inventor Alfred Nobel astounded Sweden's king by deeding his profits to those "who shall have conferred the greatest benefit on mankind." The 12 dishcloths that John Jacob Astor dropped off at an orphanage presaged the foundation that Vincent Astor established with his share of the nation's then greatest fortune. Rockefeller largesse to medicine, education, and the arts, is incalculable—in their lifetimes, John D. and John D. Jr. gave away $1.5 billion, and their myriad kindnesses extended to

I've never been a millionaire but I know I'd be just darling at it

DOROTHY PARKER

the Christmas presents daughter-in-law Abby Aldrich mailed to each of the 9,000 soldiers in her son's World War II regiment ("I don't want a single man not to have some remembrance").

Yesterday's profits continue to target public good. The Ford Foundation still dispenses over $500 million yearly and the Salvation Army still shelters with McDonald's proceeds from Joan Kroc's $1.5 billion bequest. Credit the myriad foundations to tax incentives but they proved the ultimate enabler. Those of media-mogul Ted Turner, eBay's Pierre Omidyar, financier George B. Kaiser, and Wipro founder Azim Premji support the climate, human rights, and education. The foundation that Hong Kong businessman Li Ka-shing calls his "third son" has funneled over $900 million to education and health; that of software entrepreneur Dietmar Hopp has donated 70 percent of his wealth to cures for childhood diseases; that of legendary investor George Soros has poured over three times his net worth into grants to fight discrimination, repression, and poverty.

The surest bid for immortality—today's papal-indulgence pass to heaven—is bottom-dollar benefaction. Attaining the stratospheric level of giving that he calls money's "second act," Warren Buffett pledged 99 percent of his fortune to the save-the-world Bill & Melinda Gates Foundation—on condition that his name appear nowhere. Brazilian oil magnate Eike Batista aims to top it: "I want to be the world's biggest philanthropist!" It's unlikely he'll outdo those holding legacy luxury's endgame. Billionaire Duty Free Shoppers founder Chuck Feeney, happily down to under $2 million, plans by life's close to give away his rumpled clothes and his subway pass, and media magnate Michael Bloomberg, for one, has promised to part with enough of his $56 billion to test benefaction's age-old best measure—that his check to the undertaker will bounce.

Is there a place here for commerce? Arguably, the over-the-top corporate gesture qualifies as a luxury. *Four* celebrity architects hired to design Ferrari's automotive works in Maranello! Seven *million* Swarovski crystals inset over 1,600 hours for Bloomingdale's 2017 Christmas window display! Corporate luxuries, too, such as Global Level's logo lettered by art star Ed Ruscha; the Karl Lagerfeld couture parades that converted the Grand Palais to a corner of Rajasthan, an ice palace, a garden; and the splendid museums that Bernard Arnault and François-Henri Pinault gave to Paris.

Nothing, though, qualifies branded luxury: not Vikram Chatwal's three-city, ten-party wedding, complete with 10-carat diamond ring, 3,000 candles, 50,000 kilos of flowers, and 65,000 meters of fabric, shown on the Discovery Channel to promote the family's hotel-restaurants; not the $3.2 million opening scene launching the

Make money, be proud of it; make more money, be prouder of it

HENRY LUCE

BBC's *The Grand Tour* on Amazon; nor the Donald and Melania Trump nuptials, whose $1.5 million ring, gown trailing 90 meters of satin, cake iced with 3,000 roses, and Cristal Champagne bubbling through Mar-a-Lago's new 20,000-square-foot ballroom, bought a *Vogue* cover that opened to a double-page ad for "Donald Trump: The Fragrance."

Add to these "business art," the oxymoron that Andy Warhol framed with a dollar sign to profile luxury-turned-commodity. How can "connoisseur" apply to Charles Saatchi, who bought up young artists' work, flipped it, and moved on? Does "collector" describe investors who warehouse masterworks (think the Nahmad brothers' 1,000 Picassos) until their worth triples? And what speaks to ritual about the Chanoyu ceremony held by tea master Sen So-oku in the Gagosian Gallery to promote Takashi Murakami's new paintings? Kicking off a decade of hype, the "scandalous" 1963, $2.2 million sale of taxi tycoon Robert Scull's Pop Art collection lobbed Jasper Johns's *False Start* to François de Menil, on to S. I. Newhouse Jr., then to David Geffen, and then, for $80 million, to Kenneth Griffin. Auction-goers applauded the $40 million profit that Argentina heiress Amalia Fortabat realized from the sale of Van Gogh's *Landscape with Setting Sun*, and the $2.9 million sale of Edward Steichen's one-of-three *The Pond—Moonlight* that triggered a gold rush for photography. Sotheby's auctioneer Tobias Meyer credited "high quality hunger from a global community," while London mega-dealer Iwan Wirth fingered titillation, calling selling "the sexy bit." So would by-invitation auctions drive records for a de Kooning ($300 million), a Monet ($110 million), and a Gauguin ($210 million). "In the end," said seminal art dealer Irving Blum of a Warhol *Soup Can* he had bought for $30, sold for $8.2 million, and knows to be worth millions more, "it all comes down to money"—a claim actualized by a Chris Burden installation of 101 kilos of gold-bullion.

The ever-urgent question remains what tops the top, what sum meets the wow factor, how far must an aspirant reach to get noticed? Has storied luxury been undermined by strivers who never need say "too expensive" settling for packaged pleasures? When a brand is proffered as "a luxury experience," when the phrase "five-star living" can be trademarked, when a celebrity purchase defines taste, when luxury itself is marketed on eBay as an "emotional category"—can large-cap Luxury survive?

ANDY WARHOL'S 1981 *DOLLAR SIGN* COMMENT ON AMERICAN CONSUMERISM: GIFTED TO JERRY HALL, IT BECAME A COMMENT ON LUXURY WHEN THE MODEL-ACTRESS SOLD IT, FOR $348,000.

And what of surfeit in a world struggling to sustain the 99%? Inordinate to strive for a life with as many highs as a culture can offer and money can buy? Wrong to crave the excess that history relates was ever the point? In the end it's a judgment call. "This famous grand French taste is too much. Real French taste is

ZANELE MUHOLI, *KHWEZI, SONGHAI, PORTO NOVO, BENIN*: BUILDING ON BLACK AFRICA'S ELABORATE STYLING, ZANELE MUHOLI'S SELF-PORTRAITS WORK HAIR INTO EXPRESSIONS OF REAL OR IMAGINED IDENTITIES.

what? It's Louis XIV, it's Mme. de Pompadour, it's Marie Antoinette, it's Napoleon and Josephine, the Third and Fourth Republics, Marie-Laure de Noailles, Coco Chanel. That's France. They're all too much. And I'm with them"—this from tastemaker designer/architect Jacques Garcia, who gave the hotel he created from the crumbling Château du Champs-de-Bataille too elaborate a makeover to turn a profit. With them too is food historian Marc Meltonville, who re-created at Hampton Court the meals and utensils from the era of Henry VIII; glass artist Carlos Scarpa, who works acrobatic techniques of *corroso, sommerso, bollicine,* and *battuto* into translucent miracles; designer and architect interior designer Geoffrey Bradfield, whose reimagined "David's Palace" for a client in Jerusalem married a

LE VAISSEAU—OPULENT BACCARAT ARTIFACT, PURCHASED BY A SAUDI PRINCE AT THE 1878 EXPOSITION UNIVERSELLE, GIFTED TO ELECTRICAL PIONEER, GEORGE WESTINGHOUSE JR., AND NOW RESIDING IN JERUSALEM ON A CLAUDE LALANNE TABLE IN A GEOFFREY BRADFIELD–DESIGNED RESIDENCE.

contemporary aesthetic to artworks once owned by sultans and Rothschilds; and Belgian floral artist Daniël Ost, who will travel 500 miles to source material for a rarefied display.

Or has luxury morphed? With the métiers headed for extinction (Paris has seen 10,000 embroiderers reduced to 200, 425 feather houses to four, 120 glove makers to three, 24 milliners to two, and ébénistes and bronziers to a handful), does the world still value the rare and exquisite? *Objets de luxe*, for example, in October 2011, became irrelevant to status. Just nine months after banker-widow Lily Safra had paid a whopping $103.4 million for one of six editions of Alberto Giacometti's

Walking Man I, the ballyhooed four-day, six-catalog, Sotheby's sale of her *d'époch* collection, a world-famous trove of the best of everything in the world of decorative art—bronzes, enamels, ebonies, silverware, stemware, lacquerware, brackets, vases, clocks, consoles, candelabra, jardinières, gueridons, secretaries, birdcages, bureaus, commodes, screens, gouaches, tea caddies, trembleuse porcelain, turned ivories, petit-point pillows, needlepoint carpets, giltwood mirrors, ormolu-mounted tortoiseshells, Brussels tapestries, Meissen figurines, Louis XV fauteuils, Louis XVI tables, the Kremlin dinner service, the Orlov vermeil service, the Popov service, the Yusupov service, the Imperial Yacht service, the Cameo service, dishes monogrammed for the Grand Duke Petrovich, the Grand Duchess Alexandra, and Alexander III—all this glory, this artistry, this history, this *luxury*, sold for only $49 million. Their inherent value intact, and yet not, those supreme signifiers had gone out of fashion.

What, then, will constitute tomorrow's high? Global warming has made a luxury of a cold drink in Ghana and overcrowding has raised to $800,000 the cost of a designated parking spot in Hong Kong. Purveyors have adjusted. Vuitton's "brand manual" engages global issues to "make all our humanity visible," Gucci pays extra for metal-free-produced leather, BMW sources sustainable paneling from Asia's kenaf plant, and haute couture works magic from recycled materials. Celebrity remains a surefire branding tool, but greater is the "brand halo" effect of restoring patria. To Bulgari, Tod's, and Fendi went the praise for saving the Spanish Steps, the Colosseum, and the Trevi Fountain.

Or might luxury refocus, in MasterCard parlance, on that which is priceless? "I don't need more money," announced billionaire "shark" investor Mark Cuban of holdings including two private jets, the NBA's Dallas Mavericks, and a yacht, "I need to be able to enjoy my money." If the dark side of inestimable is the need to purchase life's erstwhile gifts—purified water, canisters of fresh air—the bright side is our ability to regroup. Interior designer to the stars Juan Pablo Molyneux and his wife Pilar recalibrate yearly with a cross-country motorcycle adventure. Karl Lagerfeld collected the best of an era—Louis XV, Biedermeier, Art Deco, Memphis—then sold it all and moved on; "I force myself to get rid of it to clean my mind. . . ." Collector extraordinaire Mitchell Wolfson Jr. clears his mind with an annual tour of the world's operas and a biannual ocean cruise.

Enjoy life fully while you can, it is not given to man to take his property with him

LAY OF THE HARPER

The mind may be luxury's last bastion. Replacing Veblen's aspirational class with the aspirational individual, our #MeToo era is tailoring luxury to each person's idea of it. Already, in a universe that conjures fantasies on mood boards, your thoughts can transport you to a curated dreamland. Already, you can assemble a prize art collection digitally, 3D-print a coveted object, and design a personal lifestyle that derives meaning from an alternate reality.

Less clear is how luxury will gladden a digitized universe. Robots have actualized Veblen's definition of leisure as the "nonproductive consumption of time," freeing the world from driving, reading, and shopping. But can a video that lets us "test-drive Rome" replace a walk down the Via Condotti? Does a brand touted on Instagram by a paid influencer appeal? Can an item delivered by eLuxury.com bring the thrill of a blue box from Tiffany? Perhaps. Analog dreams have proven as seductive as gold. Microsoft's hit video game *Halo 3* left teenager R. J. Bollard with only 73 cents in his bank account, and Iris Ophelia, the avatar of Second Style managing editor Janine Hawkins, spent everything "she" earned in her parallel universe to clock up 31,540 virtual items in 18 months.

Alternatively, might luxury take a right turn and mutate into metaphor—what the philosopher Arthur Danto called the transfiguration of the commonplace? Muses like Luisa Casati and Isabella Blow who made a construct of their lives—their very

OPPOSITE LILY SAFRA'S GIACOMETTI *WALKING MAN I*, ACQUIRED FOR WELL OVER TWICE THE SUM THAT HER VAST AND IRREPLACEABLE COLLECTION OF DECORATIVE ARTS FETCHED AT AUCTION THE FOLLOWING YEAR.

RIGHT LEAVING CELEBRITY AT THE DOOR, JUAN PABLO AND PILAR MOLYNEUX TAKE OFF ON A SOUL-RESTORING ADVENTURE.

Less is a bore

ROBERT VENTURI

bodies—live on in brewery heiress Daphne Guinness, whose outré design ethos ravished the philosopher Bernard-Henri Lévy: "You are no longer a person; you are a concept!"

Artists have done the same for form, space, light, and time. Yves Klein autographed the sky, Tinguely fashioned a sculpture to self-destruct, Robert Smithson spiraled 6,650 tons of rock into Utah's Great Salt Lake, Walter De Maria planted 41 metal lightning poles in the wilderness, and John Cage composed *As Slow as Possible* to be performed in silence over six centuries, opening with a rest lasting

20 months. Proposing desire as effort that looks effortless, Philip Johnson built a small glass house in the woods "so spare of form that it gave little outward hint of the labor that went into it." Defining appearance by disappearance, Andy Goldsworthy sculpted ice that melted when the sun rose; Elizabeth Diller and Ricardo Scofidio created a house out of vapor; Pierre Huyghe sank a concrete structure near a far island in the Sea of Marmara that visitors cannot find; and Song Dong has been writing a daily diary with water. Positing concept as heroic, Michael Heizer has committed 48 years to creating a "City" in the Nevada desert that he may never complete; James Turrell has spent more than that carving out apertures in a volcano in Arizona to view on celestial events occurring every ten, ten thousand, or million years; and Christo and Jeanne-Claude wrapped the Reichstag, dressed 11 islands in Miami, and planted 23 miles of Manhattan with 7,500 saffron gates. As Christo observed of *The Floating Piers* (three landmasses near Brescia linked with fabric to let humans walk on water), "These projects are

LEFT DAPHNE GUINNESS: THE HIGH-SOCIETY ONE-OFF WHO WORKS FASHION INTO ALLEGORIES—FOR LIFE, NOT EVENTS, HOLDING THAT BEING ALIVE IS AN EVENT IN ITSELF.

OPPOSITE
SURROUNDED ISLANDS: THE HEROIC CHRISTO AND JEANNE-CLAUDE 14-DAY INSTALLATION IN MIAMI THAT WRAPPED 11 ISLANDS WITH 6.5 MILLION SQUARE FEET OF PINK POLYPROPYLENE TO TRANSFORM BISCAYNE BAY INTO A SHIMMERING CANVAS.

*When I'm used to
seeing diamonds, I'm
used to seeing them
shiny and in a box*

NAOMI CAMPBELL

irrational, totally useless, the world can live without them," existing only, he added,
"because we like to have them."

Filtering concept into the material aquifer of desire, Jil Sander left the mirrored
white "mindspace" of her SoHo store empty, Sèvres produced a spiky centerpiece
by sculptor Charles Simonds that is too sharp to move, and Issey Miyake created
a fragrance, L'Eau D'Issey, which, like water, smells of nothing. Flagged by the
just-opened Kisawa sanctuary-resort developed by Nina Flohr "to inspire feelings of
freedom and luxury born from nature, space, and true privacy," the new mindset will
keep seeking the intimate, the understated, the improbable, the ineffable—one more
decade, one more year, one more month, on this earth—frills be damned.

Or will it? In 2009, when Mauboussin met its chief executive's stated need to "return
to reason, decency, and discretion" with a small discount on its $22,000 diamond
solitaire, predictable as morning, the counter-irony of a diamond ring mounted
inside-out by conceptual artist Tobias Wong drew less press. Life had reverted to
glitz, defined by Damien Hirst's $100 million platinum skull crusted with 8,601
diamonds to stand as a metaphor for "luxury and hope and wealth and commerce."
Hirst's initial concern about a human head become "bling" changed to "it would
be great to do a diamond one—but just prohibitively expensive. Then I started to
think—'Maybe that's why it's a good thing to do,'" resulting in a limited edition of
$20,000, diamond-flecked skull prints—which sold out.

Let the Millennials say "enough's now enough" and opt for enriching experiences
over rich possessions, evolution studies reveal an erotic connection to material luxury
that goes deep. Bowerbirds are obsessive collectors of glitter, and several monkey
species demonstrate a preference for many over one, suggesting a genetic craving
that pins our very survival on accumulation and display. Diana Wang, thinking to
outclass her fellow *fuerdai* (Chinese scions who flash around Vancouver in white
Lamborghinis) by trading her mansion and 30 Chanel handbags for a life on the
streets, lasted only three days.

ABOVE *TUMBLEWEED*, BY
CHARLES SIMONDS:
THE COUNTER-CULTURE
LUXURY OF SÈVRES
PORCELAIN THAT IS TOO
PRICKLY TO HANDLE.

Cost, studies show, does measure satisfaction. At a recent blind tasting of variously priced wines volunteers derived more pleasure from cheap ones marked high; at currency auctions set up for score over profit bidders spent $1.50 to take home $1; and in Manhattan overnight billionaires booked the priciest hotel suite (the Four Seasons penthouse) just to show off the bill. Players derived a high, too, from such as entrepreneur Pan Sutong's 222-acre polo club complex, designed to introduce Hong Kong's fellow billionaires to fast horses, haute cuisine, a seven-million bottle wine cellar, and a 117-story office building serviced by butlers "fully conversant with royal service and protocol." And from improbable gambles, such as Ordos 100—the opera house, five-star hotel, and 100-house complex that developer Cai Jiang built in Inner Mongolia and abandoned to a ghost town three years later.

What then of the "wealth fatigue syndrome" posited by psychoanalyst Manfred Kets de Vries? Or of findings that people suffer more from depression in wealthy than in poor communities? Or that people making $200,000 per year are just 9 percent more satisfied than those making $100,000? And what of the upward-mobility anxiety factor said to make those marginally richer than their neighbors feel better, but those much richer feel worse? Downturn has been seen to rob luxury of its zing, consigning the red Porsche to the garage and reducing the trophy home to a white elephant. Shakespeare's Timon told how fortune isolates: "I have often wished I was poorer, that I might come nearer to you." "The problem with being rich," observed Baron Heinrich von Thyssen, "is that it condemns you to a life of loneliness." So may

What I want to do now is to give away everything

WARREN BUFFETT

Fortune's runaway cousin Fame: to escape detection at a gallery opening, the artist Richard Prince circulated with his head in a grocery bag.

The deeper problem may be one of manufactured desire—personal fulfillment promised by the "luxuries" commodified from Big Data. Therapists propose a new vision, urging strivers to jettison "stuff" and replace the goal of more money with those of dignity, community, and wellbeing—what Robert F. Kennedy called the "life worth living." Statisticians point to the Danes, living in the dark and the cold, and yet—warmed by a social interaction they call *hygge*—among the world's happiest people.

How, though, rewire desire that is likely genetic? Neurologists reference a pleasure zone deep in the brain that connects material gain to the same reward circuitry as cocaine. F. Scott Fitzgerald's Nick Carraway was content with the "consoling proximity of millionaires," but Gatsby wanted in. "Imagine no possessions," John Lennon proposed, but few people can. Nobody needs a watch to tell time anymore but we'll buy one for show. A study of conspicuous consumption during recession 2008 found that high-end retailers like Gucci and Vuitton who inflated their prices did well. The new profession of wantology, recognizing our addiction to shopping, posted guidelines: see what people want by what they buy; tell people what

KISAWA SANCTUARY: THE JUST-OPENED, HIGH-LUXURY, MOZAMBIQUE RESORT, 3D-PRINTED FROM SAND AND SEAWATER TO PROVIDE AN ESCAPIST EXPERIENCE FULLY SUPPORTIVE OF MARINE LIFE.

CRANES FLYING:
FOUR-SCREEN PANEL
DETAILING THE ASIAN
SYMBOL OF LONGEVITY
WITH THE PAINSTAKING
PAINTING-WITH-NEEDLES
TECHNIQUE REVIVED BY
YOUNG YANG CHUNG.

to want by what you sell. Positing luxury as identity, Anton Chekhov famously wrote: "Tell me what you want and I'll tell you who you are."

Ultimately, desire is helpless. Ignoring the expense, Mungo Park's search for Timbuktu led him "out into the unknown in obedience to an inward voice, to an impulse beating in the blood, to a dream of the future." Asked if he'd heard that some fool had paid 1,450 pounds for a Two Pence colonial stamp, the future King George V retorted: "You're talking to him." Questioned about bidding to folly for a Louis XV table, businessman Djahanguir Riahi replied: "L'amour n'a pas de prix." On refusing Saudi King Khalid's handsome offer for an exceptional set of diamonds, their owner shrugged: "How could I sell my children?" When the colossal Bamiyan Buddhas were felled, Lushan County in Henan erected a defiant record-tall Vairocana Buddha.

If, in the end, we are wired for splendor, is the impulse so regrettable? The rigorous moralist August Strindberg said that the fault in others he found easiest to forgive was extravagance. The French intellectual Georges Bataille proposed that all history is culture and all culture is luxury. Luxury is physiological, asserted the philosopher Pierre-Joseph Proudhon—nourishment taken through the pores, eyes, ears, nostrils, imagination, and memory. Happiness, maintained founder-psychologist Sigmund Freud, is the adult fulfillment of childhood dreams. "Reality," pronounced fashion icon Diana Vreeland, "is a world as you feel it to be, as you wish it into being." The aesthete Oscar Wilde nailed it: "We don't have the wherewithal to go without luxury."

It remains to be seen, post-pandemic, how the new normal will realign luxury. With longing as vital as a heartbeat, one thing is certain—the immortality of desire. The complex beings we are cannot thrive on bread alone. We need the nourishment of best, beautiful, and, yes, glorious, to flourish. To seek luxury is to deeply engage. To cultivate luxury is to fully live. As we yearn on for beyond, let us skim the cream, dream the dream, seize the day, save the planet, and eat cake.

SELECTED BIBLIOGRAPHY

Adams, Robert. *Paths of Fire: An Anthropologist's Inquiry into Western Technology*. Princeton, NJ: Princeton University Press, 1996.

Ahmad, Jalal Al-i. *Occidentosis: A Plague from the West*. Translated by R. Campbell. Berkeley, CA: Mizan Press, 1984.

Alden, Dauril. *Royal Government in Colonial Brazil: With Special Reference to the Administration of the Marquis of Lavradio, Viceroy, 1769–1779*. Berkeley: University of California Press, 1968.

Alexander, David. *Retailing in England during the Industrial Revolution*. London: Althone Press, 1970.

Amory, Cleveland. *The Last Resorts*. New York: Harper & Brothers, 1952.

Amory, Cleveland. *Who Killed Society?* New York: Harper & Brothers, 1960.

Ashton, T.S. *The Industrial Revolution, 1760–1830*. London: Oxford University Press, 1948.

Ault, Warren O. *Europe in the Middle Ages*. New York: D.C. Heath and Company, 1937.

Auslander, Leora. *Taste and Power: Furnishing Modern France*. Berkeley: University of California Press, 1996.

Bankes, George. *Peru before Pizarro*. Oxford: Phaidon Press, 1977.

Barraclough, Geoffrey. *The Medieval Papacy*. New York: W.W. Norton, 1979.

Barzun, Jacques. *From Dawn to Decadence: 1500 to the Present: 500 Years of Western Cultural Life*. New York: HarperCollins, 2000.

Bataille, Georges. *Les larmes d'Eros*. Paris: Bibliothèque International d'Érotologie, 1964.

Baudrillard, Jean. *La Société de consommation*. Paris: Éditions Gallimard, 2000.

Beaton, Cecil. *The Glass of Fashion*. London: Cassell, 1956.

Beaudrillart, Henri. *Histoire du luxe privé et publique depuis l'antiquité jusqu'à nos jours*. Paris: Librairie Hachette, 1981.

Behrend, George. *Luxury Trains: From the Orient*.

Benedict, Ruth. *Patterns of Culture*. New York: Houghton Mifflin, 1934.

Benedict, Ruth. *The Chrysanthemum and the Sword*. New York: Houghton Mifflin, 1946.

Berg, Maxine, and Helen Clifford. *Consumers and Luxury: Consumer Culture in Europe (1650–1850)*. Manchester, UK: Manchester University Press, 1999.

Bernand, Carmen. *The Incas: People of the Sun*. New York: Harry N. Abrams, 1988.

Bernier, François. *Voyage dans les États du Grand Mongol*. Paris: Fayard, 1981.

Berry, Mary Elizabeth. *Hideyoshi*. Cambridge, MA: Harvard University Press, 1982.

Binder, Pearl. *Muffs and Morals*. London: George G. Harrap, 1953.

Birmingham, Stephen. *California Rich*. New York: Simon & Schuster, 1980.

Birmingham, Stephen. *The Grandes Dames*. New York: Simon & Schuster, 1982.

Boehn, Max von. *Modes and Manners*. London: George Harrap & Co., 1932.

Bouchot, Henri. *The Printed Book. Its History, Illustration, and Adornment*. Paris: H. Grevel and Co., 1887.

Boulnois, Luce. *La route de la soie*. Geneva: Olizane, 1963.

Bowles, Hamish. *Jacqueline Kennedy: The White House Years*. New York: Bullfinch Press, 2001.

Bradfield, Geoffrey. *A 21st Century Palace*. New York: Smallwood & Stewart, 2012.

Brandon, Ruth. *The Dollar Princesses*. London: Weidenfeld & Nicolson, 1980.

Briggs, Ada, ed. *The Nineteenth Century: The Contradiction of Progress*. London: Thames & Hudson, 1970.

Brinnin, John, and Kenneth Gaulin. *Grand Luxe: The Transatlantic Style*. New York: Henry Holt, 1988.

Brooks, David. *Bobos in Paradise: The New Upper Class and How They Got There*. New York: Simon & Schuster, 2000.

Brown, Jane. *The Pursuit of Paradise: A Social History of Gardens and Gardening*. London: HarperCollins, 1999.

Bulliet, Richard W. *Islam: The View from the Edge*. New York: Columbia University Press, 1994.

Burckhardt, Jacob. *The Civilization of Rome in Italy*. London: Phaidon, 1954.

Burckhardt, Jacob. *The Civilization of the Renaissance in Italy*. London: Phaidon, 1951.

Campbell, Greg. *Blood Diamonds*. New York: Basic Books, 2002.

Campbell, Joseph. *Transformations of Myth Through Time*. New York: HarperCollins, 1990.

Cantor, Norman F. *The Medieval World, 300–1300*. New York: Macmillan, 1963.

Carlyle, Thomas. *The History of Friedrich II of Prussia.* Leipzig: Tauschnitz, 1858.

Carter, Ernestine. *The Changing World of Fashion.* London: Weidenfeld & Nicolson, 1977.

Cassini, Oleg. *In My Own Fashion: An Autobiography.* Riverside, NJ: Simon & Schuster, 1987.

Casterède, Jean. *Le luxe.* Paris: Presses Universitaires de France, 1992.

Castiglione, Baldessare. *The Book of the Courtier.* New York: Scribner's, 1903.

Chase, Edna Woolman, and Ilka Chase. *Always in Vogue.* London: Victor Gollancz, 1954.

Chevalier, François. *Land and Society in Colonial Mexico: The Great Hacienda.* Berkeley: University of California Press, 1963.

Chin, Edmond. *Gilding the Phoenix: The Straits Chinese and Their Jewellery.* Singapore: National Museum, 1991.

Chklovski, Victor. *Le voyage de Marco Polo.* Paris: Payot, 1938.

Chung, Young Yang. *Silken Threads: A History of Embroidery in China, Korea, Japan, and Vietnam.* New York: Harry N. Abrams, 2005.

Churchill, Winston. *The Hinge of Fate.* Vol. 4 of *The Second World War.* Boston: Houghton Mifflin, 1950.

Cielsik, Mark. *The Happiness Riddle and the Quest for a Good Life.* London: Palgrave Macmillan, 2016.

Clark, Kenneth. *The Gothic Revival; an essay in the history of taste.* New York: Scribner, 1964.

Cobban, Alfred, ed. *The Eighteenth Century: Europe in the Age of Enlightenment.* London: Thames and Hudson, 1969.

Collingwood, R.G. *The Idea of History.* Oxford: Clarendon Press, 1946.

Corson, Richard. *Fashions in Hair.* New York: Hastings House, 1965.

Cox, Caroline. *Luxury Fashion: A Global History of Heritage Brands.* London: Bloomsbury, 2013.

Creed, Charles. *Maid to Measure.* London: Jarrolds, 1961.

Crites, Mitchell, and Ameeta Nanji. *India Sublime: Princely Palace Hotels of Rajasthan.* New York: Rizzoli, 2007.

Crone, Patricia. *Pre-industrial Societies.* Oxford, UK: Basil Blackwell, 1989.

Davenport, Millia. *The Book of Costume.* New York: Crown, 1948.

Davidson, Ian. *Voltaire: A Life.* New York: Pegasus Books, 2010.

Dawson, Raymond. *The Chinese Experience.* London: Orion Books, 2020.

De Bourdeille Brantôme, Pierre. *Les Dames Galantes.* Paris: Éditions Gallimard, 1981.

De Dearing, Albin. *The Elegant Inn: The Waldorf-Astoria Hotel, 1893–1929.* Charleston, SC: Arcadia, 1957.

De Fouquières, André. *Cinquante Ans de Panaché.* Garden City, NJ: Doubleday & Co, 1974.

De Madariaga, Isabella. *Catherine the Great: A Short History.* New Haven, CT: Yale University Press, 1993.

De Vries, Manfred Kets. *Sex, Money, Happiness and Death: The Quest for Authenticity.* London: Palgrave Macmillan, 2009.

De Zemler, Charles. *Once Over Lightly.* New York: Private printing, 1939.

Diamond, Jared M. *Guns, Germs and Steel: The Fates of Human Societies.* New York: W.W. Norton, 1999.

Diba, Layla S. *Turkmen Jewelry: Silver Ornaments from the Marshall and Marilyn R. Wolf Collection.* New York: Metropolitan Museum of Art, 2011.

Dickens, Charles. *Essays and Sketches of Charles Dickens.* New York: Macmillan, 1951.

D'Istria, Robert Colonna. *L'art du luxe.* Paris: Transbordeurs, 2006.

Du Bois, W.E.B. *The Quest of the Silver Fleece.* Chicago: A.C. McClury & Co., 1911.

Durand, Robert. *Histoire du Portugal.* Paris: Hatier, 1992.

Eisenstadt, Shmuel. *The Political Systems of Empires.* Glencoe, IL: Free Press, 1963.

Elliott, Frances. *Old Court Life in France.* New York: G.P. Putnam's Sons, 1893.

Elliott, John H. *Spain and Its World 1500–1700.* New Haven, CT: Yale University Press, 1989.

Ellisseef, Danielle. *Hideyoshi: Batisseur du Japon moderne.* Paris: Fayard, 1986.

Etherege, George. *Man of Mode.* London: H. Herringman, 1676.

Fage, J.D. *A History of Africa.* New York: Routledge, 2001.

Fairholt, F.W. *Costume in England.* London: Chapman and Hall, 1846.

Faith, Nicholas. *The World the Railways Made.* London: Bodley Head, 1990.

Farmer, James E. *Versailles and the Court Under Louis XIV.* New York: Century, 1995.

Fass, Patrick. *Around the Roman Table: Food and Feasting in Ancient Rome.* London: Palgrave Macmillan, 2003.

Field, Michael. *Inside the Arab World.* Cambridge, MA: Harvard University Press, 1994.

Flanner, Janet. *Paris Was Yesterday.* New York: Viking, 1972.

Foan, G.A. *Art and Craft of Hairdressing.* London: Pitman, 1936.

Fogel, Robert W. *Without Consent or Contract: The Rise and Fall of American Slavery*. New York: W.W. Norton, 1989.

Frazer, James. *The Golden Bough*. New York: Macmillan, 1976.

Gabet, Olivier. *Dix mille ans de luxe*. Exhibition. Le Louvre Abu Dhabi, 2019.

Gaddis, John L. *The Landscape of History: How Historians Map the Past*. Oxford: Oxford University Press, 2004.

Gellner, Ernest. *Plough, Sword and Book: The Structure of Human History*. London: Collins Harvill, 1988.

Ghirshman, Roman. *Perse: Proto-iraniens. Mèdes. Achéménides*. Paris: Éditions Gallimard, 1963.

Gibbon, Edward. *The History of the Decline and Fall of the Roman Empire*. London: Strahan & Cadell, 1776–1789.

Gibbons, Herbert Adams. *The Foundation of the Ottoman Empire*. Oxford, UK: Clarendon Press, 1916.

Gibson, Charles. *Spain in America*. New York: Harper & Row, 1966.

Gilder, George. *Wealth and Poverty*. New York: Basic Books, 1981.

Giroud, Françoise. *Dior: Christian Dior, 1905–1957*. London: Thames and Hudson, 1987.

Gombrich, Ernst H. *The Story of Art*. New York: Phaidon, 1951.

Goodman, Jordan. *Tobacco in History: The Cultures of Dependence*. New York: Routledge, 1993.

Gottlieb, Anthony. *The Dream of Enlightenment*. London: Liveright, 2017.

Grand-Carteret, John. *Les élégances de la toilette*. Paris: Albin Michel, 1913.

Greene, Robert. *A Quip for an Upstart Courtier*. London: John Wolfe, 1592.

Grimal, Nicolas. *The History of Ancient Egypt*. Translated by Ian Shaw. Malden, MA: Blackwell, 1998.

Hammerton, J.A., ed. *Wonders of the Past*. 3 vols. London: Fleetway House, 1923.

Hassig, Ross. *War and Society in Ancient Mesoamerica*. Berkeley: University of California Press, 1992.

Hattstein, Markus, and Peter Delius, eds. *Islam: Art and Architecture*. Cologne: Koneman, 2000.

Haudrère, Philippe, and Gérard Le Bouédec. *Les compagnies des Indes*. Rennes: Editions Ouest-France, 1999.

Hayward, Maria. *Dress at the Court of King Henry Vlll*. Leeds: Maney, 2007.

Hibbert, Christopher. *The Grand Tour*. New York: G.P. Putnam's Sons, 1969.

Hibbert, Christopher. *The Dragon Wakes: China and the West, 1793–1911*. London: Longman, 1970.

Hogarth, William. *The Analysis of Beauty*. London: John Reeves, 1753.

Hopkins, A.G. *An Economic History of West Africa*. New York: Columbia University Press, 1973.

Hughes, Lindsey. *Peter the Great: A Biography*. New Haven, CT: Yale University Press, 1998.

Huizinga, John. *The Waning of the Middle Ages*. Garden City, NY: Doubleday, 1924.

Hunter, William W. *1840–1900: History of British India*. 2 vols. London: Longmans Green, 1912–1919.

Huysmans, Joris-Karl. *À Rebours*. London: Fortune Press, 1946.

Jackson, Anna, and Amin Jaffer, eds. *Maharajah: The Splendour of India's Royal Courts*. London: V&A Publishing, 2009.

Jaffer, Amin, ed. *Beyond Extravagance: A Royal Collection of Gems and Jewels*. New York: Assouline, 2013.

Jasol, Karni. *Peacock in the Desert: The Royal Arts of Jodhpur, India*. Houston: Museum of Fine Arts, 2018.

Jones, Brian W. *The Emperor Domitian*. London: Routledge, 1993.

Kautsky, John H. *The Politics of Aristocratic Empires*. Chapel Hill: University of North Carolina Press, 1982.

Keswick, Maggie. *The Chinese Garden: History, Art & Architecture*. New York: Rizzoli, 1978.

Kimbell, David. *Italian Opera*. Cambridge: Cambridge University Press, 1991.

Kirkpatrick, F.A. *The Spanish Conquistadores*. London: A. & C. Black, 1934.

La Croix, Paul. *Les arts au moyen age*. Paris: Firmin-Didot, 1880.

Landes, David. *The Wealth and Poverty of Nations*. New York: W.W. Norton, 1998.

Lapatin, Kenneth. *Luxus: The Sumptuous Arts of Greece and Rome*. Los Angeles: J. Paul Getty Museum, 2015.

Laver, James. *Clothes*. New York: Horizon Press, 1953.

Lehrman, Jonas. *Earthly Paradise: Garden and Courtyard in Islam*. London: Thames & Hudson, 1980.

Levathes, Louise E. *When China Ruled the Seas: The Treasure Fleet of the Dragon Throne 1405–33*. New York: Simon & Schuster, 1994.

Lewis, Bernard. *The Muslim Discovery of Europe*. New York: W.W. Norton, 1982.

Liberman, Alexander. *Greece, Gods and Art*. New York: Viking Press, 1968.

Lovegreen, Sylvia. *Fashionable Food*. New York: Macmillan, 1995.

Lynch, John. *Spain 1516–1598: From Nation State to World Empire*. Oxford: Basil Blackwell, 1991.

Lynes, Russell. *The Tastemakers*. New York: Harper & Brothers, 1955.

MacCulloch, Diarmaid. *The Reformation: A History*. London: Church House, 2001.

Machiavelli, Niccolò. *The Prince*. London: Penguin Classics, 2011.

Mackey, Sandra. *Inside the Desert Kingdom*. New York: W.W. Norton & Co, 1987.

Mâle, Emile. *Religious Art in France*. Princeton, NJ: Princeton University Press, 1978.

Mandler, Peter. *The Rise and Fall of the Stately Home*. New Haven, CT: Yale University Press, 1977.

Mann, Michael. *The Sources of Social Power: The Arm of Revolution*. 4 vols. Cambridge: Cambridge University Press, 1986.

Marcus, G.J. *The Conquest of the North Atlantic*. New York: Oxford University Press, 1981.

Markus, H. & P. Delius, ed. *Islam Art and Architecture*. New York; Konemann, 2004.

Massie, Robert. *Catherine the Great: Portrait of a Woman*. New York: Random House, 2012.

Mauries, Patrick. *Cabinets of Curiosities*. New York: Thames & Hudson, 2002.

Maxwell, Elsa. *How to Do It: Or, the Lively Art of Entertaining*. Boston: Little, Brown, 1957.

McConathy, Dale, and Diana Vreeland. *Hollywood Costume: Glamour! Glitter! Romance!* New York: Harry N. Abrams, 1976.

McCullough, David. *Great Achievements in American History*. New York: Simon & Schuster, 2017.

McKensie, Jordan. *Deconstructing Happiness: Critical Society and the Good Life*. New York: Routledge, 2016.

McPhee, Laura. *A Journey into Matisse's South of France*. Berkeley: Roaring Forties Press, 2006.

Means, Philip. *Ancient Civilization of the Andes*. New York: Scribner, 1931.

Mehta, Ved. *Portrait of India*. New York: Farrar, Straus and Giroux, 1970.

Michelet, Jules. *Histoire de France*. Lausanne: Éditions Recontre, 1966.

Milton, Joyce. *Sunrise of Power: Ancient Egypt, Alexander and the World of Hellenism*. New York: HBJ Press, 1980.

Mitchell, Edwin V. *Concerning Beards*. New York: Dodd, Mead & Co., 1930.

Mitford, Nancy. *Madame de Pompadour*. New York: HBJ Press, 1980.

Morley, John. *The Making of the Royal Pavilion, Brighton: Design and Drawings*. London: Philip Wilson Publishers, 2003.

Mote, F.W. *Imperial China, 900–1800*. Cambridge, MA: Harvard University Press, 1999.

Moynihan, Brian. *The Russian Century: A History of the Last Hundred Years*. New York: Random House, 1994.

Mumford, Lewis. *The City in History: Its Origins, Its Transformations, and Its Prospects*. New York: Brace and World, 1961.

Naipaul, V.S. *The Return of Eva Perón*. New York: Vintage Books, 1981.

Northrup, David. *Indentured Labor in the Age of Imperialism, 1834–1922*. Cambridge, UK: Cambridge University Press, 1995.

Norton, Lucy, ed. *Memoirs of Duc de Saint-Simon, 1691–1709: Presented to the King*. London: Carlton Publishing Group, 1999.

Norwich, John Julius. *A Short History of Byzantium*. New York: Vintage Books, 1999.

Norwich, John Julius. *The Middle Sea*. New York: Doubleday, 2006.

Ober, Josiah. *Mass and Elite in Democratic Athens*. Princeton, NJ: Princeton University Press, 2005.

Ober, Josiah. *Rise and Fall of Classical Greece*. Princeton, NJ: Princeton University Press, 2015.

Parlett, David S. *The Oxford Guide to Card Games*. Oxford: Oxford University Press, 1979.

Parrot, André. *Assur*. Paris: Librairie Gallimard, 1961.

Parry, John H. *The Age of Reconnaissance*. London: Weidenfeld & Nicolson, 1963.

Perrot, Jean, ed. *The Palace of Darius at Susa*. London: I.B. Tauris, 2013.

Peyrefitte, Alain. *The Immobile Empire*. New York: Knopf, 1992.

Pick, Michael. *Be Dazzled! Norman Hartnell: Sixty Years of Glamour and Fashion*. New York: Pointed Leaf Press, 2007.

Piesse, G.W.S. *The Art of Perfumery*. London: Piesse and Lubin, 1862.

Pirenne, Henri. *Mohammed and Charlemagne*. London: George Allen & Unwin, 1954.

Plutarch. *Selected Lives*. London: Franklin Library, 1977.

Praz, Mario. *An Illustrated History of Interior Decoration: From Pompeii to Art Nouveau*. London: Thames & Hudson, 1964.

Quant, Mary. *Quant by Quant*. London: Cassell, 1966.

Raban, Jonathan. *Arabia: A Journey Through the Labyrinth*. New York: Simon & Schuster, 1979.

Runciman, Steven. *A History of the Crusades*. 3 vols. Cambridge: Cambridge University Press, 1951–1954.

Rydell, Robert. *World of Fairs*. Chicago: University of Chicago Press, 1993.

Rykwert, Joseph. *The Palladian Ideal*. New York: Rizzoli, 1999.

Samuels, Ernest. *Bernard Berenson: The Making of a Connoisseur*. Cambridge, MA: Belknap Press of Harvard University Press, 1987.

Schama, Simon. *The Embarrassment of Riches: An Interpretation of Dutch Culture in the Golden Age*. New York: Knopf, 1987.

Scharma, Ruchir. *The Rise and Fall of Nations*. London: W.W. Norton, 2016.

Scheips, Charlie. *American Fashion*. New York: Assouline, 2007.

Scheips, Charlie. *Elsie de Wolfe's Paris: Frivolity before the Storm*. New York: Abrams, 2014.

Secrest, Meryle. *Duveen, A Life in Art*. Chicago: University of Chicago Press, 2005.

Sitwell, Sacheverell. *British Architects and Craftsmen*. London: B.T. Batsford, 1948.

Smith, Vincent. *Early History of India*. London: Atlantic Books, 1999.

Soros, George. *The Alchemy of Finance*. New York: Simon & Schuster, 1987.

Spear, Percival Thomas George. *The Nabobs: A Study of the Social Life of the English in Eighteenth-Century India*. London: Oxford University Press, 1932.

Spence, Jonathan. *Emperor of China: Self Portrait of K'ang-hsi*. New York: Knopf, 1974.

Spence, Jonathan. *The Search for Modern China*. New York: W.W. Norton, 1990.

Strong, Roy. *The English Icon: Elizabethan and Jacobean Portraiture*. New York: Pantheon Books, 1969.

Subrahmanyam, Sanjay. *The Portuguese Empire in Asia 1500–1700: A Political and Economic History*. New York: Wiley-Blackwell, 1993.

Tapert, Annette. *The Power of Style: The Women Who Defined the Art of Living Well*. New York: Crown, 1994.

Thompson, Harrison. *Europe in Renaissance and Reformation*. New York: Harcourt, Brace & World, 1963.

Thompson, Paul. *The Edwardians*. London: Weidenfeld & Nicolson, 1975.

Thorndike, Joseph J., Jr. *The Very Rich: A History of Wealth*. New York: American Heritage Publishing, 1976.

Thucydides. *The Landmark Thucydides*. New York: Free Press, 1996.

Topsfield, Andrew, ed. *In the Realm of Gods and Kings*. London: Philip Wilson Publishers, 2004.

Toynbee, Arnold. *A Study of History*. 12 vols. New York: Dell, 1934–1961.

Tracy, James, ed. *The Political Economy of Merchant Empires: State Power and World Trade 1350–1750*. New York: Cambridge University Press, 1991.

Tully, Andrew. *Era of Elegance*. New York: Funk & Wagnalls, 1947.

Vanderbilt, Gloria/Thelma, Lady Furness. *Double Exposure: A Twin Biography*. Philadelphia: D. McKay Co., 1958.

Vasari, Giorgio. Trans. E.L. Seeley. *Stories of the Italian Artists from Vasari*. New York: Dutton, 1908.

Veblen, Thorsten. *The Theory of the Leisure Class: An Economic Study of Institutions*. New York: Macmillan, 1899.

Verheiden, Jacob. *Portraits of Famous Men from the Reformation*. The Hague, 1602.

Villiers-Stuart. *Gardens of the Great Mughals*. Chicago: Hard Press, 2012.

Viollet-le-Duc, Éugene. *Dictionnaire raisonné du mobilier français de l'époque carlovingienne à la renaissance*. Paris: Librairie Centrale d'Architecture, 1873.

Voltaire. *Siècle de Louis XIV*. Berlin: C.F. Henning, 1751.

Von Boehn, Max. *Modes and Manners*. 4 vols. London: George G. Harrap, 1932–1935.

Waldron, Arthur. *The Great Wall of China: From History to Myth*. New York: Cambridge University Press, 1990.

Walker, Danielle. *Flowers Underfoot: Indian Carpets of the Mughal Era*. London: Thames & Hudson, 1998.

Wang, Daisy Y., and Jan Stuart, eds. *Empresses of China's Forbidden City, 1644–1912*. Salem, MA: Peabody Essex Museum; and Washington, DC: Freer/Sackler, Smithsonian Institution, 2018.

Williams, Eric. *Capitalism and Slavery*. Chapel Hill: University of North Carolina Press, 1944.

Williams, Karel. *From Pauperism to Poverty*. London: Routledge & Kegan Paul, 1981.

Williams, Roger L. *The World of Napoleon III: 1851–1870*. New York: Collier Books, 1962.

Wilson, Derek. 1994. *Rothschild: A Story of Wealth and Power*. London: Mandarin, 1994.

Woronov, Mary. *Swimming Underground: My Years in the Warhol Factory*. Boston: Journey Editions, 1995.

Yergin, Daniel. *The Prize: The Epic Quest for Oil, Money and Power*. New York: Simon & Schuster, 1991.

Young, G.F. *The Medici*. New York: Modern Library, 1933.

Young, G.M. *Victorian England: Portrait of an Age*. Oxford: Oxford University Press, 1936.

Young, Sheila. *The Queen's Jewelry: The Jewels of H.M. Queen Elizabeth II*. London: Ebury Press, 1969.

Young-Tsu, Wong. *A Paradise Lost: The Imperial Garden*. Honolulu: Hawai'i Press: 2001.

Ziskin, Rochelle. *The Place Vendôme: Architecture and Mobility in Eighteenth-Century Paris*. Cambridge: Cambridge University Press, 1999.

IMAGE CREDITS

INDEX

Jill Spalding IS A JOURNALIST, ART CRITIC, RADIO HOST, AND AUTHOR OF THE BESTSELLER *ONLY THE BEST*. FOLLOWING STINTS AT ÉDITIONS GALLIMARD IN PARIS AND WEIDENFELD & NICOLSON IN LONDON SHE BUILT A LIFELONG CAREER AT CONDÉ NAST. IN 1969, AS FEATURES EDITOR OF *BRITISH VOGUE*, SPALDING INITIATED ITS FAMOUS ECOLOGY-ORIENTED "BLUE ISSUE," ALERTING READERS TO THE DEPLETION OF WILDLIFE AND NATURAL RESOURCES. AFTER MOVING TO LOS ANGELES SHE WROTE A FOOD COLUMN FOR *VOGUE ENTERTAINING AND TRAVEL* AND INTERVIEWED PERSONALITIES SUCH AS FIDEL CASTRO, NANCY REAGAN, HUNTER THOMPSON, CARL SAGAN, MICHAEL CRICHTON, TOM WOLFE, AND BUCKMINSTER FULLER. UNDER HER EDITORSHIP, *VOGUE* WAS AMONG THE FIRST TO PUBLISH THE WORK OF FRANK GEHRY, ROBERT MAPPLETHORPE, HERB RITTS, AND DAVID HOCKNEY.